# A Doré gallery

Arco Publishing Company, Inc.
New York

Published 1974 by Arco Publishing Company, Inc.
219 Park Avenue South, New York, N.Y. 10003

Library of Congress Catalog Card Number 73-91686

ISBN 0-668-03444-0

Printed in Great Britain

# Contents

# MEMOIR OF GUSTAVE DORÉ.

———◆———

F the life of Gustave Doré there is not much to relate. The great French artist is too young a man to have accumulated about him those incrustations of anecdote and reminiscence, which grow round the name and fame of men whose working life dates backward half a century or so. His career resolves itself, for the most part, into a list of art-productions of singular variety and extraordinary power; and in recording these we give the liveliest idea possible as yet of the brilliant genius now so popular both in Europe and America.

PAUL GUSTAVE DORÉ (for such are his full names) was born on the 6th of January, 1832, at Strasburg. His father was an engineer, and, judging by his name, seems to have been of pure French stock; but Strasburg is to a great extent a German town, and indeed the whole of Alsace, to which it belongs, has more of the Teutonic than the Gallic element. This eastern province was ceded to France by Austria at various periods of the seventeenth century. Its German character is evinced in the names of its towns, in the patronymics of many of its inhabitants, and in the dialect spoken by the humbler orders. At Strasburg the Protestants are numerous, and statues of German celebrities, and of French celebrities with German names, are found in the churches, squares, and public buildings. Whether the touch of German wildness in the genius of Doré is to be attributed to his birthplace, might be a curious subject for discussion; but, as remarked elsewhere, his characteristics are mainly French.

That which probably exercised a much greater influence on the youthful mind of Doré was the picturesque scenery by which he was surrounded in his early days. Strasburg itself is (or at least was, before the late bombardment) a quaint old town, with lofty stone houses, high-pitched roofs, dormer windows surmounting each other in tiers, a fine Gothic cathedral, ancient public buildings, and vast

fortifications, planned and carried out by Vauban. Other towns in the same department—that of the Bas-Rhin—have also various features of a striking character, and the country is in many parts extremely charming. The Bas-Rhin is bounded on the west by the Vosges mountains—rugged eminences, thickly wooded, and breaking out here and there into precipitous rocks of sandstone, limestone, and marl. The valleys lying among the folds of these mountains are distinguished for their pastoral loveliness, while on the peaks that surround them the snow lies unmelted until the middle of the summer, feeding the numerous streams which course down the sides of the Vosges, and ultimately find their way into the Rhine. The valley of the Rhine is a large tract of country, of great interest and beauty; and all about lie famous old battle-fields, which have quite recently come again into prominent notice as scenes of mortal conflict. A country such as this was sure to affect the imagination of a boy such as Doré. France is not generally a picturesque land, but the Vosges mountains and valleys fully merit that appellation.

At a very early period of life, Gustave Doré began to draw. Like our own George Cruikshank, he was fond, while yet a mere child, of making sketches on pieces of paper, and it is said that he could draw with facility before he was eight years old. He was excited to emulation by some of Grandville's pictorial satires, wherein human life is caricatured by assimilating it to certain types in the lower orders of animals. Young Doré produced some sketches of the same description; and Grandville, to whom they were shown, was so delighted that he prophesied the future greatness of the boy, and strongly advised the parents not to oppose his natural inclinations, which they appear to have felt rather inclined to do. Grandville also gave Gustave occasional instruction in the principles of his art, and encouraged his tentative efforts by sympathy and kindness. Some time after this, the elder M. Doré was appointed chief engineer in the department of the Ain, and Gustave was sent to be educated at the College of Bourg. Here he went on with his desultory sketches, covering his copy-books and other volumes with scenes from ancient history, and from the Algerian campaigns, then bringing out into brilliant relief all the wonted courage and military prowess of the French people.

It was in September, 1847, during the closing months of the reign of Louis Philippe, that Gustave Doré first visited Paris. His parents intended to stay no longer than three weeks; but Gustave was so charmed with the brilliance of the capital—not so brilliant then, indeed, as in more recent times, yet full of attraction

for a provincial boy—that he at once vowed he would remain there. Very shortly an incident occurred which helped to fix his career. A certain print-shop in the Place de la Bourse was kept by one M. Philippon. Great numbers of caricatures —varied from time to time, as the events of the day suggested—were exhibited in the window, and at these young Doré gazed with the utmost admiration. He thought he should like to do the same kind of work himself, and, running home, he rapidly sketched a caricature, returned with that and some other drawings to the shop, and asked to see the publisher. Philippon was both a good-natured man and a good man of business. He looked over the sketches, talked kindly to the boy, sought out his father, and added his exhortations to those of Grandville, that the youth should be made an artist.*

In consequence of this advice, Gustave was left by his parents in Paris to do as he pleased, with the stipulation that he should attend the Lycée for the completion of his education. Meanwhile, Philippon accepted a great many of the boy's drawings; and when the publisher started his well-known *Journal pour Rire*, Gustave, though still a student at the Lycée, was engaged on it. He left college in 1850; and during the three years that he had been there he produced a very large body of designs. Three years later, his compositions, dating from 1847, amounted to more than a thousand; they are now, it is said, more than twenty thousand. Shortly after leaving the Lycée, Doré was strongly urged by his friends to study painting, and not throw away his genius on frivolous and ephemeral work. This he was very willing to do; but want of means for a time thwarted his ambition, and kept him to the daily drudgery of producing inferior sketches for the cheap periodicals. However, he was at length assisted in the required way, and set to work painting in oils. An extraordinary number of pictures rapidly started into life under his brush, for here, as with the pencil, he evinced amazing facility and fecundity. He contributed pictures to the Paris Exhibition of 1852 and 1853, and these were highly commended by some. In 1855 he exhibited " Les Pins Sauvages," " Le Lendemain de l'Orage," " Les Deux Mères," and " La Bataille d'Alma;" in 1857, " La Bataille d'Inkermann." Oil-painting, however, is not M. Doré's strongest point, and he himself prefers simpler forms of designing. He has always desired to address the great body of his fellow-countrymen, and of the public of foreign lands.

* Memoir of Gustave Doré in the *Quiver*, Vol. I.

Pictures, in the technical sense of the term, are seen by only a comparatively small number. They do not tell with the masses; they are the luxuries of the rich, or the playthings of connoisseurs. Our times are essentially democratic, and France is the most democratic of European nations. Gustave Doré desired to be the artist of the people, rather than the artist of the wealthy. He saw how much was to be done with the help of the wood-engraver; how some of the effects of painting itself were capable of being reproduced by the cunning employment of powerful yet graduated blacks and whites; and he probably felt that in this direction, more than in any other, lay the special bent of his genius. Accordingly, he abandoned the practice of painting for several years, and it was only when his fame was thoroughly secured that he resumed the use of the brush as a means of giving expression to the moods of his fancy.

Energetically throwing himself into the ranks of popular artists, Gustave Doré lived the life of a hard-working Parisian man of genius, with nothing to depend on from day to day but the ingenuity of his teeming brain. At this period there was doubtless a spice of "Bohemianism" in his existence. The artist is generally a Bohemian, more or less. The easy vagabondage of life up three pair of stairs, of late hours, irregular ways, unlimited smoking, slight responsibilities, immeasurable good-fellowship, and quickly-recurring fun, is highly attractive to the pictorial and literary fraternity; and Gustave Doré determined to see "the world," as that term is understood in Paris. Many of his earlier sketches display this side of things with a truthfulness that is not very agreeable. But he had far nobler capabilities within him, and in the year 1854 he produced an illustrated edition of Rabelais, which contained some admirable work in the way of wild humour and picturesqueness. The book was cheaply printed on thin, coarse paper; so that the illustrations did not come out at all well. Some of the designs, however, were so excellent that they made the fame of Doré as a book-illustrator, and introduced him to a better kind of employment than he had previously found. Yet even a few years later we find him illustrating a cheap weekly periodical, called the *Journal pour Tous*, with wonderful spirit, oddity, and invention.

The Crimean war of 1854-5-6 opened a new field to the nimble wits of M. Doré. He projected a monthly journal giving engravings of the chief events of the war, and this was brought out by his old friend, M. Philippon. It was entitled *Musée Franco-Anglaise*, and was published simultaneously in

France and England. Such a work was necessarily of a somewhat clap-trap character; but it spread the artist's name over the two countries more particularly concerned, and doubtless helped to maintain the war feeling of the time. To the same period belongs a comic History of Russia (1854), containing a vast number of cuts, characterised by the grotesque farcicality of the designer's earlier days.

In a somewhat similar style to the Rabelais were the illustrations which M. Doré supplied in 1861 to the " Contes Drôlatiques" of Balzac. These were full of exuberant fancy, sometimes of a painful character, as treating in a burlesque mood of matters which, if represented by the pencil at all, should be touched only in a grave and considerate manner; but everywhere showing the presence of an original and daring genius. In 1856 our own public was introduced to a version of the ancient French romance of " Jaufry the Knight and the Fair Brunissende, a Tale of the Times of King Arthur," to which M. Doré had furnished twenty engravings, steeped in the glamour of faëry. The plates to " The Wandering Jew," belonging to the same year, were even more remarkable. They were of large folio size, and were reproduced in England in 1857, accompanied by an English version of the story by Mr. Walter Thornbury. These magnificent designs greatly increased the reputation of M. Doré as an artist of unusual powers and singular fancy; but he did not reach the full altitude of his celebrity until the publication, in 1861, of his illustrations to Dante's " Inferno," re-issued in this country in 1866. With the illustrations to the " Purgatorio" and " Paradiso " French and English readers were made familiar in 1868. The number of Dante designs, altogether, is one hundred and thirty-six—an astonishing number, considering their excellence, their variety, the extraordinary height and range of their conceptions, and the pictorial elaboration of their handling.

The " Don Quixote" was published in France in 1863, and in England in the following year. It is a delightful set of illustrations—the most purely fascinating, though not the grandest, of M. Doré's works. Previous to executing these plates, the artist made a tour in Spain; and the scenery, architecture, and national characteristics represented in them are studied from fact, and bear the unmistakable impress of truthfulness. To the same year (1863) belongs the " Atala," republished here in 1867. In 1865, M. Doré illustrated Moore's " Epicurean." The Bible appeared in London and Paris in 1866, and the Milton in this country alone in 1866, having been executed expressly for

Messrs. Cassell, Petter, and Galpin. For the La Fontaine (which was produced in France in 1867, and in England in 1868) M. Doré made very careful studies of animal life. In 1866 we had the "Baron Munchausen" and the "Croquemitaine," which had previously appeared in Paris in 1862 and 1863; and during the last ten years M. Doré has illustrated a great many other works—such as Shakespeare's "Tempest" (1860), the Nursery Tales of Perrault, and "Captain Castagnette" (1862)—which have exhibited his brilliant fancy in a hundred prismatic lights. He has also contributed several exquisite plates to the poems of Tennyson and of Thomas Hood, and has illustrated various works by Malte-Brun, and a great many histories, romances, and works of light literature.

It is said that he has illustrated a book of travels in every country in the world. This is probably an exaggeration; but he has certainly done much in this way. He has likewise, of late years, taken again to oil-painting, and the exhibition in New Bond Street has given our countrymen an opportunity of estimating this great artist's skill in the manipulation of colours. Some of the pictures are undoubtedly very fine; but that which, from its subject, and the brilliance of its pigments, attracts most attention, is by no means the best. "The Triumph of Christianity over Paganism," though striking, is somewhat tawdry and theatrical. It is not without M. Doré's fertility of invention and cleverness of execution; but it is wanting in sublimity, and even in dignity. A confused rout of figures tumbles from top to bottom of the picture, and the effect is almost pantomimic in its glitter of vestments and extravagance of action. Of a far higher character is the "Paolo and Francesca," corresponding, save in a few variations, with one of the illustrations to the "Inferno," included in the present volume (Plate CCXLIII.). The figure of Francesca is transcendently beautiful and extremely pathetic. With a face of classic loveliness (classic after the Italian model, which was softer and more womanly than the Greek), and with an expression of pain, of horror, of weariness, of hopeless suffering, yet of overmastering affection and faithfulness, she floats upon the lurid storm beneath the eyes of her unhappy lover. The wound upon the bosom has grown livid; the arms are passionately stretched up; while above, bending downwards, hangs the dumb, despairing face of Paolo. Some way below, in the background, the figures of Dante and Virgil are seen dimly through the hot red air. The conception is worthy of Dante's terrible story, and the colouring is pure and masterly. Not, perhaps, equal to this, yet still

very admirable, is the painting, "Christian Martyrs in the Reign of Diocletian," where all the accessories help to produce a solemn and awful impression. "The Victor Angels" is from Milton, and similar to one of the illustrations to "Paradise Lost." The scarlet glare of sunset is here very fine; and somewhat the same effect is introduced, with exquisite gradations of tint, fading off from red to translucent amber, and from amber to clear blue, in "The Flight into Egypt." In "The Neophyte" we have an excellent piece of character-painting; while "Evening in the Alps" is a noble landscape, full of grand, austere reaches of atmospheric colour, and instinct with a most poetic feeling. Very charming, also, is "The Prairie"—a study of grasses, flowers, and butterflies, brilliant in positive colours, and in the suggested splendour of all-investing sunshine.

M. Doré is not married, but lives simply and quietly with his mother, who is very proud of the genius and fame of her son. His nature is affectionate, and his manners are friendly and pleasant. The same energy and industry which he exhibits in the pursuit of his art, he manifests in everything else; and it is related that he learnt English by devoting spare moments in bed to its study. A contemporary writer says of the subject of this sketch :—

"Doré has recently had a studio built for himself in the Rue Bayard. It is the largest in Paris, but in spite of its extent he has scarcely room enough in it for his numerous pictures—many half completed, and many still in execution. This studio is daily visited by persons of all grades of society. Doré receives all in the most friendly manner—talks, jests, listens, and tells the news of the day—never ceasing, at the same time, the bold touches of his brush upon the canvas. His appearance is very attractive. He looks like a youth of twenty-four, who, with bright, happy eye, is gazing forwards into the world. He possesses unusual strength of body, which is doubtless to be traced to his great fondness for gymnastic exercises. He pursues these with eagerness, and he was formerly one of the boldest climbers. When he was in Rouen some years ago, he climbed up to the highest point of the cathedral there, to the great astonishment of the crowds who looked on at this unexpected scene. But immediately after this aërial journey he was arrested by the police, who accused him of having placed the inhabitants of Rouen in the utmost alarm by his perilous boldness. He was the first to make the ascent of the Aiguille de

Floria, in Savoy, and he made many attempts also to ascend the Matterhorn. These attempts, however, failed. But though he has not succeeded in ascending the Matterhorn, he has painted it with masterly power. This picture is justly admired in his studio by all friends of art. . . . . . Few can compete with Doré in social talents. He talks well; he sings admirably; he plays the violin, if not, perhaps, with professional skill, yet with great understanding; and he is a clever conjuror, rarely failing in a trick. There is, therefore, no *salon* in which he is not gladly received; and when he visited the Court at Compiègne, some years ago, he arranged all the festivities there, and was, so to speak, the soul of the Court life. In his own *salon* he often gathers together a distinguished circle of friends, and many an excellent artist and musician is to be met there. Doré loves music passionately, especially German music, and no one admires and esteems Beethoven more than he does. Some work of Beethoven's is always sure to be heard in Doré's *salon*."

An interesting article on Gustave Doré was contributed by Mr. Blanchard Jerrold to the *Gentleman's Magazine* for September, 1869. Mr. Jerrold has been intimate with M. Doré for many years. He knew him in his early days, when he was striving for the position he has since attained; and he knows him now that he is honoured and prosperous. His account of this variously-gifted artist presents to us a vivid portrait of a bright and happy nature. "The appearance of the man," writes Mr. Jerrold, "is in complete harmony with his function and his force. He has the boyish brightness of face which is so often found to be the glowing mask of genius. The quick and subtly-searching eye; the proud, handsome lip; the upward throw of the massive head; and the atmosphere encompassing all—an atmosphere that vibrates abnormally—proclaim an uncommon presence. The value of his work apart, he is a remarkable figure of his time." Mr. Jerrold relates that he saw Doré at an Embassy ball at Paris in the autumn of 1868. He had been very gay all the evening, but at a little before three A.M. he left, saying, "I must to bed. Three hours are barely rest enough for a worker." In the summer of the same year, Doré and his English friend were driving through Windsor Park, and, though the eye of the artist ceaselessly ranged over the landscape, in which he took great delight, no notes or sketches were made. A lady asked whether he would not stop, and jot down a few pictorial memoranda. "No, no," he replied; "I've a fair quantity of collodion in my head." In other words, he could carry away with him a mental photograph of what he had seen. Mr. Jerrold continues :—

" When we were at Boulogne together in 1855, to see the disembarkation of the Queen, Doré intently watched the leading points of the great ceremonial, and, by way of fixing a few matters of detail in his memory, made some hasty pencil-marks in a tiny book he carried in his waistcoat pocket. This power of fixing a scene in the memory correctly belongs to the student who has been true and constant to nature. Just as Houdin so educated his son's observation as to impress every article in a toyshop window upon his memory at a glance, so the student whose training has the grandest object, that of giving enduring forms to beauty, acquires the power of eliminating his material from a confused scene, through which he is fleetly travelling. . . . . That which distinguishes Doré, *chez lui*, is the art atmosphere in which his pleasures take their rise. In the spacious *salon* of the Faubourg St. Germain, covered with his work, is a little world of art. The professor of science, the man of letters, the gifted songstress, the physician, the composer, the actor, make up the throng; and the amusements are music and discourse of things which are animating the centres of intellect. A happier and nobler picture than this handsome square *salon*, alive with the artist's friends, each one specially gifted, and with the painter-musician in the centre, dreamily talking of some passing incident of scientific interest, with his fingers wandering listlessly over the strings of his violin, could not be—of success turned to worthy ends. The painter has been through a very hard day's toil. You have only to open a door beyond the *salle-à-manger* to light upon a work-room packed with blocks and proofs, pencils and tints and sketches. A long morning here, followed by a laborious afternoon in the Rue Bayard, have earned the learned leisure among intellectual kindred upon this common ground of art, where all bring something to the pic-nic. Frolic fancy is plentiful. Old friends are greeted with a warmth we formal people cannot understand. The world-famous man is *mon cher Gustave*, with proud motherly eyes beaming upon him, and crowds of the old familiars of childhood with affectionate hands upon his shoulders. Dinner is accompanied by bright, wise, unconstrained talk; coffee and cigars in the lofty saloon; and music and laughter, the professor parleying with the poet, the song-bird with the man of science."

On the 15th of August, 1861, M. Doré was decorated with the Cross of the Legion of Honour. France has more means of recognising art than England possesses; and Gustave Doré deserves whatever his country can bestow on him as the reward of his genius and his toil. Though cosmo-

politan in his sympathies, he is a thorough Frenchman as to his personal feelings; and probably his proudest thought is in the reflection that at this moment he stands before Europe and America as the representative artist of France.

# THE DORÉ GALLERY.

HE art of illustrating books has been so largely developed within the present century, that the greater part of its history belongs to our own era. It is true that the mediæval monks bestowed a good deal of labour, taste, skill, and invention on the illumination of their missals : but this would be more correctly described as the adornment than the illustration of books; at any rate, it had only a very limited application, and, like authorship itself, hardly reached the mass of the people at all. The invention of block-printing—that great precursor of the discovery of movable types—extended the sphere of ornamental literature, so that some approach was made to the modern system of book-illustration; and with the age of Dürer and Holbein, real art came into requisition in connection with the works of various writers. Still, there was yet only a small public for such productions, and in the seventeenth century wood-engraving sank into barbarism. At the same time, copper-plate engraving was introduced into works of a costly description, and this was the kind of illustration which, with a few cheap and worthless exceptions, prevailed throughout the seventeenth and eighteenth centuries. With the revival of the art of wood-engraving by Bewick, nearly a hundred years ago, the illustration of books entered on a new career, and, both here and on the Continent, a race of artists arose, whose greatest triumphs were achieved in connection with the printing-press.

Certainly, the most remarkable book-illustrator of our own or any other time—at once for the multiplicity of his works and the splendour of his genius—is the extra-ordinary man whose pencil has created the many forms of grandeur, power, and beauty to be found in this volume. GUSTAVE DORÉ has originated a new style in art, developed a new taste in the public, and discovered capabilities in book-illustration which were not previously suspected. He has his faults, like other men; but his genius is so predominant as almost to blind us to its drawbacks. He takes people by storm, and scarcely allows time for their judgment to interfere with their admiration. The marvellous number of his designs—the immense extent of literature which he has illuminated by the conceptions of his vast and wild imagination—the poetic beauty of some of his illustrations, the elfin humour of others, and the lurid glare and gloom of not a few—

are so many sources of that feeling of amazement which fills the mind when once it has fallen beneath the spell of this magician. Fecundity alone is an evidence of power; but when we find enormous productiveness associated with an equal wealth of imaginative insight—with fancy as various in its forms as Ariel at the bidding of Prospero, and with manipulative skill that exhausts the technicalities of art to describe it—the sense of wonder is excited to its highest, and we are led to inquire how this man obtained his privilege of entering so many grand and lovely regions, and of reflecting them, as by an enchanted mirror, on the page he touches. M. Doré has already associated his genius with Dante, with Milton, with Cervantes, with Tennyson, with La Fontaine, with the Old and New Testaments, with the terrible legend of the Wandering Jew, with the grotesque extravagances of Munchausen, with the quaint drolleries of Balzac, and with a hundred other creations, less remarkable in themselves, though perhaps hardly so in their power of bringing out his finest gifts. He threatens, apparently, to take the whole field of literature to himself, and future artists will ask what remains for them to conquer.

Twelve or thirteen years ago, Gustave Doré was scarcely known in England. He had already made something of a name in France, but even there his reputation was not great, and beyond the bounds of his native country he was almost an undiscovered genius. In the course of the year 1857, however, a translation from the French was published in London, accompanied by the original illustrations of Doré. It was a chivalric romance, based on an early Provençal poem, called " Jaufry the Knight and the Fair Brunissende." The story abounded in incidents peculiarly fitted to bring out the most striking and characteristic elements of Doré's faculty : wild forests and gloomy valleys, black tarns in mountain hollows, scenes of beautiful or of wicked enchantment, dwarfs with an evil leer, making horrible the shades of ghostly twilight, knights in full caparison of battle, the vaporous brightness of enchanted towers, and pageants of the courts of faëry. This was the book which first made M. Doré known in England, and it set people talking of the artist who could furnish such strange and weird drawings in illustration of a work not strikingly above the average of romantic tales. It was not then known that this daring young genius was contemplating, or actually producing, illustrations of the leading poets and romancers of Europe, and that his name would speedily be hailed throughout the civilised world as the most successful book-illustrator of the day. The Dante series was that which placed Doré in the front rank of art, and proved that he was not merely a clever designer on the wood, but a draughtsman with many of the highest qualifications of the painter. No one, indeed, has ever given to wood-engravings such a singularly pictorial character. He rivals mezzotint itself in the splendid depth and richness of his glooms ; he leaves copper-plate and steel engravings behind in the extraordinary variety of his sunlight and moonlight effects ; his *chiar'-oscuro* has often the tender touch

and mysterious intimations of Rembrandt; his atmosphere shows all the soft degrees and infinite extension of the natural air; while his power of suggesting colour, especially as exhibited in the stormy tumult of light and darkness, almost equals, in plain black and white, the varied pigments of the palette. Some of these results are obtained in part by the method of drawing which M. Doré follows whenever it suits his purpose. Such of his drawings as require unusually strong contrasts he *paints* upon the block, so to speak, with a stiff brush dipped in Indian ink. Some, it is said, are drawn in opaque white upon a block previously stained black. He thus secures a greater breadth and intensity of colour than he could possibly derive from the comparatively meagre lines of the common lead-pencil, and he compels the engraver to work in great masses of light and shadow, rather than by a finer and more minute process. With artists and wood-engravers it is a matter of controversy whether this method of tinting on the block is allowable. It certainly has a tendency to destroy the original character of wood-engraving, which depends for its most legitimate effects on a free, and sometimes even rough, use of definite lines. The smaller sketches of M. Doré are generally executed in this manner, and are often characterised by a simple and quiet beauty, in singular contrast with the lurid grandeur of his more ambitious works. But it cannot be denied that his Indian ink effects are among the most remarkable results of his peculiar genius, and that he has thus been enabled to attain a degree of pictorial richness which amounts to the discovery of a new power in wood-engraving. It is evident that in no other way could M. Doré, working on the block, have brought before our eyes the prodigious glooms and baleful fires of Tartarus, as represented in the illustrations to Dante and Milton; nor have piled such masses of dark rock-architecture, nor spread such clouds of forest shade, as we see in many of his works; nor have struck upon his page such contests of light and dark, such lowering of overshadowed heaven, such wrath of storm and bickering of celestial flames, as startle us in several of his designs from the Bible. The thing may at times degenerate into a mannerism; it may indicate too great a willingness to excite by vehemence of contrast, rather than to elevate by depth of intuition; and, assuredly, in the hands of third-rate imitators, such a style would soon pass into vulgarity and trick. But M. Doré is privileged by genius to work out his conceptions after his own methods; and, in the case of a mind so marvellously productive, repetition itself is an evidence, not of poverty of ideas, but of strong faith in the excellence of certain developments of art; in fact, of imaginative intensity and strength of will in a particular direction. This quality of imaginative intensity is indeed one of the most remarkable of M. Doré's characteristics, and, taken in conjunction with his fruitfulness and his variety, is indisputable evidence that he possesses the great, mysterious gift of genius. Mere talent may pour forth thousands upon thousands of sketches, and amaze us by the unresting activity of its work; but the work will be frivolous or dull, not earnest and exalted. Or mere talent may once in a way, by some lucky and unaccountable accident, reach a sudden elevation of grandeur;

but its efforts in this respect are rare, and speedily exhaust the agent. Nothing is more astonishing in M. Doré than the continuity and permanence of his greatness.. Since he has taken to the higher walks of art, he has produced no work which has not abounded in largeness of conception, in force of thought, in strangeness and even awfulness of imagination, and in mastery of style. Of course, he has his higher and his lower levels, and every one of his great collections will show less happy inspirations by the side of special masterpieces. In all you may find particular faults; but you likewise find an amount of intellectual power which appears as yet to have no determinate measure or arbitrary limits. Some men attain a species of greatness by the slow accretion of trifles; others become famous by a few commanding successes, purchased by sharp toil and life-long sacrifice. To this man only it seems reserved to pour forth his genius at the demand of the public, as commoner men pour forth those average productions which are born to perish.

The multiplicity of M. Doré's works has led to some wonderful, and perhaps mythical, stories. It is certain, however, that his drawings on the wood alone must be counted by tens of thousands, to say nothing of his designs for steel engravings, or of his paintings, some of which are on a very large scale. When it is recollected that he is even now barely thirty-eight years of age, the amount of work which he has performed per day since the commencement of his career must have been enormous. Many of his sketches, it is true, are of small size, especially in the books and periodicals which he illustrated during his earlier years; but the number of large designs, elaborately wrought in every detail, is also great, and the aggregate of labour on the total work of his hands would be startling, if we could only put it into any tangible form. Already there are Doré collectors; but it would probably be impossible to recover everything that proceeded from his pencil ere he was yet famous. Perhaps it would be the kindest and most respectful thing to this great artist not to attempt to do so. Much of his earlier work was crude, and in some respects objectionable. Like many other clever young artists, he used his pencil as a means of gaining his livelihood, and in the less reputable scenes of Parisian life he found some inspirations which not even genius could render othewise than distasteful. He made sketches for the cheap periodicals, and produced an immense number of social caricatures for the comic journals, of which it must be said that, if they represent French nature at all, they represent the worst part of it. Ugliness and degeneracy characterise the figures; a jaded air of Bohemianism—of late hours, and questionable haunts, and stale tobacco-smoke—of mirth that is not happy, of suffering that is not pathetic, of poverty that is not honourable—breathes out from them. There is no more remarkable contrast between English and French humour than that which is afforded by a comparison of the social sketches of Leech with those of Doré. The Englishman is hearty, cheerful, and, above all, healthy; the Frenchman has a morbid extravagance, such as turns fun into mournfulness. The illustrations supplied by M. Doré to the

"Contes Drôlatiques" of Balzac are certainly superior to those which he contributed to the cheap periodicals, for they share the elevating influences of fancy; but they are not pleasant—nay, they are sometimes even horrible. It is impossible, however, not to admire the prodigal invention and free, agile fancy of these sketches. They are fetched out of the strangest regions of the grotesque, and display a wonderful power of imagining unwonted shapes and dreamlike incidents. They helped to make M. Doré famous, and the sale of this edition of the "Contes Drôlatiques" has been enormous. A great deal of fantastic ingenuity, also, is exhibited in the illustrations to "Captain Castagnette," and in some designs contributed by Doré to a Parisian weekly miscellany, the *Journal pour Tous*, fourteen or fifteen years ago. These latter are not known in England, but they are full of whimsical conception. The artist's name was also greatly advanced by the publication of his illustrated Rabelais, about the time of the Crimean war. It was by efforts such as these that M. Doré was led upwards from the common work of delineating Paris life to the lofty heights of Dante, of Milton, and of the Scriptures. Rabelais offered an admirable intermediate ground. The licentious humour of that prodigious satirist has its points of contact with the cynical side of Doré's genius; while in the endless invention, the poetical creativeness, of the originator of Gargantua and Pantagruel, the young artist had a magnificent field for exercising his own fancy, and for developing his matchless powers of picturesqueness. The licence of such a writer as Rabelais is a very different thing from that of the scribblers for cheap Parisian prints. It has the elevation and the inalienable nobility of genius—that sacred privilege, which only genius possesses, of rising into pure and lofty air, even from low and gross beginnings. Carlyle has told us that genius was never yet wholly base; and Coleridge has said of Rabelais that he could write a treatise in praise of his moral elevation, "which would make the Church stare and the conventicle groan, and yet would be truth, and nothing but the truth." M. Doré passed from a lower to a higher stage of art by the road of Rabelais.

Early impressions will often do much towards shaping and colouring a man's faculties. Though the name would seem to betoken a genuine French descent, M. Doré was born in that curious frontier town, Strasbourg, which, having been originally German, still retains a Teutonic rather than a French character. This may in some measure account for the element of Germanism which is visible in several of M. Doré's works; and to the fact that the earlier years of the artist were spent amidst the mountainous and rocky scenery of the Vosges may be ascribed much of that wild and gloomy spirit which we see in many of his landscapes. It is said that he never forgets a landscape which he has once beheld, and his pictures of natural scenery have often an individuality, a literal accuracy of characterisation, which proclaims their general fidelity to truth, however much they may be heightened by the informing eye of a poet, or clad in the atmosphere of romance and passion. He told an English artist and art-critic that he could mentally

dissect any view that he had seen, and, by a process of division and subdivision, could preserve all the details in his memory. In order to illustrate "Don Quixote" with the greater fitness, M. Doré journeyed through those parts of Spain to which the narrative refers; and thus we have a series of magnificent views in the Sierra Morena, which, but for the figures, might be taken, apart from the story, as admirable pictures of Spanish mountain scenery. It is not often that M. Doré draws landscapes simply for their own sake, and without reference to some narrative with which they are associated; but when he does, they show the hand of a poetic artist, as skilled to fetch out what may be called the soul of a landscape—its sentiment of mournfulness, terror, or beauty—as to delineate its actual features of mountain, wood, and water.

As regards the touch of Germanism in his works, it would be a mistake to give it much importance. It is there, but it is far from being the principal element. Doré's genius owes something to German inspirations; but it is more French than anything else—as far, that is to say, as genius belongs to any nationality at all. In its highest qualities genius transcends nationality, and rises into the common air and light of general sympathy; and this is particularly true of the painter or draughtsman, who speaks in a universal language to all conditions of men. Yet it is likewise true that every country is distinguished by peculiarities of temperament and emotion, of perception and understanding. Even the delineation of form has its "schools," and the schools are modified, or rather created, by national characteristics, by local influences, by climate, by scenery, by institutions, and by the long transmission of favourite ideas in religion, morals, and politics. We do not need to be told whether a given painting by one of the old masters is the product of Italian or of Flemish genius. In the former case, indeed, the connoisseur will have no difficulty in telling you whether the particular work belongs to the Roman or the Venetian school. More modern times have developed a great variety of schools, for all the leading countries of Europe have added to the artistic riches of earlier days. France has a distinct territory in this great world of simulated forms; and Doré, upon the whole, is unmistakably French, despite the touch of German wildness to which allusion has been made. It might even be said that he is Parisian, always bearing in mind that large overplus of power and creative force which, as just pointed out, belongs to the cosmopolitan region of pure genius, lying beyond the frontier lines of nationality. Doré is French in his vividness, his adaptability, his rapid and ready skill, his intellectual nimbleness, his mobile and facile touch, his dramatic (sometimes melodramatic) instincts, his sensuous spiritualism (if the phrase may be allowed), and his union of vivacity in the manner with a lurking and saturnine spleen in the spirit of his work. He is Parisian in the intense feeling of town life which pervades his humorous designs, in the ultra-selfconsciousness of some of his figures, in occasional touches of theatrical glitter, and, from time to time, in a certain excess of effort. It may also be said of him that his genius is pre-eminently modern—a quality more likely to be found in connection with a French than a German inspiration. Prone as he is to illustrate

mediæval fables and fancies—and, indeed, it is these which he treats with the most consummate power and beauty—the feeling with which he apprehends them, and the manner in which he translates their meaning to the general mind, are those of the nineteenth rather than of the thirteenth or fourteenth century. He brings to bear upon the legends and dreams of elder times all the most elaborate resources of the present day. His style has nothing of the asceticism of early art : it is full, rich, sumptuous, adorned ; subtle in spirit, sensuous in form, complex in detail, critical in the method, rapid yet masterly in the handling, and with a constant suggestion of the workman's superiority to the work. Perhaps the most complete contrast between mediæval and modern art consists in the fact that the modern artist, when at his best, seems to possess his subject, while the more primitive craftsman is possessed *by* it. Let any one look heedfully at the works of Giotto and Cimabue, and he will see that those great painters were literally carried away by their subjects. They were so thoroughly dominated by the spirit of their conceptions, and were apparently so devoid of the critical capacity by which to assay their own work, to compare and test results, to consider effects, and to estimate the value of divers methods, that they seem to have merely copied the visions which came to them in moments of religious exaltation. Hence a perplexing union of the sublime and the ridiculous in their compositions; figures and faces the most touching and dignified side by side with others of incomparable meanness and inefficiency ; revelations of Paradise contradicted by the vulgarest recollections of the cloister. The reason is that the men, great as they were in some respects and at special moments, had neither a real nor a fancied superiority to their work. They were enthusiasts in the faith they professed, stirred to particular efforts by particular accessions of zeal, and very much at the mercy of the prevailing mood, whether it carried them into the higher or the lower air. In other words, they did not stand outside their subjects, and master them by force of will, and by the varied weapons of instructed art. Now, the modern artist is seldom dominated by his theme : he places himself in the position of command, and insists on doing what he will with his own. When he is a man of merely mediocre talent, the results are unsatisfactory enough. Neither does *he* dominate his subject, nor does his subject dominate *him*. He simply bullies the unfortunate theme, and gets nothing out of it. With Doré it is altogether different. His designs are distinguished by nothing more than by mastery. Whatever he takes in hand, he executes with the conscious power of one who knows that the whole armoury of art is at his disposal. He seizes on the ground with a certain regal authority, and is neither cowed nor intoxicated by the vastness of its range. He always gives you, even in his wildest flights, the impression that every stroke has been made with a precise knowledge of the effect it will produce ; that he has surveyed his territory, and is acquainted with the happiest aspects of it ; that his visions and his dreams obey him as their lord and ruler. As Solomon controlled the genii by virtue of his magic ring, so M. Doré governs these shapes of terror and of beauty by right of intellectual power and of consummate artistic genius. He does not

tremble before the conceptions he has conjured up : he commands them. He is never at the mercy of his own impressions : sanity and self-possession go with him in the most untrodden ways.

We shall the more readily understand this remarkable predominance of M. Doré over the sources of his inspiration by glancing for awhile at the productions of that astonishing, in some respects appalling, but manifestly diseased painter, William Blake. Whether or not Blake was mad in the legal or medical sense of the word, there can be no doubt that he was not sane as an artist. He drifted before the winds and waves of his own emotional impressions, and had apparently no sort of authority over them. Like Swedenborg, he had ecstasies and visions, which he accepted with awe as revelations of the unknown. He saw an apple-tree swarming with angels, as other men might see it swarming with bees; he conversed with Adam and Eve; he had audiences of Homer, Moses, Pindar, Virgil, Dante, and Milton; he drew the ghost of a flea. All this tyranny of the imagination is to be seen reflected in his works. Metaphorically speaking, he passes from the angel to the flea at the mere caprice of his disordered fancy. Where he is grand, he is inconceivably so; but at any moment he is liable to tumble into the inane. His successes are the exaltation of rapture; his failures are the reaction of lassitude, or the stolidity of the Pythian priestess from whom the vapour and the inspiration have passed away. At its best, his style seems to stagger under the weight of incommunicable knowledge; at its worst, it becomes dry, harsh, stiff, and conventional, with transmitted types and ugly and non-natural forms. In neither case does the artist seem to have his subject in his own keeping. At times he gives you a greater sense of the supernatural than, perhaps, any man who ever drew; but at others he is ridiculously incompetent. He opens the abyss, and reels back shuddering and incoherent. He is the exemplar of an insane artist, taunted by spirits whom he can summon from the deep, but lacks the power to rule.

In studying the works of M. Doré, we cannot fail to be struck by the absence of any such weakness in the greatest extravagances of his fancy. We suspect that he is not a haunted man; that what he imagines is imagined by strength of will as much as by nervous impressionability, and that when the vision is done with it is dismissed. His technical proficiency alone shows that he works in cool blood, and does not grow hysterical with thick-coming fancies. He may thus occasionally lose in mystery and awfulness, but he gains in force and in continuity of power. The greatest geniuses, on the whole, are those who prove themselves to be thorough masters in their own domain. The lordly supremacy of Shakespeare is worth any number of broken and dismayed glimpses into the shadowy world. Blake will always be a marvel to the initiated; but Doré will continue to appeal, as he now appeals, to the general perception of poetry, romance, and humour. He has entered those great territories by many roads, and has not yet lost himself on one. The clear, strong, calm face which we see represented in

the portrait of this gifted Frenchman, reveals one of those temperaments to whom command is native, and success habitual.

There is another English artist to whom M. Doré has a certain resemblance. As long ago as the year 1812, the London public were startled by a picture in the Royal Academy Exhibition, called "Sadak in Search of the Waters of Oblivion." It was by a very young man, named John Martin, and it represented a vast prospect of rocks and precipices under a gloomy sky, with a solitary figure faintly dragging itself up from one ledge to another. The painter soon became famous, and he handled a great variety of subjects, chiefly of the portentous order, in a style of veritable, yet monotonous and somewhat overwrought, grandeur. " Belshazzar's Feast," " The Destruction of Herculaneum," " The Seventh Plague," " The Deluge," " The Fall of Nineveh," " The Celestial City and River of Bliss," " Pandemonium," and " The Last Man," are among the matters which he selected for pictorial treatment during the forty years of his working life. He illustrated Milton's " Paradise Lost" in a series of plates which Lord Lytton has described as sublime, and he drew largely from the Bible for scenes and events of majesty and awe on which to employ his pencil. With much greater variety, M. Doré sometimes reminds us of this now almost forgotten genius. Martin delighted in the elements of size, vagueness, and preternatural gloom. His buildings were mountainous; his mountains had something of an architectural character. He spread the blackness of night upon his canvas in great reaches of shadow, or reddened it with smouldering fires of tempest, or gashed it with the livid strokes of lightning. In all this there was an anticipation of one side of Gustave Doré's genius; but the Englishman, it must be admitted, was far inferior to the Frenchman. For supernatural grandeur, for the beauty and the wildness of enchantment, for elfin strangeness and unearthly landscape, it may be doubted whether M. Doré has ever yet been equalled.

Revelling though it does in the remote, the shadowy, and the unreal, the genius of M. Doré can hardly be called spiritual. He seldom suggests to you anything finer than he represents. He is wanting in those indescribably subtle touches which reveal more than they define. His main object is to be effective, and that object he never forgets. His style is always popular, and, although its grandest elements may be beyond the popular apprehension, the chief characteristics are such as every man with ordinary eyesight can at once perceive. The strong contrasts of light and shadow; the enormous masses of rocks and rock-like castles; the vast extension of forest glooms (all worked out with a minute and painstaking elaboration of details)—are materialistic rather than spiritual. His angels are handsome youths or beautiful women, more than celestial intelligences. He sometimes reminds you of the contrivances of the scene-painter, and this is precisely on those occasions when the highest inspiration is most required. The fact is that M. Doré can seldom entirely get rid of his quality of a Frenchman. He cannot lose himself in his subject—partly on account of his technical mastery and skill, and partly because he

partakes of that Parisian egotism which will recognise nothing greater than itself. He sometimes fails in his figures—not in the grouping, which is often superb, but in the individual faces, which are not always equal to the idea they are intended to illustrate. To this observation, indeed, there are many exceptions ; but probably most of Doré's admirers have felt that his strength lies more in landscape than in the delineation of human character. His finest figures are those of a portentous or diabolical nature—such as the lost souls in Dante's " Inferno," or the strange inhabitants of Purgatory. He succeeds in the grotesque and fantastic, but seldom in simple manhood and womanhood. His landscapes, however, are perfect ; and the grander the subject to be represented, the higher are his powers of interpretation. If, in addition to the solemnity of Nature in her austere and savage moods, he has to throw a sense of mystery and enchantment over the composition, he makes every mountain peak and sterile vale, every shadowing tree or stretch of solemn woodland, every lake among black rocks, with cold reflections of the alien sky, every castle on the distant crags, every cottage by the lonely road, every glimmer of the fading twilight, or weird communion of the moonlight and the clouds, instinct with marvel and with supernatural awe. He would seem to have drunk deeply of the music of that bird of night which, according to Keats,

> " Oft-times hath
> Charm'd magic casements, opening on the foam
> Of perilous seas, in faëry-lands forlorn."

Among the special marvels of M. Doré's skill should be mentioned his extraordinary power of representing space. In many of his designs he seems to plunge you into infinity. This is very observable in several of the illustrations to the " Paradiso " of Dante. The sense of limitless extension is really prodigious : the eye is carried upward and onward, as if the heavens themselves were opening before its glance. The same power is observable in the terrible scenes of the " Inferno " and of " Paradise Lost," and in some of the Bible subjects. The doleful cliffs and valleys stretch outward into endless night ; the sky oppresses you with its immeasurable dark. Not less remarkable is M. Doré's capacity of flooding his page with light. He can do this without the aid of strongly contrasted shadows : by some subtle gradation of tints, he throws the golden fulness of sunshine over grove and meadow. Even more difficult, perhaps, is the representation of atmosphere ; yet here again he is supreme. You look across miles of intervening space towards a line of distant hills, and all between is air and light. It is not necessary that he should have the tangible effects of wind to help him in the production of this result : he makes you feel the invisible presence of still air, as you perceive it in fact, connecting the near with the far-off, and softening the edges of material forms.

In the delineation of pure human beauty Doré is often deficient. His great strength lies in the direction of rage, terror, cruelty, grandeur, and wildness ; in vastness of size, energy of action, immensity of space, splendour of circumstance, grotesqueness of contrast,

awfulness of suffering, and general sense of the remote, the weird, and the supernatural. His ideal of the female face and figure is frequently unpleasing; the face insipid, the figure lank and ungraceful. But there are exceptions to this, and some of the nude figures in the "Dante" have the grace and majesty of a sublime horror. Francesca of Rimini, gashed to the heart, and driven eternally to and fro on the hot blasts of Hell —her lover by her side, but no longer any possibility of love between them—is at once terrific and beautiful, fully realising the conception of Dante, and forcibly reminding the English reader of those noble lines by Keats, in which he imagines himself borne in a dream, after reading this episode of the "Inferno,"

> "—— to that second circle of sad Hell,
>     Where, 'mid the gust, the whirlwind, and the flaw
> Of rain and hailstones, lovers need not tell
>     Their sorrows. Pale were the sweet lips I saw,
> Pale were the lips I kiss'd, and fair the form
> I floated with about that melancholy storm."

But here the beauty is allied with agony, with vehement passion, with mingled longing and remorse, with tortured memory and unrelieved despair. It is not beauty for its own sake; not calm and reposing womanhood. Other female figures might be pointed out in Doré's works which have either animal luxury or the splendour of strong emotion; but they are rarely characterised by the gentleness and grace of the female character in its perfection of physical culture and moral loveliness. When M. Doré wishes to draw a woman of this description, he becomes tame or uncouth, except in a few instances. He wants the stimulus of some fierce or awful experience of life, or of some terrific dream of fancy, to raise his powers to their height. He has not the art of making the flats and shallows interesting. He must have altitude and space; storm, and the conflict of great passions; suffering or triumph; love in its fierceness, or hate in its fury; the tragedy or the farce of life (both dealing in extremes and idealities); the common earth transfigured by strange lights and shadows, or visions out of phantom lands. He disdains the petty. He can be coarse, and in a certain sense vulgar, when he pleases, but not small. His work is seldom mediocre. It is too full of energy to take the easier and the smoother paths.

Pathos of the gentle kind he does not frequently exhibit. Suffering, it is true, must always be pathetic, and he abounds in suffering; but he gets his pathos chiefly by the road of physical horror—not of moral sweetness, conquering misery by patience. And the pathos of his horrors is generally secondary to their sublimity or grimness, or even to their merely pictorial effect. His drawings do not suggest any great amount of sympathy on the part of the artist with the characters whom he so often represents writhing in every species of agony. You cannot imagine the artist shedding tears over the scenes in his "Dante," or expecting any one else to do so. Doré probably went to

bed very placidly after drawing the worst of them. The spectator shudders, is depressed, is horrified, is sickened sometimes; but does not weep. Dante, with all his ferocity, had occasional touches of pathos; as where, describing some miserable soul whose fate it is to be transfixed by fiery serpents, and burnt to ashes, from which, phœnix-like, it instantly starts up in its original form, he says that, after one of these fierce spasms of death-in-life, it arose "sighing"—a word which expresses the uttermost poignancy of quiet and helpless anguish, of weariness beyond words, and despair too deep for raving. Touches of this kind are not in Doré's manner. He does not "sigh," nor does he usually make the spectator melt with pity. Yet one of his most intelligent critics, Mr. Philip Gilbert Hamerton, says, in an article in the *Fine Arts Quarterly Review* for October, 1864, that he has seen in Paris a picture of Doré's, called "La Famille du Saltimbanque," which attains the greatest heights of pathos. One of the characters is a boy dressed in the "tights" of a gymnastic performer, but visibly hungry and wretched, with a forlorn face, and eyes running over with tears. This painting was exhibited a few years ago in the window of a picture-dealer, and it attracted such crowds of people that the circulation of the street on that side of the way was stopped. Still, it cannot be said that the sense of pure pathos, as distinct from horror, is usual in the works of this artist. He afflicts more than he softens us. If he has tears at all, they are the "iron tears" of Pluto, rather than the gentle waters of human grief.

M. Doré is very happy in grouping large masses of figures; and the more there are, the greater is his skill in disposing of them in the most effective manner. The wild fury of battle, the confused movements of flight, the gathering of mailed warriors, the swarming of fiends and condemned souls, the illimitable circles of angelic life in heaven—all these things he pictures with astonishing force, vividness, and variety of invention. His power of representing movement is truly extraordinary. Mr. Hamerton, who is personally acquainted with him, says that he is "himself physically as active as a young Athenian of the days of Pericles;" and this will be readily believed by any one who has studied his drawings. They abound in vitality—in motion that seems hardly suspended by the fixing touch of art. His men run, and leap, and do fierce battle with one another; his angels and devils take bird-like possession of the air. He can also reproduce the stagnation of gloom and languor; but he prefers the energy and ebulliency of life.

Among the greatest works of M. Doré must be reckoned his illustrated editions of Dante, Milton, the Bible, "Don Quixote," La Fontaine, "Atala," and "The Wandering Jew." The earliest of these, and one of the first works in which the young artist attempted a large and grand style, is "The Wandering Jew." The enormous size of these illustrations has led to a coarseness and exaggeration in the figures, which are not among the best of M. Doré's productions; and the Jew himself, with his somewhat theatrical appearance, does not reach the height of the great argument contained in that marvellous

old legend, the most tremendous creation of fancy of which we have any knowledge. The figure is wanting in real sublimity—in that imaginative faith in the story which ought to have inspired the artist for the time being. But the landscapes, the still life, and the supernatural life are prodigious. Never were such dreams of marvel and mystery; never were such shapes that are not shapes, but phantasms of gleam and shadow; never were such mountains and forests, such seas and desolate roads; never were such castles, stretching cloud-like into cloud, such churches and churchyards of spectral meaning, such visionary skies, crowded with dim suggestions of unutterable things, such goblin significance and such ghostly menace in every aspect of the earth and heavens. The cross starts out again and again with a dreadful pertinacity of self-assertion; faces of sadness or of wrath flicker in the air, shape themselves in the dust, glimmer in the waters, writhe in the twisted boughs of trees, lurk in the shadows of familiar objects, or fade and wither in the vaporous distance. The amount of imagination expended in these twelve designs is immense, and would of itself be sufficient to stamp M. Doré as a great artist-poet. The unusual size of the engravings prevents any specimens being given in the present volume; but they are among the most striking productions of this extraordinary genius.

In "Atala" we have a collection of exquisite landscapes, depicting, in the greater number of instances, the glories of Indian scenery in the southern part of North America, while much of it was yet in its primitive wildness, and the red man roamed from place to place with but little interruption from European settlers. The beauty of these illustrations consists almost entirely in their rendering of some of the grandest manifestations of inanimate nature. The human figures are comparatively trifling; in many of the designs they are wholly absent, and even when present they seem dwarfed by the inexpressible majesty of the scenes amidst which they are placed. The splendour and largeness of tropical vegetation, the overshadowing breadths of mighty forests, the dark entanglement of branches, leaves, and creepers, the rush of torrents, the shining of broad and lonely lakes, the towering cones and enormous buttresses of mountain ranges, the weary stretch of interminable deserts, the raging darkness of storms, the airy gold of sunrise or of noonday light, and all the magnificence of creation in its most rich and sumptuous conditions, are here presented in a series of noble drawings. M. Doré has evidently been penetrated by the spirit of his subject, and has caught with marvellous subtlety the sense of solitude and privacy belonging to all wild and primitive landscapes. In many of these views we seem to be alone with Nature in her virgin beauty and awfulness. The finest skill of the painter has never rendered to us more magnificent specimens of natural scenery than the design illustrating the passage, "At intervals, the swollen river raises its voice whilst passing over the resisting heaps;" that depicting the rapids between Lake Erie and the Falls of Niagara; and several of the forest scenes in Chateaubriand's romantic tale.

Dante's great poem presented M. Doré with a number of subjects calculated to

develop some of the most wonderful elements of his genius. The grim old Florentine was a poet, as Doré is an artist, of the intense order. He had an awful power of conceiving visions of endless suffering and varied horror, and of imagining localities full of the dolorous light and ghastly shades of Hell — the Hell of mediæval Catholicism, which, grotesque and almost ludicrous as some of its features seem to the modern intellect, was a terrific reality to the believing minds of old. M. Doré, though he approaches these dreams from the modern point of view (which is the picturesque or artistic point of view, not the religious), has a special sympathy with them as creations of the imaginative mood. His own genius, as before remarked, leans very much to the side of terror, agony, and a saturnine enjoyment of vast woeful experiences. Accordingly, he is quite in his element when he gets among the fiery circles and Tartarean pits of Dante's "Inferno." He has drunk deeply of the inspiration manifest throughout the first portion of Dante's work, and has unrolled before our eyes an enormous panorama of guilt and misery and despair. It may be said that he has sometimes exaggerated; but the charge is scarcely fair as regards *him*, however much it may attach to his subject. Dante exaggerated the exaggerations of Catholic faith till they toppled over into a kind of diabolical burlesque. The education of Europe in more recent times has carried nearly all but the utterly uninstructed beyond the species of belief which Dante endeavoured to fix and render tangible in his astounding conceptions. In these days, religious disputants, with but few exceptions, forbear from devoting each other to eternal punishment because they differ in certain articles of faith; and the abominable cruelty and downright personal rancour of some of Dante's imaginings would now shock many who go with the poet in the main parts of his belief. M. Doré, however, has not been deterred by any of these considerations. He hesitates at nothing. He makes us sup as full of horrors as Macbeth after his conscience had been hardened by years of crime. He will not spare the spectator a single iota. At the bidding of his master for the time, he accumulates the most sickening incidents of the hospital or the dissecting-room, and adds to them all the ecstasies of infernal anguish. Chaucer, after briefly telling the story of Ugolino of Pisa, who, with his children, was starved to death in a tower (one of the episodes of the "Inferno"), says that whoever would read it in a longer form—though he thinks his own more concentrated narrative ought to suffice—must go to Dante, who will pursue the dismal record "from point to point; not one word will he fail." In a similar spirit, M. Doré takes us from point to point of the regions of eternal woe. He "fails" in nothing that his author suggests in the way of appalling misery. It should be added, however, that many of his designs are characterised rather by the majesty—one might almost say the beauty—of terror, than by its loathsome and repellant features. M. Doré has exhibited an extraordinary amount of invention in the scenery of the nether world. It is impossible to conceive anything more unreal, remote, shadowy, and forlorn than these rocky mountains, these dark valleys and ravines,

these gloomy waters, these accursed forests, these hollows and dens of fire and smoke. The sense of an immeasurable misery, of a fatal wickedness, hangs over them : you feel that they are divorced eternally from all influences of good; that an overwhelming distance separates them not only from the beatitudes of heaven, but from the mixed constitution of the earth. The treatment of mountain forms, whether geologically true or not, is extremely grand and poetical : the ponderous masses heave themselves uncouthly into the dun air, or strike downward in sheer lines of descent into abysms of blackness and solitude, or enclose the melancholy valleys with insurmountable barriers of adamant. The management of the lights and shadows is also amazing. The dismal twilight of some—the portentous darkness, troubled by brassy glow of muffled fires, in others— burden the eye with their intensity and weight; and the way in which the cliffs and peaks of this dread region recede into the gloom, losing the sharpness of their edges in a vast expansion of dim air, is a signal triumph of pictorial art. The various scenes of torture are touched with a pitiless rigour of interpretation; the fiends and monsters of Tartarus are as impressive as such very fantastic creations can be; and the figures of Dante and Virgil, especially of the latter, are graceful and dignified. The sea of ice, the forests of semi-human and conscious trees, the living graves of the heretics, glaring with quenchless fire, and the heart-rending story of Ugolino and his sons, are among the most tremendous of the illustrations. Indeed, the last-named is so terrible with the cadaverous faces of the starving youths, shut up in the Tower of Famine with their miserable father, that it is a relief to turn aside from such an appalling reality, or at any rate possibility, to the imaginary horrors of Hades. The finest of the landscapes, perhaps, are the view of the entrance to the infernal regions, showing the arch inscribed with the celebrated line—

" All hope abandon, ye who enter here "

(a picture full of the wildest desolation and gloom), and the scene in Hell, in illustration of the passage in which the alchemists and forgers are described as being tormented in a valley of intense blackness :—

" We on the utmost shore of the long rock
Descended stiil to leftward.      .      .

.      .      .      .      .      .      .

More rueful was it not, methinks, to see
The nation in Ægina droop, what time
Each living thing, e'en to the little worm,
All fell, so full of malice was the air
(And afterward, as bards of yore have told,
The ancient people were restor'd anew
From seed of emmets), than was here to see
The spirits that languish'd through the murky vale,
Up-piled on many a stack."

But there are other scenes almost equally grand, the details of which cannot here be given.

In the " Purgatorio " we have several landscapes scarcely less severe than those of the " Inferno," yet softening into a mild and melancholy beauty as we approach the borders of Paradise; and in the last division of the poem M. Doré gives us some astonishing glimpses into the glories and angelic raptures of Heaven. Here again he exhibits his unrivalled power of suggesting boundless space and measureless effulgence. In many of the illustrations to the " Paradiso," the ascending ranks spread, burning and glowing in ardencies of white flame, through the blue immensity of air, until the eye dazzles in the attempt to follow them. Very lovely are some of " the milder shades of Purgatory "—landscapes touched with a divine sadness, as of mingled regret and hope. Especially exquisite are the designs illustrating the beautiful passage—

> " The radiant planet, that to love invites,
> Made all the orient laugh, and veil'd beneath
> The Pisces' light, that in his escort came · "

the approach of the angel over the waters of Purgatory, a vision of glorious and tender loveliness, with a sky of troubled light, vapoury, yet sweet and tranquil; the arrival of the angel in his boat crowded with human souls, a picture in which the figures of Dante and Virgil are extremely noble, and the sky most delicately and subtly touched; the grove in which the Mantuan and the Florentine are addressed by the melancholy spirit of Pia, where the air seems to thrill with a soft misty sunshine; the scene based on the opening lines of Canto IX.—

> " Now the fair consort of Tithonus old,
> Arisen from her mate's beloved arms,
> Look'd palely o'er the eastern cliff; her brow,
> Lucent with jewels, glitter'd "—

a stretch of solitary sea, flanked by enormous cliffs, at the foot of which the two poet-companions sit under the mournful-sweet radiance of coming day, and dying stars, and sinking crescent moon; the golden brightness of Dante's dream of Leah—

> " About the hour,
> As I believe, when Venus from the east
> First lighten'd on the mountain (she whose orb
> Seems always glowing with the fire of love),
> A lady young and beautiful, I dream'd,
> Was passing o'er a lea ; and, as she came,
> Methought I saw her ever and anon
> Bending to cull the flowers ; "

the dance of the three nymphs; and the sacred stream at the limits of Purgatory, where Dante drinks of the purifying waters, previous to mounting with Beatrice into Heaven. The scenes in Paradise are of course less varied, but are perhaps even more remarkable, considering the inherent difficulties of the subject. The feeling of immensity that prevails

throughout is in the highest style of poetry. Vast beams of light traverse unfathomable depths of air; bird-like flights of angels, countless in number, and barely descried through the radiant whiteness of their robes, go circling through the infinite blue heavens; and higher and higher, in the raptures of love and adoration, the blessed spirits mount and burn in undistinguishable ranks. M. Doré has here shown himself not unworthy of Dante's sublime visions. It should also be mentioned that many of the figures in the "Purgatorio" are full of a dignified beauty, and that the drapery is managed with great art. The Beatrice, however, is not among the best of the figures. It is generally feeble.

From Dante it seems natural to pass to Milton. The Englishman, like the Italian, sang of Hell and Heaven; and although, being a Protestant, he did not recognise Purgatory, the garden of Eden, in which a large part of the action of "Paradise Lost" takes place, furnishes a species of middle region. The differences between Dante's poem and Milton's, however, are very great. The "Paradise Lost" has a more positively epic character than the "Divina Commedia," because it has a more closely-woven and clearly-defined story; and this has enabled M. Doré to give to his illustrations of the great English classic a different character from those of Dante's poem, notwithstanding the degree of similarity in the two subjects. The scenes in Hell have none of the physical tortures with which the "Inferno" abounds, for Milton dwelt more on the mental agonies of despair, and of the sense of exclusion from the Divine countenance, than on the horrors of mangled limbs, serpent-stung bodies, and fiery pits of anguish. Besides, Dante was chiefly concerned with the spirits of those who had once been human beings, regarding the devils of the lower world simply as the agents of their punishment; while Milton's Hell is that of the pre-human period, and the sufferers are the rebel angels who had fallen from Heaven. In the great drama of the celestial war and its consequences, in the creation of man, the sweet pastoral life of Eden, the temptation, and the fall, M. Doré has abundant material for varied illustration, distinct, for the most part, from the incidents of the Italian poem. The pictures representing the conflicts of the angels are somewhat conventional in their character; but designs of great power might be pointed out. It was a mistake on the part of M. Doré to illustrate the passage commencing with the words—"No sooner had the Almighty ceased," &c., for any endeavour to depict the Creator is an audacity which must necessarily fail; but many of the scenes in the firmament and in Chaos are full of bold conception and effective drawing. The views in Eden, also, are very lovely. These commence with the lines in Book IV.—

> "Now to the ascent of that steep, savage hill
> Satan hath journey'd on, pensive and slow."

The Fiend is seen on the top of a high mount, from which he overlooks the billowy sea of verdure lying beneath, warmly illuminated by the slant beams of the setting sun.

The next design gives a nearer view of the garden, and in some of the following pictures Adam and Eve are seen alone, or in the society of angels. Among the best of the illustrations are those which depict the creation of the world. The separation of the waters as, pouring between the newly-risen rocks and mountains, they flow towards the great bed of the ocean, is most felicitously rendered : the soft, dark, fluent outlines of the torrents, and the mist of steam spreading over the whole composition, admirably embody the suggestions of the text. Equally good is the generation of the fishes and the birds; and in the drawing illustrating the passage—

> " Meanwhile the tepid caves, and fens, and shores
> Their brood as numerous hatch,"

the effect of fresh young sunshine, and swarming winged life, is very noticeable. The arising of the seventh evening in Eden is perhaps the most beautiful landscape in the book. The beasts of the field, in their first innocence and bloodless fraternity, are couched in a grassy meadow, beneath vast shadowy trees, and at the back of the picture a large yellow moon glimmers between thin streaks of cloud, casting a slumberous light over earth and sky. A view of wild grandeur, tumultuous with rocks and foamy waters, is that in which Satan stands contemplating the point at which the river Tigris, according to the ancient legend, sinks underground " at the foot of Paradise," to rise up again within the happy boundary, in the form of a fountain. The wily approach of the Serpent up a shady walk, at the end of which Adam and Eve sit beneath bowers of drooping foliage, is very intense in its contrast of trusting innocence and malevolent design ; and the picture in which the primitive man and woman, after having eaten of the apple, give way to transports of grief, is full of grand forest glooms, in keeping with the sentiment of the piece. The enormous tree-trunk against which Adam is leaning is drawn with great force and mastery, and the two figures are well conceived. The expulsion from Paradise is a little theatrical; but the illustrations of Biblical history in connection with the prophetic visions of Adam are good, especially that of Moses on Mount Sinai with the tables of the law—a magnificent prospect of barren, dusky land, and cloudy sky. There are several reasons why it is surprising that M. Doré should have been so successful in his illustrations to " Paradise Lost." A Frenchman seldom entirely sympathises with an Englishman, or with the creations of English genius. M. Doré might have been in a measure chilled by the Puritanism of Milton, or depressed by the austerity of his verse, or checked by an imperfect acquaintance with the language of his original. It may, indeed, be thought by some that he has entered more fully into the spirit of the Catholic Italian than into that of the Protestant Englishman ; but it is certain that he has worthily interpreted some of the finest points in the latter. It should also be borne in mind that M. Doré, in illustrating Milton after Dante, was forced to go over similar, though certainly not identical, ground. Still, the illustrations to " Paradise Lost,"

had they been the first work of the designer, would have sufficed to make him a reputation. It is only by comparison with greater achievements that they in any respect disappoint. The least good are effective, and the best are touched with something of Miltonic sublimity. M. Doré has followed the intention of his author in giving to Satan the dignity of a spirit once ranked among the blessed. He even goes beyond Milton in this matter—at least, in the earlier scenes. The poet tells us that the form of Satan, on his first arrival in Hell,

> " Had yet not lost
> All her original brightness, nor appear'd
> Less than archangel ruin'd, and the excess
> Of glory obscured ;"

but his face was scarred with thunder, and his cheek faded with care. The Satan of M. Doré, at the commencement of the poem, is a handsome and by no means malignant-looking youth, dressed in a Roman costume, and furnished with wings. In the later designs, however, the infernal character of the Spirit becomes apparent, and Milton's conception is then very faithfully rendered. It must have cost M. Doré something to adopt the Miltonic rather than the mediæval notion, for his personal inclinations are in the direction of the fantastic rather than the stately. He would probably have preferred to make Satan as grotesque a figure as those which we see in the external sculptures of old Gothic cathedrals ; and, apart from the conditions prescribed by his author, he would not have been without warrant, in the opinion of some modern critics. The Germans in the time of Goethe revived the older conception of the aspect of evil spirits, and contended that they should be made as ugly and repulsive as possible. Their nature being inharmonious and horrible, their appearance should correspond, and, instead of retaining something of their original angelic beauty, however darkened by malice and exasperated by defeat, they should be described and pictured as dwarfish, deformed, and incongruous goblins—capable of inspiring fear, indeed, yet in a certain sense contemptible. Some English writers have adopted the same view, and Dr. Newman, in his striking dramatic poem, " The Dream of Gerontius," has given it the sanction of his distinguished abilities. But Milton thought otherwise, and it must be confessed that the mediæval idea is inconsistent with the dignity of that awful old Manichæan doctrine of two co-eternal principles, the Principle of Good and the Principle of Evil. In any case, the matter was settled for Doré by the poet he was illustrating, and some of the French artist's sketches of Satan are in strict harmony with the text.

When M. Doré undertook to illustrate the Bible, he staked his reputation on a very serious issue. Such a work would tax the genius of the greatest artist that the world has ever known ; and indeed it may be safely affirmed, without derogation from the illustrious Frenchman, that no one designer could possibly do justice to the enormous variety of grand, sublime, tender, dramatic, supernatural, and wondrous scenes and

incidents contained in the Old and New Testaments. To discharge such a task worthily, a man should possess the simple human dignity in figure-painting of Raphael, together with the several qualifications of the other great masters, and the highest skill in landscape-drawing of the best of the modern school. It is extraordinary that M. Doré should have been able to produce so many of these credentials; it is but natural that in certain respects he should have failed. Whatever may be said on the score of a too violent and gorgeous treatment of some of the subjects, M. Doré's designs for the Bible will always be recollected for the grasp and power they exhibit. The artist has no personal knowledge of the East, and has therefore been obliged to compile his accessories (if the expression may be allowed) from books and museums. It may consequently be objected that the scenes are not locally true; but at any rate they are instinct with Oriental feeling, as that is commonly apprehended in this part of the world, and they have a degree of poetical or ideal truth which, in such a work, may be of greater value than literal accuracy. The old Italian painters of scriptural stories knew much less of the East than M. Doré, or any educated man in these days; yet who objects to their works because the scenery, the architecture, and the draperies are not exactly those of Egypt and Judea in ancient times? If the sentiment of the piece is simple, primitive, and patriarchal, that is as much as, on grounds of art, we have any need to demand. But Doré really does more. His Egyptian and Assyrian architecture has evidently been studied from good models, and the costumes of many of his figures are full of Eastern pomp and flowing amplitude. The landscapes are probably deficient in fidelity as portraits of real places; but they are characterised by an Asiatic largeness and magnificence, and the atmospheric effects are admirably managed, so as to bring out the incidents of the narrative in the most striking light. The scenes in the Desert and in the cities of Egypt and Assyria burn with the great heat and glory of those sultry lands; while others are overshadowed with the gloom of mountainous and rocky countries, or rendered austere with massive buildings and the manners of semi-barbarous tribes.

The number of the designs alone is extraordinary, for M. Doré has taken us through the whole of the Old Testament, the Apocrypha, and the New Testament, and we find that most of the leading events are illustrated. The effect of looking through this wonderful gallery is bewildering. We see passing before our eyes a pageant of prodigious circumstances and awful scenery: the old traditions of creation, and the legends of the early world; the sweetness of pastoral doings, and the simple grandeur of patriarchal ways; kings in their glory of gold and jewels, and heroes in their pride of strength; manhood in its splendour and its fierceness, and womanhood in the grace of its divine beauty; feasting and battle, enjoyment and despair, triumph and defeat; all gentle and all cruel deeds of primitive wild nature; the sanctities, and the abasements of love; the rage of jealousy and the hunger of revenge; prophet and preacher going forth

among unbelievers, contending with savage beasts and more relentless men, suffering imprisonment, or holding intercourse with unimaginable Heaven; angelic visitants, coming in love or wrath, or making divine and fair the poverty of lowly dwellings and the nakedness of barren lands; priests and warriors, shepherds and merchants, the life of cities and the life of fields; mountains and seas and deserts, forests and grassy plains; broad gold of sunshine and great depths of night; storm and terror, ruin and desolation; the majesty of temples and palaces, reared in those ages when men built as if for gods; visions and dreams and portents; the actions and the death of Jesus, and the miracles of Gospel narrative. In treating such subjects, especially those connected with the New Testament, M. Doré necessarily comes into frequent collision with the great masters of the Italian, Spanish, and Flemish schools; and it says much for his versatility and skill that he should bear the inevitable comparisons so well. It would, of course, be unfair to expect in a popular work, executed with rapidity, and with the rough agency of wood-engraving, anything like the dignity of Raphael's Cartoons, or of the great works of Michael Angelo, Leonardo da Vinci, Murillo, and Rubens; but it may certainly be said that not one of those famous men ever attempted to traverse the immense stretch of territory which M. Doré has covered, and successfully covered, with the productions of his pencil in these scriptural illustrations. There is capability enough in them to make a dozen reputations of widely distinct character; and, at first thought, one is disposed to regret that M. Doré should not have concentrated his powers on two or three departments of art, instead of distributing them over so many divisions, and thus apparently losing a certain degree of force by profuse expenditure. Yet the regret would be foolish after all. A man of genius may be generally credited with having taken the best course for the development of his special gifts of insight and expression; and to wish him other than he is, is to throw a doubt upon the validity of his mission, or to murmur at the lily because it is not the rose. Had M. Doré devoted himself to the elaborate cultivation of some one branch of art, he might possibly have attained a greater, though a solitary, elevation; but he would not have spoken to the popular mind as he now does, nor would he have created so many forms of beauty and of power. It is doubtful even whether he would have equalled in any one walk what he has now performed in several. The abilities of some men are fittest for concentration, those of others for diffusion; and it may be that Doré has actually gained in strength, instead of lost, by the splendid audacity with which he takes possession of many territories at once, and "flames amazement" on the spectators. The chief quality of his genius is rich productiveness; and in none of his numerous works is this quality exhibited in a more remarkable degree than in the series of drawings with which he has adorned the Bible.

With "Don Quixote" we enter upon a totally different class of designs. M. Doré is here seen in his lighter vein, and excellent are the results. In no other of his works has he so admirably combined the humorous and the picturesque. The illustrations to

Rabelais exhibit the same qualities, but in a far lower stage of development. The artist was then very young; his style was not matured, and he worked cheaply, rapidly, and somewhat coarsely. Striking, original, and full of promise as the Rabelais sketches were, they did not reach the level attained some years later in the "Don Quixote" series. The wonderful story of Cervantes has been here realised in all its elements. Its drollery, its pathos, its grotesqueness, its grandeur, its dramatic characterisation, its romance, its wildness of scenery, richness of accessories, and quaint union of the chivalrous and the satiric, are by turns embodied in the numerous wood-cuts with which M. Doré has embellished the work. The conceptions of the two chief characters are for the most part very good. In the novel itself, the high-souled but insane nature of the Don is effectively relieved by the practical good sense, but coarse and somewhat sordid disposition, of Sancho Panza; and this contrast of two very distinct characters is clearly brought out by the artist. In a few of the illustrations the figure of Quixote is exaggerated in its excessive length and tenuity; but the face is generally most felicitous. M. Doré seldom forgets that the Don is a gentleman and a fine human creature, however far he may have gone astray in the pursuit of a generous but visionary idea. There is nothing more touching than the devotion of unselfish natures to impossible schemes of perfection—or what they conceive to be perfection. Quixotism, with all its failures and mad errors on its head, is one of the great redeeming facts of the world, because it springs from a profound belief in good, and a strong desire for natural justice. The "Republic" of Plato, the "Utopia" of Sir Thomas More, the "Oceana" of Harrington, the modern democracy of French and other Continental revolutionists, the communism of Fourier and Owen, the Pantisocracy of young Coleridge and Southey, the commonwealth which good old Gonzalo would have established on Prospero's enchanted island, and fifty more such dreams : what are they but so many forms of Quixotism ?—extravagant, absurd, impossible, mischievous, it may be, when too hotly pressed, yet with something noble at the heart of them. This idea appears to have been present to the mind of Cervantes in his development of the character of Don Quixote, and it has evidently not escaped the perception of M. Doré. His knight of La Mancha is a fine old Spanish hidalgo, distraught with a monomaniacal idea, and identified with all kinds of ludicrous disasters, yet preserving to the last a certain moral grandeur. The Don is in fact a madman—in these days we should place him under restraint, after due inquiry before a commission—and the shadow of his insanity is seen in M. Doré's representation of his face. The illustration in which he is shown reading his romances of chivalry, surrounded by a shadowy crowd of phantom creatures, and another in which he is riding along a dreary road towards nightfall, with a sky full of visionary and ominous shapes, begotten of the sunset and the clouds, are in the highest mood of imaginative sympathy. The views in the Sierra Morena, the long, bright, dusty plains of the Peninsula, and the softer glimpses of Spanish scenery, are beautiful as specimens of landscape-drawing; and the architectural subjects, with their fascinating combination of Gothic and Moorish forms,

are pleasant to look on and to linger over. Many of the smaller sketches are admirable pictures of Spanish life, as it is now, as it was in the days of Cervantes, and as it had been then for centuries; and the spirit, humour, movement, and vitality of the whole set of illustrations are worthy of the highest praise. M. Doré has done greater things than his designs for "Don Quixote," but nothing so thoroughly delightful. They introduce us to one of the most charming provinces in the great domain of European literature; and they refract as from a prism the many-coloured rays of the most fanciful, the most gallant, and the most gorgeous civilisation that modern times have known.

The Fables of La Fontaine gave M. Doré an opportunity of exhibiting his skill in the delineation of brute life, of which, however, he has not taken as much advantage as he might. Availing himself of the "moral" generally attached to fables, he has interpreted some of the narratives in a human sense, and has converted quadrupeds, birds, and insects into men and women. Thus, in the very first story, "The Grasshopper and the Ant," the grasshopper is personified by a girl who goes about the country singing and playing the guitar during the summer months, and the ant by a homely, industrious housewife, to whom, as she stands knitting at her door on a snowy day in winter, the poor wandering artist applies for alms—obviously, with no probability of getting them. The picture is most effective and striking, but it is a perversion of the tale. The moral of the fable is simply against idleness and selfish indulgence; the pictorial moral strikes against the pursuit of art as a means of living, and is a strange lesson for an artist, and a successful artist, to teach. The poor singer has doubtless diffused a larger amount of pleasure than ever the austere knitter at the door has given, or will give; and, although nobody wishes the world to be composed solely of troubadours, and disregard of prudential arrangements is at all times a fault, it is too much to suggest that the dull plodders are entitled to look with scornful indifference on the sufferings of the more finely-wrought natures who make the poetry and music of the world. Again, "The Fox and the Grapes" is illustrated by a scene in the garden of a grand château, in which we see two rather shabby cavaliers looking up towards a terrace on which some gay holiday people are disporting themselves. One of the ragged rufflers below is pointing to the merry-makers above, and apparently depreciating while envying their happiness, much after the manner of the fox with the bunch of grapes. The design is very charming, reminding one of the festive paintings of Watteau; but nobody could guess that it was an illustration of "The Fox and the Grapes" if it were not placed side by side with the fable. Other instances might be mentioned, but these will suffice to show that M. Doré has allowed himself considerable latitude in treating the old Æsopian fables as told by La Fontaine. In this way he has obtained great variety, and a large degree of pictorial richness, for he has adopted the costumes of any age or country which appeared suitable to his purpose, and has introduced whatever accessories might tend to the general effect. But the liberties thus taken are in some respects injurious. The ancient spirit of fable is dispossessed by all this wealth of modern allusion. The

realism is too much for the figment with which it is associated, and the latter loses, while the former does not gain, by the partnership. Even in those illustrations where the characters are all brutes or birds, the style is too ambitious to suit the grave simplicity of fable. Yet many of the designs, considered in themselves, are admirable. They form a series of effective pictures, and the smaller drawings, introduced as vignettes, are full of delicate bits of landscape, lightly yet exquisitely touched with the mastery of a practised hand.

"Croquemitaine" and "The Fairy Realm" contain striking specimens of M. Doré's fanciful and humorous invention. The first is a grotesque romance of Charlemagne and his knights, and of the Saracens who threatened the north-west of Europe with sub-jugation in the reign of the great Emperor. The martial adventures of Christian and Moslem heroes are interspersed with the still wilder features of a fairy tale—enchanted castles, giants and magicians, ghosts and hobgoblins; all of which M. Doré has represented in a true spirit of enjoyment, blending the horrible with the droll, the picturesque with the extravagant, until we seem to have entered some phantom world where everything is possible but the probable. In "The Fairy Realm" we find this versatile artist realising the leading incidents of our old familiar nursery tales in a set of vivid pictures. "The Sleeping Beauty," "Little Red Riding Hood," "Puss in Boots," "Cinderella," and "Hop o' my Thumb," are the stories illustrated, and some of the designs are quite seductive in their elfin grace. Particularly excellent is "The Sleeping Beauty." The chief points in that fascinating legend are very poetically interpreted, and we wander with the handsome young prince through a stately world of marvels. We view the strange old castle within and without; see it from afar, with its towers and peaks muffled in shadowy woodland, and glimmering across ravines and rocky glens; approach its mysterious portals up avenues of trees that make a solemn twilight out of sun and shadow; note the wild vegetation of a hundred years twining round pillar and buttress, or wreathing oriel windows with quainter tracery than their own; pass through the slumberous rooms and echoing courts; and stand beside the lovely princess in her bed, with creepers tangling over wall and floor, and great beams of light slanting in from the high casements, warming the carven figures on the vast heraldic mantelpiece, and prophesying that the end of the long sleep has come. Nothing can be more dreamy, remote, and magical than these designs; and the man who retains anything of his childhood's love of the wonderful will appreciate them even more than the younger generation. "Hop o' my Thumb" also contains some beautiful drawings, and the childish figure in "Little Red Riding Hood" is full of infantine sweetness. M. Doré is not without some formidable rivals in the illustration of these stories. Our own country-man, Mr. George Cruikshank, has exhibited a remarkable capacity in this respect. In the quainter regions of elf-land he is perhaps unrivalled; but M. Doré is more elegant and more pictorial. It is the difference between the rough, abrupt, German intensity of the Brothers Grimm, and the ornate and courtly elaboration of Madame d'Aulnoys.

The utmost triumph of burlesque is reached in the illustrations to "Baron Munchausen." They overflow with oddity and fun, and many of them touch upon the borders of imaginative grandeur. The volume gives us a veritable glimpse into wonder-land ; or rather a number of glimpses, ascending higher and higher up the cloudy rack of fancy. Munchausen is a creation of genius, and we here go with him in all his glorious ways, and participate in his adventures to their utmost ecstacy of lying.

Such is the genius of Gustave Doré, and such are some of its main achievements. When we glance rapidly over the field that has just been traversed, the variety of its riches cannot fail to strike the mind. Dante and Munchausen—Milton and the fairy tales of the nursery—the Bible and "Don Quixote"—"La Fontaine" and "The Wandering Jew"—"Atala" and "Croquemitaine :" what strange contrasts are here ! and what wonderful plasticity of mind, wealth of imagination, and breadth of sympathy must that man possess who is at home in such widely different countries ! Much, however, yet remains to be conquered. It is true that M. Doré has done enough for a life of eighty years ; but he is still in his prime, and we may reasonably hope for many more productions of his pencil. The "Arabian Nights" is to be his next work, and countless other creations of genius still await his hand. A "Doré Shakespeare" has been talked of for some years, and we can all understand what pictures of Prospero's island, and of the moonlit groves of Oberon and Titania, such a book would contain, however much the artist's interpretation of the purely human element in the great dramatist might contradict our English sense of what would be appropriate. In Goethe's "Faust" M. Doré would find a most congenial theme, by no means exhausted by the splendid designs of Retzsch. The "Pilgrim's Progress," "Robinson Crusoe," the "Faëry Queene," Coleridge's "Ancient Mariner," the poems and novels of Sir Walter Scott, the works of Byron—all these abound in materials for the facile handling of the illustrious French book-illustrator. The classics of his own country he does not seem to favour in an equal degree with foreigners—perhaps because they are not so rich in pictorial suggestiveness ; but he will probably find some mines in that territory also, besides what he has already explored. At any rate, he has earned a magnificent reputation by the work of the past ; his name is a familiar sound all over the civilised world, conjuring up, as by a talisman, associations of beauty and grandeur, of humour, drollery, and fun ; and it cannot be doubted that, if life and health are granted him, he will make many more claims upon our gratitude, and move our astonishment and delight by new creations and yet fairer forms.

# THE WORKS ILLUSTRATED.

---

## DANTE'S "INFERNO," "PURGATORIO," AND "PARADISO."

FULLY to appreciate, or even to understand, the great work of Dante, it is necessary to bear in mind the leading events in the life of the poet. He was in every respect one of the most remarkable men of his age: a man of strong will, of strong passions, of strong prejudices; of a vehement and yet a saturnine nature; a soldier and a politician, as well as a singer; and one so bound up with the history of Italy at the time in which he lived, and with those Italian aspirations which have only recently found their complete fulfilment, that it would not be possible to write the annals of his land without frequent reference to him. His "Divine Comedy" presents a singular union of lofty grandeur with local politics and personal quarrels. Whether in Hell, in Purgatory, or in Heaven, the writer never forgets the affairs of Florence, or the differences of Guelphs and Ghibellines; never lets slip an opportunity of lampooning his enemies or exalting his friends. Many of the allusions in this prodigious poem are so circumscribed and temporary in their interest, that one marvels how so great a genius could have consented to lift them into the broad and universal air of poetry. Yet such is the creative force of the work, that it has attained all over the civilised world, a position only second to that of the "Iliad" and "Odyssey." Its wildest imaginings have the power, the directness, the fulness of detail, and yet the simplicity of general effect, that belong to actual facts; and it is not difficult to understand that Dante may really have believed he saw the visions of his brain pass before him with a distinct existence.

Dante Alighieri was a Florentine, and his family had been Florentines for many generations. He was born in May, 1265. Having while yet a child lost his father, he was placed for education with Brunetto Latini, a man of great learning, and, apparently, of amiable qualities, although his pupil has placed him among the condemned in Hell, on account of some vices of which he is accused. On meeting Brunetto in the seventh circle of the infernal regions, Dante holds a somewhat long discourse with him, and says :—

"Were all my wish fulfill'd,
Thou from the confines of man's nature yet
Hadst not been driven forth; for in my mind
Is fix'd, and now strikes full upon my heart,
The dear, benign, paternal image, such
As thine was, when so lately thou didst teach me
The way for man to win eternity:
And how I prized the lesson, it behoves
That long as life endures my tongue should speak."

*Inferno, Canto XV., lines* 79—87.

In describing Plate CIX. of this series, we have remarked on the cruelty of Dante's putting his old preceptor and friend into the hopeless agonies of Tartarus, because of accusations which may or may not have been true, and which, at any rate, the tenor of his writings rather induces one to disbelieve.

Under this learned instructor Dante acquired a large amount of book-knowledge; and this he afterwards increased by studying at the universities of Bologna, Padua, Florence, Paris, and perhaps Oxford, giving special attention to natural and moral philosophy and theology. But he did not neglect the martial exercises common to youths of good family in those ages, though it is said he temporarily entered the order of the Frati Minori. When a young man of twenty-four—that is to say, in 1289—he was present at the battle of Campaldino. This was one of the numerous contests arising out of the dissensions of the Guelphs and Ghibellines, two parties into which the Italians were divided for a very long period. The Ghibellines were the adherents of the Emperor; the Guelphs, the partisans of the Pope. Both names are held to be of German origin; but a good deal of obscurity involves the beginning and final extinction of these factions. At the date of the battle of Campaldino, the Florentines were, for the most part, followers of the Guelph or Papal interest. Their opponents were the people of Arezzo, who, after a severe struggle, were totally defeated. Dante was also engaged in a battle (fought the following year) between the Florentines and Pisans, in which the former were again victorious. In his earlier years, the poet seems to have been an unquestioning adherent of the Pope; but circumstances occurred to change his views, and to modify the whole course of his life. A family quarrel among the people of Pistoia spread to the Florentines. The parties to the quarrel were known respectively as the Neri and Bianchi, the former of whom were generally supporters of the Guelphs, and the latter of the Ghibellines. Dante was at that time chief of the Priors, a body exercising supreme authority in the Republic; and it was decided by this body, at the instigation of the poet, that the leaders of the two factions should be banished from the city. This was in the summer of 1300. It is held by the biographers of Dante that he exhibited great impartiality in the affair; but he was accused by the Neri of favouring their opponents, and the charge received some colour of probability from the fact that shortly afterwards the Bianchi were allowed to return from

their place of banishment, while no such privilege was accorded to the heads of the other faction. Dante defended himself by showing that when this was done he was no longer in office, and that the return of the Bianchi had been permitted because the unhealthy air of Serrazana (where they had been sent) had stricken Guido Cavalcanti, one of the leaders of the party, with a mortal illness. The Pope, however, took up the question in the interests of his adherents, and, dispatching Charles of Valois to Florence, caused such a revolution in the administration of affairs in that city, that the Neri were recalled, and the Bianchi driven out. Dante was then at Rome, where he was discharging the office of ambassador from Florence to the Papal court, with a view to the arrangement of differences. His enemies at home, however, seized the opportunity to pass a sentence of two years' banishment against him (January, 1302), and at the same time to fine him to the extent of eight thousand lire. He was condemned shortly afterwards to be burned, if taken; and his possessions had previously been pillaged by the populace.

These events made, if they did not already find, Dante a Ghibelline, though at first not of an extreme order. Like most patriotic Italians, he regarded with something like adoration the principle of the old imperial rule, by which Rome was to be the capital and sovereign of the whole world; and as the Ghibellines were Imperialists, he was to that extent a Ghibelline himself, now that he had reached mature years, and had suffered in his own person from the tyranny of the Guelphs. But he saw many faults in the Ghibellines, and, through the mouth of the Emperor Justinian, in the sixth canto of the "Paradiso" (lines 99—116), he expresses some severe opinions on both parties :—

> "Judge then for thyself
> Of those whom I erewhile accused to thee,
> What they are, and how grievous their offending,
> Who are the cause of all your ills. The one
> Against the universal ensign rears
> The yellow lilies;

(*i.e.*, the Guelphs, enlisting the aid of France, oppose the *fleur-de-lis* to the "universal ensign" of Rome, or of the Empire;)

> and with partial aim
> That to himself the other arrogates:
> So that 'tis hard to see who most offends.
> Be yours, ye Ghibellines, to veil your hearts
> Beneath another standard: ill is this
> Follow'd of him who severs it and justice.
> And let not with his Guelphs the new-crown'd Charles

(either Charles II., King of Naples and Sicily, or Charles of Valois)

Assail it; but those talons hold in dread
Which from a lion of more lofty port
Have rent the casing.   Many a time ere now
The sons have for the sire's transgression wail'd :
Nor let him trust the fond belief that Heaven
Will truck its armour for his lilied shield."

In 1303, Dante joined a council of Ghibellines belonging to the party expelled from Florence, who, after deliberation at Arezzo, made (in 1304) an unsuccessful attack on the city to which they owed their misfortunes.   Subsequently to this event, Dante seems to have wandered, in poverty and dejection, over Italy, depending on the kindness of various patrons for the means of life.   How bitterly he felt these misfortunes is sufficiently manifested in several of his writings.   In his prose work, the " Convito " (or Banquet), he speaks on the subject in a passage of great pathos :—" Ah, that it had pleased the Dispenser of the Universe that neither others had committed wrong against me, nor I suffered unjustly ; suffered, I say, the punishment of exile and of poverty ; since it was the pleasure of the citizens of that fairest and most renowned daughter of Rome, Florence, to cast me forth out of her sweet bosom, in which I had my birth and nourishment even to the ripeness of my age ; and in which, with her good will, I desire with all my heart to rest this wearied spirit of mine, and to terminate the time allotted to me on earth.   Wandering over almost every part to which this our language extends, I have gone about like a mendicant ; showing, against my will, the wound with which Fortune has smitten me, and which is often imputed to his ill-deserving on whom it is inflicted.   I have, indeed, been a vessel without sail and without steerage, carried about to divers ports and roads and shores by the dry wind that springs out of sad poverty ; and have appeared before the eyes of many who, perhaps, from some report that had reached them, had imagined me of a different form ; in whose sight not only my person was disparaged, but every action of mine became of less value."*   And in Canto XVII. of the " Paradiso," the spirit of Cacciaguida, the poet's ancestor, is made to describe, in a prophetic manner, the miseries which Dante was to endure :—

" Thou shalt leave each thing
Beloved most dearly : this is the first shaft
Shot from the bow of exile.   Thou shalt prove
How salt the savour is of others' bread ;
How hard the passage to descend and climb
By others' stairs.   But that shall gall thee most
Will be the worthless and vile company
With whom thou must be thrown into these straits."          *Lines* 55—62.

From time to time he addressed supplicatory epistles to the government and people of Florence, imploring them to allow of his return ; but in vain.   In 1310, however, the

* Quoted by Cary in his " Life of Dante."

election of Henry of Luxemburg to the Imperial crown of Germany raised the hopes of Dante, as Henry was known to have resolved on visiting Italy, with a view to asserting his rights as King of the Romans. Dante hereupon changed his beseeching tone for one of defiance and menace, and addressed a circular to the ruling powers and people of Italy, threatening the vengeance of Henry on the "felons" who had opposed him. He told the Florentines that they had not sufficient power to resist the Emperor, and he joined heartily with the Ghibellines in supporting the new-comer. About this time he wrote his work on Monarchy, in which he contends that to the Emperors, as successors of the Cæsars of old time, belonged the supreme temporal power, and that the Popes were simply the spiritual heads of the Church. It must be admitted that Dante's conduct, in first humbling himself to his fellow-citizens, and then fulminating against them when he thought the way prepared for a triumphant return, was far from dignified, or even creditable. He has been censured also, and with some reason, for his willingness to lay Italy open to the foreigner, in the hope of attaining his private ends, and of serving the interests of the party to which he was now attached. But he saw, as so many others have seen, the incalculable evils resulting from the temporal power of the Popes; and it is curious to find him advocating, more than five centuries and a half ago, the very settlement of Italian affairs which is only now being carried into practice.

The hopes of Dante were doomed to disappointment. The Emperor at first made some progress in the north of Italy, and Dante addressed to him a letter, begging him to proceed to Florence, and put down the spirit of Guelph sedition, which showed itself in an unnatural revolt against the parent city, Rome, the seat of Empire. Henry shortly afterwards entered Tuscany, and threatened Florence, but without success; and in August, 1313, he died suddenly near Sienna. This extinguished the sanguine anticipations of the poet. He resumed his wanderings about Italy, and never again adopted a tone of entreaty towards his fellow-citizens. Indeed, when, in 1316, it was suggested to him by a friend that he would be allowed to return if he acknowledged his errors and asked for absolution, he haughtily replied :—

"No, this is not the way that shall lead me back to my country. But I shall return with hasty steps, if you or any other can open me a way that shall not derogate from the fame and honour of Dante; but if by no such way Florence can be entered, then to Florence I shall never return. Shall I not everywhere enjoy the sight of the sun and stars? May I not seek and contemplate truth anywhere under heaven, without rendering myself inglorious—nay, infamous—to the people and commonwealth of Florence? Bread, I hope, will not fail me."

His final home was with Guido Novello da Polenta, lord of Ravenna; "a splendid protector of learning," says Cary in his biography; "himself a poet; and the kinsman of that unfortunate Francesca whose story had been told by Dante with such unrivalled pathos." (See Plates CXCI. and CCXLIII. of the present series, and the descriptions of

them.) Dante seems to have been more happy with this the last of his patrons than with any of the others; the nature and disposition of Polenta being more congenial with his own. He also derived considerable solace from the fame which his great poem procured for him, and which was indeed so great that in his treatise " De Vulgari Eloquentia" he says it had in some measure reconciled him to the misery of banishment. It would appear to have been in 1319 that he went to reside with the great man of Ravenna, and two years later he was dispatched by him on an embassy to the Venetians. The rulers of the Republic, however, refused to receive him, owing to their hostility to the prince; and the mortification threw Dante into an illness, of which he died in the summer or autumn of 1321. Guido da Polenta honoured his memory with a sumptuous funeral, and himself died some two years later, after having been deposed from his sovereignty.

The lady of whom we read so much in the " Paradiso"—Beatrice Portinari—was a sort of Platonical flame of the poet's. He first fell in love with her when they were both in their ninth year. She died (a married woman) sixteen years later, and in the following year Dante espoused Gemma de' Donati, with whom it is said he lived unhappily, owing to her violent temper. A French biographer of Dante has doubted the statement; but Gemma was a kinswoman of one of the poet's most inveterate opponents, and this may have embittered their intercourse. They had a family of five sons and one daughter, the latter of whom was christened after the object of the father's early attachment. For the support of this family, Gemma exerted herself nobly after her husband's banishment. Two of the sons, named Pietro and Jacopo, were poets, though they are now chiefly known as commentators on their parent's " Divina Commedia." Dante was a man of grave deportment, of dark complexion, with a long face, an aquiline nose, large eyes, prominent cheek-bones, a projecting under lip, and black curling hair and beard. The celebrated portrait by Giotto realises this description, with the exception of the beard, for the face is closely shaven. It shows us a visage melancholy, abstracted, disappointed, somewhat irritable, but with the visionary eyes of a poet, and the rapt intensity of a seer. The biographers relate that Dante's manner was often absent, and that in his deportment he was grave and dignified; speaking seldom, and then slowly, but with great subtlety and point. His temper was haughty, and disposed to sarcasm, and after his repeated misfortunes he seems to have been much soured. His fellow-citizens, however, soon honoured his memory above that of any other Florentine, and at the commencement of the fifteenth century they requested the people of Ravenna, but ineffectually, to give them back the poet's remains. Negotiations to the same effect were opened in subsequent ages, one of which was conducted by Michael Angelo, acting on behalf of Pope Leo X.; but all failed, and it was not until 1830 that a monument to the great Florentine was erected in his native city. In May, 1865, the six hundredth anniversary of Dante's birth was celebrated at Florence with extraordinary pageantry and splendour, King Victor Emmanuel making

it the occasion for the transfer of the seat of government from Turin to Florence; and, by a curious coincidence, some long-missed bones of Dante were accidentally discovered a few days afterwards at Ravenna.

The "Divina Commedia," the poem by which Dante is principally known, was written at various times, and reflects to a remarkable extent, considering the abstract nature of the subject, the personal feelings of the author, and the leading events of his age and country. In a letter to a friend, the poet says that he called it a "comedy" because, contrary to the style of tragedy, it begins with sorrow and ends with joy. It seems doubtful if the whole poem was put forth during his life, the text abounding in such virulent attacks on a great variety of persons that it would hardly have been possible for him, had the entire work been known, to find a shelter anywhere. Portions, however, were distributed, and, as we have seen, gave the writer a reputation unexampled in modern Italy. Very shortly after his death, a number of commentators on the poem arose, and a public lecture was founded at Florence and in other cities, with a view to explaining the mysteries and inner purport of the divine song. As Dante had himself declared that his intention was sometimes allegorical, and that his poem might be called "polysensuum"—having many meanings—endless scope was given to the ingenuity of the critics, and the result is a whole library of comment, including much that is fantastic and arbitrary.

The origin of the "Divina Commedia," as regards the main scheme of the work, is involved in some doubt; but that the leading conception is not absolutely original must be conceded. A monk named Alberico wrote, in barbarous Latin prose, about the commencement of the twelfth century, an account of a vision which he alleges he had had during a fit of illness and insensibility, and in the course of which he seemed to be taken through Hell, Purgatory, and Heaven, under the guidance of St. Peter and two angels. Some similarity is also to be traced in other works—especially in the "Tesoretto" of the great poet's teacher, Brunetto Latini. The descriptions of the regions beyond the grave occurring in Plato's Dialogues—as, for instance, the eight circles opening downwards out of one another in the story related towards the end of "The Republic"—may also have suggested certain points to Dante. But there is no such thing as an absolutely new creation: the greatest poet does but build with the material that he finds. Dante was a man of large and varied reading, and pressed many things into the service of his vivid imagination. His ideas in the main, however, were those of mediæval Catholicism. Though opposed to the temporal power of the Popes, he was thoroughly orthodox as a theologian. In the mirror of his "Divine Comedy" we may see what the best class of minds in the fourteenth century considered to be religion and morality; and we have no cause to regret that the expansion of modern knowledge and the freedom of modern thought have carried us away from some of the standards which then seemed to be immutably established. That Dante's poem contains many noble conceptions of moral

beauty and grandeur, is unquestionable; but its spirit is often vindictive and ferocious in the last degree. The modern conscience revolts against its loathsome and fantastic Tartarus, the judgments in which are frequently the mere expression of personal irritation; and even its Purgatory and Paradise, in spite of the pathos of the one and the rapturous beauty of the other, are largely tinctured with earthliness. But power and poetic exaltation are apparent throughout. A marvellous capacity of word-painting is united to a profound insight into the subtleties of the human heart, and the weaknesses, heroisms, aspirations, agonies, wants, and satisfactions of the human soul. In these stupendous visions, dreams acquire the reality of facts, and abstractions become dramatic. Many of the episodes, moreover, are told with extraordinary force and concentration; witness the stories of Paolo and Francesca, and of Ugolino. We are now, however, speaking of the poem at its best; for, as already observed, it contains many things, which seem too petty and evanescent for poetical treatment.

Dante supposes himself to have seen the visions in the year 1300, when he was thirty-five years of age—the year in which the troubles with the Neri and Bianchi occurred at Florence. He speaks of himself as being lost in a dismal and ominous wood:—

" In the midway of this our mortal life,
I found me in a gloomy wood astray,
Gone from the path direct; and e'en to tell
It were no easy task, how savage wild
That forest, how robust and rough its growth;
Which to remember only, my dismay
Renews, in bitterness not far from death.
Yet, to discourse of what there good befel,
All else will I relate discover'd there.
    " How first I entered it I scarce can say,
Such sleepy dulness in that instant weigh'd
My senses down when the true path I left.
But when a mountain's foot I reach'd, where closed
The valley that had pierced my heart with dread,
I look'd aloft, and saw his shoulders broad
Already vested with that planet's beam
Which leads all wanderers safe through every way.
    " Then was a little respite to the fear
That in my heart's recesses deep had lain
All of that night so pitifully past:
And as a man, with difficult short breath,
Forespent with toiling, 'scaped from sea to shore,
Turns to the perilous wide waste, and stands
At gaze; e'en so my spirit, that yet fail'd,
Struggling with terror, turn'd to view the straits
That none hath passed, and lived.   My weary frame
After short pause re-comforted, again
I journey'd on over that lonely steep."         *Inferno, Canto I., lines* 1—28.

While making his way through this wilderness, the poet is threatened by savage beasts, and, perceiving a human figure in the distance, calls for help. The apparition proves to be the shade of Virgil, who tells Dante that he will conduct him through the regions of punishment and of repentance; after which, if he desires to ascend to the dwellings of the blest, a worthier spirit must be his guide. Virgil proceeds to say that he has been bidden on this errand by the glorified spirit of Beatrice. After some hesitation, Dante follows the Mantuan, and both enter the gloomy archway of the gate of Hell. They are ferried by Charon across the river Acheron (we see here, and in other places, how much of Paganism there was in Dante's ideas on such subjects); and, having reached the infernal regions, pass successively through the nine circles, with their subdivisions and inner gulfs,* into which the dolorous domain is distributed. These circles open out of one another, pit within pit, descending in blackness and horror from bad to worse and worse; and the agony of the damned increases with every remove. The first circle contains the souls of those who, although they lived virtuously, and are therefore not subjected to rigorous torments, were not Christians, and are consequently unworthy of Paradise: among these Dante finds the sages, poets, and other great men of antiquity. The second circle is devoted to the punishment of carnal sinners; the third, to the chastisement of gluttons. In the fourth circle, the prodigal and the avaricious are tormented by being forced to meet in eternal conflict, rolling great weights against each other, with mutual upbraidings. The wrathful and gloomy suffer in the fifth circle, and the heretics in the sixth. Sins of violence and depravity are punished in the seventh circle, and a great variety of other mal-practices in the eighth and ninth. In our descriptions of the Dante plates, we have alluded to many of these forms of misery, and need not here repeat them in detail. Having passed through the whole of the infernal territory, the two poets ascend by a secret path to the surface of the earth, re-issuing in the southern hemisphere.

> "That hidden way
> My guide and I did enter, to return
> To the fair world; and heedless of repose
> We climb'd, he first, I following his steps;
> Till on our view the beautiful lights of heaven
> Dawn'd through a circular opening in the cave:
> Thence issuing, we again beheld the stars."
>
> *Inferno, Canto XXXIV., lines* 127—133.

On the shore of the solitary ocean that encircles the island of Purgatory, the two poets encounter Cato of Utica, who gives them certain directions. They afterwards behold a boat, containing the souls of newly-deceased persons, arrive under the conduct

---

* This distinction between the circles and the gulfs included in them should be borne in mind. In our account of Plate LXIX., the expression, "the third gulf of Hell," should have been, "the third gulf of the eighth circle of Hell."

of an angel; and among the souls Dante recognises his friend Casella, a Florentine musician with whom the poet had been very familiar, and whom he now induces to sing, after his habit in old days—a circumstance to which Milton alludes in his Sonnet to Henry Lawes:—

> "Dante shall give Fame leave to set thee higher
> Than his Casella, whom he wooed to sing,
> Met in the milder shades of Purgatory."

At a rebuke from Cato, who blames them for tarrying, they move forward, and begin the ascent of the Mount of Purgatory. The region of repentance is divided into seven cornices, circling, tier above tier, round the side of the mountain. In each of these cornices, one of the seven capital sins is punished. During their progress upward, Dante and Virgil meet with the spirit of the Latin poet, Statius, who, having been cleansed, is on his way to Heaven. The last ascent of all leads to the Terrestrial Paradise, situated at the top of the mountain. Here Dante wanders about for some time by himself, and sees many marvellous sights. He ultimately beholds Beatrice, and, having been drawn through the cleansing waters of Lethe by a female spirit named Matilda, he (together with Statius) is presented to seven virgins representing particular virtues, and is finally made to drink of the stream Eunoe:—

> "More sparkling now,
> And with retarded course, the sun possess'd
> The circle of mid-day, that varies still
> As the aspect varies of each several clime;
> When, as one sent in vaward of a troop,
> For escort, pauses, if perchance he spy
> Vestige of somewhat strange and rare; so paus'd
> The sevenfold band, arriving at the verge
> Of a dun umbrage hoar, such as is seen
> Beneath green leaves and gloomy branches oft
> To overbrow a bleak and Alpine cliff.
> And where they stood, before them, as it seem'd,
> I Tigris and Euphrates both beheld
> Forth from one fountain issue, and, like friends,
> Linger at parting.    .    .      .    .    .
>   .    .    .    .    .    .      .    .    .
>   .    .    .    .    .    As a courteous spirit,
> That proffers no excuses, but, as soon
> As he hath token of another's will,
> Makes it his own; when she had ta'en me, thus
> The lovely maiden moved her on, and call'd
> To Statius, with an air most lady-like:
> 'Come thou with him.' Were further space allow'd,
> Then, reader, might I sing, though but in part,
> That beverage, with whose sweetness I had ne'er
> Been sated. But, since all the leaves are full

Appointed for this second strain, mine art
With warning bridle checks me.   I return'd
From the most holy wave regenerate,
E'en as new plants renew'd with foliage new,
Pure, and made apt for mounting to the stars."

*Purgatorio, Canto XXXIII., lines* 100—142.

Dante is now carried through the successive spheres of Heaven by Beatrice.   In this division of the work there is much theological and scholastic matter, which to the modern intellect is barren and uninteresting, besides some discussions on Italian politics that seem unworthy of the general subject ; but there are also several magnificent visions of celestial beatitude.   At the conclusion, the poet is admitted to a sight of the Divine Majesty, and—

" Here vigour fail'd the towering fantasy ;
But yet the will roll'd onward, like a wheel
In even motion, by the love impell'd
That moves the sun in heaven, and all the stars."

*Paradiso, Canto XXXIII., lines* 132—135.

Thus ends this amazing poem, of which the range is co-extensive, not merely with the physical universe, but with all that mediæval faith had imagined of the spiritual world beyond its bounds.

---

# MILTON'S "PARADISE LOST."

As the prevailing sentiment of Dante's " Divine Comedy" is that of Italian Catholicism in the thirteenth and fourteenth centuries, so the spirit of Milton's " Paradise Lost" is an expression of the Calvinistic Protestant belief of two hundred years ago.   Both poems are theological works, though their theologies differ in many important respects.   It cannot be said that there is much to choose between them in this matter.   The religions of Dante and Milton were narrowed by sectarian antagonism, and embittered by wrathful and gloomy views, besides being complicated by a number of needless subtleties, derived rather from the schools than from the natural instincts of affection, reverence, and awe.   As influencing the great mass of humanity, both poems are now out of date in this particular element of their composition ; but their poetry is *not* out of date, and never can be.   It appeals to men of all faiths, and casts a various and noble light from age to age.   Dante and Milton might have met in amity on this common ground, and forgotten the uproar of polemical dissensions.

The English poem, however, is even more theological than the Italian.   The latter, as we have seen, has considerable reference to the politics of the author's time and

country : Milton, though equally a politician, and equally identified with the active history of his day and race, has introduced no such matters into his great work, excepting in the form of an occasional allusion or comparison, of a dark and symbolical character. The nature of the story, indeed, would not have permitted, without very great violence, any discussions on the folly and wickedness of the nation in re-admitting kingship and episcopacy ; and, moreover, the triumph of the reaction would have made the expression of such views highly dangerous. As it was, the publication of the poem was delayed, owing to the official licenser apprehending a treasonable intent in the celebrated comparison about the sun in eclipse perplexing monarchs with fear of change. Disappointed by the turn of political events, relegated to obscurity, and compassed round (as he himself says) with darkness and dangers, Milton was compelled to abandon politics ; and in " Paradise Lost " he chose a subject which might give the largest scope to his imagination, without tempting him on to forbidden ground. The religious agitation of the previous forty years had inclined a large section of the public to receive with favour a poem having a directly Scriptural basis. Many readers were of opinion that our poetical literature had hitherto been too much imbued with the spirit of old Greece and Rome ; in other words, had betrayed too strongly its pagan origin. It is true that " Paradise Lost," both in form and style, has many classical affinities ; but its subject and its opinions are of the Hebrew stock.

Milton, however, was not the first in the field of religious poetry. Several years before the publication of his great work, Richard Crashaw, a Roman Catholic, had translated the " Sospetto d'Herode " of Marini ; Dr. Beaumont had written " Psyche, or Love's Mystery ;" Giles Fletcher had produced his beautiful, but now little read, " Christ's Victory and Triumph ;" and Cowley had composed an epic on the life of David. Indeed, other instances might be cited ; for throughout the greater part of the seventeenth century there was a strong disposition to effect an alliance between poetry and the various religious systems that were adopted by different parties. Cowley, in the Preface to the collected edition of his works, very loudly condemns those poets who look in other directions than the Bible for their subject-matter. " It is not without grief and indignation," he writes, " that I behold that divine science [Poetry] employing all her inexhaustible riches of wit and eloquence either in the wicked and beggarly flattery of great persons, or the unmanly idolising of foolish women, or the wretched affectation of scurril laughter, or at best on the confused, antiquated dreams of senseless fables and metamorphoses. Amongst all holy and consecrated things which the Devil ever stole and alienated from the service of the Deity (as altars, temples, sacrifices, prayers, and the like), there is none that he so universally and so long usurped as poetry. It is time to recover it out of the tyrant's hands, and to restore it to the kingdom of God, who is the Father of it. It is time to baptise it in Jordan, for it will never become clean by bathing in the water of Damascus." And he adds that, after its regeneration, the art " will meet with wonderful variety of new, more beautiful, and more delightful objects ; neither will it want room

by being confined to heaven." Certainly, whatever is to be urged on behalf of technically religious poetry (for, in a wider sense, the best poetry, of whatever kind, has a natural tendency to become religious, because it gives a beautiful and adoring voice to the mystery of the world and the innate sanctity of man) has been said by Cowley with admirable ingenuity and skill; though, if this were the fitting place, it might not be difficult to show reasons against the particular forms he is here advocating. Milton, however, was probably acquainted with this passage, and it may have set him thinking of his epic. Cowley's Preface was published in 1656; Milton's "Paradise Lost" in 1667.

Not merely in matter, but in form, Milton was determined to break out of the old bounds. Rhyme was to be discarded, and the poem to be in blank verse. "The measure," he says in a few prefatory words to the second edition, "is English heroic verse without rhyme, as that of Homer in Greek, and of Virgil in Latin; rhyme being no necessary adjunct or true ornament of poem or good verse, in longer works especially, but the invention of a barbarous age, to set off wretched matter and lame metre; graced, indeed, since by the use of some famous modern poets, carried away by custom, but much to their own vexation, hindrance, and constraint, to express many things otherwise, and for the most part worse, than else they would have expressed them. Not without cause, therefore, some both Italian and Spanish poets of prime note have rejected rhyme both in longer and shorter works, as have also, long since, our best English tragedies; as a thing, of itself, to all judicious ears, trivial, and of no true musical delight; which consists only in apt numbers, fit quantity of syllables, and the sense variously drawn out from one verse into another; not in the jingling sound of like endings, a fault avoided by the learned ancients, both in poetry and all good oratory. This neglect, then, of rhyme, so little is to be taken for a defect, though it may seem so perhaps to vulgar readers, that it rather is to be esteemed an example set, the first in English, of ancient liberty recovered to Heroic Poem from the troublesome and modern bondage of rhyming."

Milton seems not to have been superior to the common artifice (even more common in his time than in ours) of magnifying one thing by a gratuitous depreciation of another. The grandeur of blank verse, and its special applicability to certain kinds of poetry, are facts which every one gratefully recognises; but the beauty of rhyme, and its peculiar adaptation to lyrical and other forms of verse, may surely be also admitted. To speak of it as a barbarous invention, as a thing "of no true musical delight," as mere "jingling," and as a "troublesome bondage," is the wilful extravagance of partisanship. The poet could not forget his controversial habits, derived from years of angry disputation. He seems to have thought he had some rhyming Salmacius to deal with, and was bound to hit him hard, and demolish him once for all. We may safely appeal to his own rhyming poems—the "Hymn on the Nativity," the "Allegro" and "Penseroso," and others —for a sufficient vindication of the charm and fitness of rhyming. Arguments drawn

from the practice of the Greek and Latin poets are not necessarily conclusive when applied to a language of different genius, and with different traditions.

It was a mistake, moreover, for Milton to say that his employment of blank verse in heroic poetry was the first example of its use in that way in the English language. The Earl of Surrey, in the reign of Henry VIII., translated into very good blank verse the first and fourth books of the "Æneid;" and in the next generation Marlowe rendered the first book of Lucan's " Pharsalia " into unrhymed verses of a most sonorous character. There was also an old translation of Ovid into the same metre, besides some original productions ; so that Milton's masterpiece was not even the first native English poem in blank verse, to say nothing of the drama.

We have seen that the "Divina Commedia" of Dante was in some measure fore-shadowed by the prose work of a visionary Italian monk of the twelfth century. In like manner, Milton's epic (if it was not more immediately derived from an Italian drama) may have been suggested by the poem of an equally visionary English monk of the seventh century, named Cædmon. This poem treats of the creation of the world, the origin of man, and the temptation of Adam and Eve by Satan. It was printed at Amsterdam in 1655, and was possibly known to Milton. A certain similarity is undoubtedly apparent, but this would necessarily result from the identity of subject. Cædmon's work is not devoid of power, but it would be absurd to hint at any detraction from Milton's prodigious genius on account of his predecessor. The later work is as superior to the earlier as the seventeenth century was superior to the seventh, or as the modern spirit, regenerated by Protestantism and the Renaissance, and enriched by the learning of ancient Greece and Rome, is superior to the narrow outlook of a cloister in the depths of the dark ages. We may put Milton and Dante on the same level, because Dante, though living long before the great re-awakening, inherited, by virtue of being an Italian, much of the culture and artistic instincts of the old civilisation. But Cædmon, whatever his natural genius, could never have been a Milton. He had not at his disposal the arms necessary to the conquering of such immortal territory.

The price paid by the bookseller Simmons for the copyright of the first edition of "Paradise Lost"—an edition of 1,500 copies—was five pounds : a sum which, even when we have made allowance for the greater value of money then as compared with now, seems preposterously small. Of course we are not to judge of Milton's reputation in his own day by the measure of his subsequent fame ; yet he was a man of mark, had held a high position in the State, and had made a great name as a prose writer. The sum given for "Paradise Lost" is therefore a proof that Milton was hardly regarded as a poet by the public of 1667. There was a stipulation, however, that the author should receive three other sums of five pounds when 1,300 copies should have been sold of the first, second, and third editions respectively. A second edition was reached in about seven years, and a third in another four years. In less than two years from the time of issuing the first

edition, Milton received his second five pounds; so it may fairly be presumed that in that period 1,300 copies had been sold. Reckoning each edition at the stipulated number of 1,500 copies, it appears that 4,500 purchasers were obtained in the course of something more than eleven years; which, for those days, and considering the tastes of the public, and the shadow that had fallen on the author's fortunes, is by no means a small number. After the death of Milton, his widow (in 1680) sold the copyright for eight pounds to Simmons, who disposed of it for twenty-five pounds to Aylmer, the bookseller, by whom it was transferred, at a great advance of price, to the celebrated Jacob Tonson. Six editions were published in twenty years, and men like Dryden and Andrew Marvell acknowledged in the warmest language the extraordinary poetic genius of the work. Yet it seems not improbable that the larger part of the sale for many years was among those who belonged to the same political and religious party as the author; and that even in the literary circles (allowing for a few exceptions) the poem did not at first obtain as great a reputation as might have been anticipated. Old Gerard Langbaine, in his " Account of the English Dramatick Poets" (Oxford, 1691), gives but a few words, and those quite uncritical, to the poems of Milton, as distinguished from the dramas, "Comus" and "Samson Agonistes;" and Jeremy Collier, in his " Dictionary," published in 1701, devotes only a very brief memoir to Milton, and does not allude by name to any one of his poems. Both these writers, however, were opponents of the great poet in political and religious matters; but their example is sufficient to show that " Paradise Lost," even at the end of the seventeenth and commencement of the eighteenth centuries, had not yet attained a universal reputation as one of the great classics of the English tongue. It was the publication of Addison's critical papers in the *Spectator*, in 1712, that first lifted this magnificent epic to its full height of fame.

Milton's three last poems—" Paradise Lost," " Paradise Regained," and "Samson Agonistes"—mark the termination of the great epoch of English poetry which had commenced in the reign of Elizabeth. When those works were published, the new taste in literature, imported from France by Charles II. and his courtiers, had already set in. That taste made rapid strides, and by the time of Milton's death, in 1674, the earlier style must have been growing antiquated. Dryden was the rising star, and the contrast between the manner of Dryden and that of Milton is like the contrast between two distinct ages. The race of the gods was extinct, and a lower though still an admirable form of literary art had taken possession of the ground.

The first book of " Paradise Lost" describes the revolt of the malcontent angels, and their precipitation into the abyss of chaos. Satan is at once brought on the scene as one of the principal actors in the drama.

> " Nine times the space that measures day and night
> To mortal man, he with his horrid crew
> Lay vanquish'd, rolling in the fiery gulf,
> Confounded, though immortal : but his doom

Reserv'd him to more wrath; for now the thought
Both of lost happiness and lasting pain
Torments him. Round he throws his baleful eyes,
That witness'd huge affliction and dismay,
Mix'd with obdùrate pride and steadfast hate.
At once, as far as angels ken, he views
The dismal situation waste and wild :
A dungeon horrible, on all sides round,
As one great furnace flamed.    .   .   .

   .    .    .    .    .    .    .    .

Such place eternal justice had prepared
For those rebellious; here their prison ordain'd
In utter darkness; and their portion set
As far removed from God and light of heaven
As from the centre thrice to the utmost pole :
Oh, how unlike the place from whence they fell!
There the companions of his fall, o'erwhelm'd
With floods and whirlwinds of tempestuous fire,
He soon discerns; and, weltering by his side,
One next himself in power, and next in crime,
Long after known in Palestine, and named
Beëlzebub."

*Book I., lines* 50—81.

Satan addresses his compeers, rallies them from their despondency, speaks of the possibility of their yet regaining Heaven, and lastly refers to an ancient prophecy of " a new world and new kind of creature," to be presently formed by the Deity. To discuss the questions suggested by this prophecy, a full council of demons is resolved on. Pandæmonium is built, and the devils assemble in that palace of evil splendour. In the second book, the debate is described. After much deliberation, it is determined that search shall be made into the truth of the prophecy; and Satan himself undertakes the expedition. He passes on his way to Hell-gates, but finds them shut, and guarded by the terrible figures of Sin and Death. These for a while dispute his further progress, but at length open the gates, and allow Satan to go forth into the vast, dark region that lies beyond. Here Chaos addresses him, but Satan, pausing not to reply,

" Springs upward, like a pyramid of fire,
Into the wild expanse; and through the shock
Of fighting elements, on all sides round
Environ'd, wins his way; harder beset,
And more endanger'd, than when Argo pass'd
Through Bosporus betwixt the justling rocks;
Or when Ulysses on the larboard shunn'd
Charybdis, and by the other whirlpool steer'd.
So he with difficulty and labour hard
Moved on, with difficulty and labour he

   .    .    .    .    .    .    .    .

But now at last the sacred influence
Of light appears, and from the walls of heaven
Shoots far into the bosom of dim Night
A glimmering dawn : here Nature first begins
Her farthest verge, and Chaos to retire,
As from her outmost works, a broken foe,
With tumult less, and with less hostile din ;
That Satan, with less toil, and now with ease,
Wafts on the calmer wave by dubious light ;
And, like a weather-beaten vessel, holds
Gladly the port, though shrouds and tackle torn ;
Or in the emptier waste, resembling air,
Weighs his spread wings, at leisure to behold
Far off the empyreal heaven ;     .     .     .

.     .     .     .     .     .     .     .

And fast by, hanging in a golden.chain,
This pendent world."                          *Book II., lines* 1,013—1,052.

The colloquy in Heaven touching the nature of man, the fall, and the redemption (a singularly feeble, unsatisfactory, and to many minds repulsive, portion of the poem) occupies the first half of the third book, and the remainder describes the wanderings of Satan in search of the habitation of the newly-created being, Man.    Having been directed thither by Uriel, we find him, in the fourth book, entering Eden, and determining to tempt Adam and Eve through the medium of the Tree of Knowledge.    The picture of the human occupants of the garden, as contrasted with the beasts, is very charming :—

" Two of far nobler shape, erect and tall,
Godlike erect, with native honour clad
In naked majesty, seem'd lords of all ;
And worthy seem'd, for in their looks divine
The image of their glorious Maker shone,
Truth, wisdom, sanctitude severe and pure,
Severe, but in true filial freedom placed ;
Whence true authority in men : though both
Not equal, as their sex not equal, seem'd.
For contemplation he and valour form'd ;
For softness she, and sweet attractive grace :
He for God only, she for God in him.
His fair large front and eye sublime declared
Absolute rule ; and hyacinthine locks
Round from his parted forelock manly hung
Clustering, but not beneath his shoulders broad :
She, as a veil, down to the slender waist
Her unadornéd golden tresses wore
Dishevell'd, but in wanton ringlets waved,
As the vine curls her tendrils ; which implied

Subjection, but required with gentle sway,
And by her yielded, by him best received,
Yielded with coy submission, modest pride,
And sweet, reluctant, amorous delay.

·   ·   ·   ·   ·   ·   ·   ·   ·   ·

So pass'd they naked on, nor shunn'd the sight
Of God or angel, for they thought no ill:
So hand in hand they pass'd, the loveliest pair
That ever since in love's embraces met;
Adam the goodliest man of men since born,
His sons,—the fairest of her daughters Eve."   *Book IV., lines* 288—324.

Shortly after this, Uriel warns Gabriel, who has in charge the gate of Paradise, that some evil spirit has escaped the deep, and entered the enclosure. Gabriel, during the night, sends two angels to Adam's bower, where Satan is found sitting like a toad at the ear of Eve, tempting her in a dream. He is forced to disclose himself in his true form, and is obliged to flee from Eden. In the fifth book, Raphael warns Adam and Eve of their danger, admonishes them not to forget their obedience, and relates the history of Satan's war in Heaven against the Divine Power. This relation is continued through the whole of the sixth book, which brings it to a close. The creation of the world and of man is described by Raphael in the seventh book; and in the eighth we find a long conversation between Adam and his celestial visitor on various subjects. The action of the story, which has been almost suspended since the close of the fourth book, is resumed in the ninth; when, Raphael having returned to Heaven, Satan re-enters Paradise by night as a mist, and glides into the form of the serpent. At length meeting with Eve, he tempts her to eat of the fruit; she in her turn tempts her husband, and the evil consequences are immediately felt. The other three books follow the well-known course of the story, with the introduction of other matters, such as a vision by Adam, foreshadowing the fate of his descendants through several generations. The expulsion of Adam and Eve from Paradise is very nobly described at the end of the poem :—

" Now, too nigh
The archangel stood ; and, from the other hill
To their fix'd station, all in bright array
The cherubim descended ; on the ground
Gliding meteorous, as evening mist,
Risen from a river, o'er the marish glides,
And gathers ground fast at the labourer's heel,
Homeward returning.  High in front advanced,
The brandish'd sword of God before them blazed,
Fierce as a comet ; which, with torrid heat,
And vapour as the Libyan air adust,
Began to parch that temperate clime : whereat,

In either hand the hastening angel caught
Our lingering parents, and to the eastern gate
Led them direct, and down the cliff as fast
To the subjected plain ; then disappear'd.
They, looking back, all the eastern side beheld
Of Paradise, so late their happy seat,
Waved over by that flaming brand ; the gate
With dreadful faces throng'd, and fiery arms.
Some natural tears they dropp'd, but wiped them soon.
The world was all before them, where to choose
Their place of rest, and Providence their guide.
They, hand in hand, with wandering steps and slow,
Through Eden took their solitary way."                 *Book XII., lines 625—649.*

Well might Addison say that the lines which conclude the poem "rise in a most glorious blaze of poetical images and expressions." The comparison of the mist is extremely beautiful; and the passage about "the brandished sword of God" *parching* the temperate clime of Paradise is a wonderful instance of the force and reality of imaginative expression. The waving of the flaming brand over the lost inheritance of bliss, and the thronging of the gate with "dreadful faces" and "fiery arms," are circumstances that affect us like beautiful, awful dreams; while the transition from this prodigious and supernatural terror to the human pathos of the tears shed by the outcasts, and to the quiet mournfulness of that consummate last line, is the very perfection of feeling and of art.

We may regret some parts of "Paradise Lost," and may think it occasionally dry and pedantic, for in truth its power is unequally displayed. But on the whole it is a stupendous drama, and, when at its highest range, is one of those mental creations which seem to enlarge the compass of the universe, and to aggrandise the facts of life.

---

# THE BIBLE.

IT would be an idle waste of labour to enter here into any descriptive account of the Old and New Testaments. The subjects selected for illustration by M. Doré are well known to all our readers, and have been made the ground-work of specific remarks in our Introductory Essay and our Descriptions of the Plates in this volume. None of M. Doré's works are more popular than his illustrations to the Bible. They are remarkably rich and varied, and in many instances realise the spirit and meaning of the text.

---

## "DON QUIXOTE."

WHEN Cervantes undertook the composition of his most celebrated romance (for he was the author of others, less generally known to the world), the taste for stories of knight-errantry was beginning to decline, although it was still sufficiently prevalent to invite attack. How vast a literature of this nature had been created, may be in some measure inferred from the books mentioned in the sixth chapter (Part I.) of "Don Quixote," and in many other places in that work. The whole of Europe was filled with the most astounding and fantastic traditions of the knights of earlier days, and many of these seem to have been actually believed by all but the critical. King Arthur, and Lancelot, and Amadis of Gaul, and Palmerin of England, and Don Belianis of Greece, and Rinaldo of Montalban, and Tirante the White—the Knights of the Round Table, the Paladins of Charlemagne, the Seven Champions of Christendom, the Cid and his fellows, and many more—occupied a very important position in the popular mind, as representatives of Christian chivalry who had worthily asserted the principles of their faith against giants, ogres, and enchanters, the Paynim and the infidel. It is supposed, with great probability, that many of the details of these wild fictions were derived, through the Crusaders, from the East; but it is certain that they had also a considerable basis of ancient European legends, belonging in the main to the Celtic populations, and especially to the early races of Britain. The stories of Arthur came back to us in the Middle Ages through French channels; but their original source was native. Even "Amadis of Gaul" means, not Amadis of France, but Amadis of Wales. Caxton, who printed an edition of the "Morte d'Arthur" in 1485, vindicates the reputation of his hero as a real historical personage; and so no doubt he was, though the Arthur of history is a very different being from the Arthur of romance. It was the fictitious Arthur, however, who attracted the greatest amount of attention in the time of Cervantes, and for some generations before. The records of his marvellous adventures were read by noblemen and ladies, and reproduced in ballads for the delight of the commonalty, until the fame of the great king and his companions in arms became the common property of Christendom. To these attractive tales were added similar relations of the great warriors of other lands; and in no country did such fables strike deeper root than in Spain. The chivalric nature of the Spanish people—the picturesque character of their history—the long and stirring contest which they waged with their Moslem subjugators, and the touch of Oriental extravagance and exaltation which they acquired from contact with the Saracen—inclined the countrymen of Cervantes to receive with peculiar favour the romantic chronicles of knight-errantry. They had a glorious set of legends and ballads about their own semi-mythical champion of the eleventh century, the Cid Ruy Diaz de Bivar; but their hearts were large enough to

receive all the heroes of Europe. The library of a Spanish gentleman of the sixteenth century abounded in romances of chivalry, both of native and of foreign growth.

Such was the taste which, carried to an unhealthy and ridiculous extent, Cervantes set himself to laugh out of countenance. Many of the old romances were works of real genius, full of fine invention, of poetry, and of grandeur, and not devoid even of considerable insight into human nature, if we grant the ideal and fabulous surroundings. Milton loved them; has frequently alluded to them in his works; and in a passage in "Paradise Lost" has spoken in sonorous words of

> "what resounds
> In fable or romance of Uther's son,
> Begirt with British and Armoric knights;
> And all who since, baptized or infidel,
> Jousted in Aspramont or Montalban,
> Damasco, or Morocco, or Trebisond,
> Or whom Biserta sent from Afric shore,
> When Charlemagne with all his peerage fell
> By Fontarabia."
>
> *Book I., lines* 579—587.

Our own Arthurian legends have stimulated the Muse of Spenser and of Mr. Tennyson, besides attracting that of Milton; and literature would be a loser if this branch of it were destroyed. But it was rapidly degenerating in the era which produced "Don Quixote." The extravagances were becoming coarser and less genuine; simplicity of feeling was lost in elaboration of style; and it was evident that the civilised world had reached an epoch in its history which required food of a more intellectual character than that which had satisfied its childhood. Yet even in the time of the great Spaniard, the old knightly legends were being illustrated in a beautiful poetic form by our own Spenser, who followed in the wake of his Italian predecessors, Bojardo, Pulci, Ariosto, and Tasso.

His object in writing "Don Quixote" was described by Cervantes himself as being "to overthrow the ill-contrived machinery of those knightly books, abhorred by many, but applauded by more." It cannot be doubted that the continual reading of such compositions encouraged and increased the vaunting character of the Spanish hidalgoes, and disposed them towards a policy of ruthless conquest in the New World, and of haughty aggression in the Old. Deluded by these dreams, they forgot the due cultivation of their estates, and the development of those matchless resources with which Spain is naturally endowed. Cervantes saw the mischief, and exposed it with admirable wit and fancy. He says that Don Quixote, during his periods of idleness, which spread over the greater part of the year, "applied himself wholly to the reading of books of knighthood, and that with such gust and delight that he almost wholly neglected the exercise of hunting, and the very administration of his household affairs; and his curiosity and folly came to that pass, that he made away with many acres of arable land to buy him books of this kind." He

was chiefly delighted with those written by Felician of Sylva; "and principally when he read the courtings or letters of challenge which knights sent to ladies or to one another; where, in many places, he found written : ' The reason of the unreasonableness which against my reason is wrought, doth so weaken my reason as with all reason I do justly complain of your beauty.' Or—' The high heavens, which with your divinity do fortify you divinely with the stars, and make you deserveress of the deserts which your greatness deserves,' &c. With these and other such passages the poor gentleman grew distracted, and was breaking his brains day and night to understand their sense. An endless labour; for even Aristotle himself would not understand them, though he were resuscitated only for that purpose." The passages quoted in the foregoing are either bits of actual romances, or allowable burlesques of the inflated and ridiculous style in which some of them (belonging, we conceive, to the later period) were written. Certainly, when such follies had been arrived at, it was time for satire to step in.

Cervantes goes on to say that the Don plunged himself so deeply in the reading of these books, that he often spent whole days and nights in their perusal; the result of which was that he quite dried up his brains with little sleep and much study, and utterly lost his senses. " His fantasy was filled with the things he read of—enchantments, quarrels, battles, challenges, wounds, wooings, loves, tempests, and other impossible follies. And these toys did so firmly possess his imagination with an infallible opinion that all the machinery of dreamed inventions which he read was true, that he accounted no history in the world to be so certain and sincere as they were. He was wont to say that the Cid Ruy Diaz was a very good knight, but not to be compared with the Knight of the Burning Sword, who with one cross blow cut asunder two fierce and mighty giants. He agreed better with Bernardo del Carpio, because he slew the enchanted Roland in Roncesvalles. He praised the giant Morgante marvellously, because, though he was of that monstrous progeny who are commonly all of them proud and rude, he was affable and courteous. But he agreed best of all with Rinaldo of Montalban, especially when he saw him sally out of his castle, to rob as many as ever he could meet, and when he robbed the idol of Mahomet, made of gold, as his history recounts; and he would have been content to give his old housekeeper—ay, and his niece also—for a good opportunity on the traitor Ganelon, that he might trample him into powder."

At length, the poor gentleman determines that he will himself go forth as a knight-errant, and eclipse all the achievements of his predecessors. He therefore furbishes up certain pieces of ancient armour, once belonging to his great-grandfather, which had lain many ages neglected and forgotten in a by-corner of his house; re-names his old horse by the designation of Rozinante; and then bethinks him of a fitting title for himself. "Some say his surname was Quixada, or Quisada, for authors differ in this particular. However, we may reasonably conjecture he was called Quixada, that is, Lantern-jaws." But, after eight days' cogitation, "he determined to call himself Don Quixote:

whence the author of this most authentic history draws the inference that his right name was Quixada, and not Quisada, as others obstinately pretend." The name of Quixote is really formed from *cuish*, a piece of armour for the thigh, and the termination *ote*, which in the Spanish language implies something ridiculous. Finally, the Don calls to mind that every knight must have a lady; remarking to himself, "If I should, for my sins, or by good hap, encounter some giant (as knights-errant ordinarily do), and should overthrow him with one blow to the ground, or cut him with a stroke in two halves, or finally make him yield to me, it would be very expedient to have some lady to whom I might present him, and that he, entering into her presence, should kneel before her, and say, with a humble and submissive voice, 'Madam, I am the giant Caraculiambro, lord of the island called Malindrania, whom the never-too-much-praised knight, Don Quixote de la Mancha, hath overcome in single combat, and hath commanded to present myself to your greatness, that it may please your highness to dispose of me according to your liking.'" For this important post he selects a handsome village girl, with whom he had formerly been in love, though not to her knowledge; and to the humble lass he gives the high-sounding appellation of Dulcinea del Toboso, after her native place—"a name in his conceit harmonious, strange, and significant."

The Don sets forth on his adventures, but presently reflects that he has not been knighted in due state. He accordingly manages that that ceremony shall be performed by the landlord of an inn which he mistakes for a castle. His first sally in quest of achievements ends very unluckily; but after awhile he determines upon a fresh attempt, and resolves to be accompanied by a squire. He therefore persuades an honest clown to serve him in this capacity, though to do so he must leave his wife and children. "Among other inducements to entice him to do it willingly, Don Quixote forgot not to tell him that it was likely such an adventure would present itself as might secure him the conquest of some island in the time that he might be picking up a straw or two, and then the squire might promise himself to be made governor of the place." This squire is the famous Sancho Panza, whose shrewd, unimaginative, matter-of-fact, worldly nature, dry humour, and pithy proverbs, present such a dramatic contrast to the lofty, demented phantasies of his master. The name is formed from the Spanish words *zancas*, spindle-shanks, and *panza*, a paunch; and is intended to denote the uncouth figure of this worthy. His donkey, Dapple, makes a capital companion to the knight's steed, Rozinante. "At first," says Mr. Ticknor, "Sancho is introduced as the opposite of Don Quixote, and used merely to bring out his master's peculiarities in a more striking relief. It is not until we have gone through nearly half of the First Part that he utters one of those proverbs which form afterwards the staple of his conversation and humour; and it is not till the opening of the Second Part, and, indeed, not till he comes forth, in all his mingled shrewdness and credulity, as governor of Barataria, that his character is quite developed and completed to the full measure of its grotesque yet congruous proportions." After a

career full of surprising incidents, Don Quixote has a severe illness, and, being restored to his senses, and made to see the folly of his ideas about chivalry, he dies quietly in his bed.

The adventures of the Don and his squire constitute the main portion of this glorious tale. The art with which the author has varied those adventures is only equalled by the skill which has enabled him, while always maintaining his design of ridiculing the extravagances of the books of knight-errantry, to preserve a sentiment of romance which enchants and fascinates the reader. The story becomes more complicated as it proceeds; its humorous insight into the oddities of human nature is quite Shakespearian; and its episodes are charming novelettes. "Don Quixote" is one of the conspicuously great works of universal literature. Witty, droll, fantastic, pathetic, original, full of thought, and pre-eminently delightful, it is perhaps the most popular story that ever was written; and it is pleasant to think that the writer was as good as his work, and has left behind him a name without a blemish.

The First Part of "Don Quixote" was printed in 1605; the Second Part in 1615; and in the following year Cervantes died, at the age of sixty-eight, after a life of much vicissitude and many troubles.

---

## "BARON MUNCHAUSEN."

To the account of the origin of this celebrated work which has been given in connection with Plate CXI., we have not much to add in the present place. "There can be little doubt," says Mr. Teignmouth Shore, in his Introduction to the edition of the romance illustrated by M. Doré, "that 'Munchausen's Travels' is really a collection of curious incidents and adventures from various sources, and that the work owes its title to the fact of the original edition being chiefly composed of tales with which a certain Baron Munchausen used, in Germany, to amuse his guests. It may be interesting to refer to one adventure as a remarkable instance of a story which has 'gone the rounds' of different countries. The story of sound being for a time frozen in the post-horn is to be found, with little variation, in French, in Rabelais (liv. iv., cc. 55, 56). A writer in *Notes and Queries* is of opinion that something like it is to be found in one of the late Greek authors; while Bishop Taylor uses it in a sermon as an illustration. Once, in the south of Spain, a muleteer with whom I was journeying related to me the following legend, which he informed me was of great antiquity, as no one remembered the author of it; and it seems to me that this Spanish legend (which I have never seen in print) may probably be the source of the remarkable stories about frozen sounds. My muleteer told me that a certain don, having travelled to the cold regions of Russia, vowed that if the Holy Virgin would bring him safely back to his sunny fatherland, he would dedicate a bell to her, and hang it in his village church steeple. He went to a celebrated bell-maker in Russia to procure

the offering for the Virgin. Having selected the most beautiful one he could find, he asked the maker to sound it, so that he might judge of the quality of its tone. The master informed the don that they had been for three weeks ringing it, but that, owing to the intense cold, the sound was frozen, and they could not get a note out of it. He, however, gave the don a guarantee of its quality, and he returned to Spain, where, having arrived in safety, the bell was hung up in the church steeple. Scarcely had the ceremony of hanging the bell been accomplished, when, without any one striking it, the most wonderfully melodious sounds were heard to issue from it; and they were poured out incessantly for three weeks. Crowds of priests and people flocked to hear and see so wonderful a thing; the priests attributed it to the special favour of the Virgin, 'but,' added my muleteer, with a knowing wink, 'really these were the sounds which resulted from the three weeks' ringing in Russia, and had remained frozen until the bell was in the warm climate of Spain, when they gradually thawed.' In a book of Italian jests (1528) also appears a similar story about frozen sounds, in this case the sounds being the human voice."

Pantagruel, in the passage of Rabelais here alluded to, quotes the Greek writer, Antiphanes, who says that Plato's philosophy was like words which, being spoken in some country during a hard winter, are immediately congealed, so as not to be heard; for that what Plato taught his youthful scholars could scarcely be understood by them when they grew up. Butler, in " Hudibras," has the comparison,

" Like words congeal'd in northern air;"

and in No. 254 of the *Tatler* is an amusing story (foisted on Sir John Mandeville) of whole speeches frozen during a long winter in Nova Zembla, and thawed in the spring. We also find the same quaint idea alluded to in Peter Heylyn's " Little Description of the Great World " (fourth edition, 1629), where, in the account of Muscovy, it is said: —" This excess of cold in the air gave occasion to Castilian, in his 'Aulicus,' wittily and not incongruously to feign, that if two men, being somewhat distant, talk together in the winter, their words will be so frozen that they cannot be heard; but if the parties in the spring return to the same place, their words will melt in the same order that they were frozen and spoken, and be plainly understood." The joke seems to be almost as old as frost itself.

" Baron Munchausen " and " Don Quixote " are both books of extravagant adventures, and to that extent there is a certain similarity between them; but the points of dissimilarity are greater, and the Baron is far inferior to the Don. The Anglo-German work, however, is an extremely clever and very entertaining production. It abounds in singular and fantastic invention, and the air of scrupulous exactness with which the several incidents are related is admirable. The Baron " lies like truth," and preserves his gravity in the very crises of his most audacious fooling.

# CHATEAUBRIAND'S "ATALA."

CHATEAUBRIAND—that strange bundle of contradictions, who was always leading some forlorn hope, and always in opposition to the very parties which he had helped to put in power —visited America in 1791, and there, while roaming through the vast and primitive forests which have since given place to towns and cultivated fields, conceived the idea of his Indian story, "Atala." The work first appeared serially in the columns of the *Mercure*, in the year 1800; it was afterwards frequently reprinted, and now ranks as an acknowledged French classic. The author, in his Preface to the first separate edition of this tale, says :—"'Atala' was written in the desert, beneath the huts of the savages. I do not know whether the public will like the story, which quits all beaten tracks, and represents a nature and manners altogether foreign to Europe. There is no adventure in 'Atala.' It is a sort of poem, half-descriptive, half-dramatic; it consists entirely in the portraiture of two lovers walking and talking together in the solitudes, and in the picture of the trials of love in the midst of the calm of the desert. I have endeavoured to give to this work the most antique forms : it is divided into Prologue, Recital, and Epilogue. The principal parts of the story have each a denomination, such as 'The Hunters,' 'The Labourers,' &c.; and it was thus that, in the early ages of Greece, the rhapsodists sang, under different titles, fragments of the 'Iliad' and of the 'Odyssey.'" Anything less "antique" in spirit and manner than Chateaubriand's Indian romance—anything more thoroughly French, rhetorical, and self-conscious—it would be difficult to conceive. One great fault of the work is that it is a mere masquerade of fancy characters, the real nationality of whom is plainly visible through their thin disguise. Beneath the paint and feathers of the Red Indian, the sentimental Parisian is everywhere apparent.

Of Chactas, the chief character in "Atala," Chateaubriand observes :—" He is a savage more than half-civilised, since he knows not only the living but also the dead languages of Europe. He can therefore express himself in a mixed style, suitable to the line upon which he stands, between society and nature. This circumstance has given me some advantages, by permitting Chactas to speak as a savage in the description of manners, and as a European in the dramatic portions of the narrative. Without that, the work must have been abandoned : if I had always made use of the Indian style, 'Atala' would have been Hebrew for the reader." Chateaubriand seems here to betray a consciousness of the unreality of his work, and to venture on an excuse. The truth is, however, that your genuine Frenchman, though he may travel the whole circuit of the globe, never gets quit of France.

The subject of "Atala" is described by its author as not entirely of his own invention. "It is certain," he says, "that there was a savage at the galleys, and at the court of Louis XIV.; it is certain that a French missionary accomplished the facts I have

related ; it is certain that I saw savages in the American forests carrying away the bones of their forefathers, and a young mother exposing the body of her child upon the branches of a tree. Some other circumstances narrated are also veritable ; but, as they are not of general interest, it is needless for me to speak of them." In defending himself, in the Preface to a later edition, from certain charges that had been brought against his book, Chateaubriand quotes a passage from another of his works, in which he says :—"Nothing forbids the reader from forming an unfavourable opinion of 'Atala'; but I venture to affirm that American nature is depicted therein with the most scrupulous accuracy. All travellers who have visited Louisiana and the Floridas render the work this justice. The two English translations of 'Atala' have reached America ; and the public prints have also announced a third translation published with success in Philadelphia. If the pictures described in the story had been wanting in truth, would they have been approved by a people who could have said at each step, 'These are not our rivers, our mountains, our forests'? Atala has returned to the desert, and it appears that her native country has recognised her as the veritable child of the solitudes." That the positive matters of fact in "Atala" are correctly stated, is doubtless perfectly true : the want of verisimilitude proceeds from the constant glitter of French sentiment and French epigram.

A good many of the incidents of this Indian story have been already detailed in connection with the Plates ; but a slight connected outline may be here acceptable.

On the banks of the Mississippi, at the time of the French domination in that part of America, lived an old Indian called Chactas, a name which signifies "the harmonious voice." By reason of his age, wisdom, and knowledge of the affairs of life, this man was regarded as a patriarch. His life had been chequered by many misfortunes, not merely in the New World, but in the Old ; for, having visited France, to tell the tale of certain wrongs he had suffered, he was, by an act of great injustice, sent to the galleys at Marseilles. Being afterwards released, he was presented to Louis XIV., and conversed with the most illustrious Frenchmen of the age, besides witnessing the tragedies of Racine, and hearing the funeral orations of Bossuet. The old man was now blind, and compelled to rely on the guidance of a young girl. He was very fond of the French, notwithstanding the injuries he had received at their hands ; and in 1725 he made the acquaintance of a Frenchman named René, who requested to be admitted as a warrior into the Natchez tribe, to which Chactas belonged. Chactas adopted this man as a son, and united him to an Indian girl. While they were pursuing a beaver-hunting expedition, Chactas, at the request of René, related the story of his life.

When quite a youth, he had marched with his father against the Muscogulges, a powerful nation of the Floridas. The Natchez warriors had on this occasion united their forces with those of the Spaniards ; but the Muscogulges prevailed over the allies, and Chactas, after being twice wounded in endeavouring to defend his father, who was ultimately slain, was dragged back by the defeated crowd to Saint Augustin, a city then

recently built by the Spaniards. Here he is received into the house of an old Castilian, named Lopez, and receives a fair amount of European education. But after awhile an eager desire to return to the desert possesses him. He parts from Lopez with many tears, and, plunging into the forest, is shortly seized by a party of Muscogulges and Siminoles. Being known for a Natchez, it is resolved that he shall be burnt alive. One night, while sitting by the war-fire, a maiden of surpassing loveliness creeps up softly, and sits down by his side. She begins talking with him, and asks if he is a Christian. Chactas replies that he is not, and the Indian girl rejoins, "I pity you for being merely a wicked idolator. My mother made me a Christian; my name is Atala, and I am the daughter of Simaghan of the Golden Bracelets, the chief of the warriors of this troop. We are going to Apalachucla, where you will be burnt." She then disappears, but comes again night after night, and one day tries to induce the prisoner to fly. This brings on a confession of their mutual love, and Chactas refuses to make his escape unless Atala will accompany him. A sudden agitation hereupon possesses the maiden, who utters some incoherent exclamations about her mother and her religion. Chactas still refusing to fly, the time for his execution grows nearer and nearer, while at the same time his passion and that of Atala increase in warmth and intensity. On the night preceding the sacrifice, Atala releases her lover from his bonds while the warriors are asleep over the camp-fires, and together they seek the desert.

Side by side they wander for many days through the magnificent scenery of those mighty forests, across stupendous mountains and rushing rivers, or by the margin of immeasurable plains; now admiring the splendour of many-coloured flowers and gorgeous birds, glowing in the warm affluence of sunlight, and then penetrating into the depths of woodland shade and secrecy. Both are happy in the consciousness of love, excepting when Atala is overcome by the strange scruples which occasionally oppress her. At one time it comes out that the maiden is a natural child of Lopez, the Spanish friend of Chactas; and the knowledge of this increases their mutual love, without in any way explaining the mysterious reluctance of Atala to bestow herself wholly on the young Indian to whom she is so fondly attached. During an appalling storm, they encounter in the solitude an old hermit who has made his place of abode in the grotto of a neighbouring mountain, where he instructs a little flock of Christianised Indians. With this holy man the lovers remain for some time, and Chactas hopes that he will soon be united to Atala. One day, however, the maiden is discovered in a sinking condition. She declares that she is dying, and adds that her mother, in the agony of giving her birth, had declared that the infant, if it could be saved, should be consecrated to a life of celibacy. Atala had just entered on her sixteenth year when her mother, being on the point of death, reminded her of the vow that had been made on her behalf, and called upon her to swear that she would fulfil that vicarious promise, so that she might not plunge her mother's soul into eternal tortures. The fatal oath was taken, and this it was that had been the cause of

Atala's hitherto unaccountable conduct towards her lover. Having related these circumstances, the maiden, in the presence of the old hermit and of Chactas, proceeds :—

"My young friend, you have been a witness of my struggles, and nevertheless you have seen but the smallest portion of them : I concealed the rest from you. No; the black slave who moistens the hot sands of the Floridas with his sweat is less miserable than Atala has been. Urging you to flight, and yet certain to die if you left me; fearful of flying with you to the desert, and still panting after the shade of the woods—ah! if it had only been required of me to abandon my relations, my friends, my country! if even (frightful thought!) I should only have incurred the loss of my soul! But thy shadow, O my mother! thy shadow was always there, reminding me of thy tortures. I heard thy complaints; I saw the flames of hell consuming thee. My nights were barren, and haunted by phantoms; my days were disconsolate; the evening dew dried as it fell upon my burning skin; I opened my lips to the breezes, and the breezes, far from refreshing me, became heated with the fire of my breath. What torture it was for me, Chactas, to see you constantly near me, far from all mankind, in the depths of the solitude, and to feel that there was an invincible barrier between you and myself! To have passed my life at your feet, to have waited upon you like a slave, to have prepared your repasts and your couch in some unknown corner of the universe, would have been for me supreme happiness: that happiness was within my reach, yet I could not enjoy it. What plans I have imagined! What dreams have passed through this sad heart of mine! Occasionally, when I fixed my eyes upon you, I went so far as to encourage desires that were as foolish as they were culpable: sometimes I wished I were the only creature living with you upon the earth; at other times, feeling a divinity that stopped me in my horrible transports, I seemed to desire that that divinity might be annihilated, provided that, pressed in your arms, I might roll from abyss to abyss with the ruins of God and of the world!"

At length, feeling that her power to resist temptation is diminishing, Atala swallows poison, and it is from the effects of that poison that she is now dying. Her mental agony is increased by learning from the hermit that she might have been released from her vows, so as to be free to marry Chactas; but the potion has gone too far to be arrested in its deadly work, and Atala expires in the arms of her lover.

The wanderings of the unhappy Indian after this overwhelming calamity need not here be followed, as they have but little to do with the main story. The tale is undoubtedly impressive, but we find it impossible to sympathise with the character of Atala. Out of an exaggerated respect for a foolish and monstrous vow, she sacrifices her lover's happiness and her own life. She mingles superstition and sensuous raving in a way that is painful to contemplate; and there is no moral gain to make up for the shocking spectacle. Had Chateaubriand designed to show the terrible results of a false conception of God and Nature, of duty and life, more might have been said for the story than can now be

advanced. As it is, the strength of the book lies in the really magnificent descriptions of savage scenery with which it abounds, and in the flaming tumult of passion that throbs and lightens through it.

---

# LA FONTAINE.

FABLES are among the earliest and most popular forms of conveying moral truths to the general mind. Setting aside that species of short narrative commonly called the parable —of which the most striking and interesting examples we possess are to be found in the New Testament—we are chiefly indebted to Æsop for our stock of fables. There can be little doubt, however, that he was not the originator of this kind of composition. A collection of Arabic fables, attributed to a sage of the name of Lokmân, contemporary with David and Solomon, bears a great similarity to that of Æsop; and indeed it has been suggested that the two persons were in fact one, for Lokmân, according to some Persian accounts, was a slave, noted for personal deformity and ugliness, and for his skill in inventing witty moral apologues—a description which exactly corresponds with the traditions of the old Greek fabulist. The Æsopian stories have a strong Oriental colour in many parts, and contain frequent allusions to animals—such as monkeys and peacocks— not to be found in that part of the world to which Æsop belonged. Assuming Æsop and Lokmân to have been distinct persons, their respective collections were probably derived from a common source—apparently some primitive Indo-Persian book, the fame of which had gradually spread westward The fables of Lokmân, as we now find them, are said to show marks of having originated at a date subsequent to the more ancient periods of Arabic literature; yet it is certain that they are old. Syntipas was another author of instructive tales. He is described as a Persian philosopher, but his stories are believed to have been of Indian origin. Of Sanskrit parentage also are the celebrated fables of Pilpay, or Bidpai, which seem to have been derived from the " Pancha Tantra," an abridgment of which, called the " Hitôpadêsa," has been twice translated into English, by Sir Charles Wilkins and Sir William Jones, and is well known in this country. Some of these Eastern narratives were more in the nature of elaborate fictions or romances, and so, probably, were the famous Milesian stories, now lost; but in others the characteristics of the fable are visible. The " Pancha Tantra " is conjecturally referred to the sixth Christian century; but it is likely enough that it merely reproduced still older Hindu stories, and that the fount of Western fable is to be sought in that great Asiatic land to which we are indebted for the first seeds of our civilisation.

Æsop, if we allow him to have been a real person at all, lived about the middle of

the sixth century B.C. Samos, Sardis, Cotiæum in Phrygia, and Mesembria in Thrace, are all credited with his birth, according to the different accounts of various authors. The early part of his life was passed in slavery; but, being enfranchised, and having acquired a great reputation for his pointed and pleasant tales, he was invited by Crœsus to take up his abode at the Lydian court, where he is said to have met Solon. He afterwards visited Athens, and was sent by Crœsus on an embassy to Delphi. Having offended the Delphians, by withholding from them, in consequence of a quarrel, a certain sum of money which he was charged to distribute, he was accused of sacrilege, and put to death. The city was soon visited by a pestilence, which the Delphians attributed to their treatment of Æsop, and they declared their willingness to make money compensation for the crime. A certain sum was subsequently paid to a grandson of one of Æsop's former masters, no actual relative of the fabulist being forthcoming.

The apologues of Æsop are mentioned by Plato and Aristophanes; and Socrates, when in prison awaiting his death, turned into verse such as he knew. Various collections of fables said to be Æsop's were made, from time to time, in the later Greek and Roman ages; but it is doubtful whether any that we possess were really written, as far as the actual composition is concerned, by the sometime slave, though their substance may have been derived from him. Among the earliest collections of these fables is that of Demetrius Phalereus; then came two metrical versions, one of which was by Babrius, a Greek writer who is thought to have lived a little before the Augustan era. From this version, a good many of the Æsopian fables with which we are all familiar have been taken. A large addition to the tales of Babrius was made in 1842, owing to the discovery of an ancient manuscript in the course of some explorations of the convents of the East, which were conducted, at the instance of the French Government, by a Greek scholar, named Minoides Minas.

Phædrus, who lived in the reign of the Emperor Tiberius, made a Latin collection of fables, based on Æsop; and in later times there were other Latin works of the same nature. In the Middle Ages, attention was again drawn towards Æsop by the set of fables that were put forth in his name, about the middle of the fourteenth century, by Maximus Planudes, a monk of Constantinople, who prefaced his book with a life of the fabulist, reproduced from some older manuscript, and containing those accounts of his personal deformity, and of his strange ways, which are now supposed to be purely imaginary, as no reference to them is to be found in any classical author. The collection of Planudes was doubtless made without due discrimination; but it is one of the quarries from which the Æsopian fables known to the modern world have been extracted.

Mankind has a natural partiality for these amusing fictions. The chief European nations — the French, Italians, Spaniards, Germans, and ourselves — have shown equal ingenuity in their production; and in the early part of the present century the Russians were delighted by the quaint inventions of Ivan Andreëvich Krilof, whose fables have

recently been introduced to the English public, in a very pleasing form, by Mr. W. R. S. Ralston, of the British Museum, one of the few Englishmen who have a· comprehensive knowledge of the Russian tongue. Gay's Fables have long been universal favourites with us, and the sprightly French collection of La Fontaine has enjoyed a European reputation for some two hundred years. That such should be the case is not surprising, for these fables are among the most attractive of the modern world. They are avowedly based in part on Æsop, but have been treated in so original and graceful a style as to be something very different from mere reproductions. The spirit and charm of French literature at its most brilliant and elegant period has been shed round these grey old tales by the witty writer, who formed one of the glories of the reign of Louis XIV. La Fontaine was the very person to execute such a task with the happiest effect. He was a man of the world, in a sense neither the best nor the worst—a man of graceful, superficial mind —a good-natured companion, a satellite of great people's houses, an easy-hearted, amiable, indolent, lax, facile, ready wit, pleased to flutter through the world, and to promote the entertainment, while slily satirising the foibles, of the rich. When he got old, and thought himself in danger of death, he became religious after the fashion of such converts in Roman Catholic countries ; took to wearing a hair-shirt, and made translations of the hymns of the Church. But his real nature was much more truthfully expressed in his Fables. It was a weak rather than a bad nature, and in the Fables it is really seen to advantage. He had published some works of an immoral character, on which account Louis XIV. had refrained from bestowing on him any of those honours which he was in the habit of showering on literary men. In the Fables, the too easy poet sought to atone for his past errors. He proposed—though apparently without any invitation from the court—to amuse and instruct the Dauphin, whose education was just then beginning. His first collection of fables, divided into six books, appeared in 1668, under the title of " Æsop's Fables, translated into Verse by M. de la Fontaine." The work was dedicated to the Dauphin, in an epistle characterised by the usual flowery adulation of the age. A second collection of fables was presented to the king himself. In his Preface, La Fontaine observes :—

" Plato, having banished Homer from his Republic, has given a very honourable place in it to Æsop. He maintains that infants suck in fables with their mother's milk, and recommends nurses to teach them, since it is impossible that children should be accustomed at too early an age to the accents of wisdom and virtue. If we would not have to endure the pain of correcting our habits, we should take care to render them good whilst as yet they are neither good nor bad. And what better aids can we have in this work than fables ? Tell a child that Crassus, when he waged war against the Parthians, entered their country without considering how he should be able· to get out of it again, and that this was the cause of the destruction of himself and his whole army ; and how great an effort will the infant have to make to remember the fact! But tell the same child that the fox and the he-goat descended to the bottom of a well for the purpose of quenching

their thirst, and that the fox got out of it by making use of the shoulders and horns of his companion as a ladder, but that the goat remained there in consequence of not having had so much foresight; and that, consequently, we should always consider what is likely to be the result of what we do—tell a child these two stories, I say, and which will make the most impression on his mind? Is it not certain that he will cling to the latter version as more conformable and less disproportioned than the other to the tenderness of his brain? It is useless for you to reply that the ideas of childhood are in themselves sufficiently infantine, without filling them with a heap of fresh trifles. These trifles, as you may please to call them, are only trifles in appearance; in reality, they are full of solid sense."

Certainly, no one has ever presented this form of composition to better advantage than La Fontaine.

---

## "CROQUEMITAINE."

"CROQUEMITAINE" is the title of a semi-picturesque, semi-ludicrous French romance by M. L'Épine. It is a story of Charlemagne, of his companions, and of his enemies; of Roland, and Oliver, and Ganelon, and Turpin, and Marsillus, and Angoulaffre, and Murad; of the wars of Christians and Saracens, and of the supernatural adventures of courageous knights. The fancy, humour, and spirit of this tale (deepening into tenderness and pathos at the close) have made it popular in France, and the agreeable translation of Mr. Hood the Younger has procured for it admirers in England. One of the principal characters is a girl named Mitaine, the godchild of Charlemagne, and a great favourite of his, because of her martial disposition. She has for her constant attendant a tame lion, taken by the Emperor from a Saracen chief. Afterwards, she is made a page of the court, and at length attains to the honour of serving the great Roland as his squire. Having, by her own unaided prowess, achieved some grand adventures, from which even celebrated knights had recoiled, she is present with Roland on the field of Roncesvalles, where both perish in that terrible battle with the Saracens. Roland, when desperately wounded, hears a faint, sweet voice pronouncing his name. "Do you know me, my dear lord?" says the voice. "Come hither, and bid me farewell." Stretched on the field among the slain, Roland beholds the godchild of Charlemagne. "Heaven be praised, my pretty one!" he exclaims. "To see you still alive makes me almost fancy Heaven smiles upon me. You will not die. The Emperor will be here soon, and will bear you back to our own beloved France." "You deceive yourself, Roland," replies Mitaine. "I shall never again behold the great Emperor—never again my native land! But tell me, have the Saracens retreated?" "They have retreated into Spain." "Then the victory belongs to

us two.  By the shrine of Saint Landri!  I am happier than I ever dreamed of being."  Roland now fastens one of his golden spurs to Mitaine's heel, saying, "There, brave little hero!  None ever better merited the rank of knight."  Mitaine, in an ecstasy of joy, throws her arms round Roland's neck.  "Quick, quick, my beloved lord!" she murmurs; "give me the accolade,* for I feel I am dying."  Sinking back on the turf, she plucks, with a last desperate effort, two blades of grass, fashions them into a cross, and expires with that symbol on her lips.  Shortly afterwards, the mighty Roland is himself a corpse.

Charlemagne, with his Peers, or Paladins, occupies a similar position in French legendary history to that of King Arthur and the Knights of the Round Table in early British fiction.  Both Arthur and Charlemagne were real monarchs, around whom a vast amount of fabulous matter has grown, like moss and lichens on an old wall; but Charlemagne having lived between two and three centuries subsequently to Arthur, we know a good deal more about the real man in the one case than in the other.  The eighth century is almost daylight, as compared with the dim obscurity of the sixth.  The Arthurian legends and those of Charlemagne have been as popular in foreign countries as in the lands that gave them birth.  We have seen, in discoursing of "Don Quixote," how much was formerly made of our own British heroes in many parts of Europe; and the same may be said of the Paladins of Charlemagne.  Roland—or Orlando, as they call him—has been a special favourite with the Italian poets.  Pulci, Bojardo, and Ariosto, have all celebrated his exploits, and commemorated him as a model knight.  His famous sword, Durandal, is the rival of King Arthur's Excalibur; and his vast magic horn, called Olivant (originally belonging to Alexander the Great, and won by Roland from a giant), figures in many of his adventures.  It could be heard at a distance of twenty miles, and a blast on this terrific instrument summoned Charlemagne to the assistance of his knights when overmatched at Roncesvalles.  Rinaldo and Astolfo (the latter of whom also has a magic horn) are two more of Charlemagne's knights distinguished by the Italian poets.  The British and the French legends are full of interest, action, passion, and romantic beauty; but an Englishman may perhaps be allowed to consider the Arthurian myths as even finer than those of the great Emperor and his peers.

* The accolade was the blow on the shoulders which conferred knighthood.

## "THE FAIRY REALM."

In the work bearing this title, M. Doré has illustrated five of those pleasant old stories which have often delighted us in the nursery, and which still retain a certain charm in later life with all those readers who have preserved anything of the freshness and fancy of their childhood. The tales in question are—"The Sleeping Beauty in the Wood," "Little Red Riding-Hood," "Puss in Boots," "Cinderella," and "Hop o' my Thumb." They have all been cleverly put into verse by Mr. Hood the Younger, and the volume contains some of the best of M. Doré's designs, of the purely fanciful and grotesque order.

The story of "The Sleeping Beauty" comes to us through the version of Charles Perrault, a French writer of the time of Louis XIV. But Grimm derives the legend from the old Northern myth of the sleeping Brynhild, and her deliverance by Sigurd; while according to Dunlop the tale was suggested by the old Greek fable of Epimenides, the Cretan poet, who, when a boy, went to sleep in a cave, and did not wake for fifty-seven years. The latter story, however, bears a greater resemblance to the legend of Rip van Winkle or Peter Klaus, or to that of the Seven Sleepers of Ephesus, than to Perrault's enchanting little romance, which appears much more likely to have been a descendant of the Norse legend. Brynhild was a beautiful *valkyria*, or messenger of the god Odin, who was discovered by Sigurd lying in a death-like trance, and clad in complete armour. For some offence, she had been condemned to this sleep by Odin. She was recovered by Sigurd. who swore to marry her, but broke his oath, and suffered many misfortunes in consequence.*

"Little Red Riding-Hood" is an old tradition, current both in Germany and Sweden The Swedish version differs somewhat from that which is commonly received; but it would seem to be from one or other of these countries that the tale has spread over the whole Western world.

For "Puss in Boots" we are also indebted to Perrault; but it is likewise to be found in the "Notti Piacevoli" of the Italian writer, Straparola (published in 1550), and German and Scandinavian counterparts are said. to exist.

"Cinderella" is a very old and very widely-diffused story. It is included in the collections of Perrault and Madame d'Aulnoys, and it is from them that the version now current in England is derived. The legend was known in Germany in the sixteenth century, but it is clearly of Eastern origin. According to a very ancient Egyptian legend, an eagle one day carried off the sandal, or slipper, of the famous beauty, Rhodope, as

* See "Wheeler's Dictionary of the Noted Names of Fiction."

she was bathing, and dropped it near the king, Psammetichus, at Memphis. The monarch was so charmed with it that he caused inquiry to be made throughout his dominions for the owner; and Rhodope, being at length discovered, was married by Psammetichus.

"Hop o' my Thumb" is an old English story, but, together with its companion tale of "Tom Thumb," it belongs remotely to the wide field of Teutonic folk-lore. All these popular legends have their roots spread abroad over the whole world; but they blossom in brightness and beauty to this day, and will continue to do so while the poetry of the human heart survives.

THE END.

# The Plates

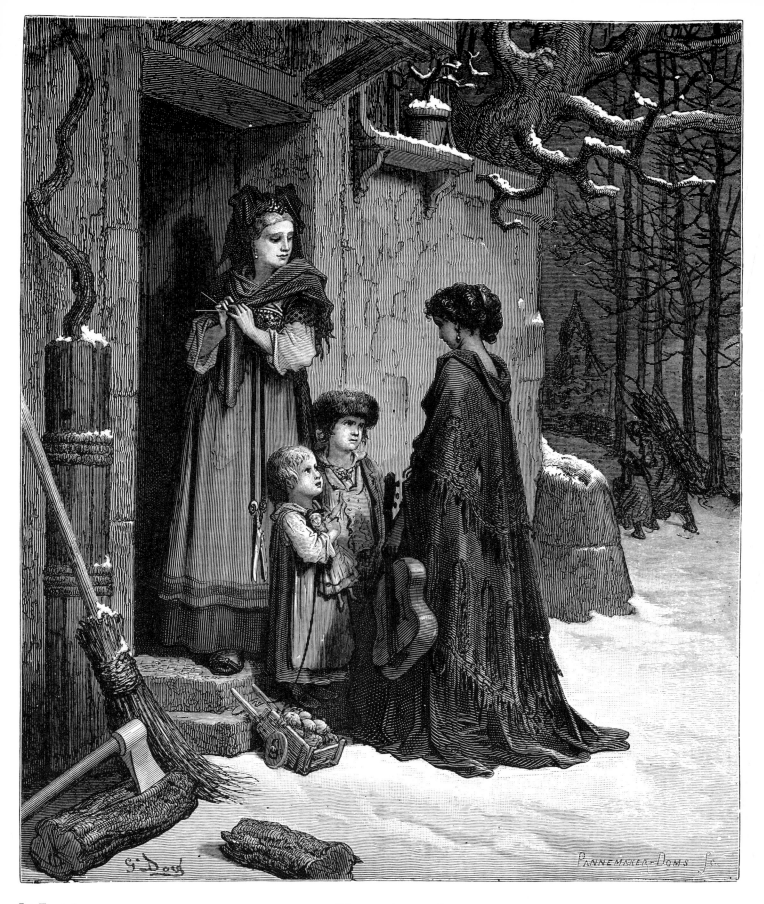

**La Fontaine**

**The Grasshopper and the Ant**

The grasshopper, here shown as an itinerant minstrel, has spent all summer singing, and with the approach of winter has no food put by. She pleads with the industrious ant, here a housewife, to lend her some food until the summer, when she will repay it in full. The ant asks, "How did you spend the summer?" and hearing the grasshopper reply "I sang day and night", retorts, "You sang? Then now you can dance."

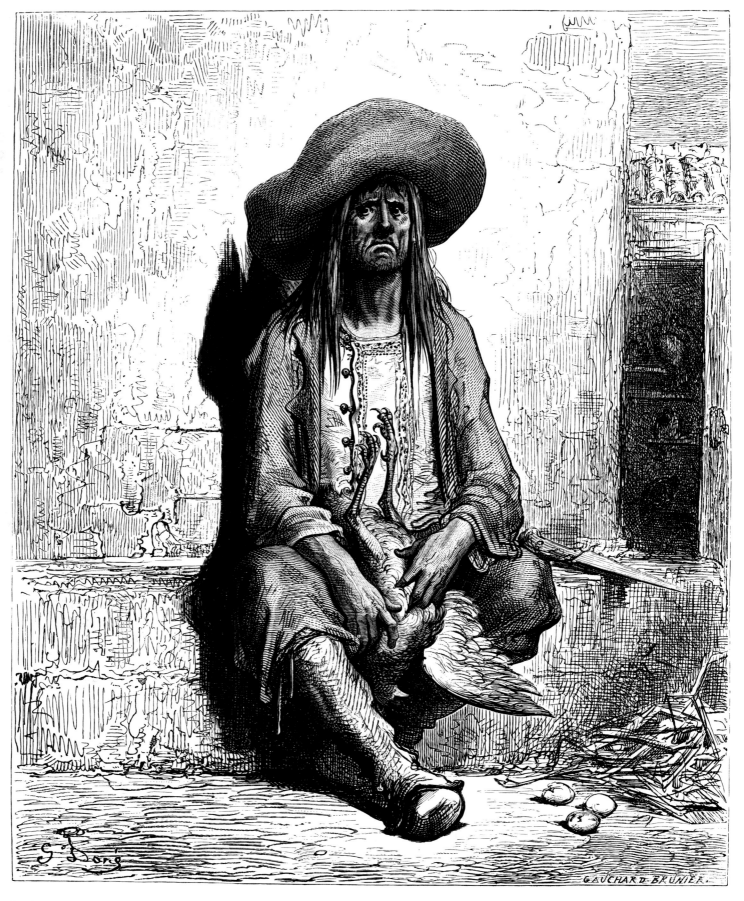

**La Fontaine**

**The Hen with the Golden Eggs**

A miser had a hen that laid golden eggs. Impatient to gain the whole treasur[e] at once, he killed the hen. But, on cutting it up, he found nothing.

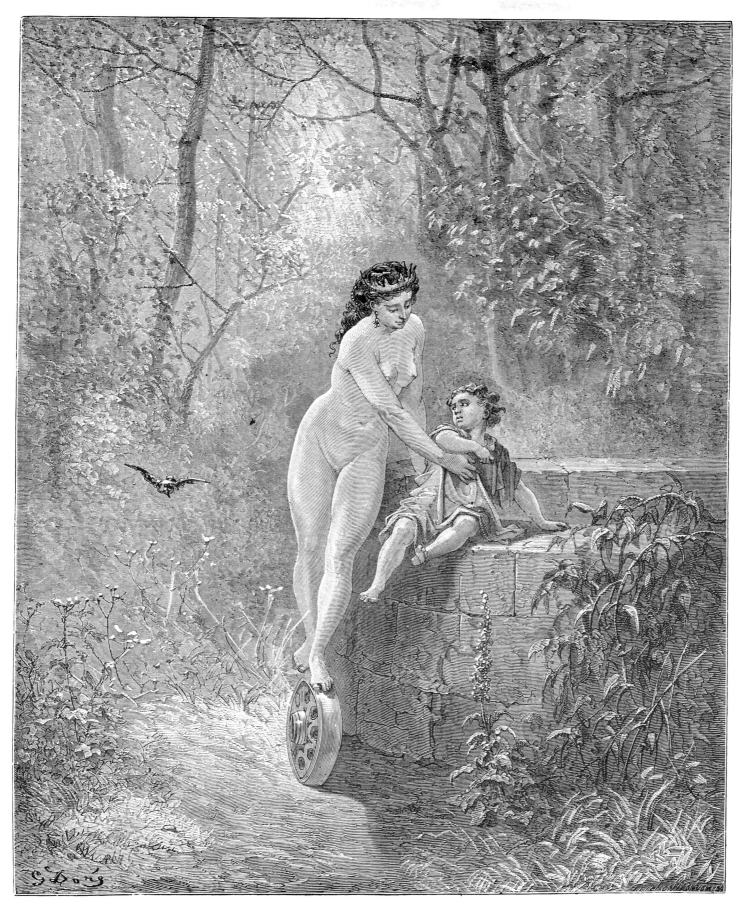

**La Fontaine**

**Fortune and the Little Child**

A child fell asleep on the edge of a well. The goddess Fortune, coming by, woke him and said, "You see I have saved your life, but you must be more careful. If you had fallen in, I would have been blamed, but you know that it would not have been my fault." With these words she vanished. She was right: no one has ever suffered a calamity without blaming her for it.

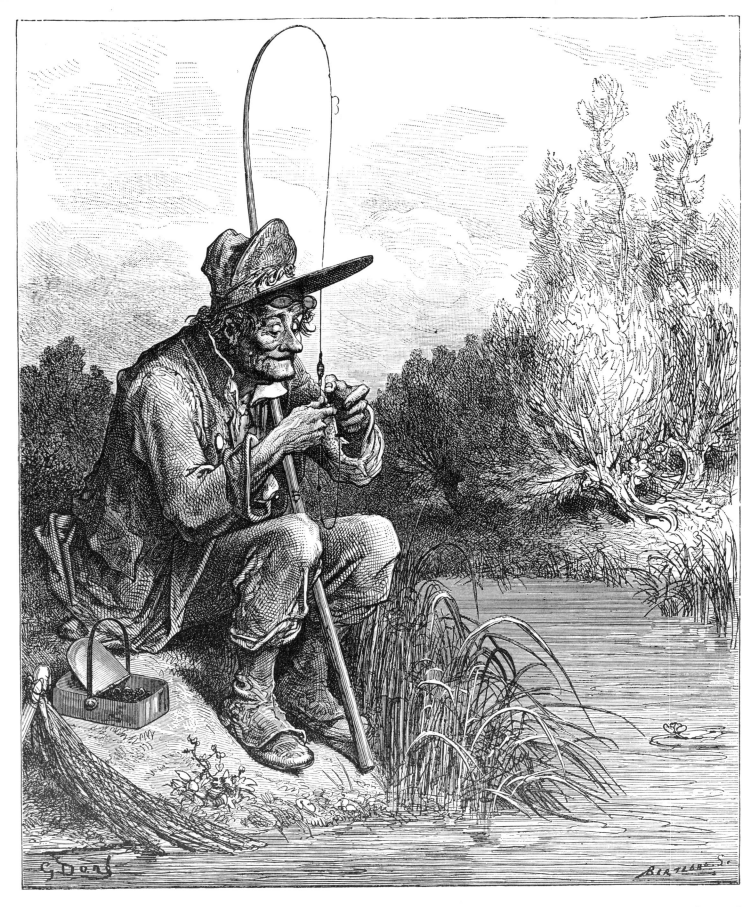

**La Fontaine**

**The Little Fish and the Fisherman**

A very small carp was caught by an angler. As he was about to be put in th
basket the fish exclaimed, "What on earth can you want with me? I'm onl
half a mouthful. Why not wait till I'm bigger and will fetch a good price? As
am I'm good for nothing." The fisherman replied "Good for nothing? Tha
was a fine speech, but I'll see how you taste."
Men of sense prefer the present to the future. They're sure of the one but no
of the other.

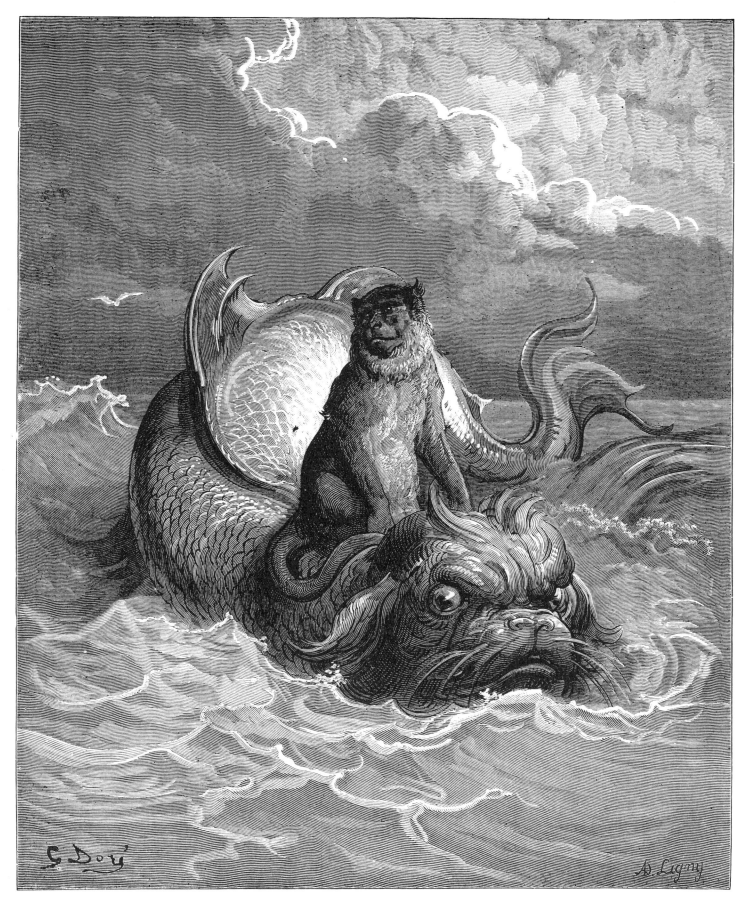

**La Fontaine**

**The Monkey and the Dolphin**

In ancient times a ship went down near Athens. All would have perished but for a friendly dolphin who carried them on his back to safety. At one point he carried a monkey, thinking him to be a sailor, and asked him whether he knew Athens. The monkey boasted of his familiarity with the place but showed such ignorance of it that the dolphin tipped him into the sea and swam off to look for some more worthy soul to rescue.

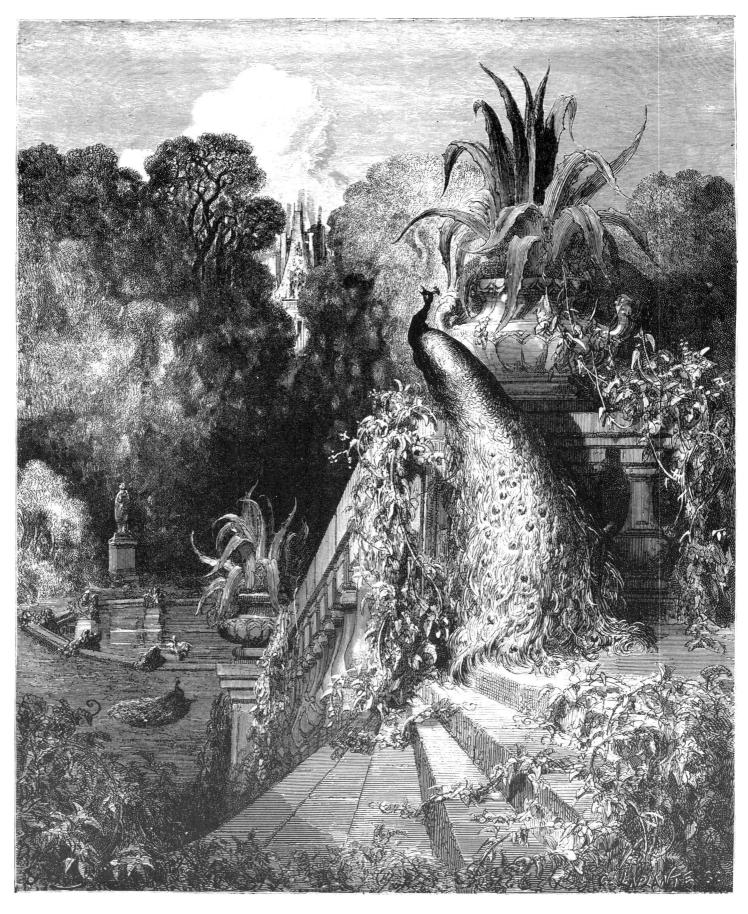

**La Fontaine**

**The Peacock complaining to Juno**

The peacock complained to Juno: "Goddess, why have you given me a harsh unpleasant voice, while the paltry nightingale's song is the delight of all?" Juno replied, "You jealous bird. Your plumage far exceeds the beauty of even jewels and gives great pleasure to man. Every creature has its special gift and all are content. So do not complain or I will tear the plumage from your foolish back."

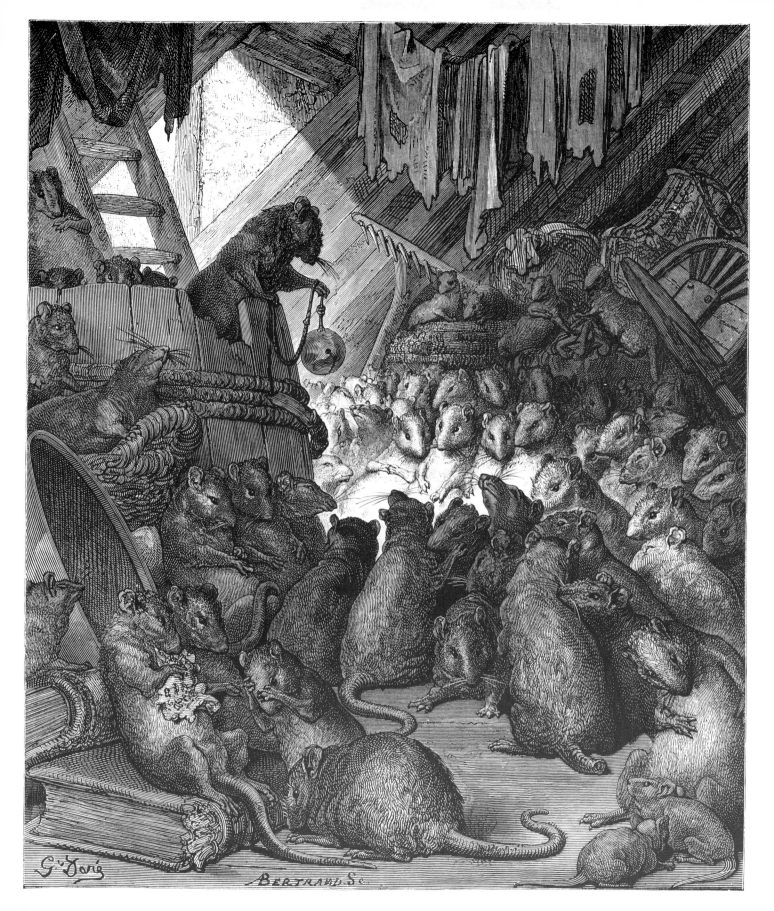

**La Fontaine**

**The Council held by the Rats**

A certain cat spread so much terror through the kingdom of the rats that they held a council to decide what should be done. One wise old rat suggested that a bell should be fastened round his neck to give warning of his approach, and all approved of this idea. But who was to do it? Nobody volunteered and the whole thing ended in talk. So it is with human affairs: plenty of suggestions but no action.

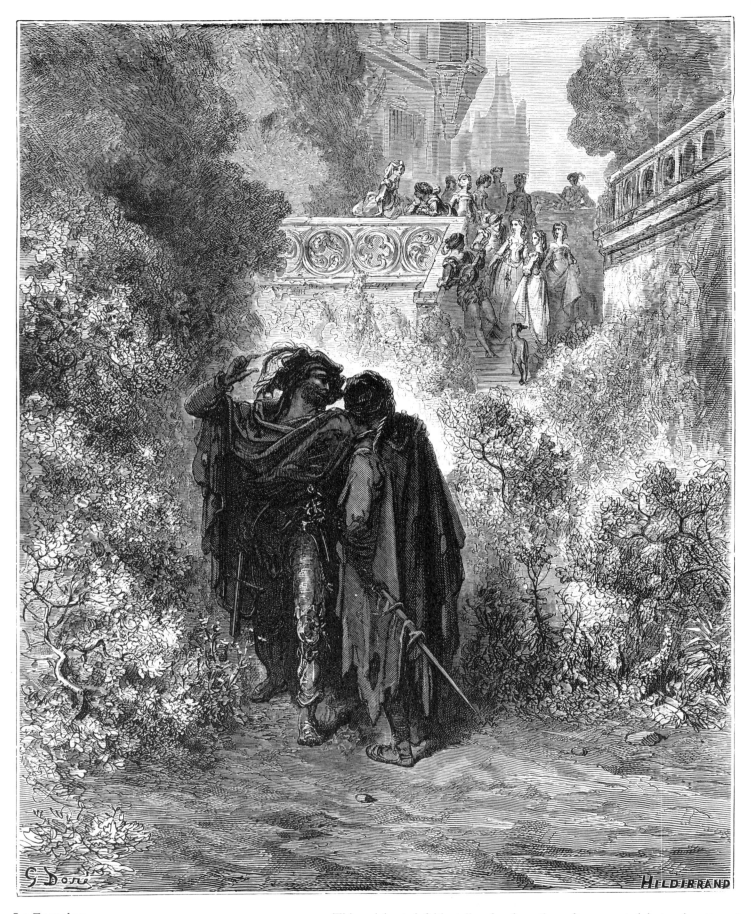

**La Fontaine**

**The Fox and the Grapes**

This celebrated fable tells of a fox who, after repeated but vain attempts to reach a tantalizing bunch of grapes, finally gives up with the remark that they were probably sour anyway. Here the fable is rendered in a human context; the vagabonds at the bottom of the garden are as obviously envious of the happy gathering on the terrace as they pretend indifference to it.

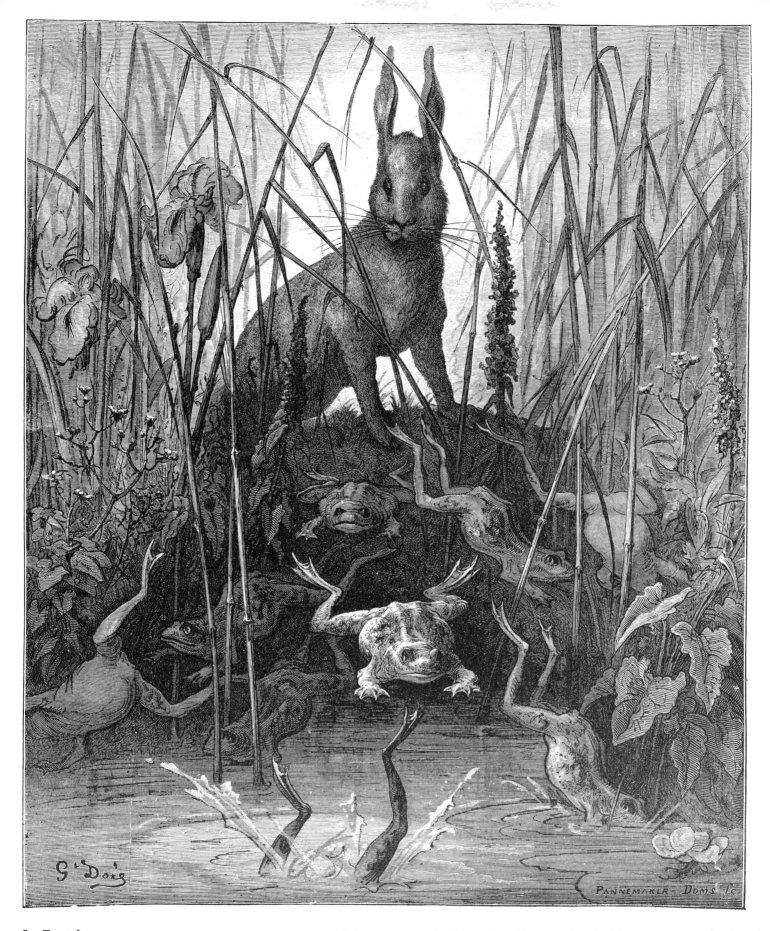

**La Fontaine**

**The Hare and the Frogs**

A hare sat one day lamenting his excessive timidity. It was a sad thing, he reflected, to have such weak nerves that even a passing shadow or a breath of wind could throw him into a state of alarm. But he was much reassured later, when, passing a pond, he took some frogs by surprise and they, panic-stricken, all jumped in and hid. "Aha", he cried, "so there *are* creatures as afraid of me as I am of men."

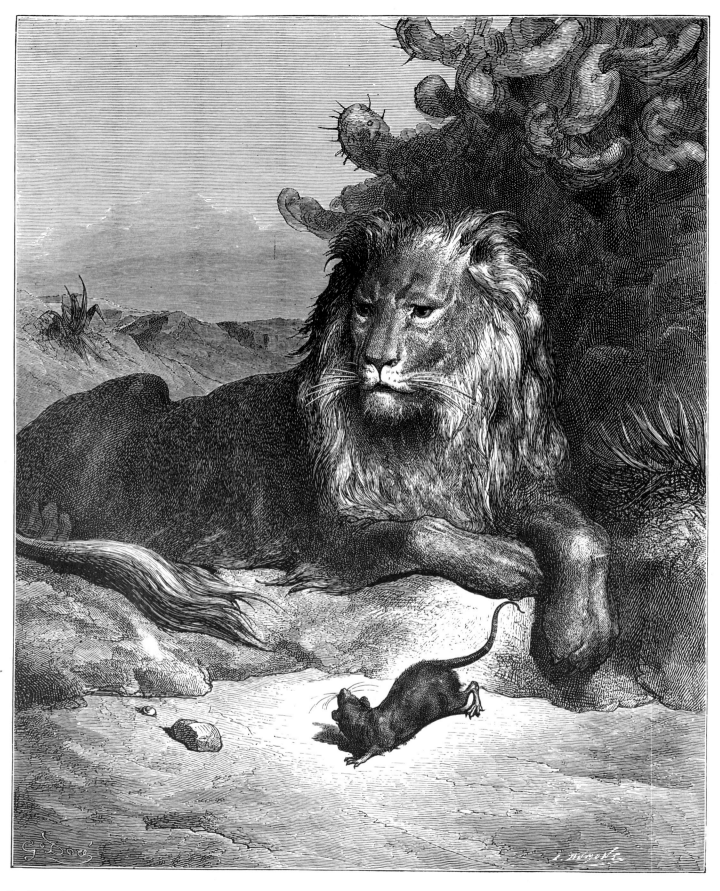

**La Fontaine**

**The Lion and the Rat**

A rat, creeping from his hole, found himself confronted by a lion, but the li[on] did him no harm. Some time after, the lion was caught in a net by some hunte[rs] and was unable to escape until the rat came along and set him free by gnawi[ng] through the meshes.

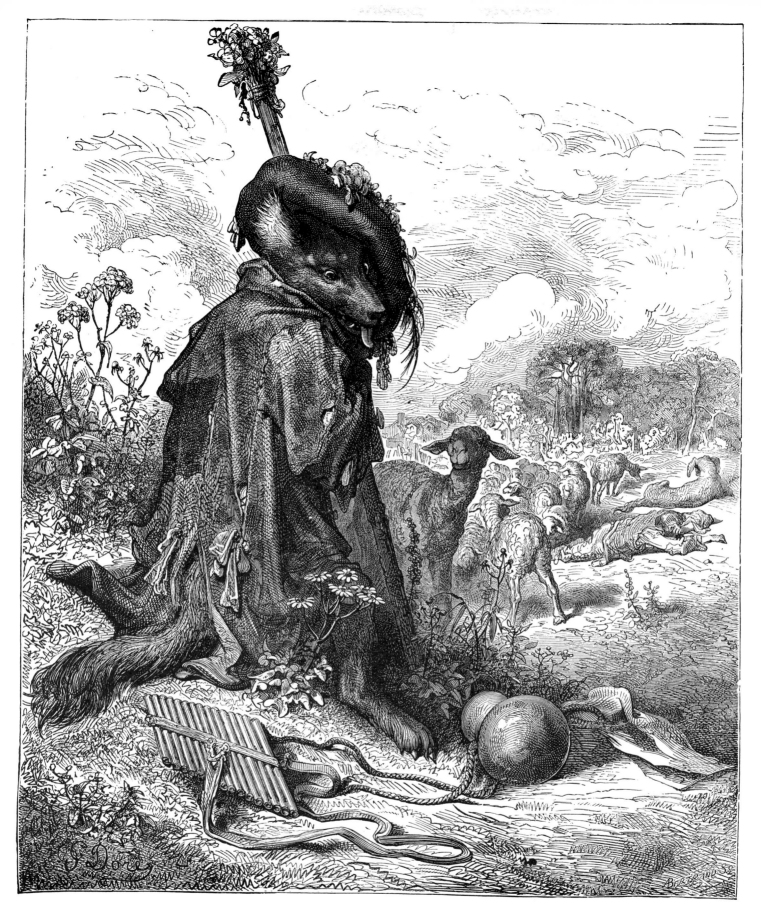

**La Fontaine**

**The Wolf Turned Shepherd**

Finding the sheep getting ever more cautious and his victims therefore fewer, a wolf had the idea of disguising himself as a shepherd and thus deceiving his prey. All went well as long as the wolf kept quiet, but as soon as he tried to imitate the shepherd's voice he was discovered and killed by the sheep.

A rascal is sure to make some mistake in his plans; the wolf must always act like a wolf.

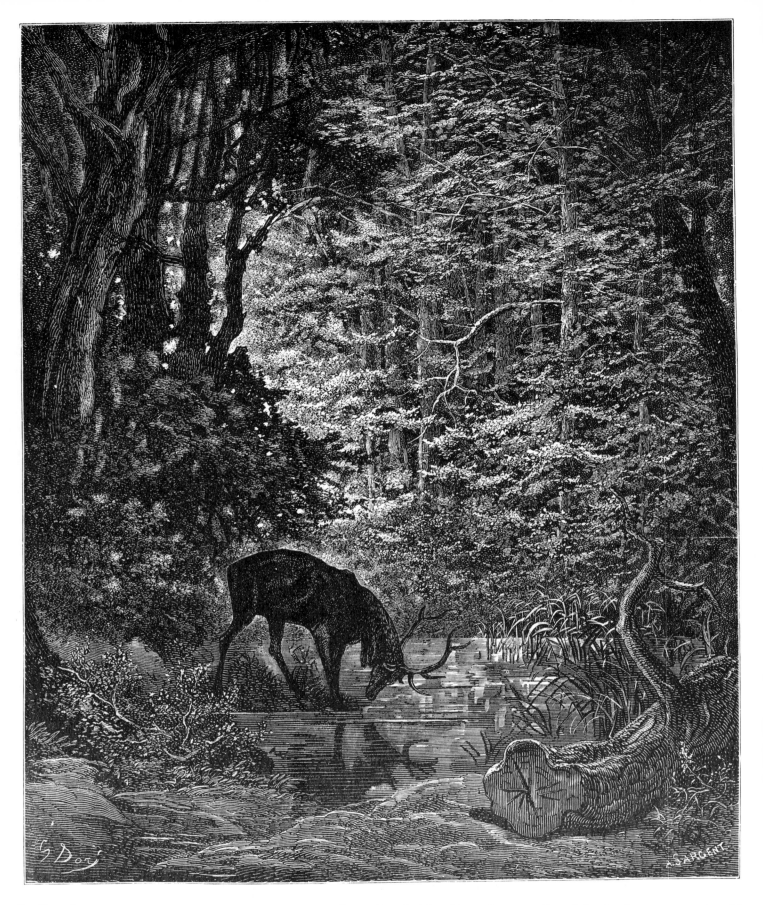

**La Fontaine**

**The Stag Looks at Himself in the Stream**

A stag is admiring his antlers as reflected in the forest stream, but blame
providence for giving him no better legs. Shortly afterwards, hearing the bayin
of hounds, the stag is off at full speed. He finds that, whereas his antlers hinde
his flight by tangling in the branches of trees, he is ultimately saved by the spee
at which his legs can carry him.
We foolishly prefer the ornamental to the useful.

**La Fontaine**

**The Old Woman and her Servants**

An old woman kept her two maids so hard at work spinning, and woke them so early in the morning, that the girls wrung the neck of the cock that roused their mistress at dawn. But they found themselves worse off than before, for the old woman, fearing they would oversleep now the bird was dead, woke them earlier. By avoiding one danger one may easily fall into another.

**La Fontaine**

**The Countryman and the Serpent**

A countryman, finding a snake frozen and half dead, takes it home and warm
it by the fire. It repays his kindness by trying to bite him, whereupon he cu
it to pieces with a hatchet.
Charity should not be bestowed indiscriminately.

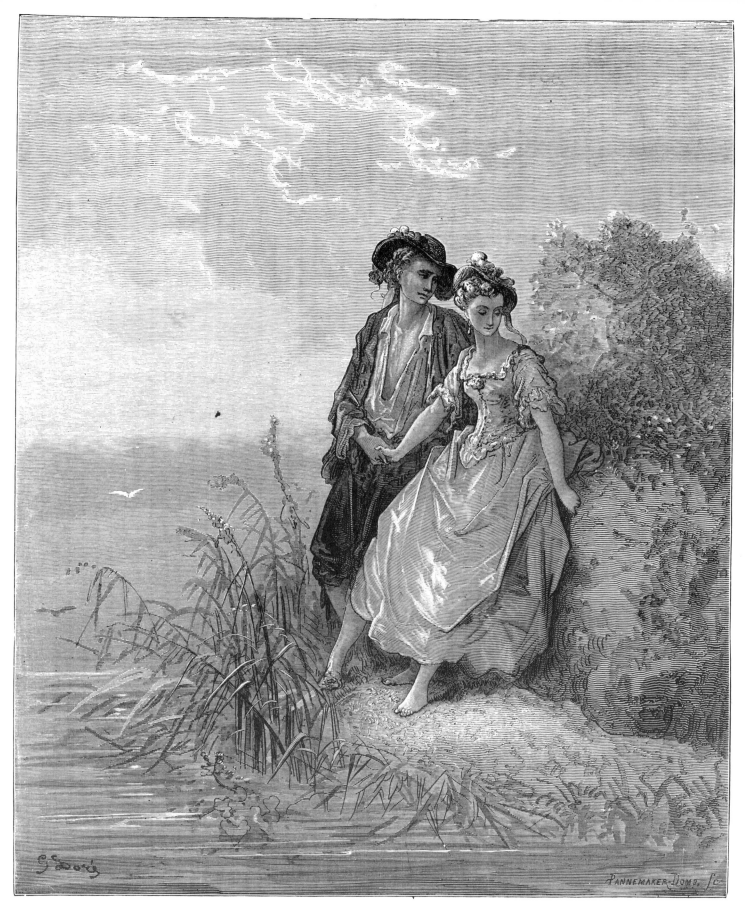

**La Fontaine**

**Tircis and Amaranth**

Tircis, who is in love with Amaranth, describes to her the state of mind that love induces, hoping that this will prompt her to profess her love for him. She recognises the symptoms he describes but, alas for Tircis, it is another, she says, that she loves.

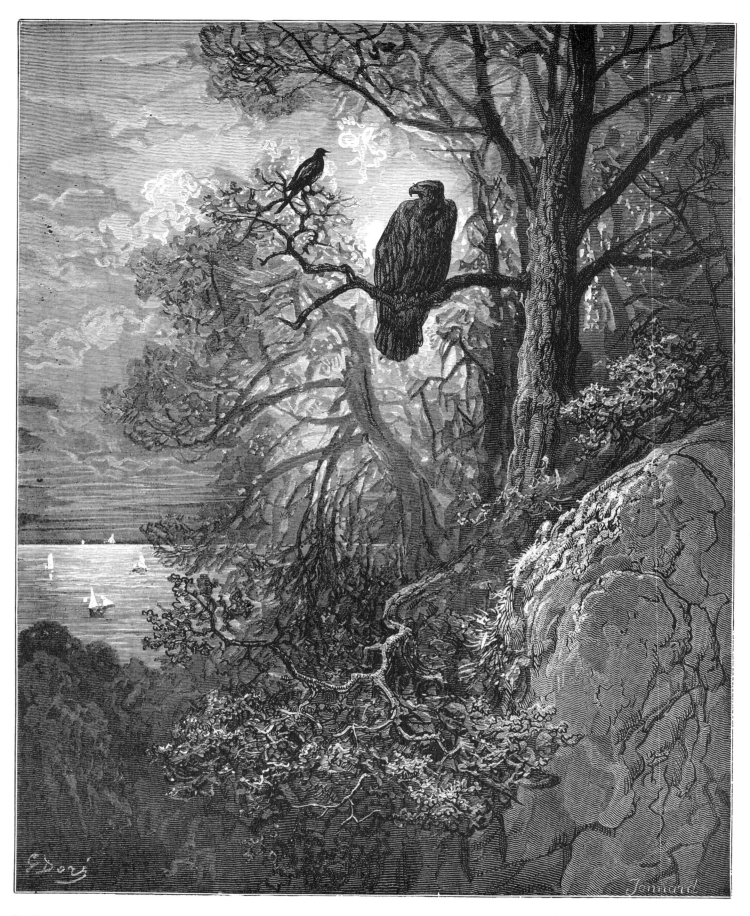

**La Fontaine**

**The Eagle and the Magpie**

The eagle one day invited a magpie to sit on the same branch with him, so as to derive a little amusement from her chatter. But the magpie was so indiscreet in her talk that the eagle told her not to leave her home for the future as he had no wish to see his court corrupted by a gossip.

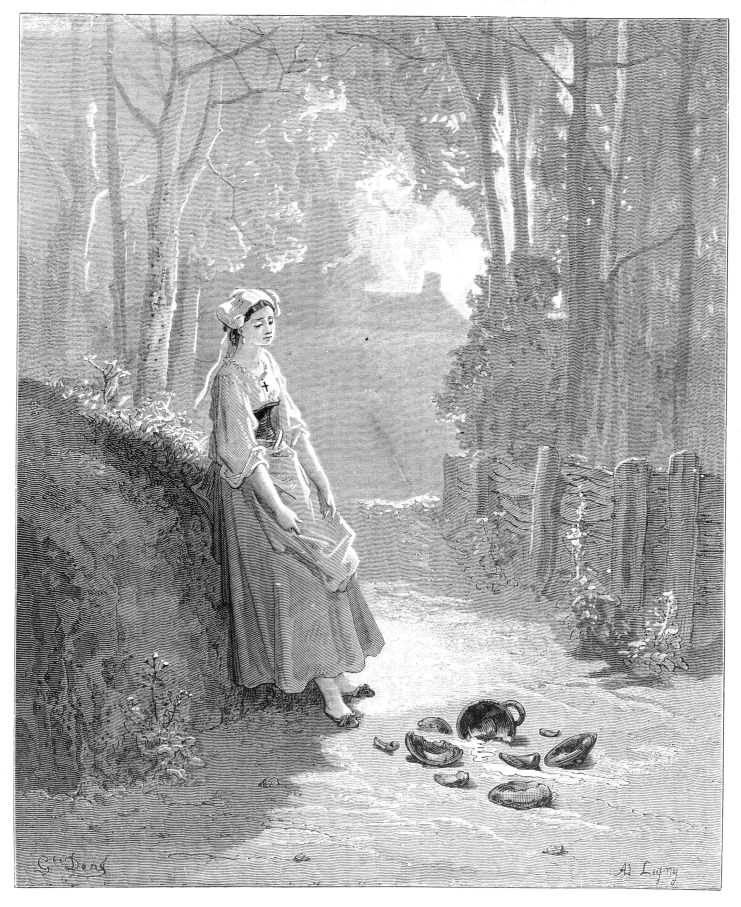

**La Fontaine**
**The Milkmaid and the Milkpail**

A milkmaid daydreams that she will one day earn a little fortune from the milk she carries on her head. But she upsets the pail and her fine plans are ruined.

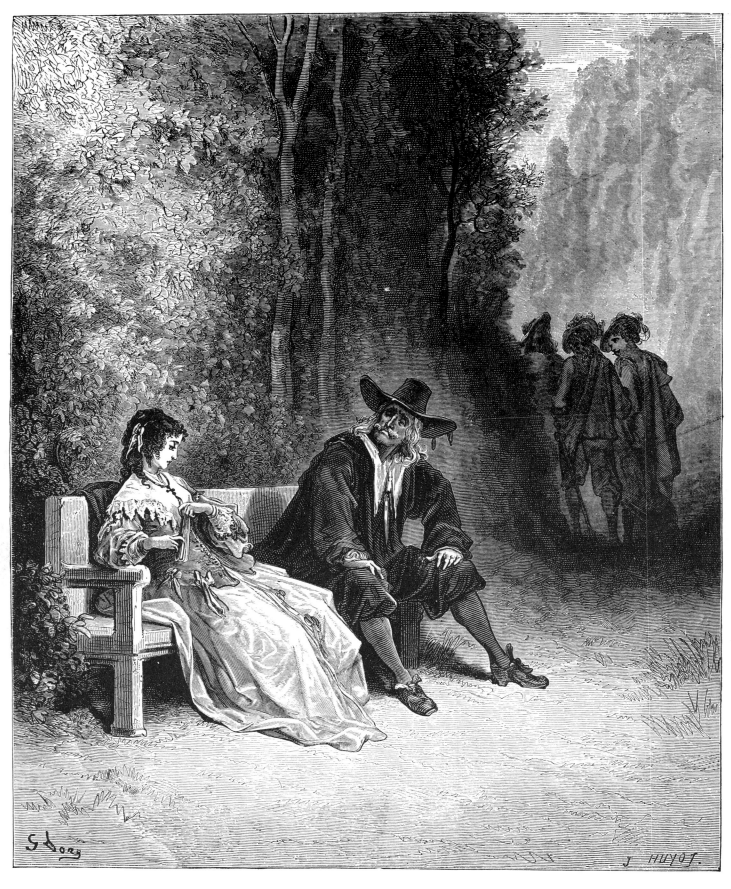

**La Fontaine**

**The Maiden**

A maiden of great beauty, but no less pride, refused suitor after suitor un finding her youth departing and her charms decaying, she was glad to accep rough and ill-mannered boor.

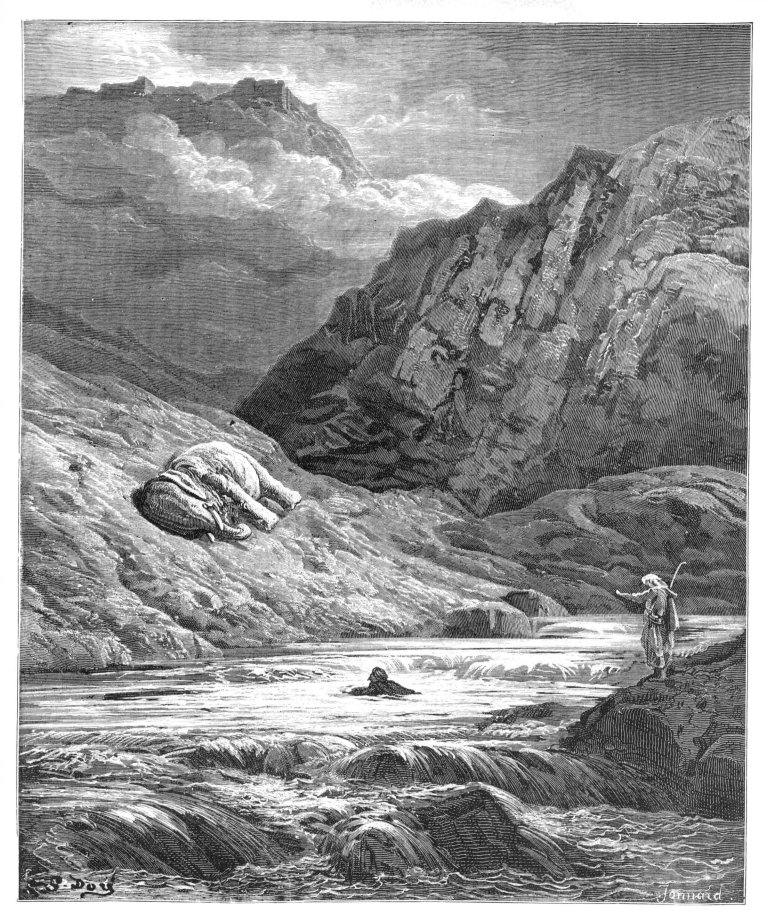

**La Fontaine**

**The Two Adventurers and the Talisman**

Two knights seeking adventures came to a sign: "If you would see that which no knight has seen cross yonder torrent, lift up the head of the stone elephant which you will find on the opposite bank and, without resting, carry it to the top of the neighbouring mountain." One of the knights scoffed but the other swam across, picked up the head and carried it to the summit. Beneath him he saw a city. Suddenly the elephant's head spoke and a band of armed men came out of the city gates. Thinking he was being attacked the knight spurred forward, but was amazed instead to hear himself proclaimed king of the city in place of one just dead.

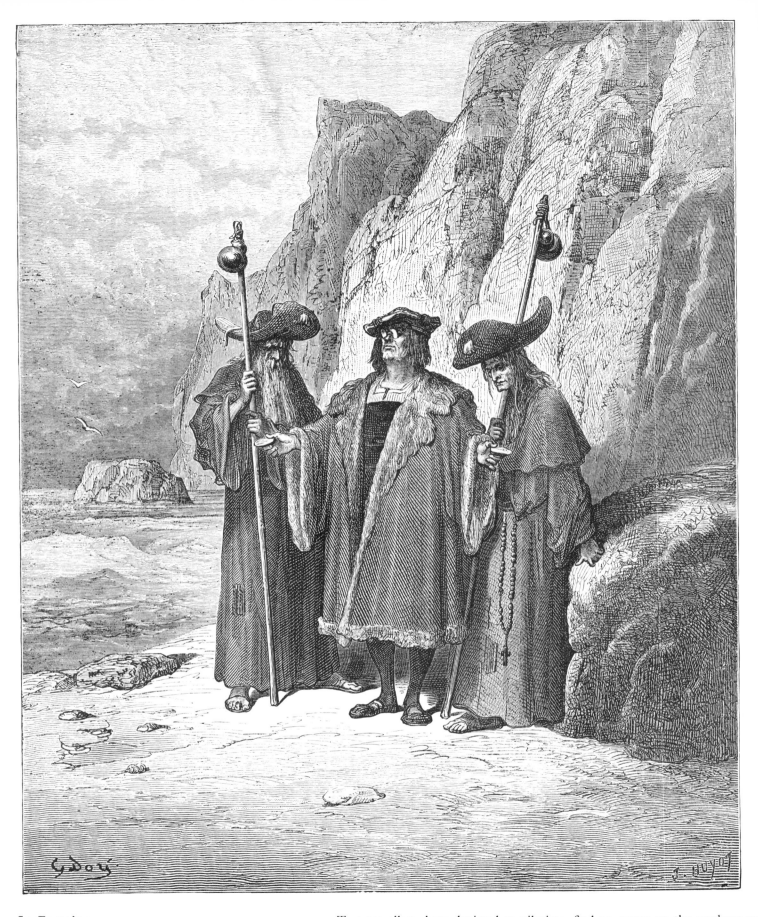

**La Fontaine**

**The Oyster and its Claimants**

Two travellers, here depicted as pilgrims, find an oyster on the seashore an
begin to quarrel over who should have it. They refer the dispute to a passin
lawyer, who eats the oyster himself and gives them each a half of the shell.

**La Fontaine**

**The Two Goats**

Two goats meet on a fallen tree trunk over a raging torrent. Each claims precedence on the grounds of a more ancient pedigree and, as neither will give way, both fall into the stream after a brief struggle and are drowned.

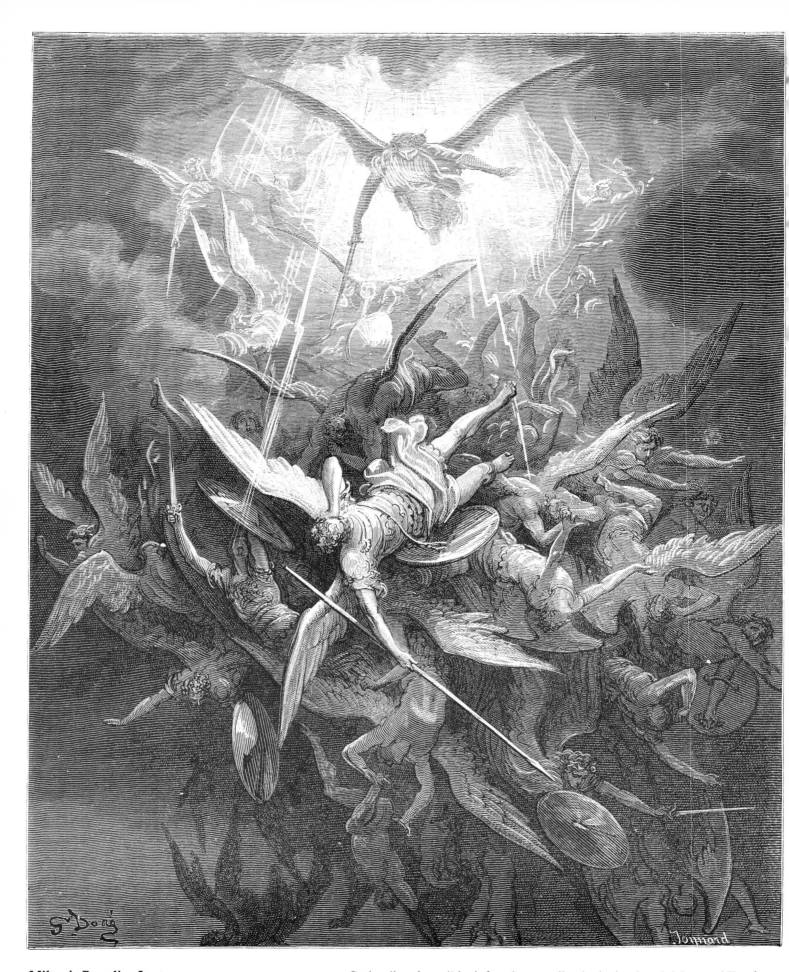

**Milton's Paradise Lost**

**Book I, lines 44–5**

*Him the almighty power*
*Hurled headlong flaming from the ethereal sky.*

God strikes down "the infernal serpent", who had seduced Adam and Eve from their state of innocence, and who has led a band of rebellious angels to challenge God's power.

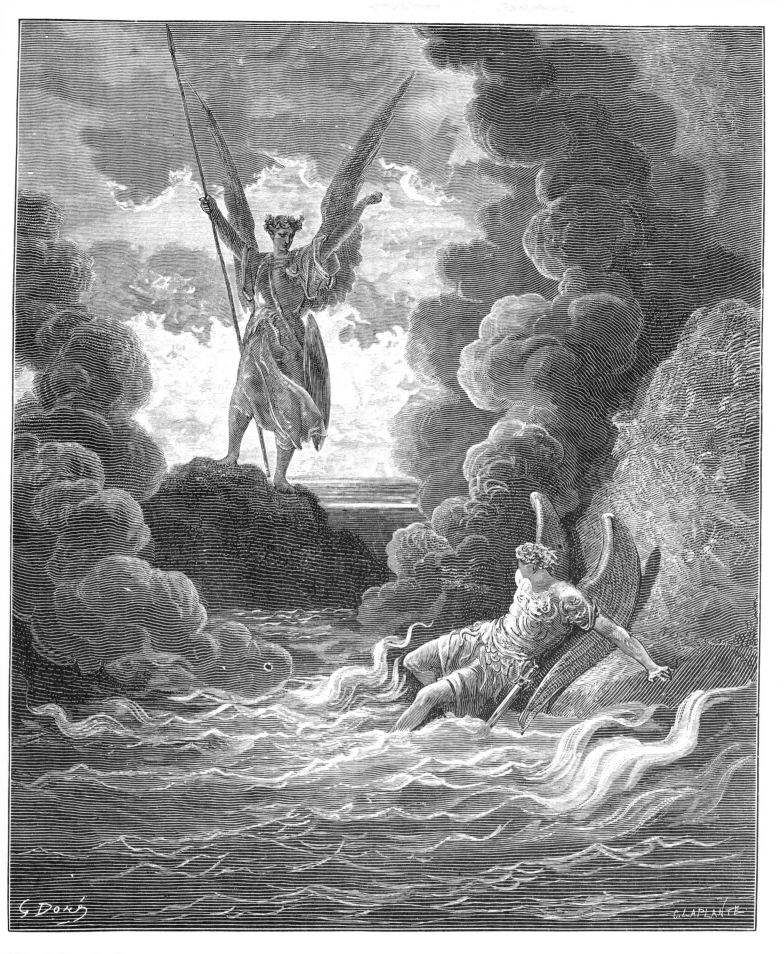

**Milton's Paradise Lost**

**Book I, lines 221–2**

*Forthwith upright he rears from off the pool*
*His mighty stature.*

In the first book of *Paradise Lost* Milton describes Satan and Beelzebub as lying, after their fall from Heaven, in an abyss of raging fire. Both are seen in this illustration, the one rearing "from off the pool", the other still tossing on the fiery waves.

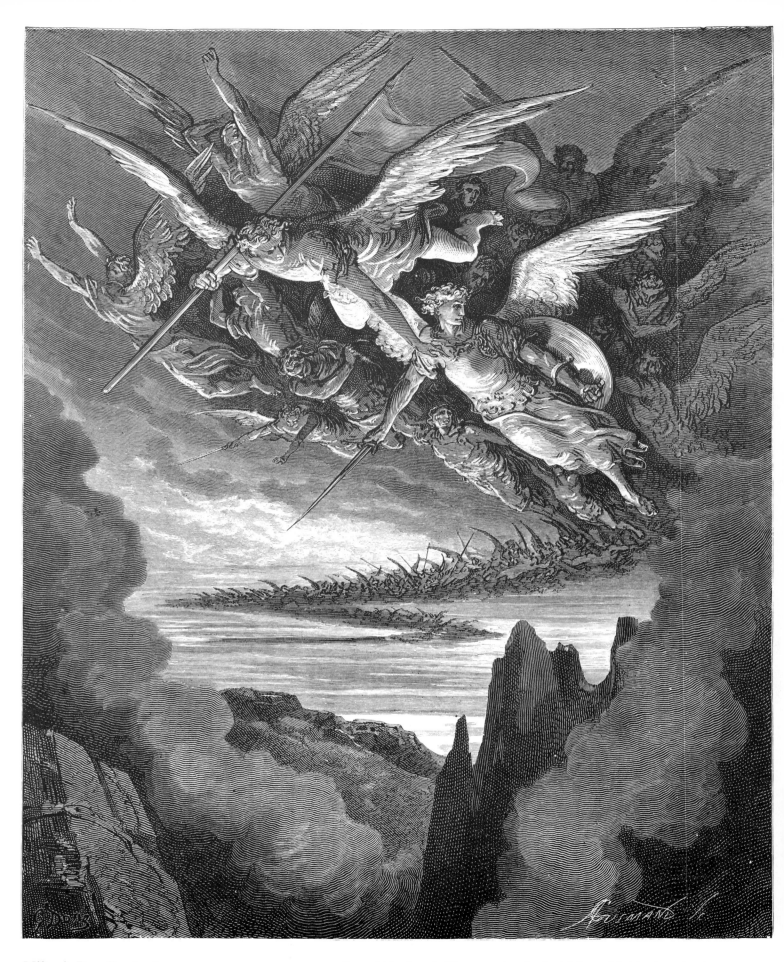

**Milton's Paradise Lost**

**Book I, lines 344–5**

*So numberless were those bad angels seen,*
*Hovering on wing, under the cope of Hell.*

Satan bids the rebellious angels who had fallen with him into the fiery abyss to take courage and rise again together.

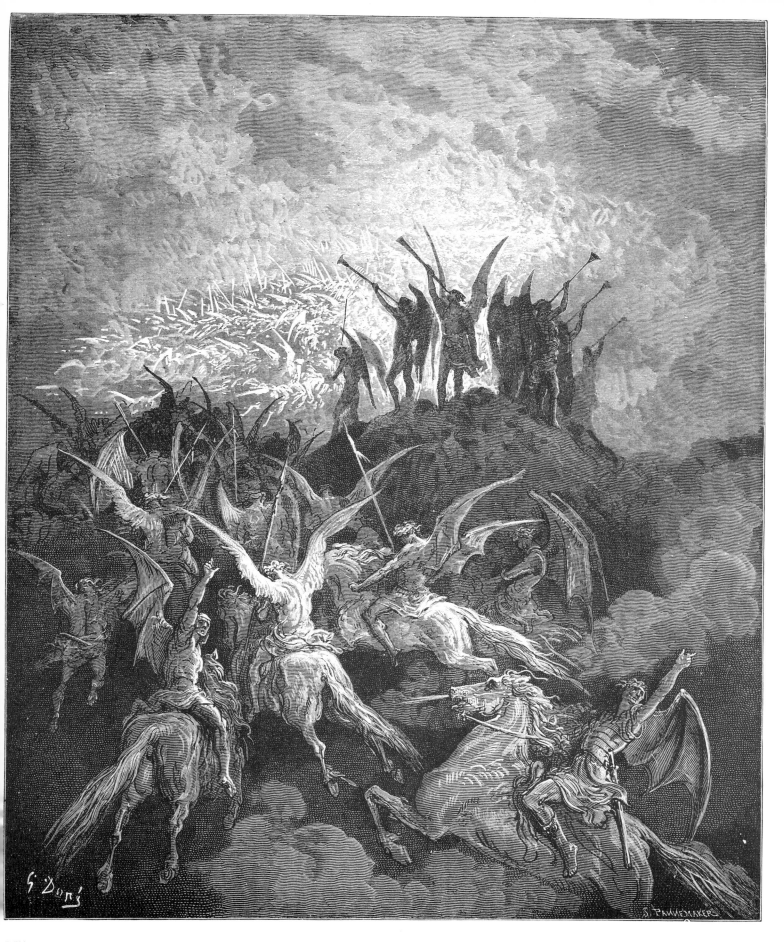

**Milton's Paradise Lost**

**Book I, lines 757–9**

*Their summons called*
*From every band and squared regiment,*
*By place or choice, the worthiest.*

The rebel angels are summoned to the conclave in Pandaemonium.

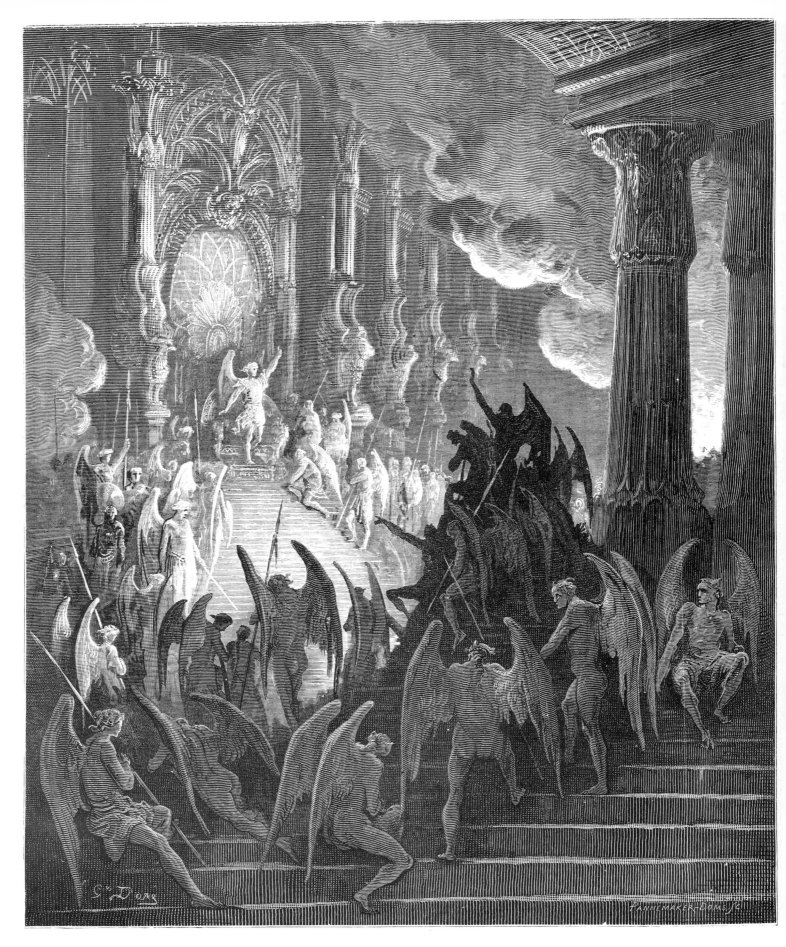

**Milton's Paradise Lost**

**Book II, lines 1–2**

*High on a throne of a royal state, which far*
*Outshone the wealth of Ormus and of Ind;*

Satan holds his council with the rebel angels in his fantastic golden palace, Pandaemonium.

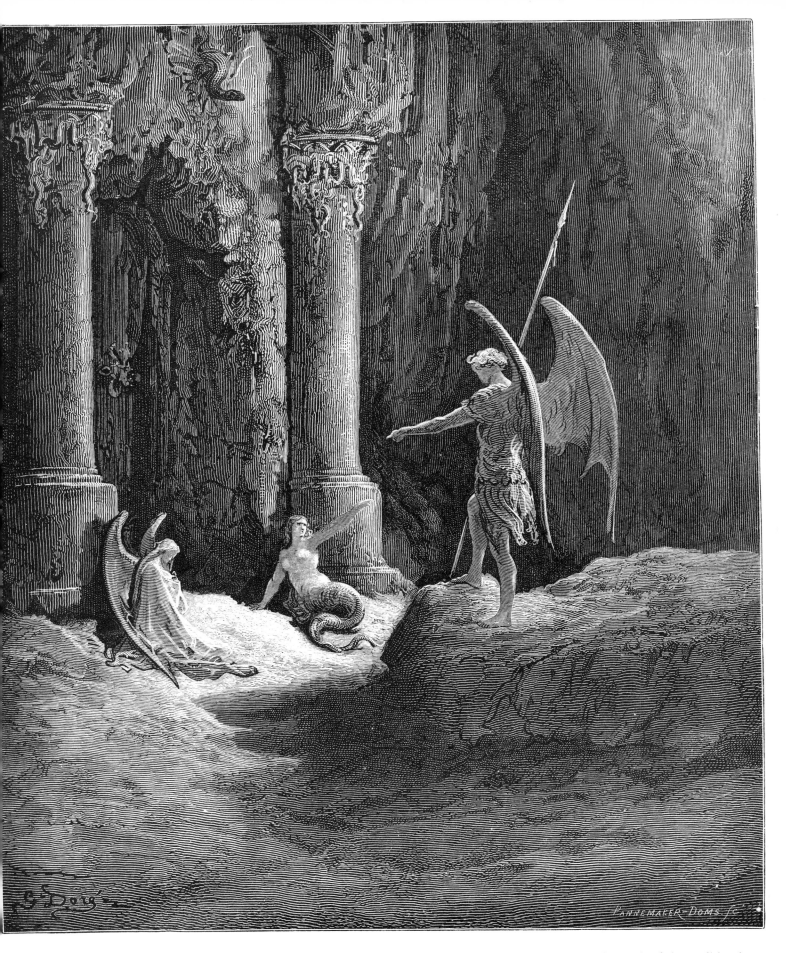

**Milton's Paradise Lost**
**Book II, lines 648–9**

*Before the gates there sat*
*On either side a formidable shape.*

The Council decides that Satan should investigate the truth of the tradition in Heaven that another world exists, and that another kind of creature is to be created. He passes on his journey to the gates of Hell, guarded by Sin and Death.

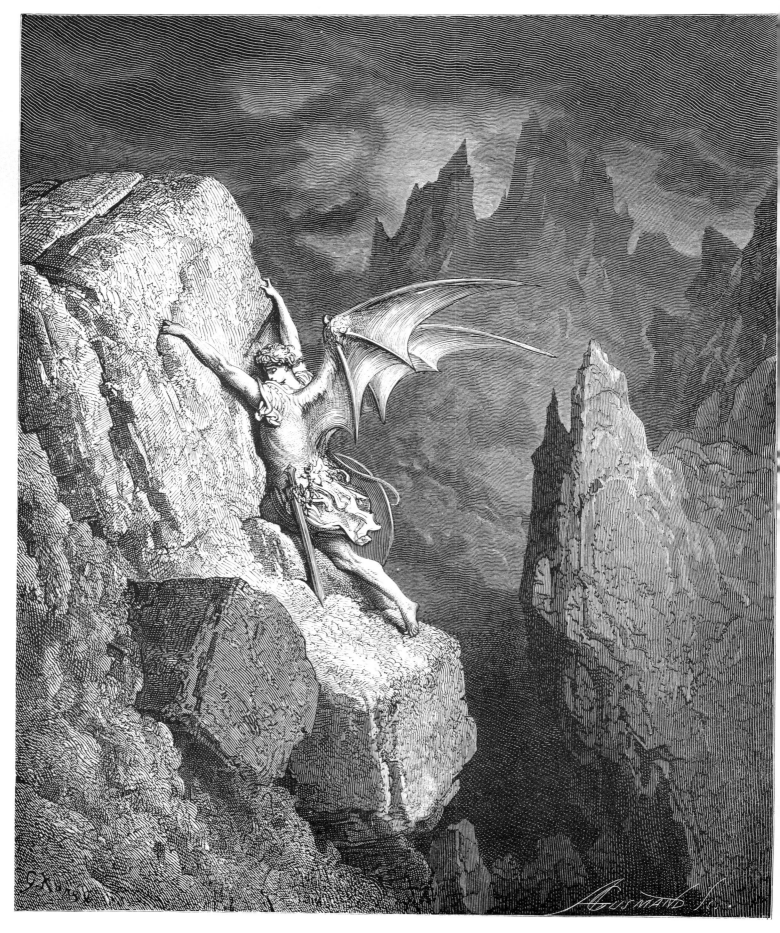

**Milton's Paradise Lost**
**Book II, lines 949–50**

*With head, hands, wings, or feet, pursues his way,*
*and swims, or sinks, or wades, or creeps, or flies*

Having persuaded Sin and Death to throw open the gates of Hell, Satan sets out across the forbidding Chaos.

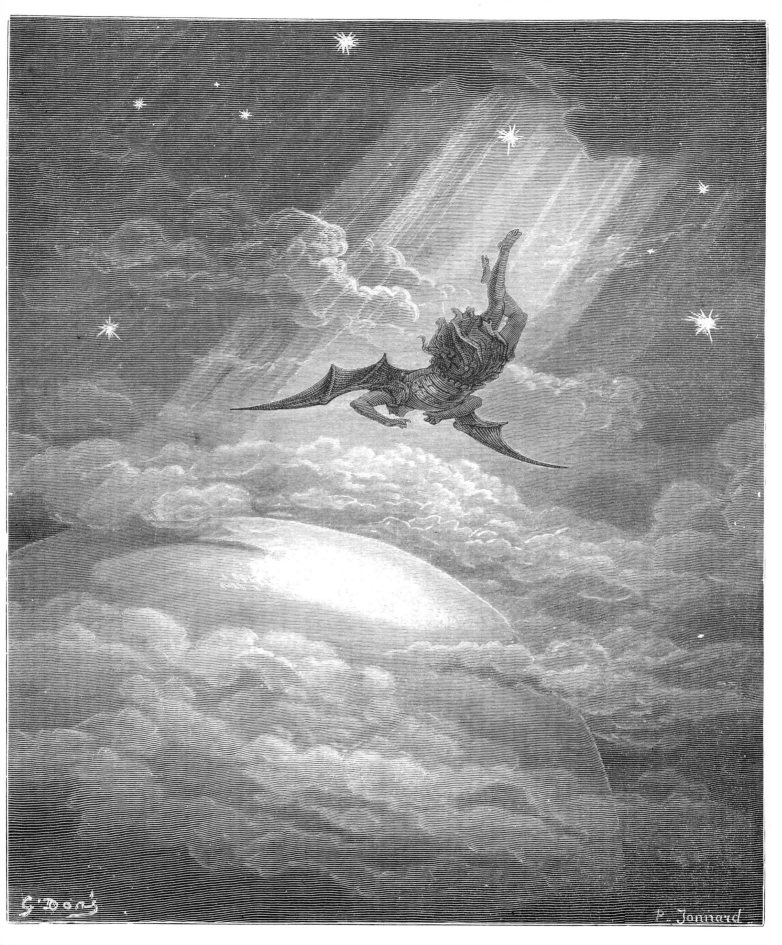

**Milton's Paradise Lost**
**Book III, lines 739–41**

After his journey through Chaos, Satan speeds down towards Earth.

*. . . and toward the coast of Earth beneath,*
*Down from the ecliptic, sped with hoped success,*
*Throws his steep flight in many an aëry wheel:*

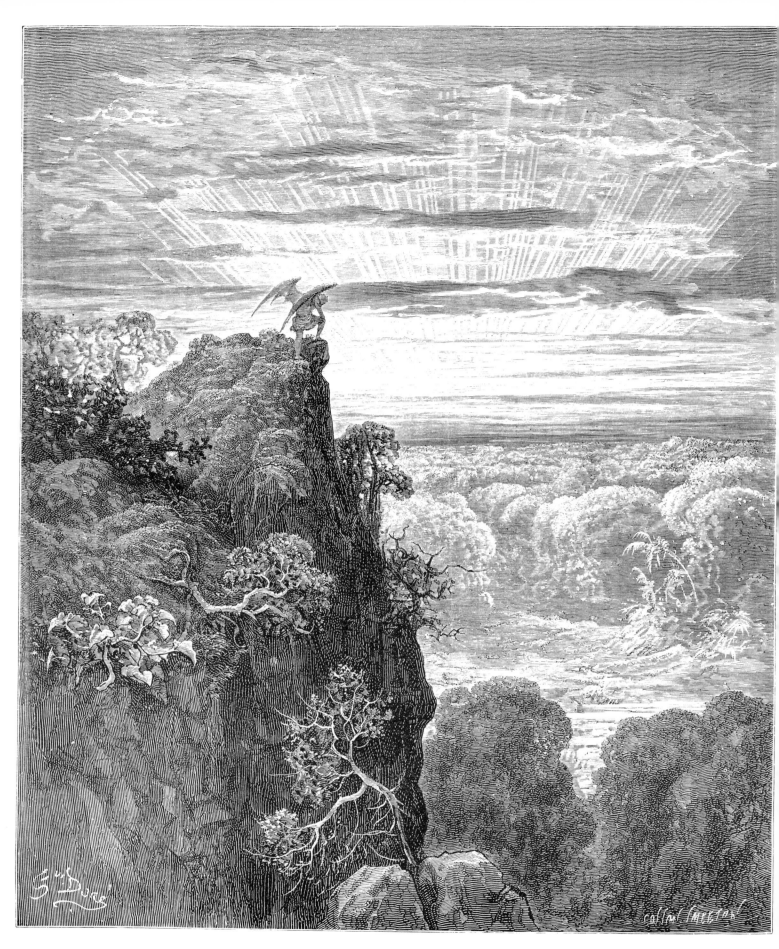

**Milton's Paradise Lost**
**Book IV, lines 171–3**

*Now to the ascent of that steep savage hill*
*Satan hath journey'd on, pensive and slow.*

Satan sees for the first time Paradise spread out before him.

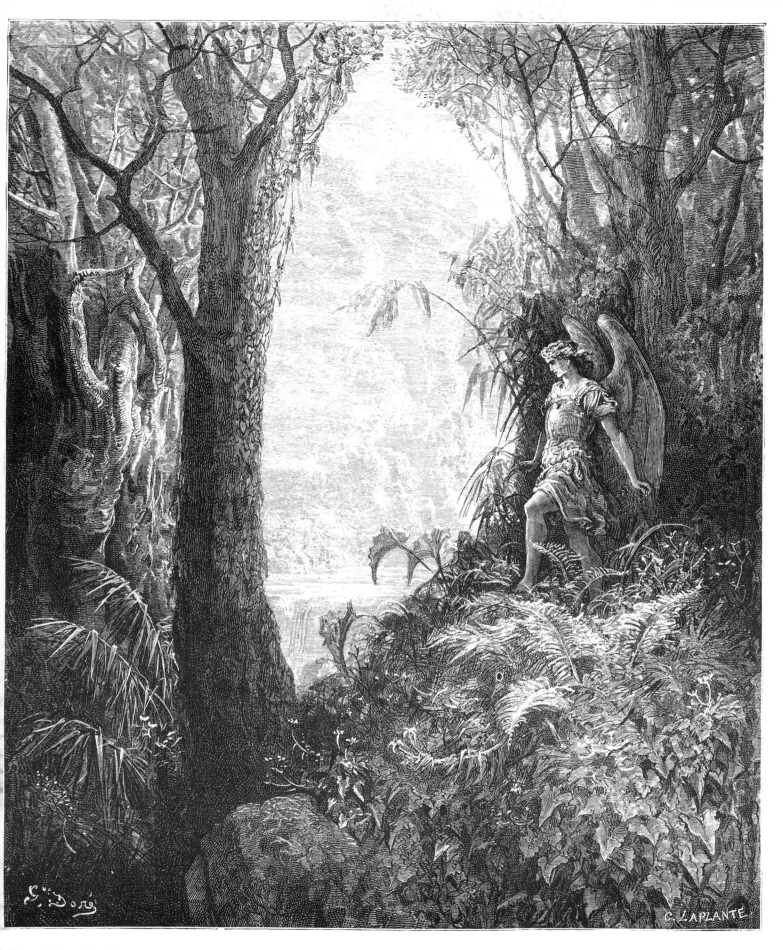

**Milton's Paradise Lost**
**Book IV, line 247**

*A happy rural seat of various view*

Having entered Paradise, Satan, standing on the Tree of Life, looks out over the beautiful landscape around him.

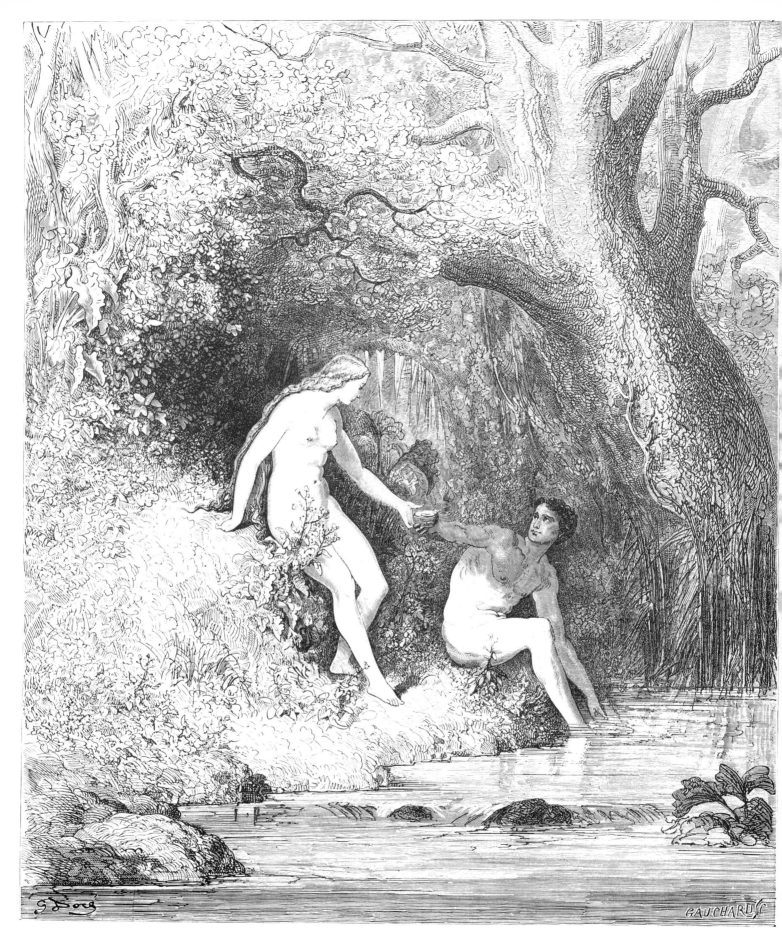

**Milton's Paradise Lost**
**Book IV, lines 335–6**

*The savoury pulp they chew, and in the rind,*
*Still as they thirsted, scoop the brimming stream;*

Adam and Eve, in Paradise and in their state of innocence, pluck the fruits of the garden for their evening meal.

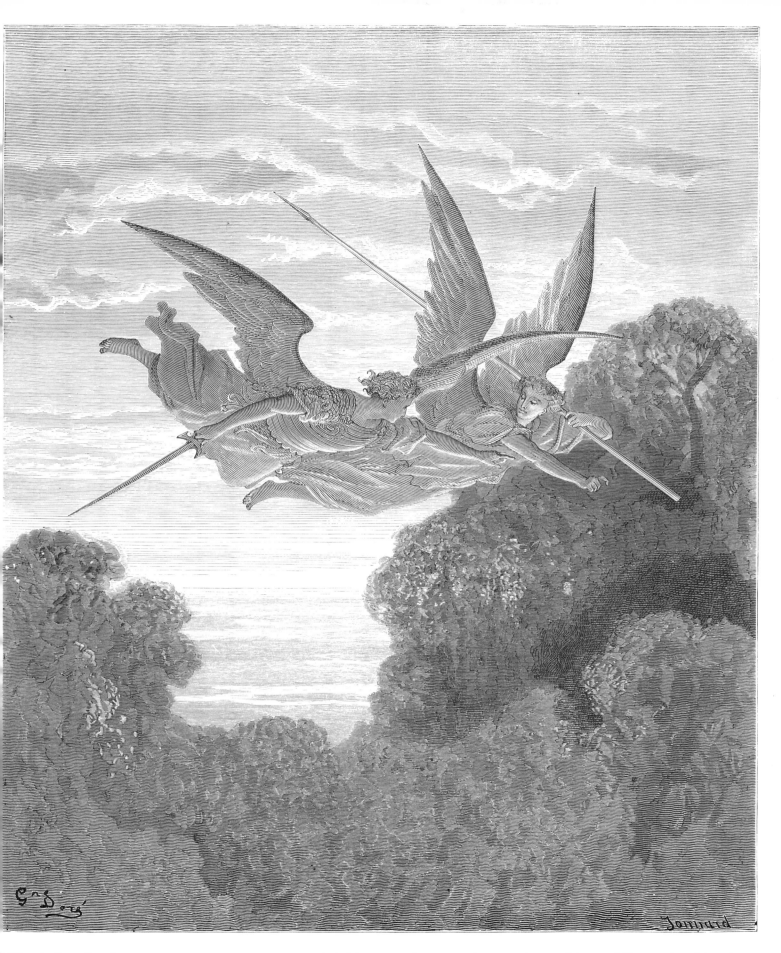

**Milton's Paradise Lost**
**Book IV, lines 798–9**

*These to the bower direct*
*In search of whom they sought . . .*

Gabriel commands two angels to watch over Adam and Eve on the night when Satan has gained entrance into Paradise. These are Ithuriel and Zephon, who find Satan sitting beside the sleeping Eve and filling her mind with temptation.

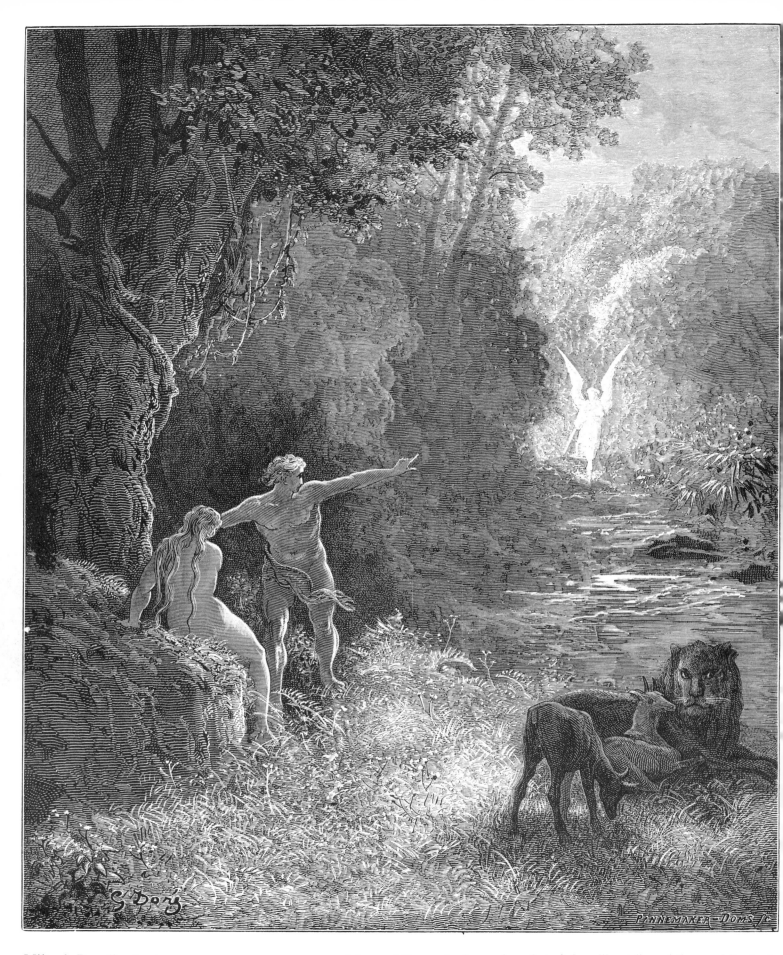

**Milton's Paradise Lost**
**Book V, lines 309–10**

*Eastward among those trees, what glorious shape*
*Comes this way moving*

Adam and Eve are in danger from Satan's beguiling talk, and the angel Raphael is sent to warn them. Adam sees him coming.

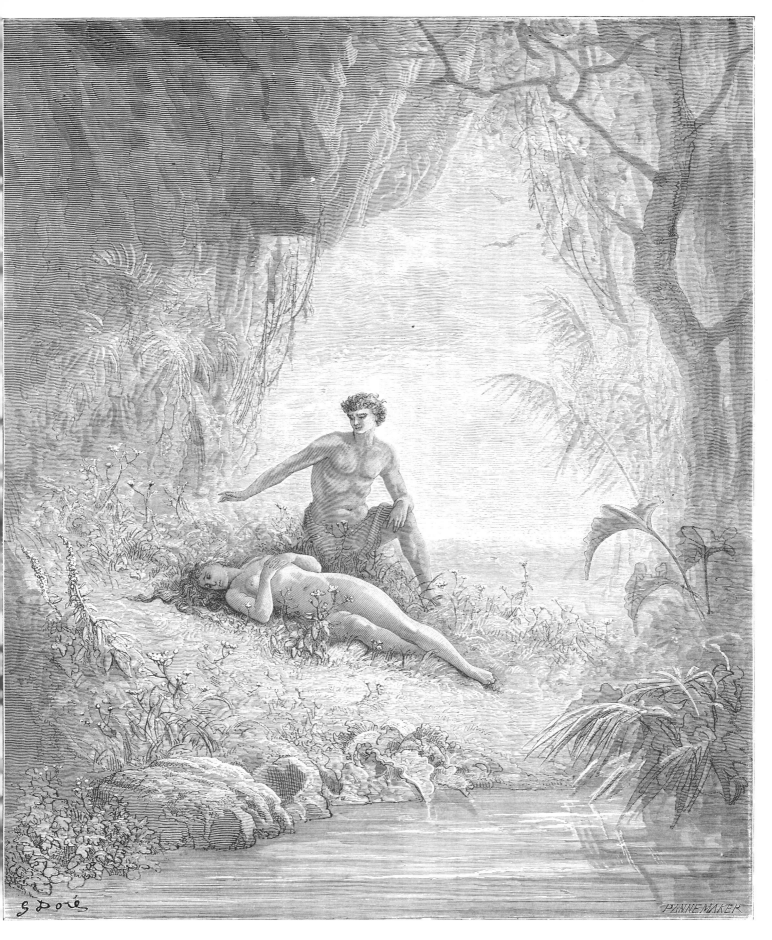

**Milton's Paradise Lost**
**Book V, lines 12–13**

*Leaning, half raised, with looks of cordial love,*
*Hung over her enamoured*

Adam and Eve awake on the morning after Eve's dream of being tempted.

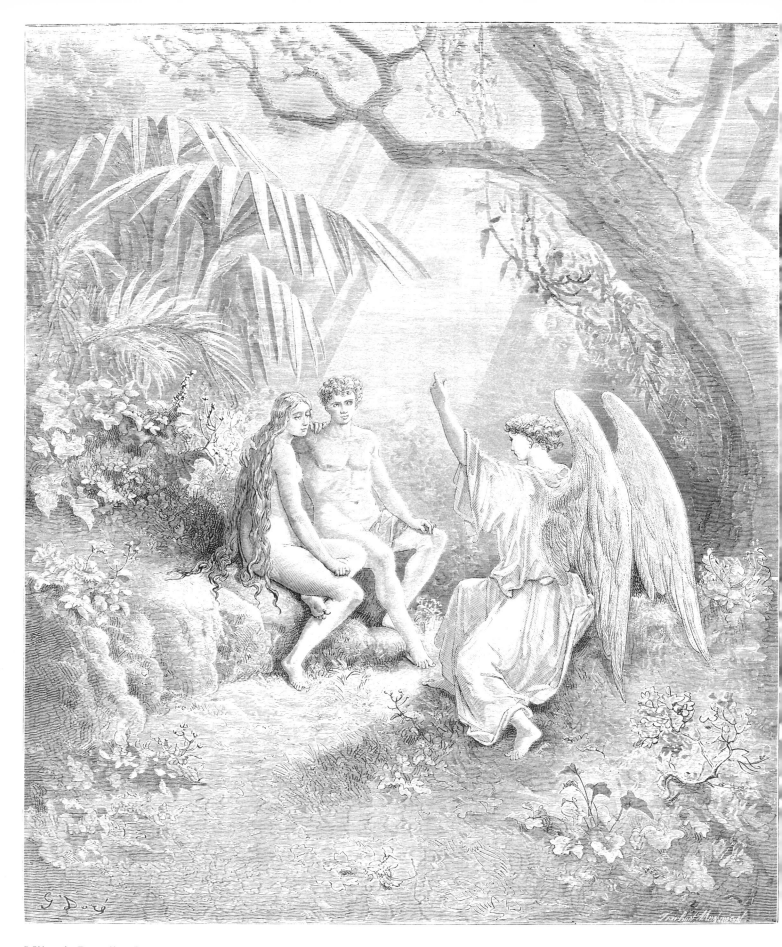

**Milton's Paradise Lost**
**Book V, lines 468–70**

      *To whom the winged Hierarch replied:*
*O Adam, one Almighty is, from whom*
*All things proceed*

Raphael joins Adam and Eve at breakfast and discourses on the nature of Heaven and the spirits inhabiting it.

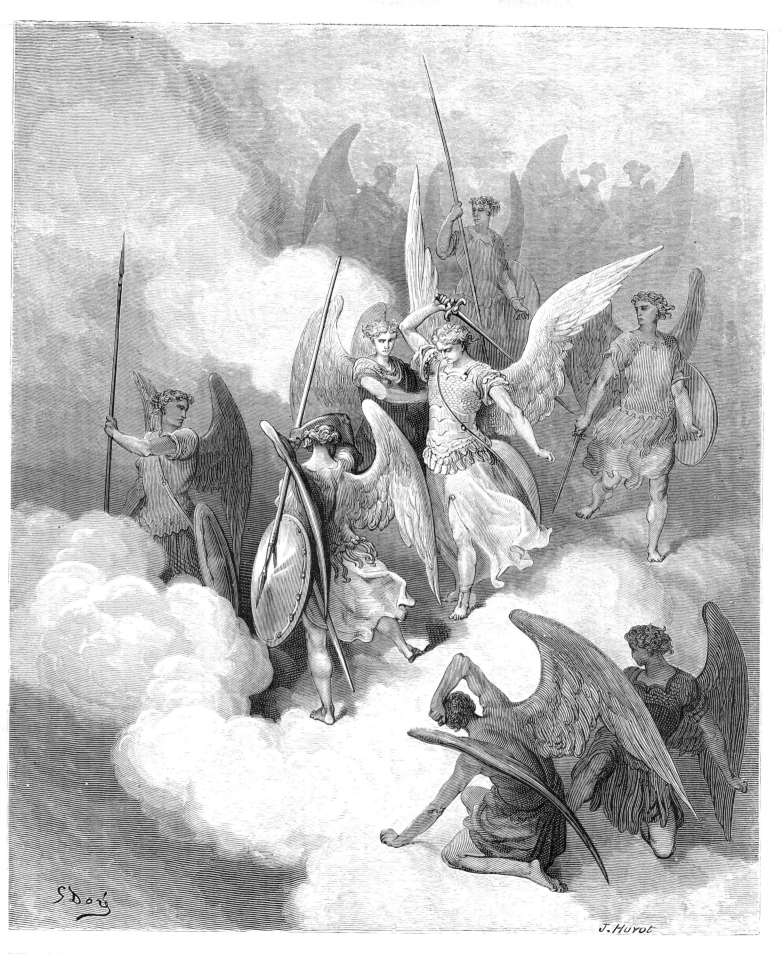

**Milton's Paradise Lost**
**Book VI, line 188**

*This greeting on thy impious crest receive*

Raphael tells Adam and Eve of how the angel Abdiel, refusing to join Satan's band of rebel angels, defies Satan and strikes him a mighty blow.

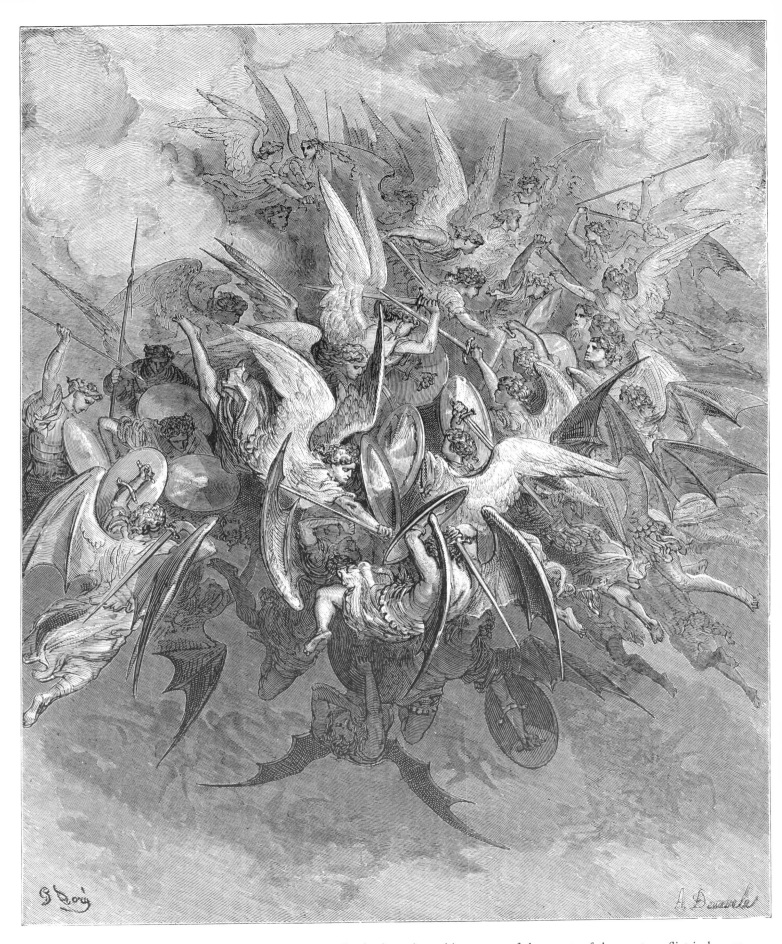

**Milton's Paradise Lost**

Raphael continues his account of the events of the great conflict in heaven.

**Book VI, lines 207–9**

*Now storming fury rose,*
*And clamour, such as heard in heaven till now*
*Was never.*

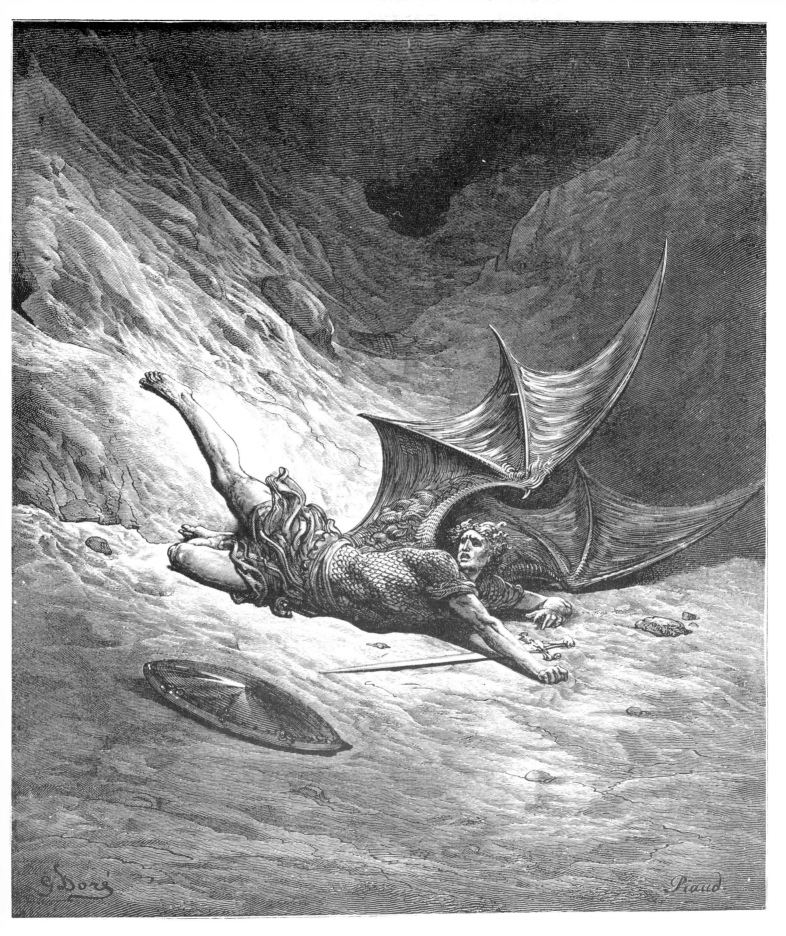

**Milton's Paradise Lost**

**Book VI, lines 327–8**

*Then Satan first knew pain,*
*And writhed him to and fro*

Satan, wounded in a bitter single combat with the angel Michaël, falls to the ground.

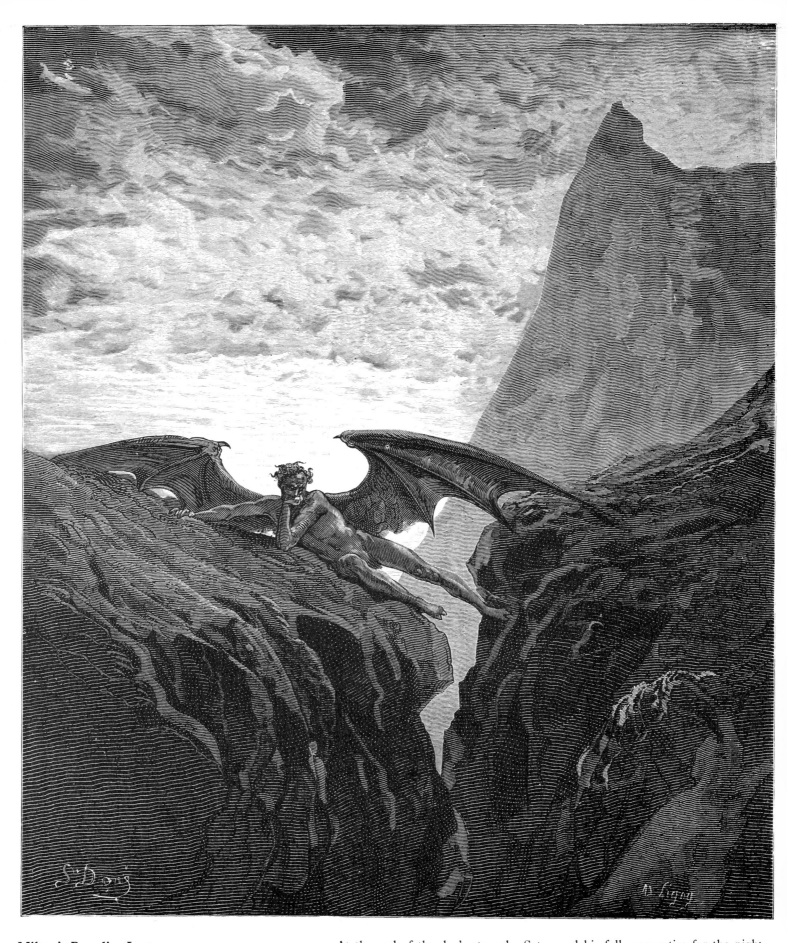

**Milton's Paradise Lost**

**Book VI, lines 406–7**

*Now night her course began, and over heav'n*
*Inducing darkness, grateful truth impos'd,*

At the end of the day's struggle, Satan and his followers retire for the night, to consider their plans for the morrow.

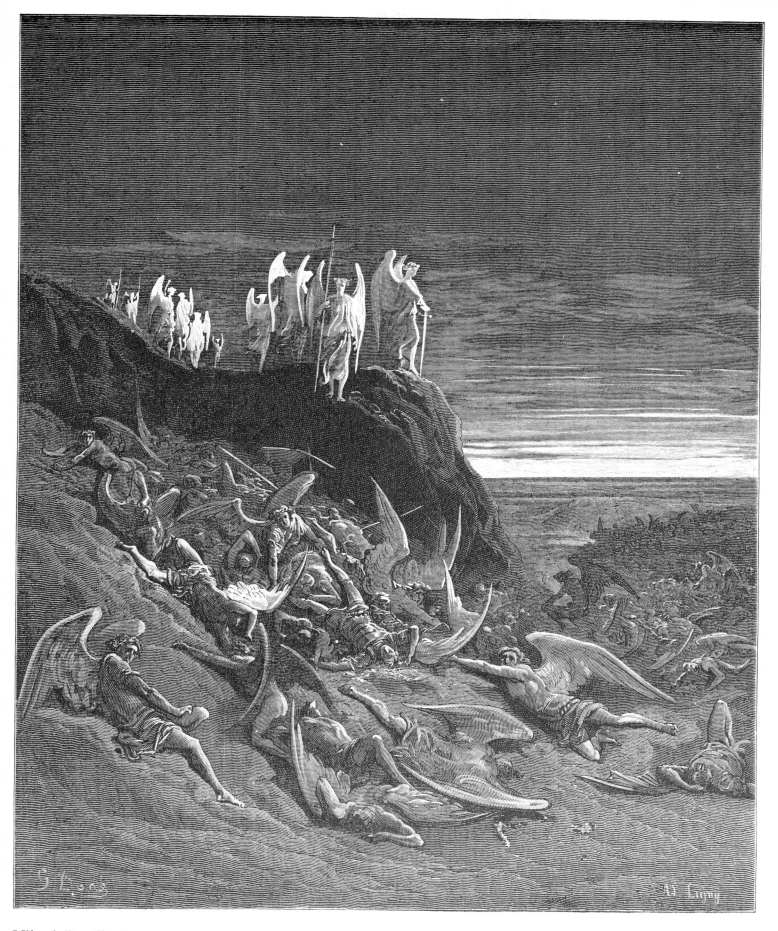

**Milton's Paradise Lost**

**Book VI, lines 410–12**

*On the foughten field,*
*Michaël and his angels prevalent,*
*Encamping, placed in guard their watches round,*

The loyal angels stand guard upon a mount, while the rebel angels lie in disorder in the valley.

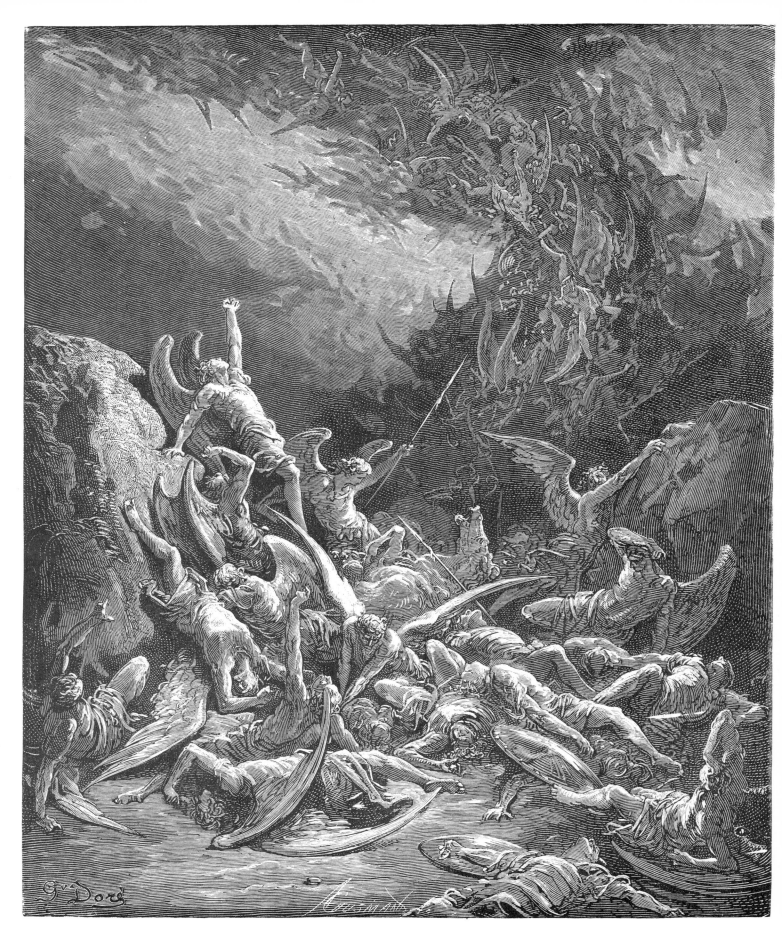

**Milton's Paradise Lost**

**Book VI, line 871**

*Nine days they fell*

The rebel angels are eventually defeated, and a breach opens in the wall of Heaven, disclosing a ghastly abyss below, from which they all shy away in horror. But, pursued by thunder and fire, they are forced to cast themselves headlong into the abyss.

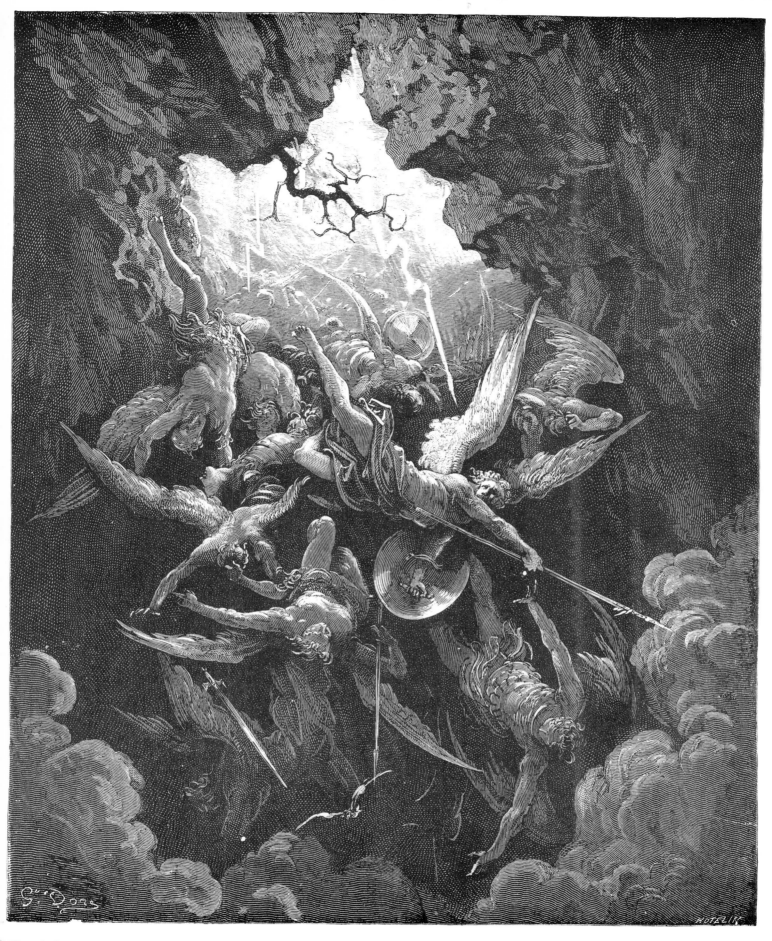

**Milton's Paradise Lost**
**Book VI, lines 874–5**

*Hell at last*
*Yawning, received them whole*

Falling through the breach in the wall of heaven, the rebel angels plunge down into Hell.

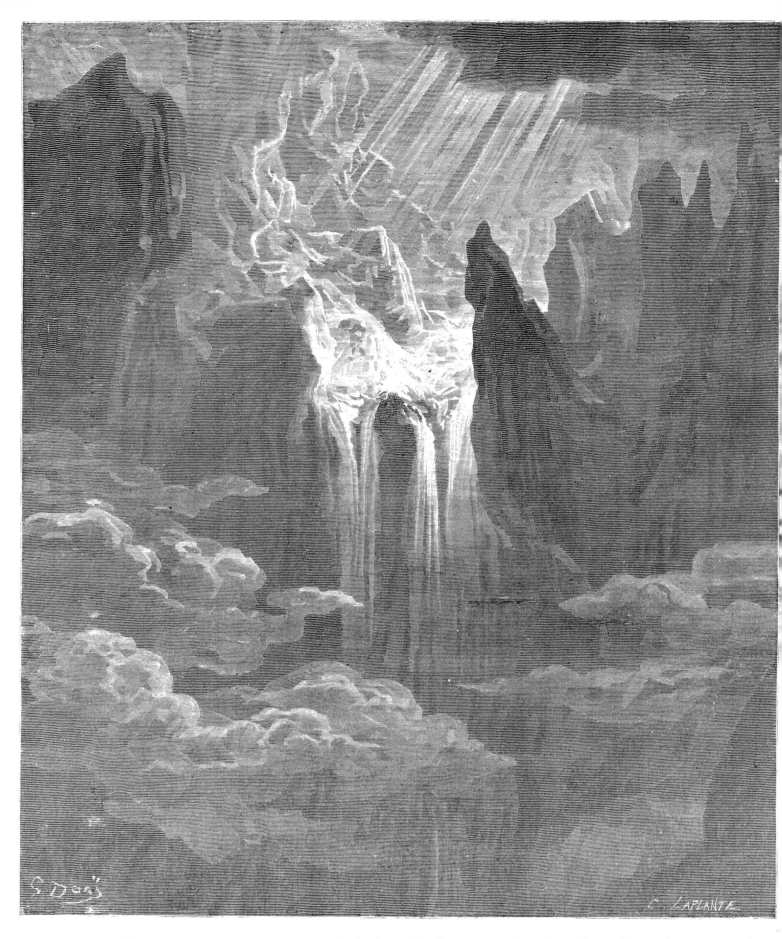

**Milton's Paradise Lost**

**Book VII, lines 298–9**

*Wave rolling after wave, where way they found;*
*If steep, with torrent rapture.*

Raphael, at Adam's request, relates how this world was first created, after Satan's expulsion from Heaven. This passage describes the gathering together of the waters at the creation.

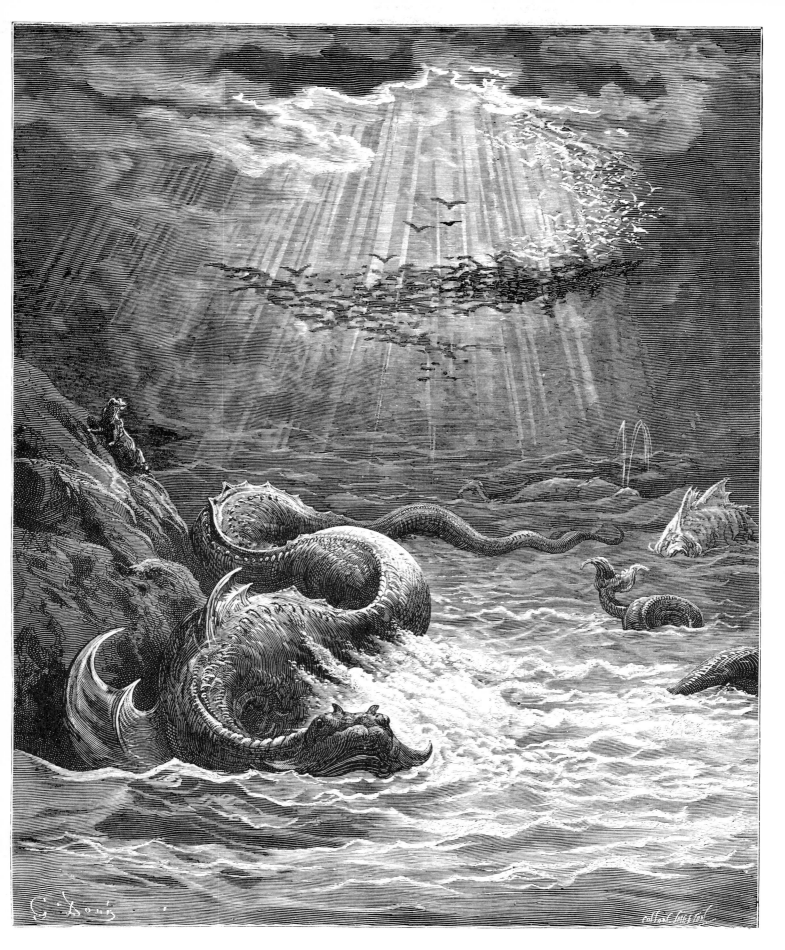

**Milton's Paradise Lost**

**Book VII, lines 387-9**

*And God said, Let the waters generate*
*Reptile with spawn abundant, living soul;*
*And let fowl fly above the earth,*

Raphael describes the creation of the fishes

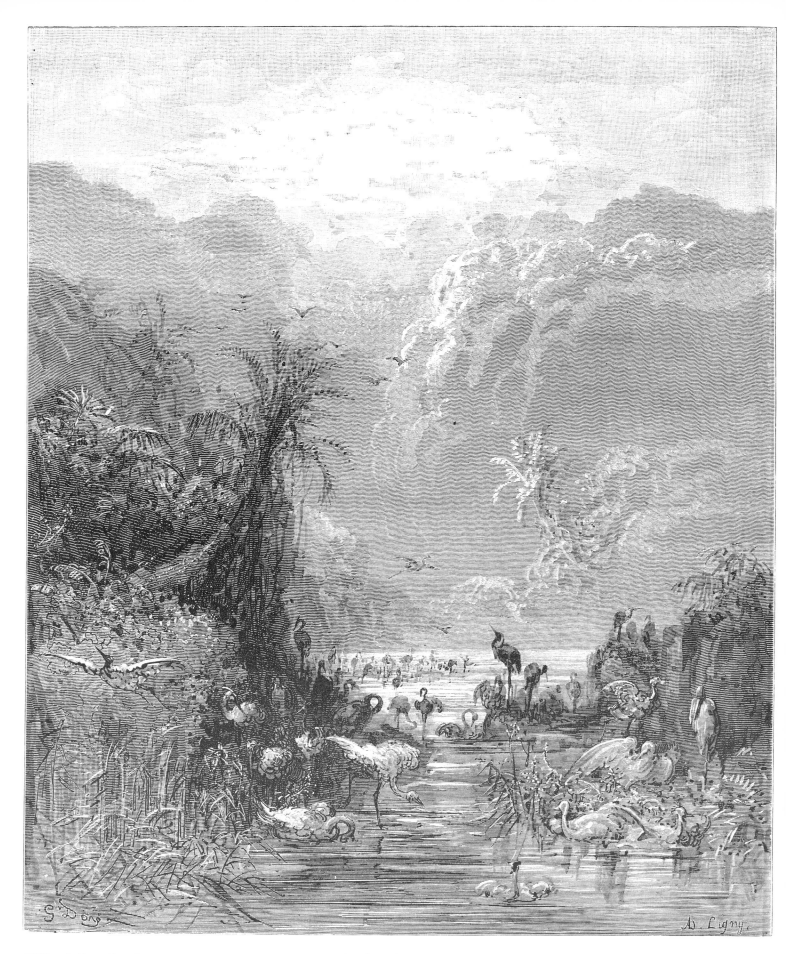

**Milton's Paradise Lost**

**Book VII, lines 417–18**

*Meanwhile the tepid caves, and fens, and shores,*
*Their brood as numerous hatch.*

Raphael describes the creation of the birds.

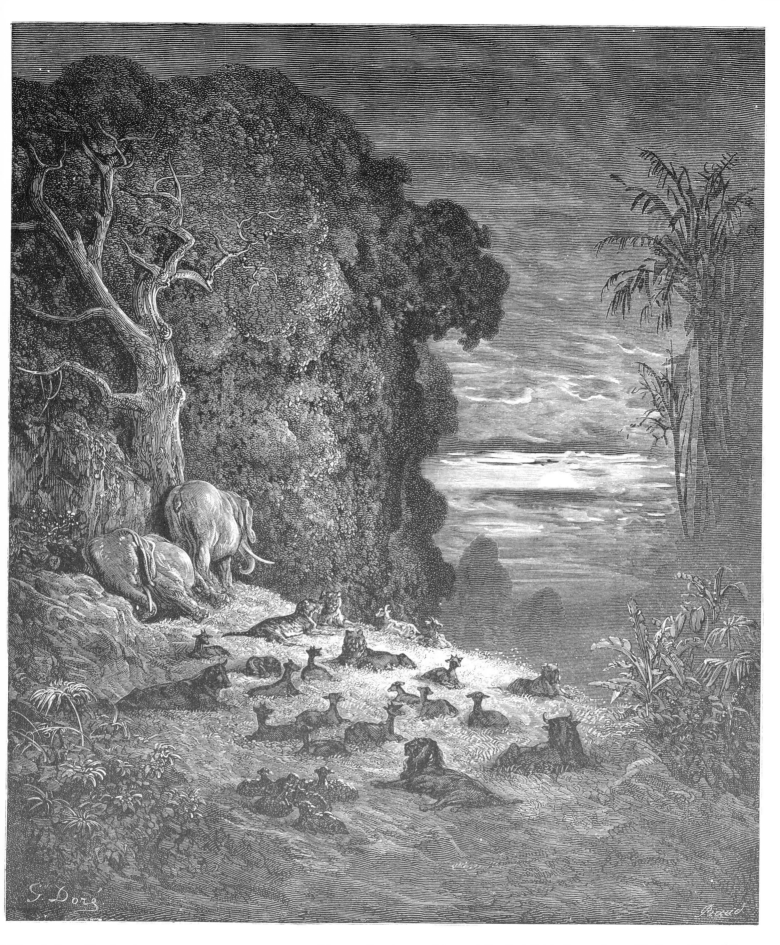

**Milton's Paradise Lost**

**Book VII, lines 581–2**

> And now on earth the seventh
> Evening arose in Eden,

The creation is complete, and the first Sabbath evening, with the setting of the sun, begins.

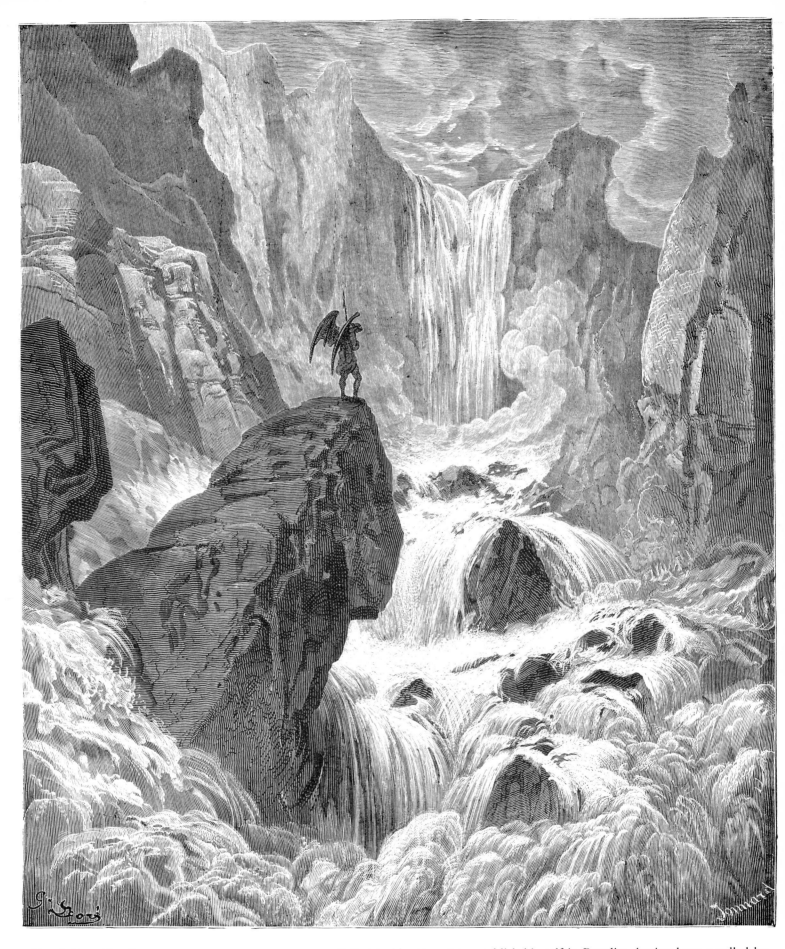

**Milton's Paradise Lost**

**Book IX, lines 74–5**

*In with the river sunk, and with it rose,*
*Satan*

Foiled in his attempt to establish himself in Paradise, having been repelled by Gabriel, Satan decides to try again. He chooses as his means of entrance "Tigris, at the foot of Paradise", a river which goes underground and emerges by the Tree of Life. Here we see him just before he plunges in.

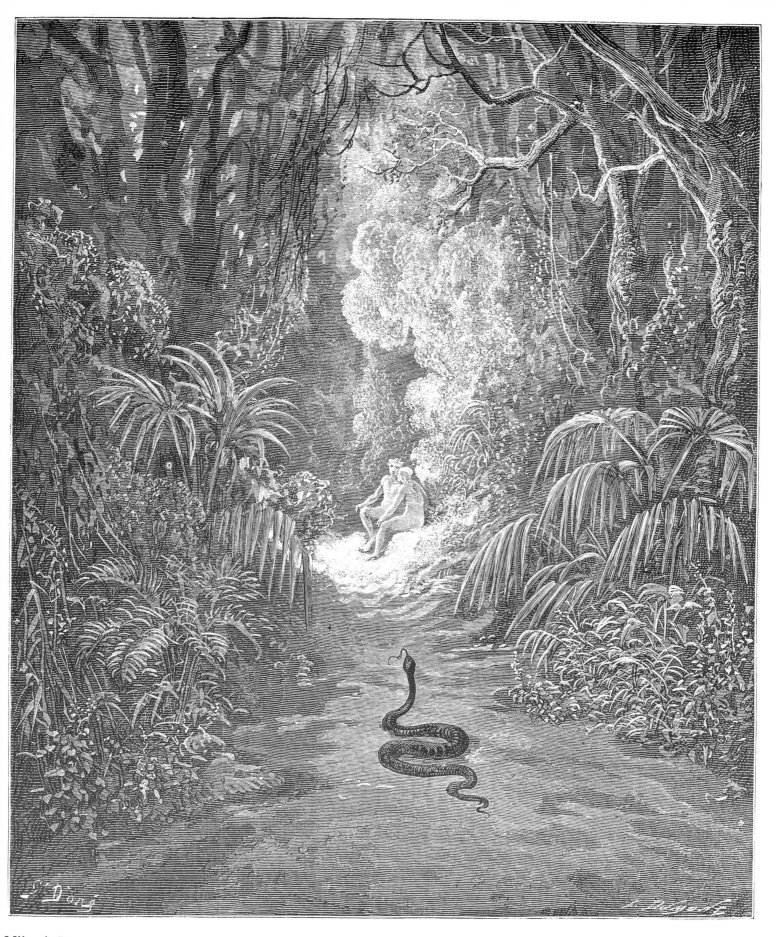

**Milton's Paradise Lost**

**Book IX, lines 434–5**

*Nearer he drew, and many a walk travers'd*
*Of stateliest covert, cedar, pine or palm;*

Once in Paradise, Satan assumes the form of a serpent and sets out to look for Eve.

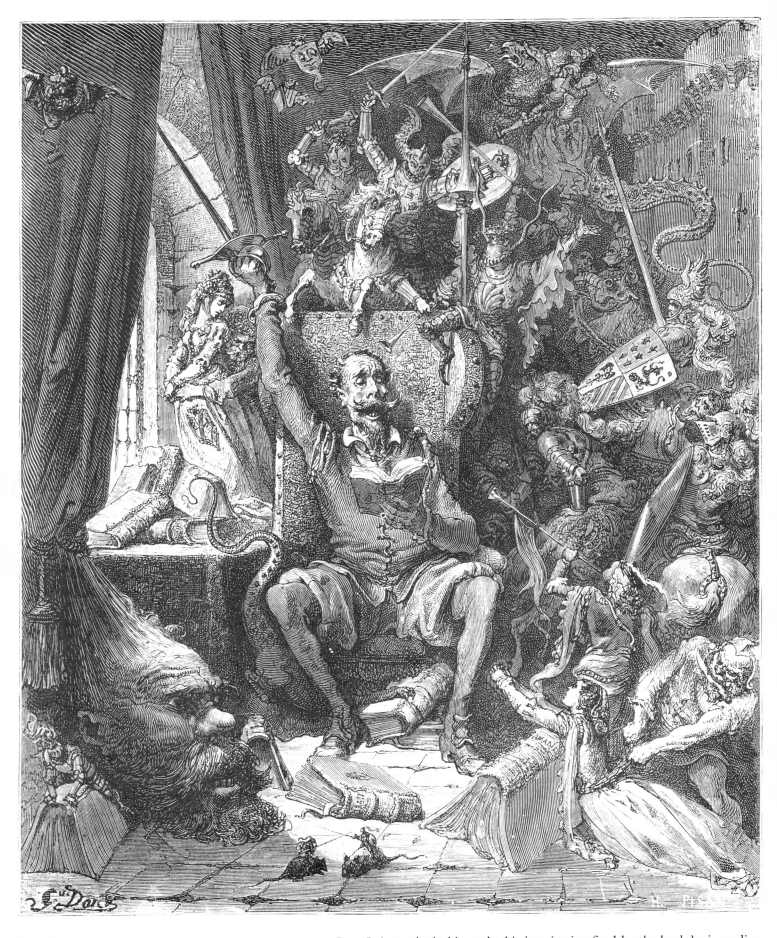

**Don Quixote**

Don Quixote sits in his study, his imagination fired by the book he is reading, and surrounded by the phantoms of his daydreams—battling knights, distressed damsels, dragons and all.

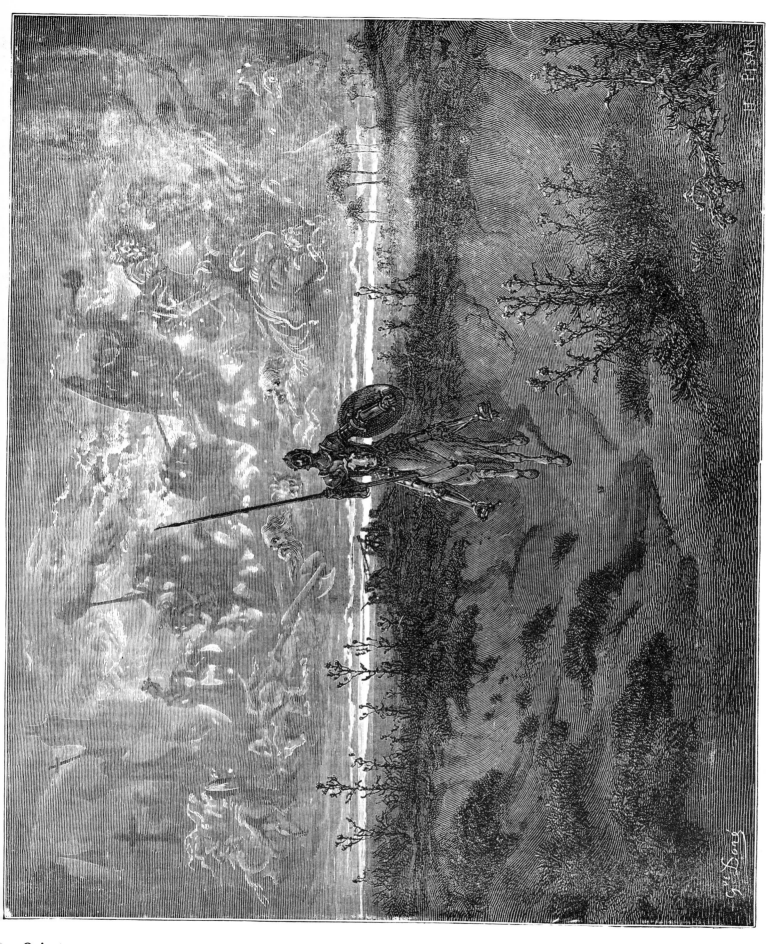

**on Quixote**

The Don sets out for the first time on his adventures. The stormy sky takes the shape of his dreams of the great deeds of chivalry that he will do.

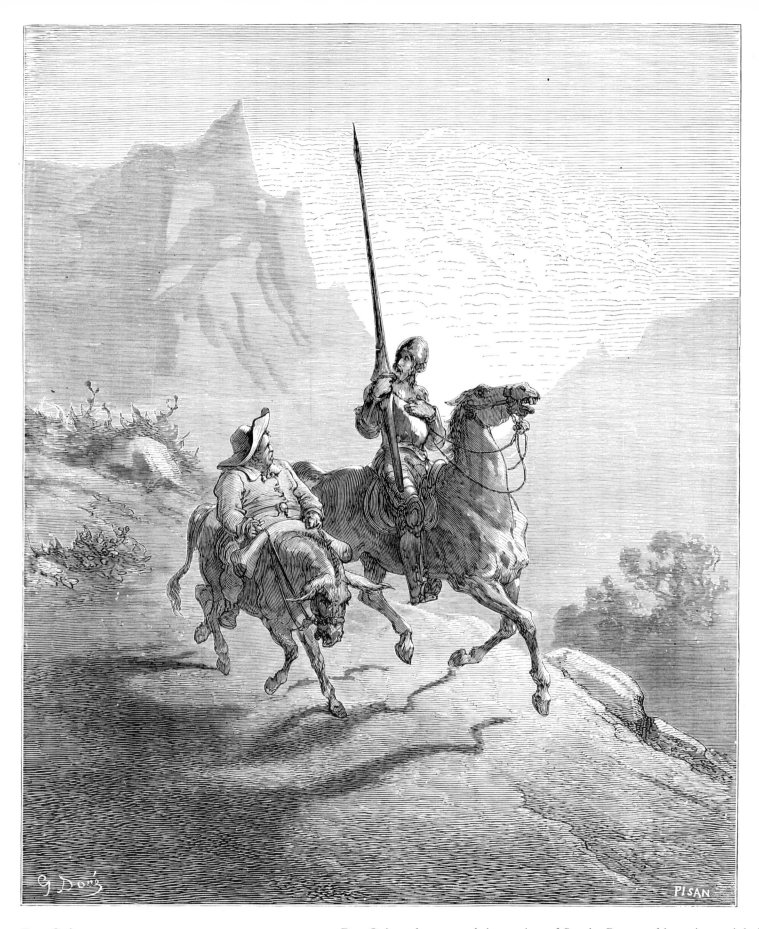

**Don Quixote**

Don Quixote has secured the services of Sancho Panza as his squire, mainly [
suggesting that some lucky adventure may bring him the governorship of a
island. Sancho Panza is taken in by this munificent yet absurd offer, and the
set out together at dawn.

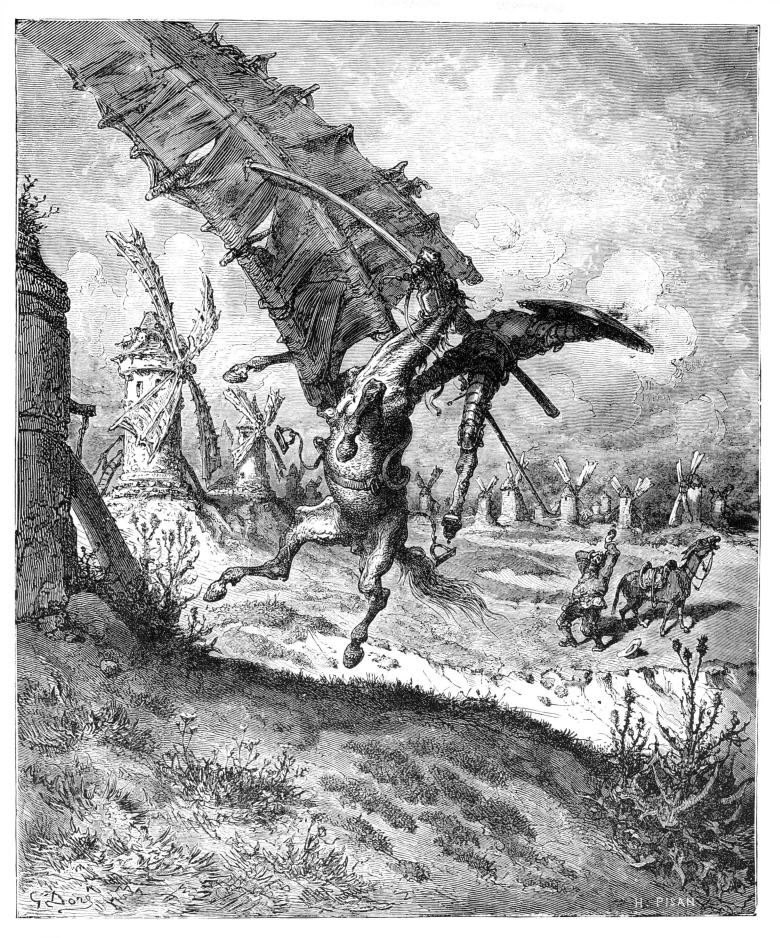

**Don Quixote**

Seeing what he imagines are some giants before him, Don Quixote charges full-tilt at them, despite Sancho Panza's assertion that they are not giants, but windmills. The outcome is disastrous.

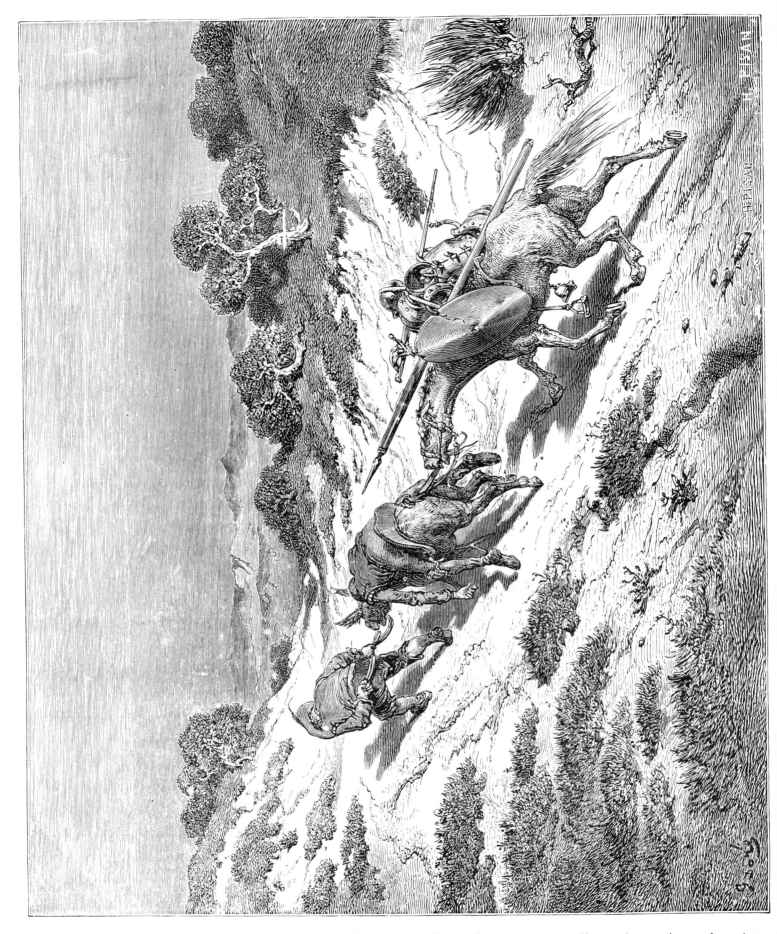

**Don Quixote**

The Don and Sancho Panza meet some Yanguesian carriers and get into a fight with them, but are so badly beaten that for a while they are unable to move. After a while Sancho gets up, puts his master on his own donkey, fastens the battered Rozinante to its tail, and plods off towards the nearest town.

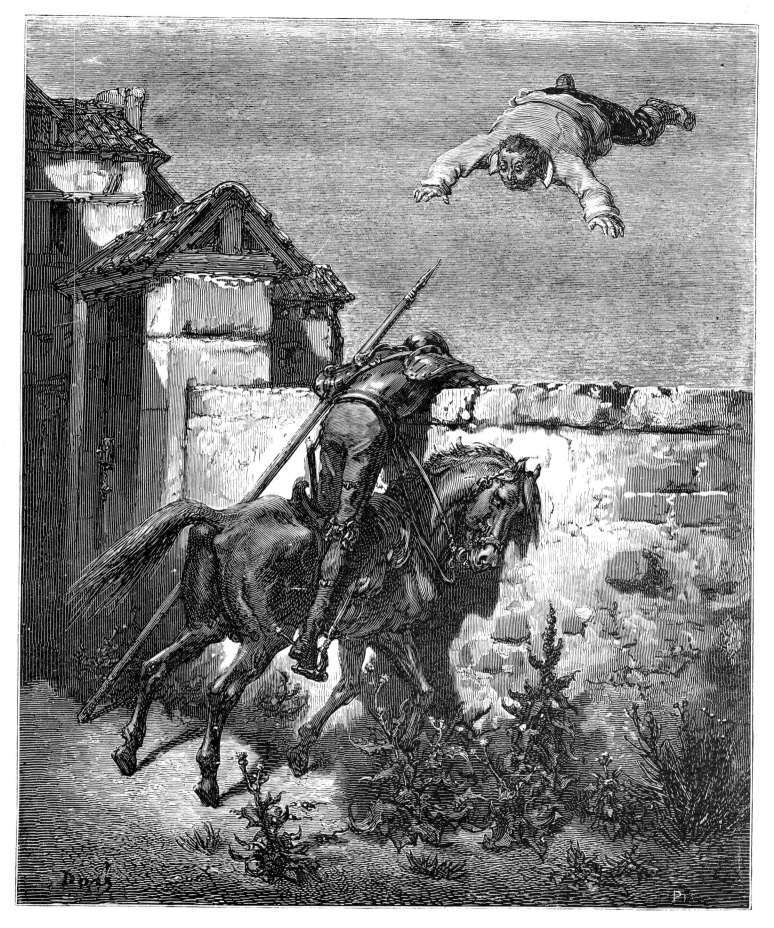

**Don Quixote**

After leaving an inn (which he had mistaken for a castle) Don Quixote notices that Sancho Panza is not with him. When he returns to the inn he finds Sancho being tossed in a blanket in the yard.

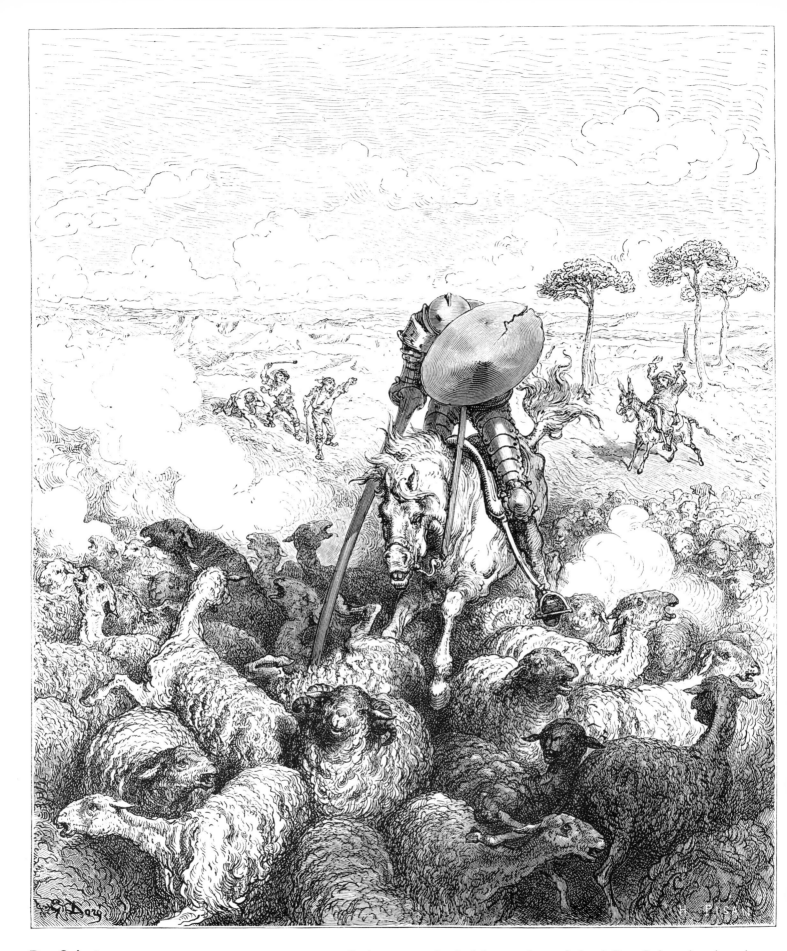

**Don Quixote**

Seeing a great cloud of dust on the road ahead, Don Quixote imagines that an army is approaching, despite Sancho's assurance to the contrary, and charges into what turns out to be a flock of sheep. He lays several dead and wounded on the ground, but is rewarded for his valour by a terrible stoning from the shepherds.

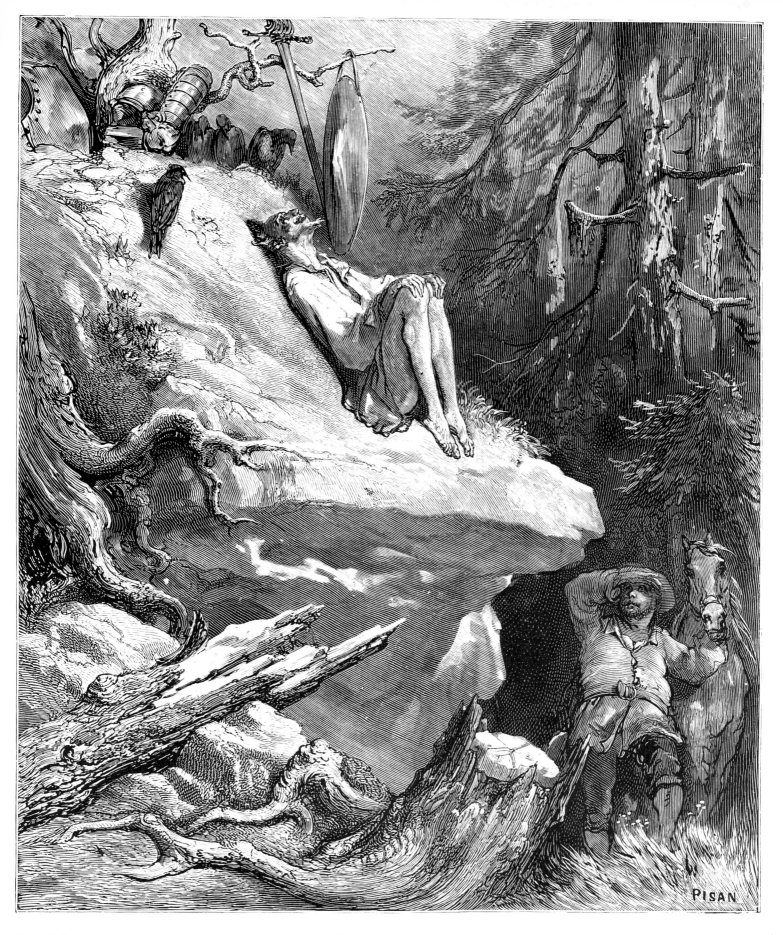

**Don Quixote**

Sancho Panza, having left Don Quixote on his own for a little while, returns to find him sitting among the rocks in his shirt, thin and pale, sighing for his Lady Dulcinea and proclaiming that he will never set eyes on her again until he has done some feats that will make him worthy of her.

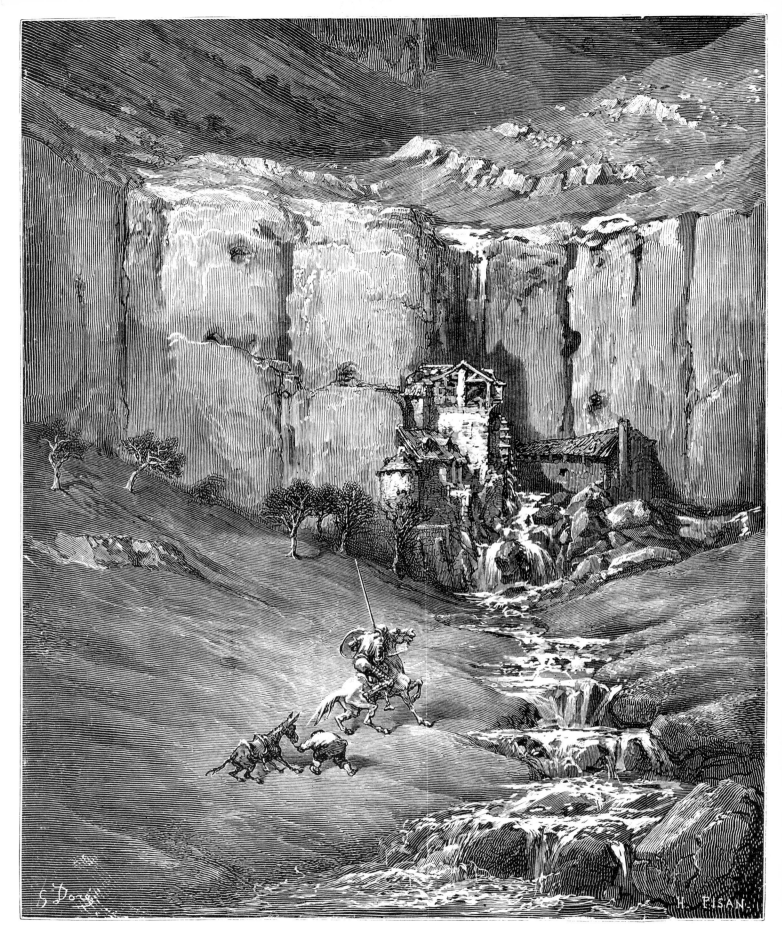

**Don Quixote**

While wandering in a lonely, wooded area Don Quixote and Sancho Panza hear a tremendous roaring, thumping and rattling. Sancho is frightened, Don Quixote jubilant at the prospect of an adventure, but on investigation the noise turns out to be coming from the huge hammers of a fulling mill. Sancho finds this anti-climax funny, but the Don is most upset and gives him a hiding for laughing at him.

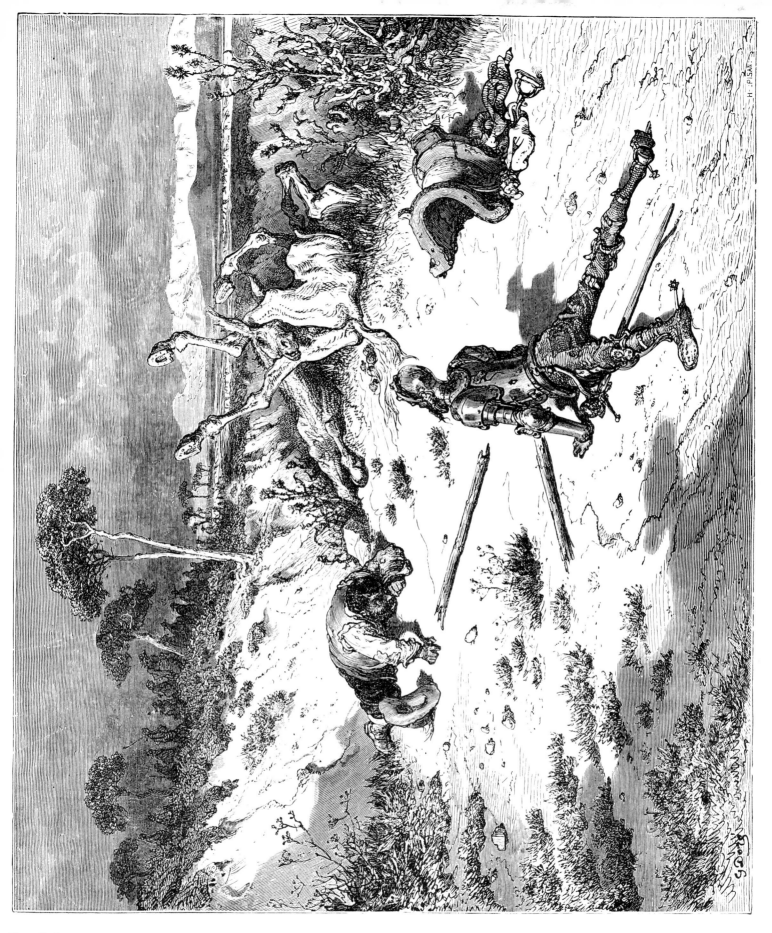

**Don Quixote**

After the adventure of the fulling mills Don Quixote and Sancho Panza come upon a train of fettered criminals being led off to serve as galley slaves. The Don demands their release, and when this is refused, attacks and routs the officers in charge. The liberated prisoners then turn on their liberators and take all their possessions. Afterwards, battered, Don Quixote observes, "to do a kindness to clowns is like throwing water into the sea."

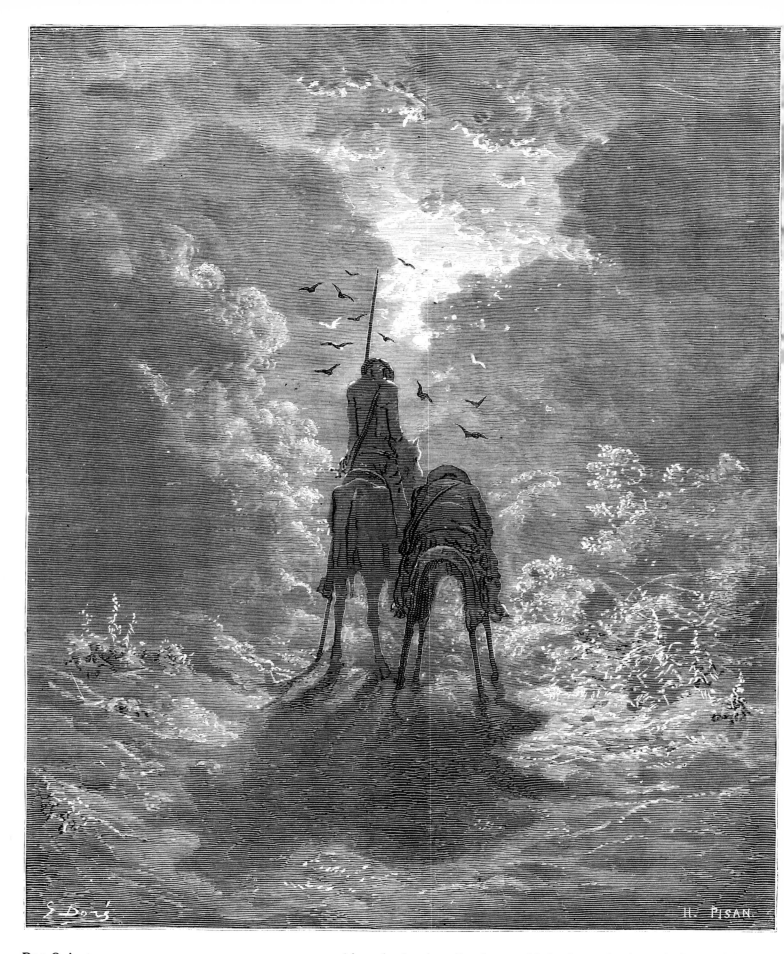

**Don Quixote**

After releasing the galley slaves and being beaten by them, the Don and Sancho slink into a wood where, exhausted, they fall asleep. During the night a thief leads Sancho's ass away from under him, leaving Sancho supported by four stakes. When he stirs, the props tumble and Sancho falls.

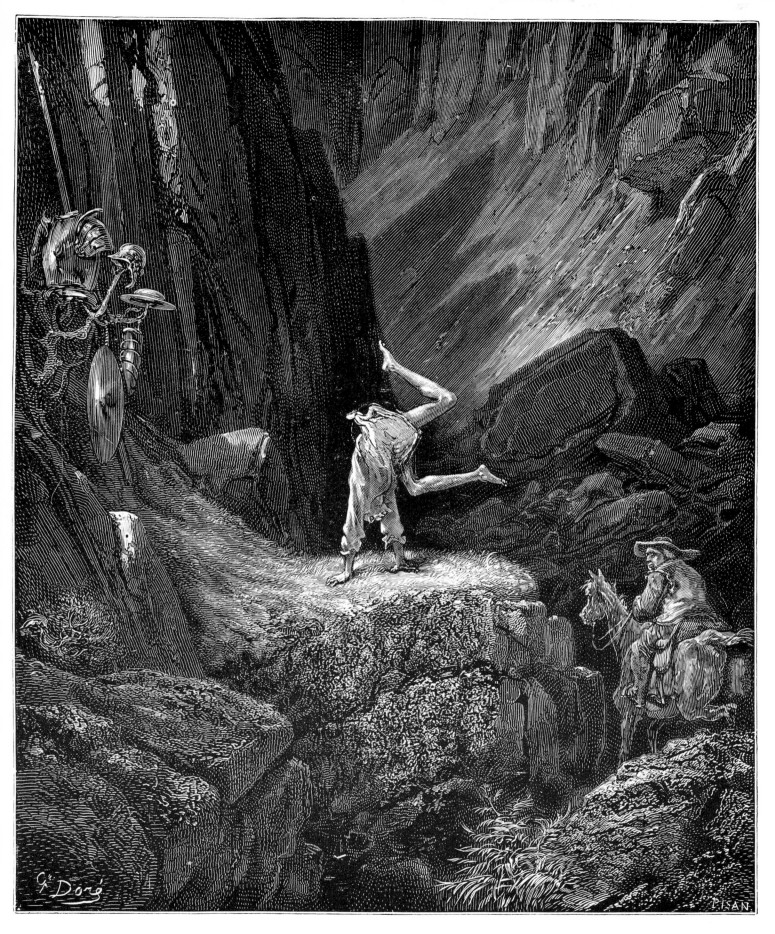

**Don Quixote**

Taking as his model the celebrated knights, Amadis of Gaul and Orlando Furioso, who "committed a hundred thousand extravagances", Don Quixote elects to show his passion for the lovely lady Dulcinea by behaving like a madman for a little while. The performance has begun.

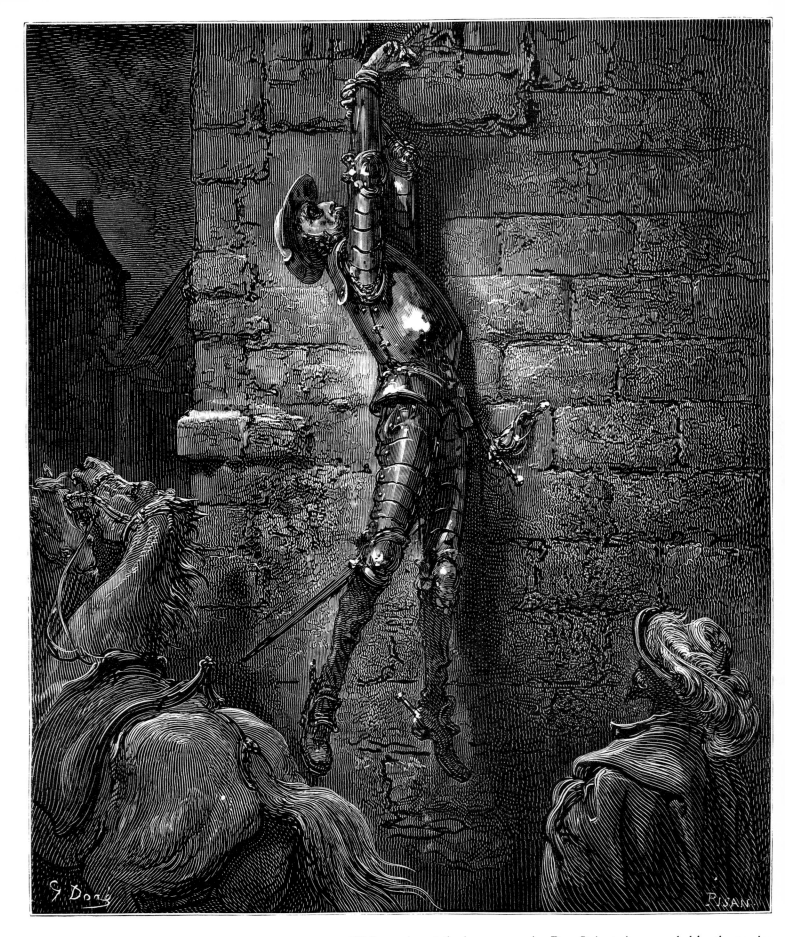

**Don Quixote**

While staying at the inn once again, Don Quixote is persuaded by the serving-maid Maritornes to wait outside a small window, where his hand will be kissed by a lady deeply enamoured of him. He stands on his horse Rozinante to reach the window, and Maritornes slips a rope around his wrist. She runs off laughing, while he believes himself trapped by the spells of a wicked magician. He becomes even more unhappy when Rozinante moves, leaving him dangling.

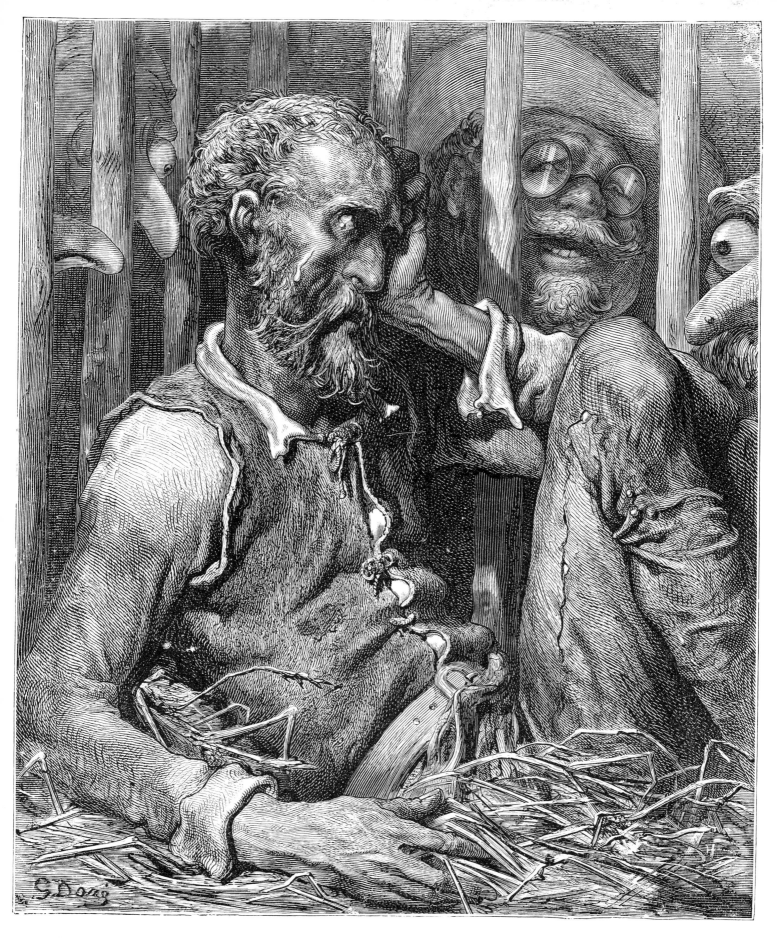

**Don Quixote**

The Don is still convinced that the inn is a castle, and, moreover, that it is enchanted. This makes him behave so oddly that he is thought by all to be mad, and a plan is evolved for taking him home. They borrow some oxen and build a cage, then all disguise themselves with masks and clothing and enter the sleeping Don's room. When they grab him he awakes and, seeing grotesque figures all around, believes himself enchanted once more. They then bundle him into the cage and send him off, still in a daze.

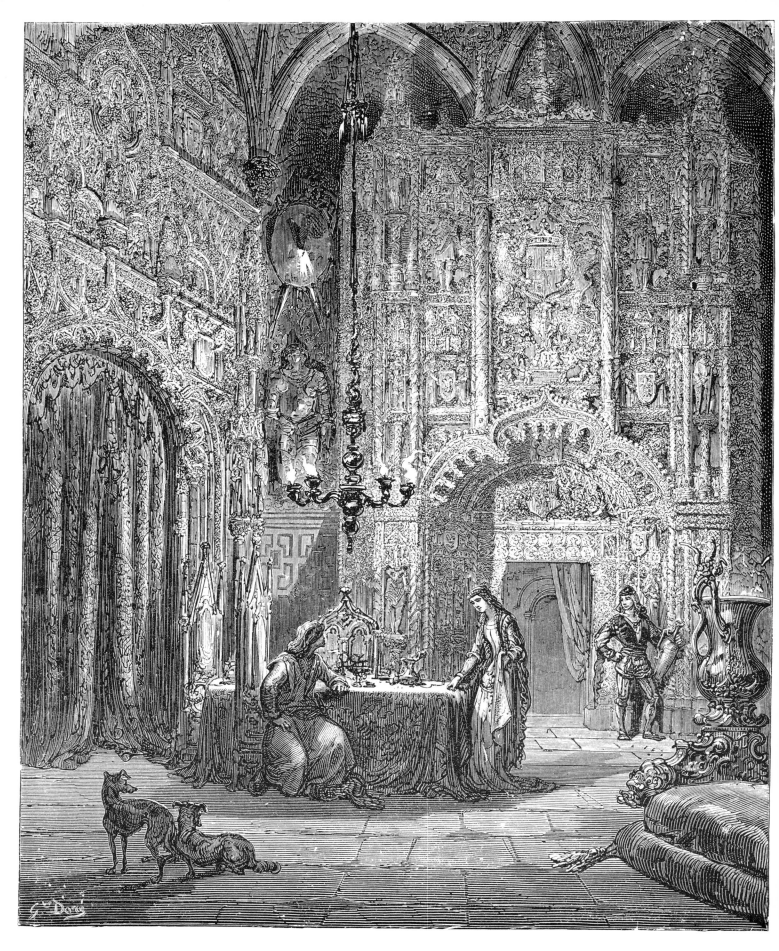

**Don Quixote**

The Don, arguing with a canon who disputes the authenticity of books of chivalry, gets very excited and insists on the delightfulness as well as truth of such stories, citing a typical adventure involving an enchanted castle at the bottom of a lake, a lovely damsel imprisoned in it by magic, and her valiant champion. Here, then, is the enchanted castle he describes.

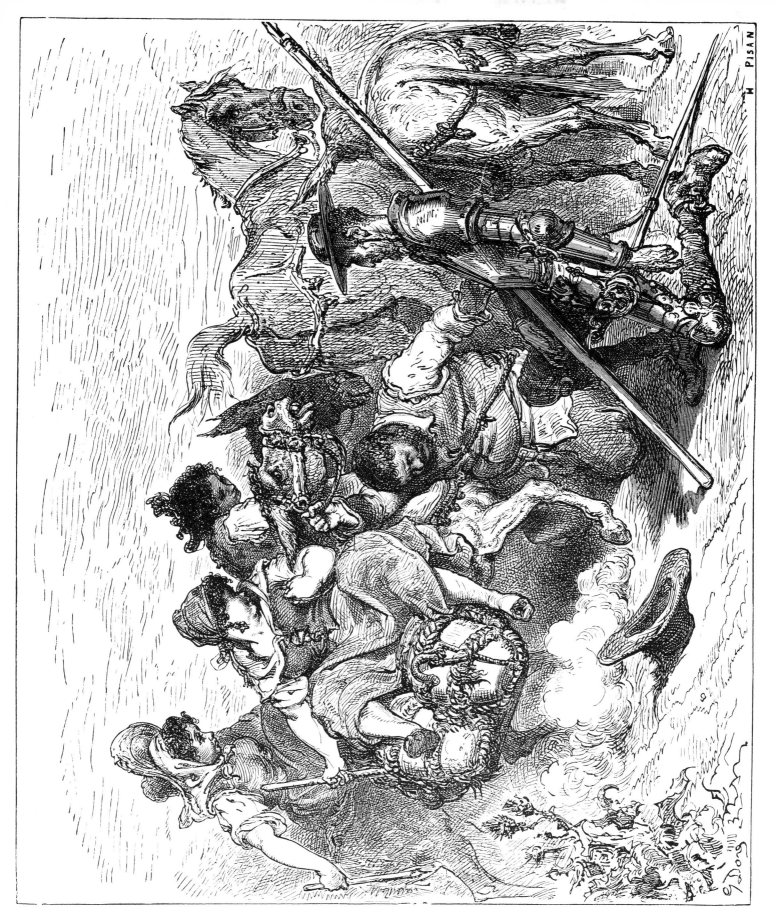

**Don Quixote**

Sancho decides to play a trick on his master by persuading him that the first country wench they meet is the lovely lady Dulcinea. When three girls on asses approach, Sancho claims so positively that the leading one, with a fat and coarse face, is Dulcinea, that the Don kneels before her, though eyeing her dubiously and disconsolately, and supposes that Dulcinea has thus been transformed by an evil magician.

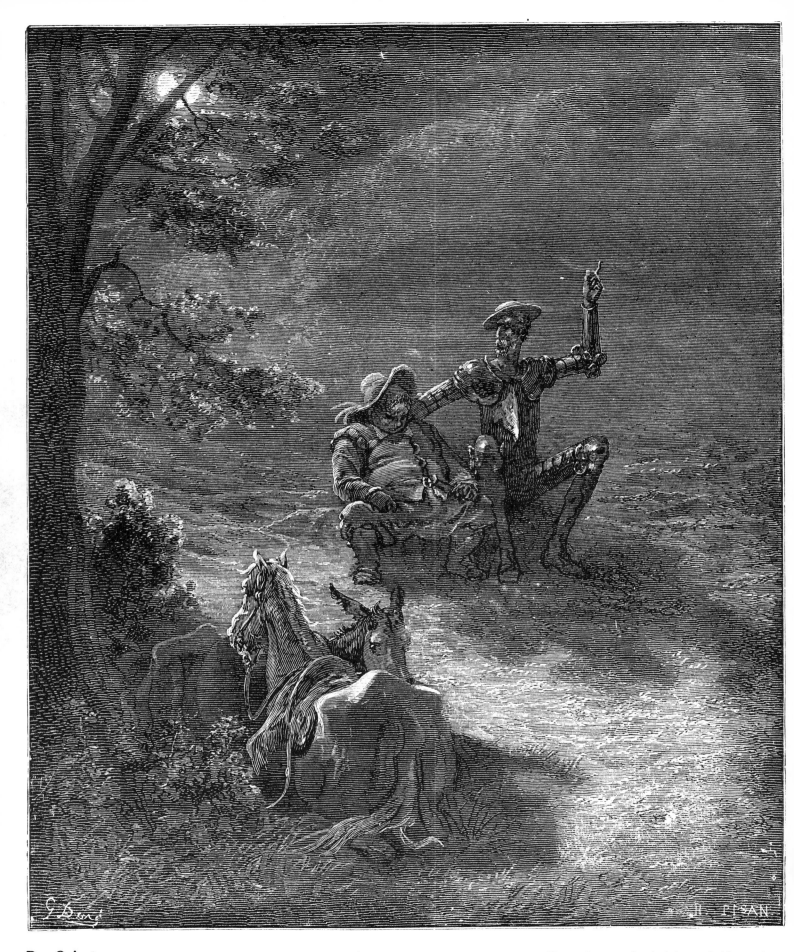

**Don Quixote**

After an encounter with some strolling players, the knight and his squire compose themselves for the night, and discuss the arts of play-writing and acting. Don Quixote draws a comparison between actors, who don all sorts of costumes and roles, but after the play are all equal, and the society of man, in which all play various parts, till death finds them and levels their quality in the grave.

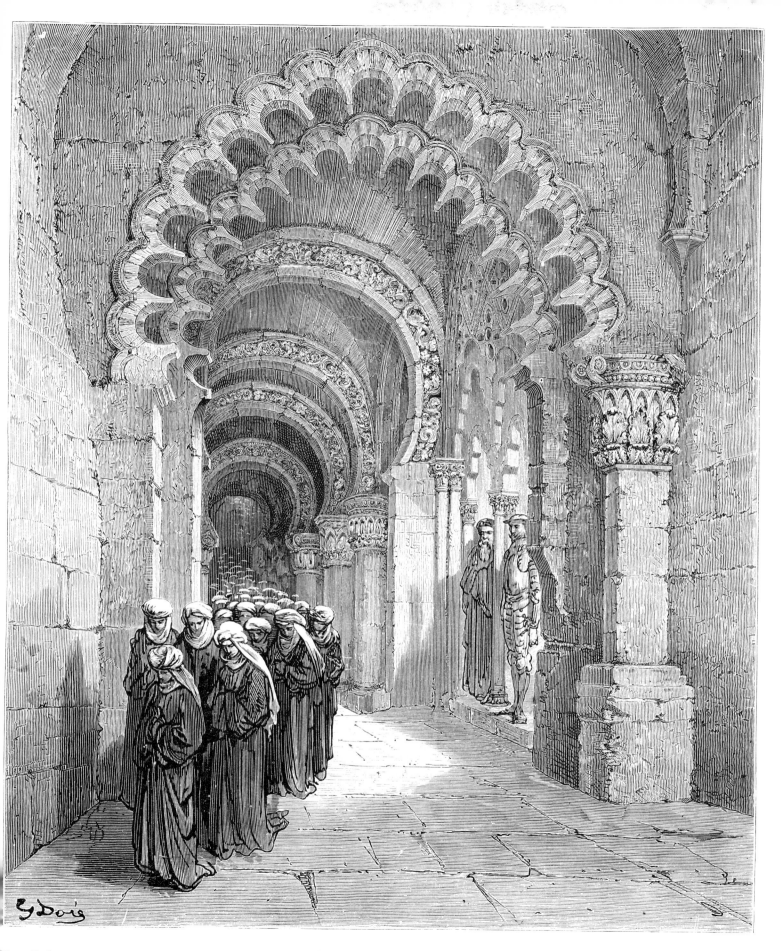

**Don Quixote**

In the enchanted palace in the Cave of Montesinos, Don Quixote watches a procession of damsels attending on Belerma, mistress of the hero Durandarte, who died in Montesinos' arms at the battle of Roncesvalles, as she laments her lover's death.

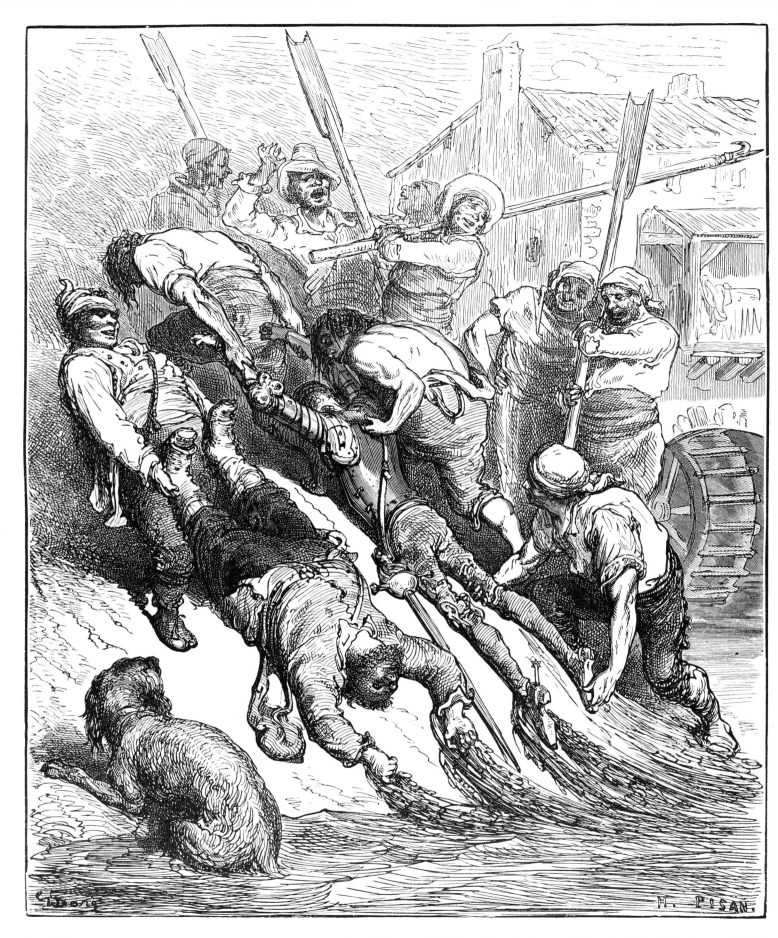

**Don Quixote**

On the banks of the Ebro Don Quixote and Sancho find a little boat, which the Don imagines has been left there by an enchanter to carry him to the aid of a knight in danger. Sancho is sceptical, but they embark and are carried downstream till they see two huge watermills. Don Quixote thinks these are castles where perhaps lies the imperilled knight, or lady, or whatever. The millers shout in warning, but the Don cruises on till they stop the boat with poles, within an ace of it being smashed to pieces by the waterwheels. Don Quixote and Sancho Panza are tipped into the river and unceremoniously dragged out by the angry millers.

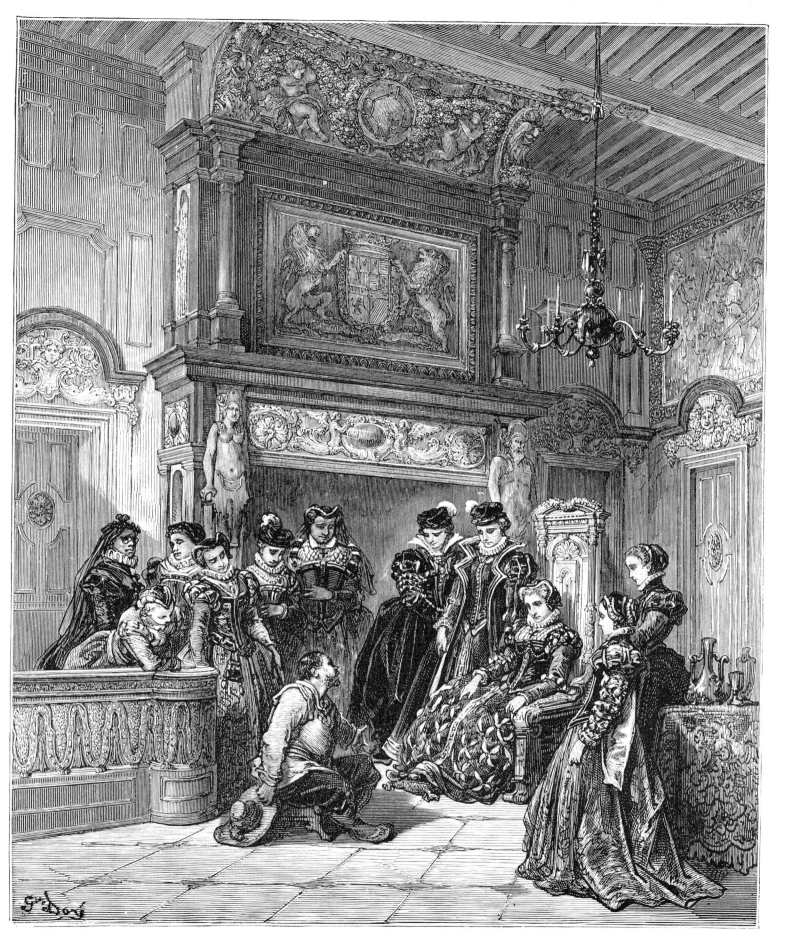

**Don Quixote**

Having made the acquaintance of a great duchess, Don Quixote stays some time at her house with Sancho; and one afternoon, while the knight is asleep, Sancho, at the duchess's request, tells her the story of the pretended enchantment of Dulcinea.

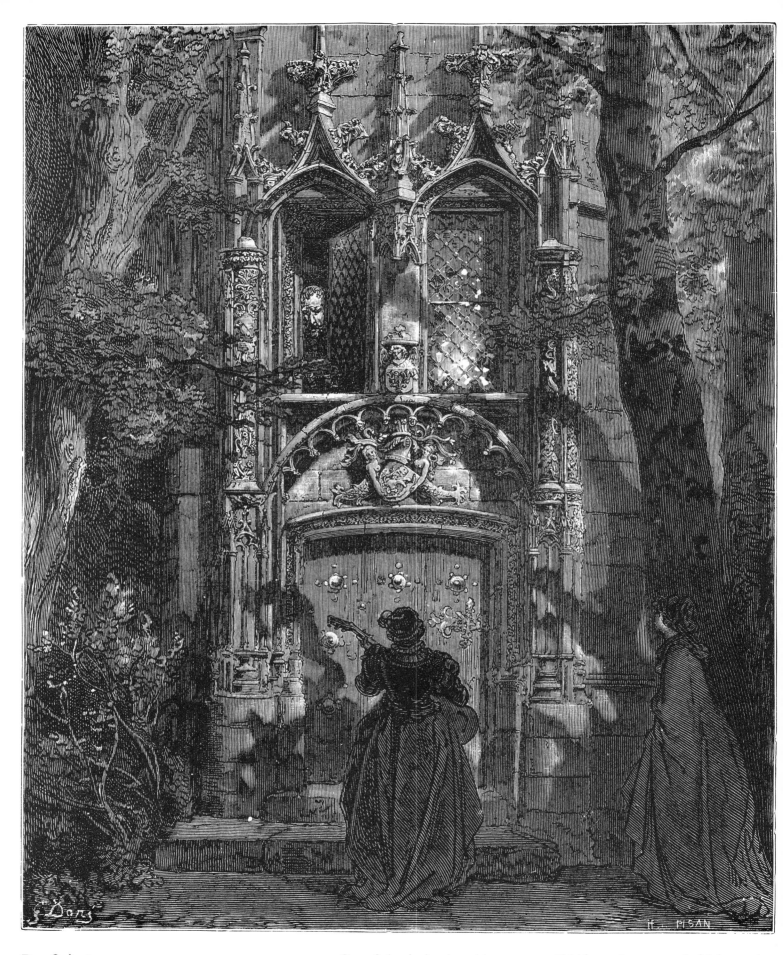

**Don Quixote**

One of the duchess's waiting women, Altisidora, plays a practical joke on the Don. Having heard him talk so much of the lady Dulcinea, she decides to test his fidelity by serenading him and singing of her love for him. Don Quixote, at the window of his chamber, wavers for a moment, but his love wins through.

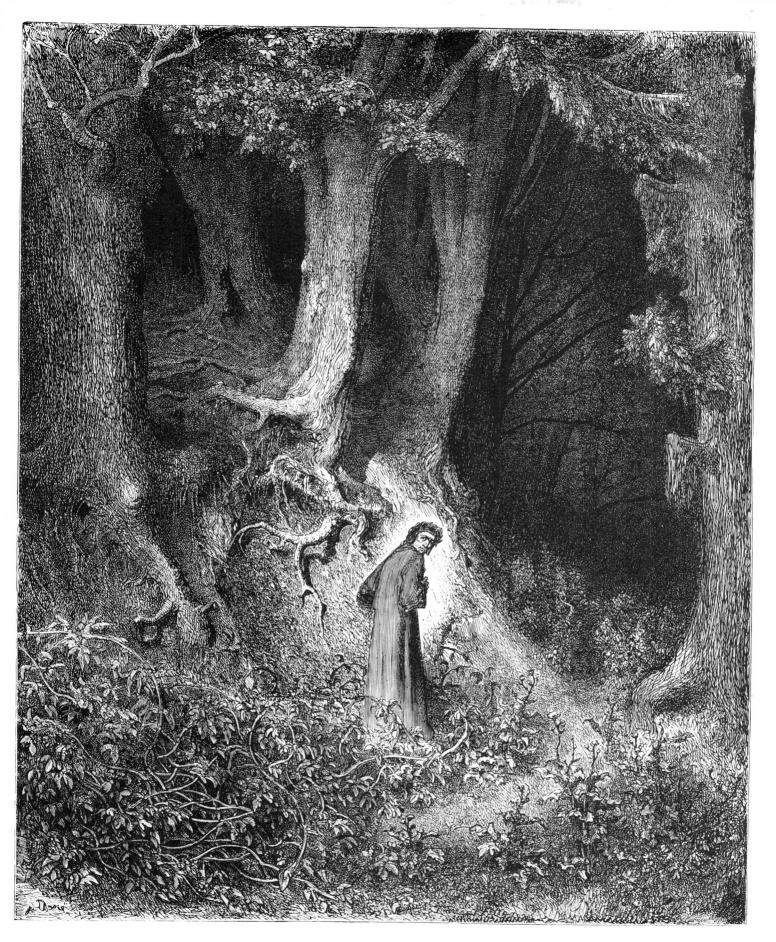

**Dante's Inferno**

**Canto I, lines 1–2**

*In the midway of this our mortal life,*
*I found me in a gloomy wood, astray.*

Dante, having "gone from the path direct", finds himself in a wild forest. Here he encounters many wild beasts, but is protected from them by the shade of Virgil and is helped on his way to Paradise by the Spirit of Beatrice.

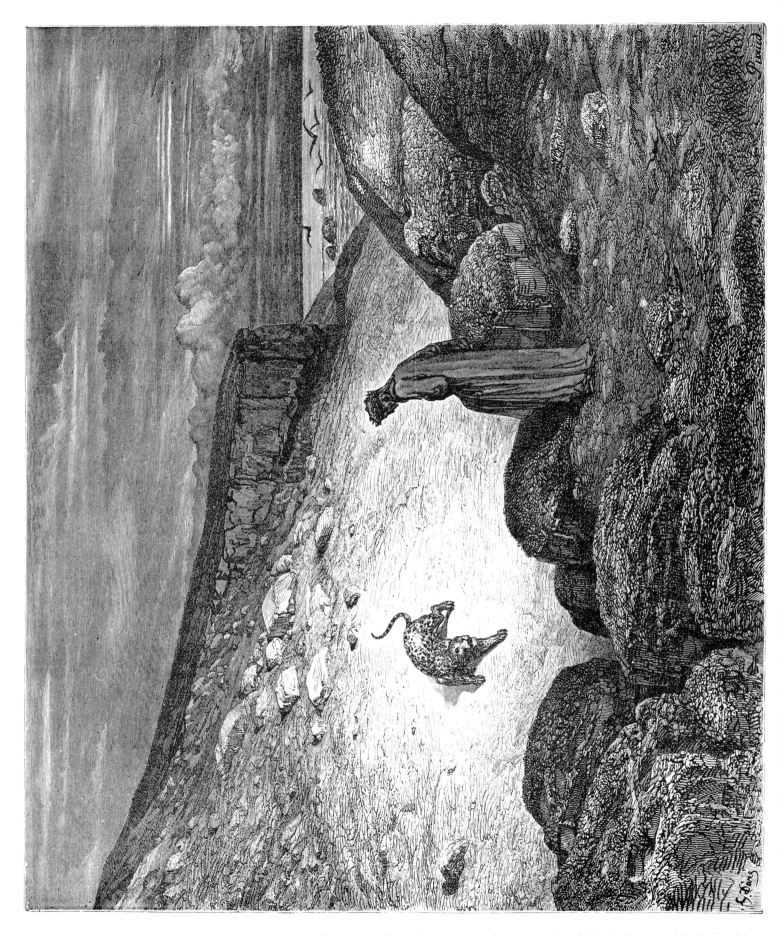

**Dante's Inferno**

**Canto I, lines 29–32**

*Scarce the ascent*
*Began, when lo! a panther, nimble, light,*
*And cover'd with a speckled skin, appear'd;*
*Nor, when it saw me, vanish'd.*

Dante is still in the same ghostly country in which he first met Virgil. In this scene his way is barred by a panther, also a symbol of pleasure or luxury.

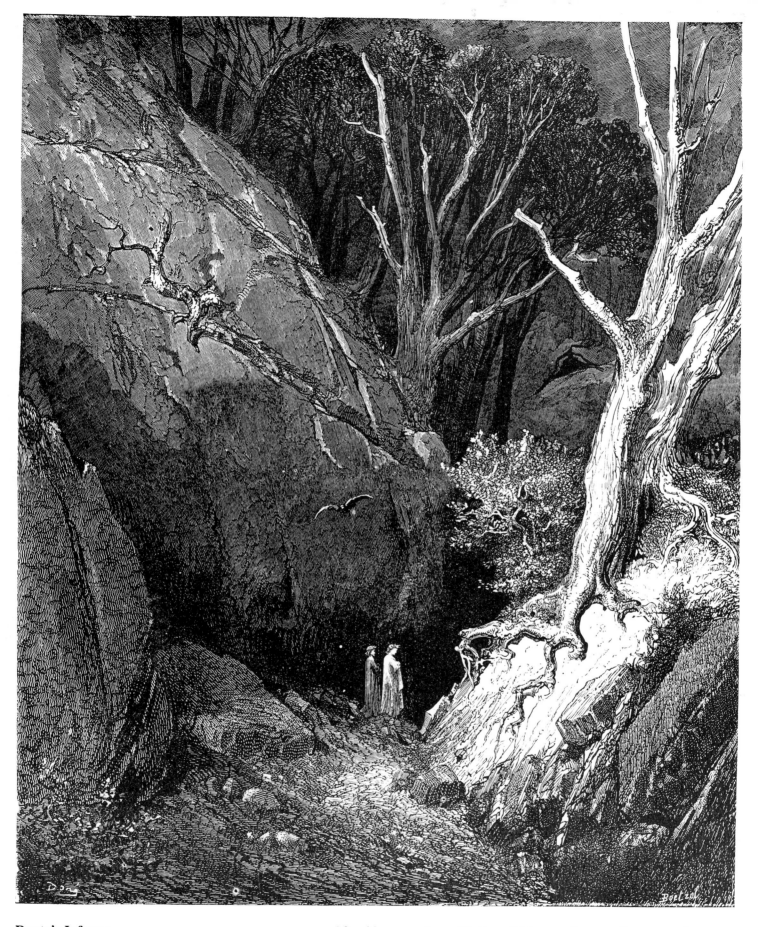

**Dante's Inferno**

**Canto I, line 132**

*Onward he moved, I close his steps pursued.*

After his encounters with the wild beasts, Dante calls out to what appears to be a man approaching. It is the shade of Virgil, who proposes to guide him through Hell and Purgatory.

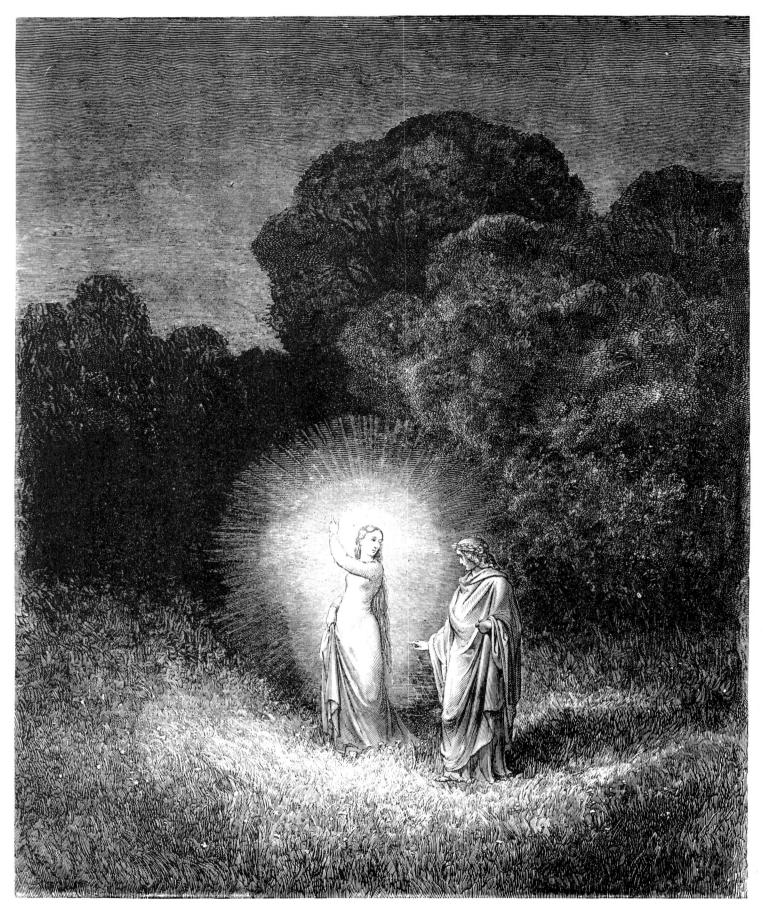

**Dante's Inferno**

**Canto II, lines 70–1**

*I, who now bid thee on this errand forth,
Am Beatrice.*

Dante, having resolved to follow Virgil, is told by the Mantuan that they are to be accompanied by a lady of surpassing beauty. This is Beatrice, who, in life, had been Dante's great love. Here Beatrice is seen appearing to Virgil.

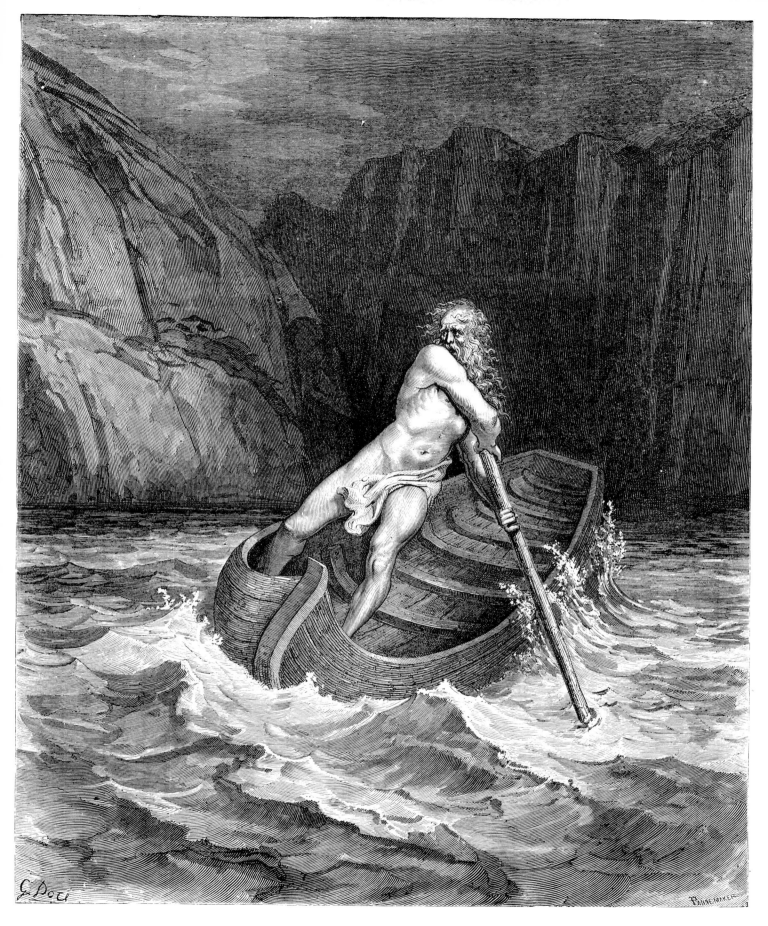

**Dante's Inferno**

**Canto III, lines 76–8**

*And lo! toward us in a bark*
*Comes an old man, hoary white with eld,*
*Crying, "Woe to you, wicked spirits!"*

Dante and Virgil, having passed through the portals of the infernal regions, reach the bank of the dark river Acheron. Here they meet the ferryman of condemned souls, Charon.

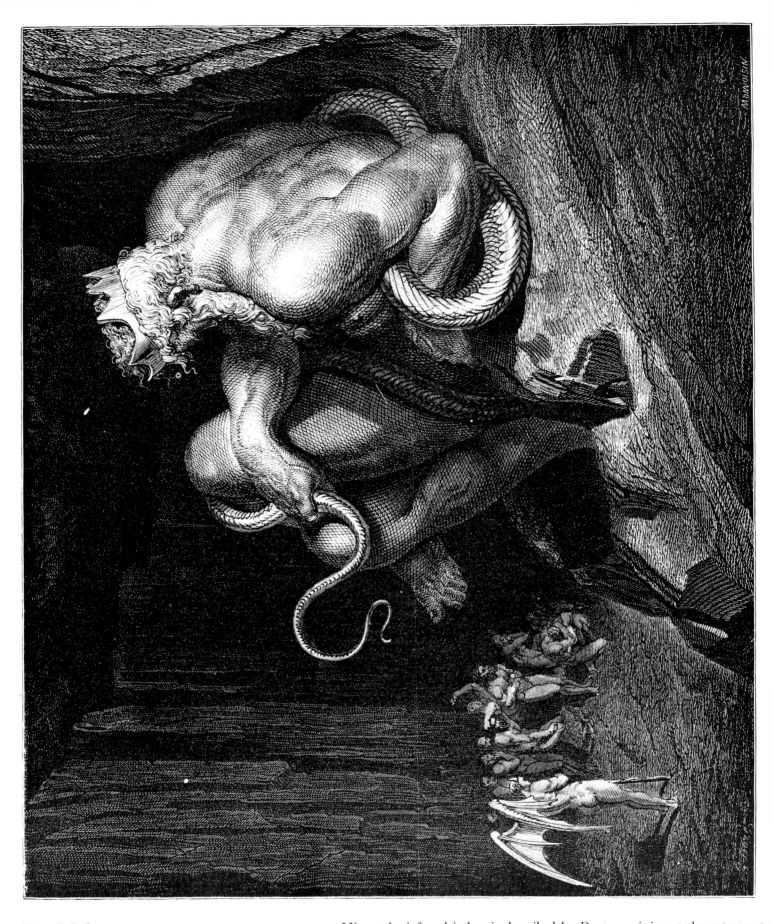

**Dante's Inferno**

**Canto V, line 4**

*There Minos stands.*

Minos, the infernal judge, is described by Dante as sitting at the entrance to the second circle of Hell. He is portrayed passing sentence on the souls brought before him.

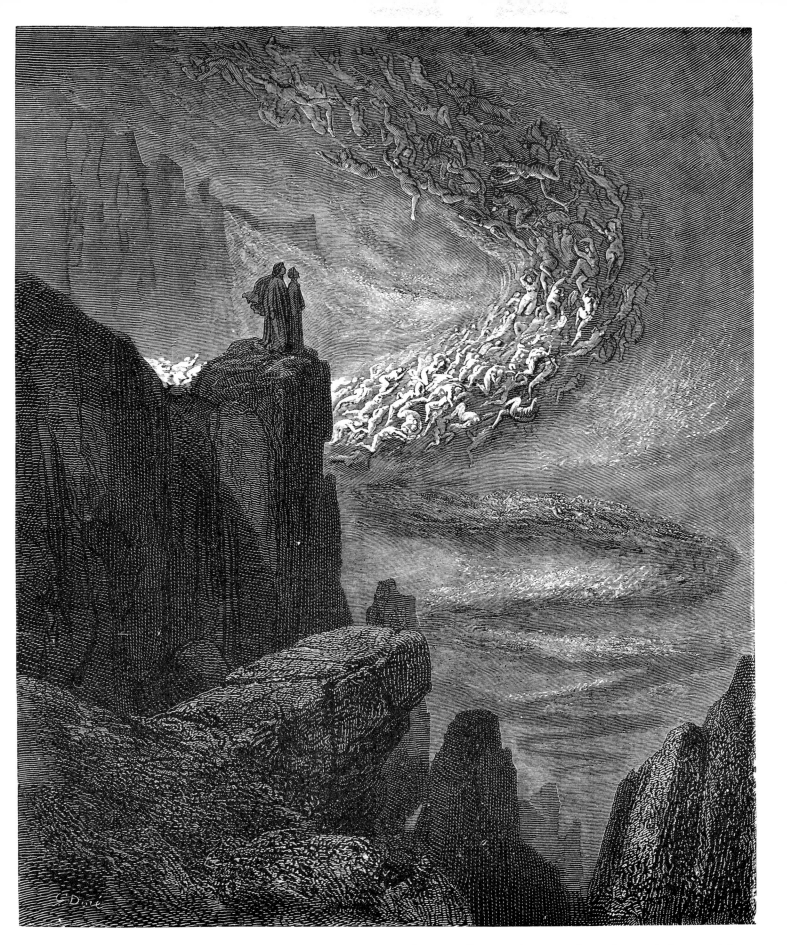

**Dante's Inferno**

**Canto V, lines 32–3**

*The stormy blast of hell*
*With restless fury drives the spirit on.*

Having passed Minos, Dante arrives at a place of great darkness and horror. Virgil and Dante are seen among the eddying circles of spirits driven ceaselessly by the infernal tempest.

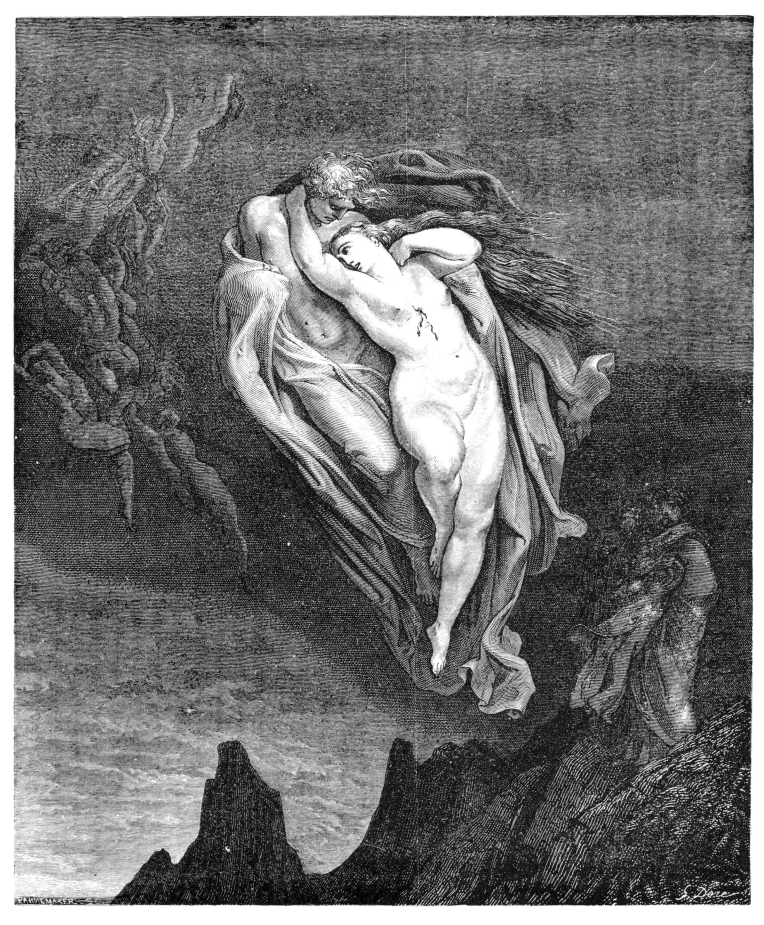

**Dante's Inferno**

**Canto V, lines 72–4**

*Bard! Willingly*
*I would address these two together coming,*
*Which seem so light before the wind.*

Here depicted are Paolo and Francesca, the latter bearing the mark of her mortal wound on her bosom.

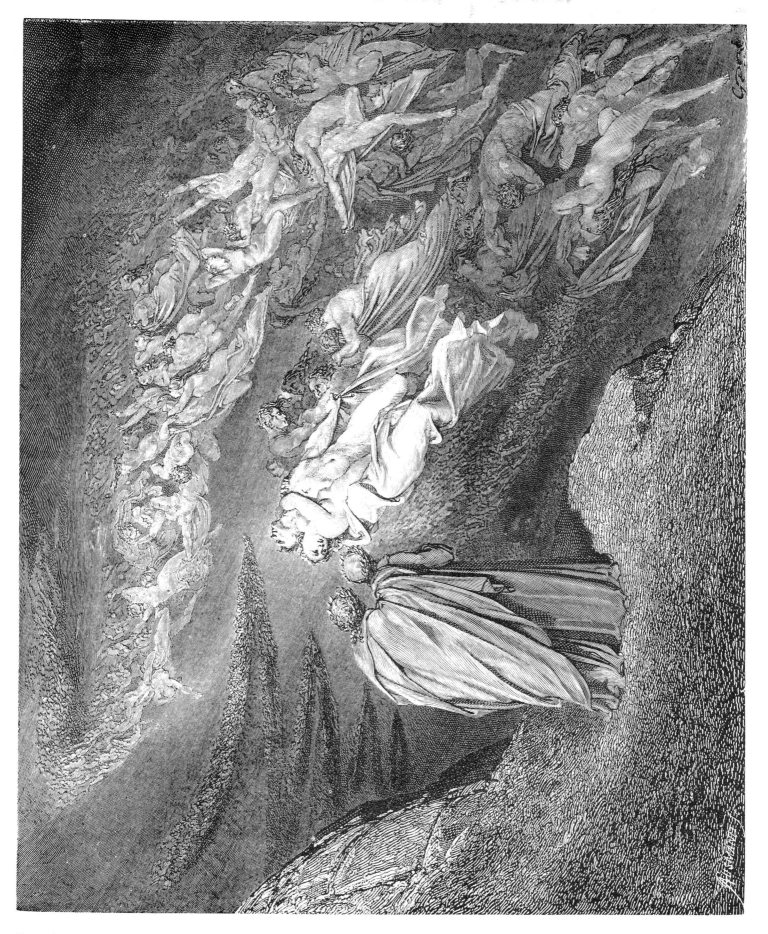

**Dante's Inferno**

**Canto V, lines 105–6**

*Love brought us to one death: Caina waits*
*The soul who spilt our life.*

In the second circle of Hell, Dante singles out from amongst the carnal sinners one couple and asks Virgil whether he may address them. They are Paolo and Francesca who, despite the wishes of their families, had become lovers. Even in the torments of Hell the two are inseparably linked.

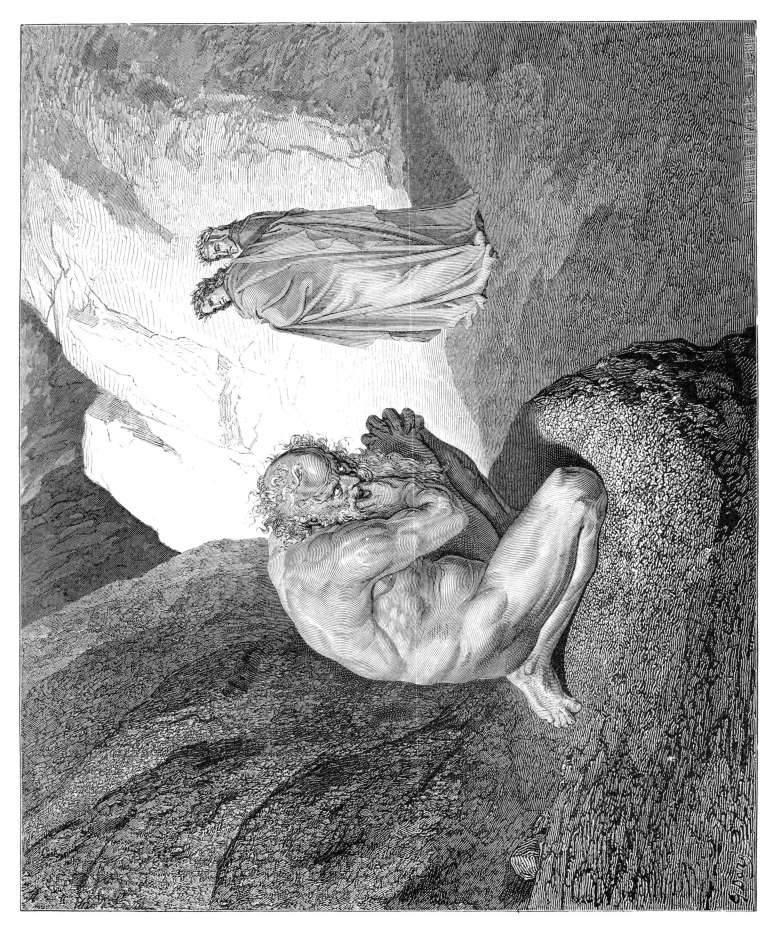

**Dante's Inferno**

**Canto VII, lines 8–9**

*Curst wolf! thy fury inward on thyself
Prey, and consume thee!*

As they prepare to descend into the fourth circle of Hell, Dante and Virgil find their way stopped by Plutus. He is the guardian of the pit. Here are punished the avaricious and the prodigal. Dante is alarmed, but Virgil allays his fears.

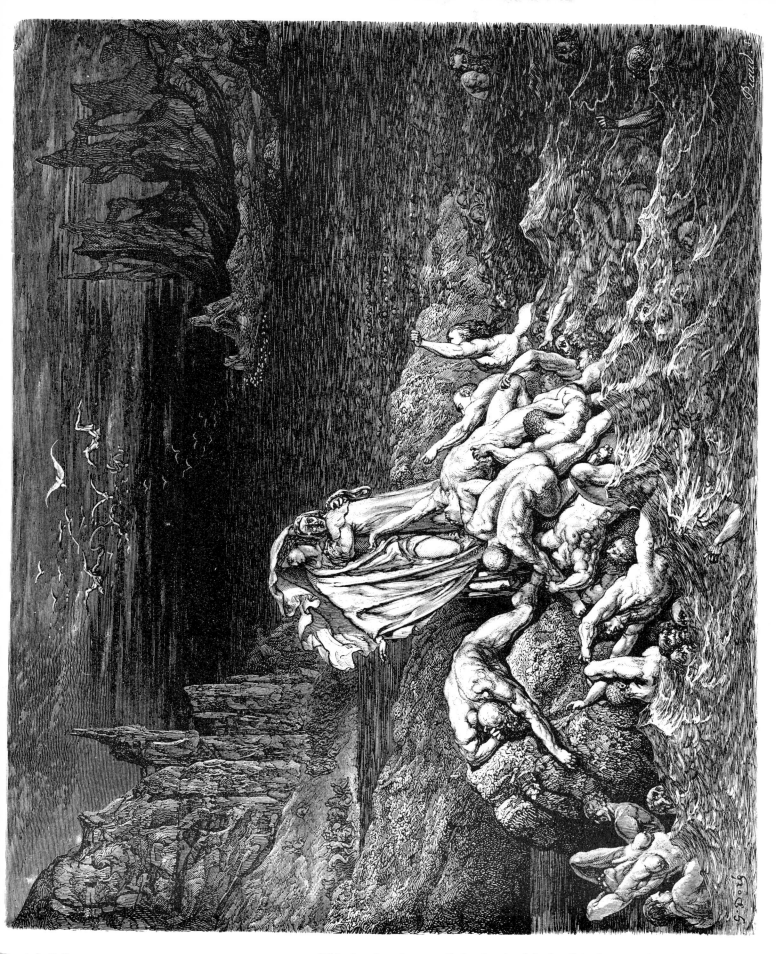

**Dante's Inferno**
**Canto VII, lines 118–9**

*Now seest thou, son!*
*The souls of those, whom anger overcame.*

This drawing shows well the Stygian lake in all its horror. The doomed figures are seen frantically trying to drag themselves on to the spit of land where Dante and Virgil are standing.

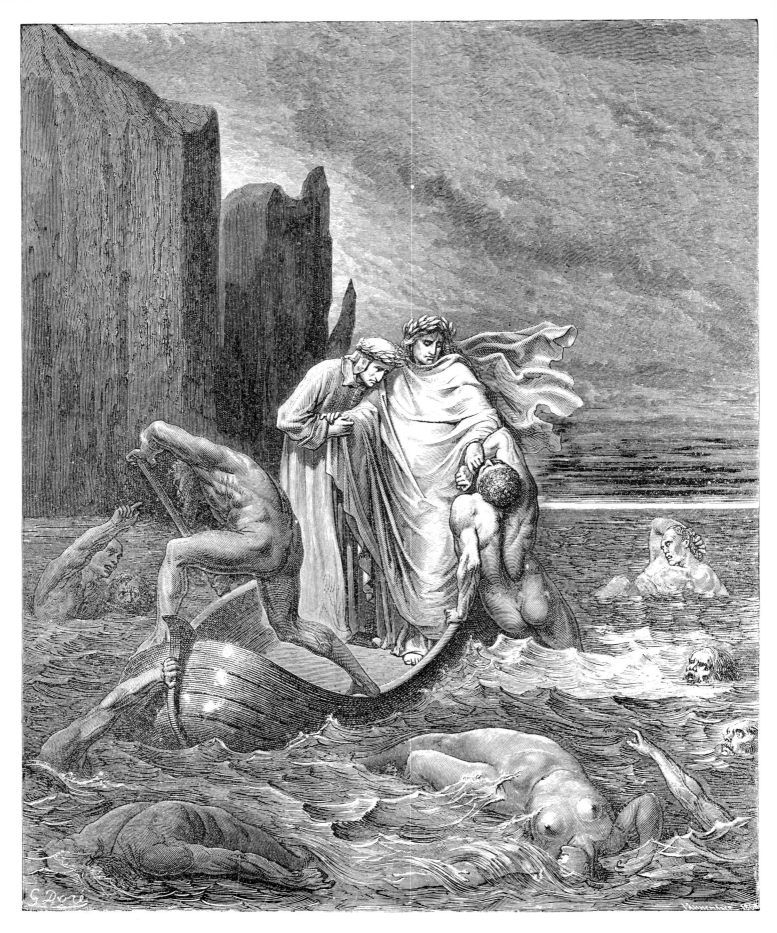

**Dante's Inferno**

**Canto VIII, lines 39–41**

       *My teacher sage*
*Aware thrusting him back: "Away! down there*
*To the other dogs!"*

While crossing the Stygian lake, at the bottom of the fifth circle of Hell, Dante and Virgil are accosted by a mire-encrusted figure. It is the spirit of Filippo Argenti, in life a man of great vigour but of extreme waywardness.

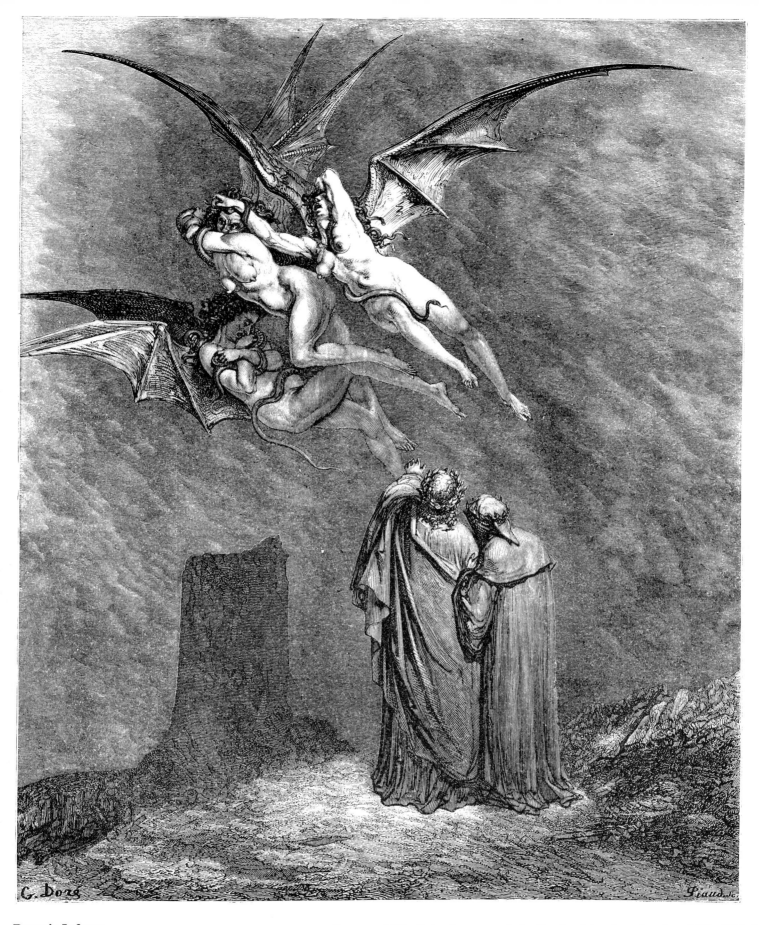

**Dante's Inferno**

**Canto IX, line 46**

*Mark thou each dire Erynnis*

Dante and Virgil, having crossed the Stygian lake, face the city of Dis. This is guarded by three hellish furies, stained in blood and female in form. They are the Eumenides, or Furies, of Greek mythology.

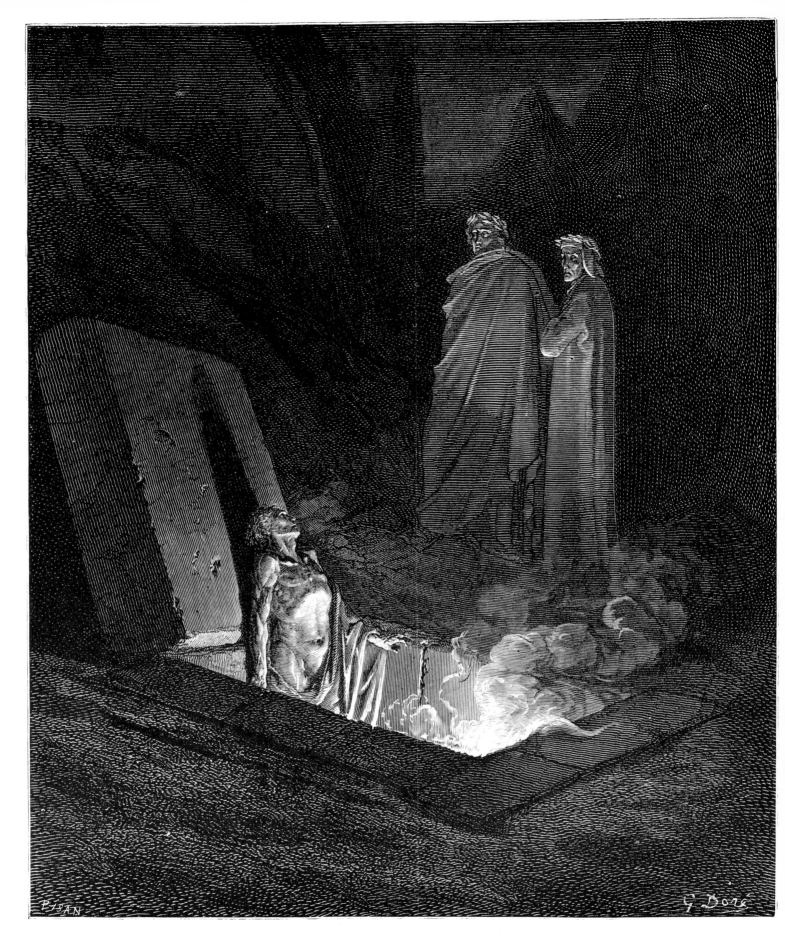

**Dante's Inferno**

**Canto X, lines 40–42**

*He, soon as there I stood at the tomb's foot,*
*Eyed me a space; then in disdainful mood*
*Address'd me: "Say what ancestors were thine".*

Entering the city of Dis, Dante and Virgil pass the heretics, whose punishment is to be confined to tombs filled with fire. A voice from one of the vaults calls to Dante; Virgil explains it to be that of Farinata, a Ghibelline in life and known to Dante.

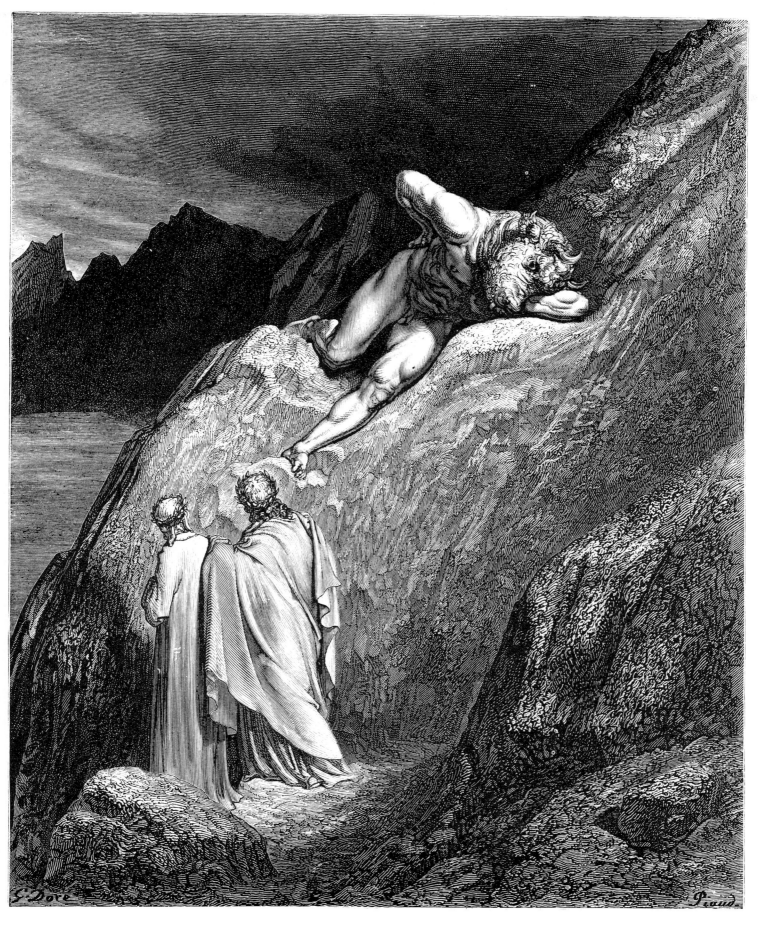

**Dante's Inferno**

**Canto XII, lines 11–14**

*And there*
*At point of the disparted ridge lay stretch'd*
*The infamy of Crete, detested brood*
*Of the feign'd heifer.*

Coming to the seventh circle of Hell, made for the punishment of crimes of violence, Dante and Virgil find their way blocked by the Minotaur. The "feign'd heifer" was Pasiphaë. Virgil taunts the beast into a storm of rage, and the companions pass on their way.

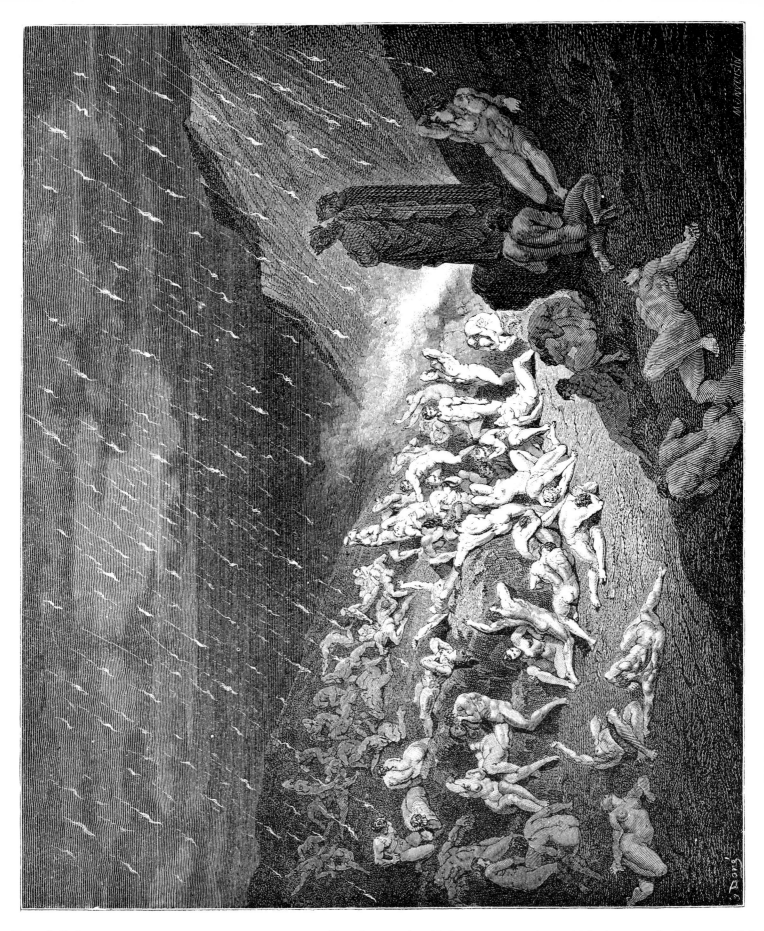

**Dante's Inferno**

**Canto XIV, lines 37–9**

*Unceasing was the play of wretched hands,*
*Now this, now that way glancing, to shake off*
*The heat, still falling fresh.*

Here is seen the third compartment into which the seventh circle of Hell is divided. The condemned spirits suffer under a perpetual torture of fiery rain.

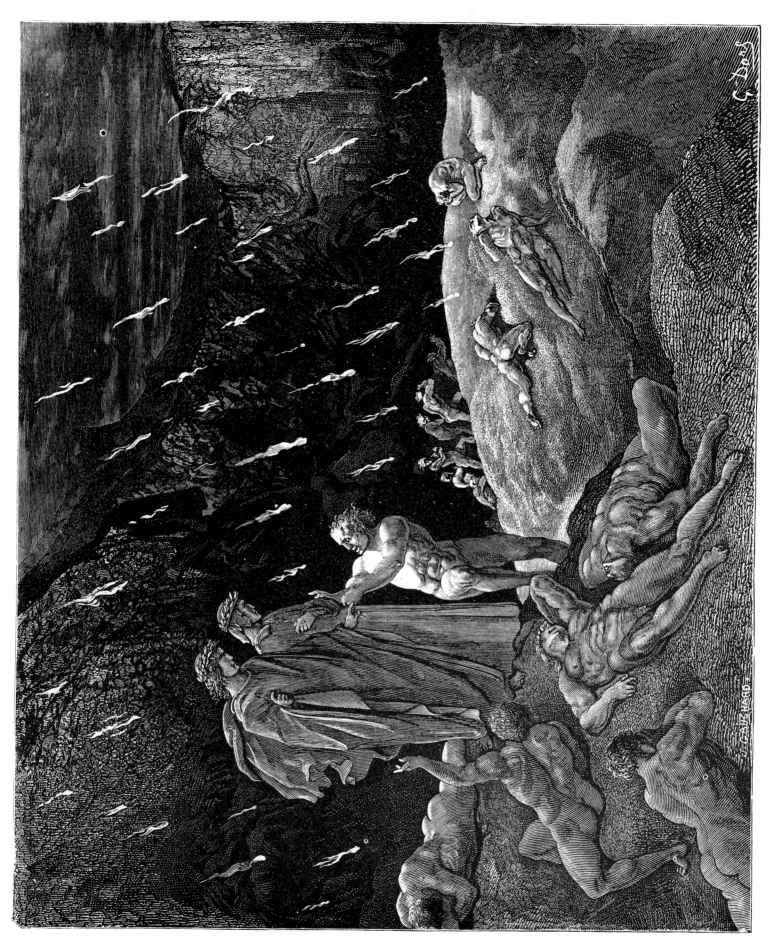

**Dante's Inferno**

**Canto XVIII, lines 116–17**

*"Why greedily thus bendest more on me,*
*Than on these other filthy ones, thy ken?"*

The eighth circle of Hell is divided into ten regions, the second of which is reserved for the punishment of flatterers. From the pit ascends a foul stream in which the sufferers struggle for ever in the filth and slime.

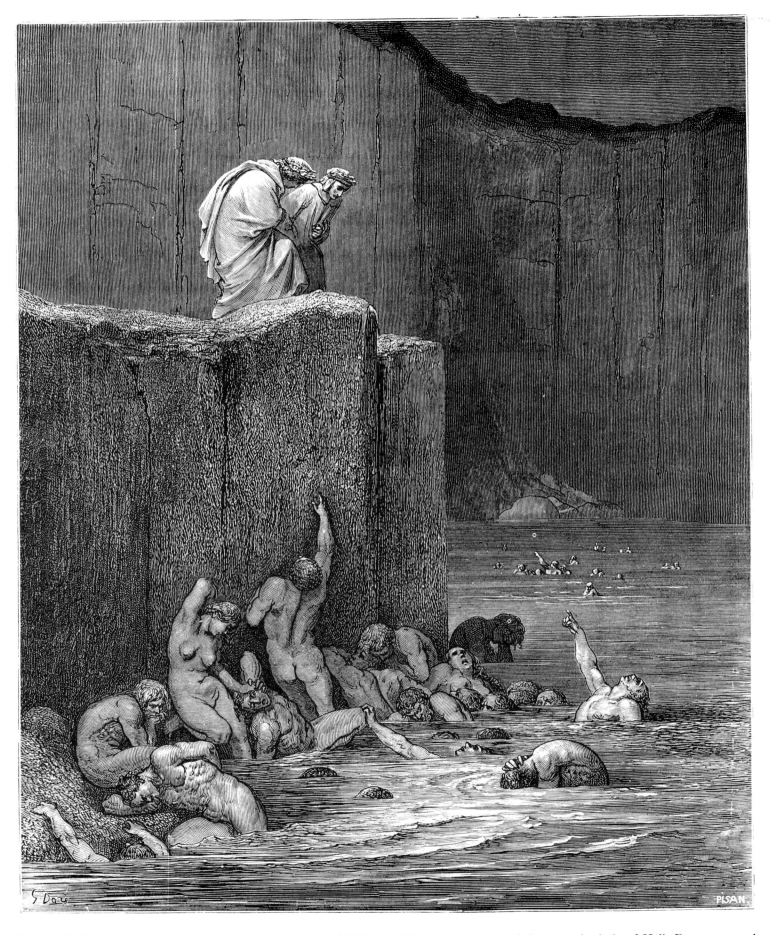

**Dante's Inferno**

**Canto XV, lines 28–9**

*"Ser Brunetto!*
*And are ye here?"*

Still in the third compartment of the seventh circle of Hell, Dante meets the spirit of Brunetto Latini, who in life had been his master and chancellor of Florence. It is difficult to understand why the poet should have depicted him in Hell, as in life he was much respected.

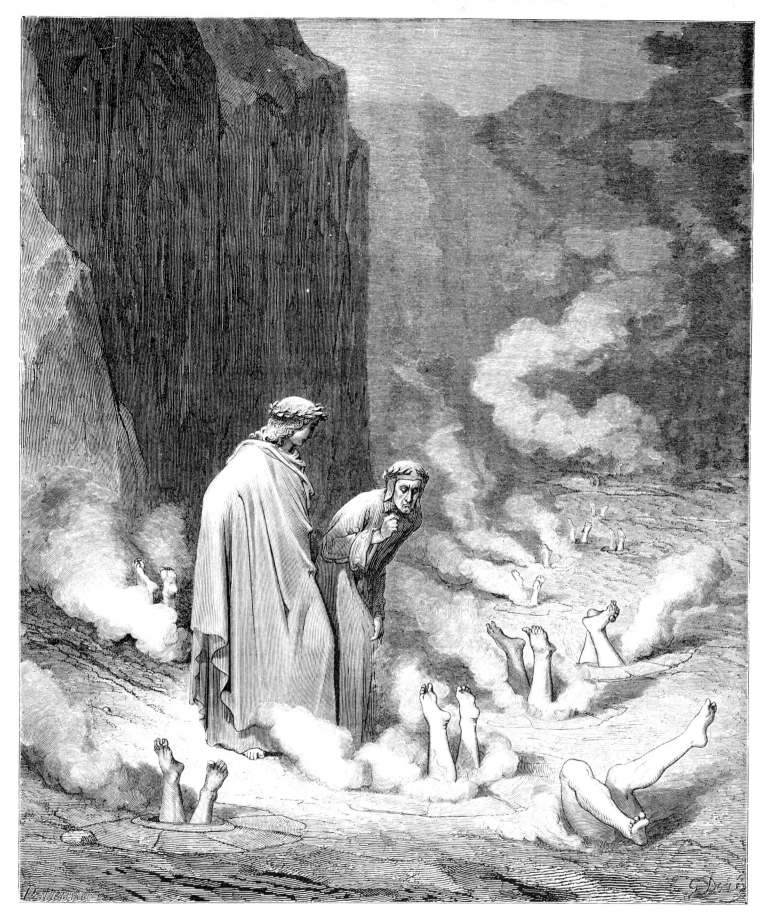

**Dante's Inferno**

**Canto XIX, lines 10–11**

*There stood I like the friar, that doth shrive*
*A wretch for murder doom'd.*

The third gulf of Hell is that in which those guilty of simony are punished. They are placed head down in circular pits from which only their writhing legs protrude. One of the wretches is the spirit of Pope Nicholas III, an Orsini.

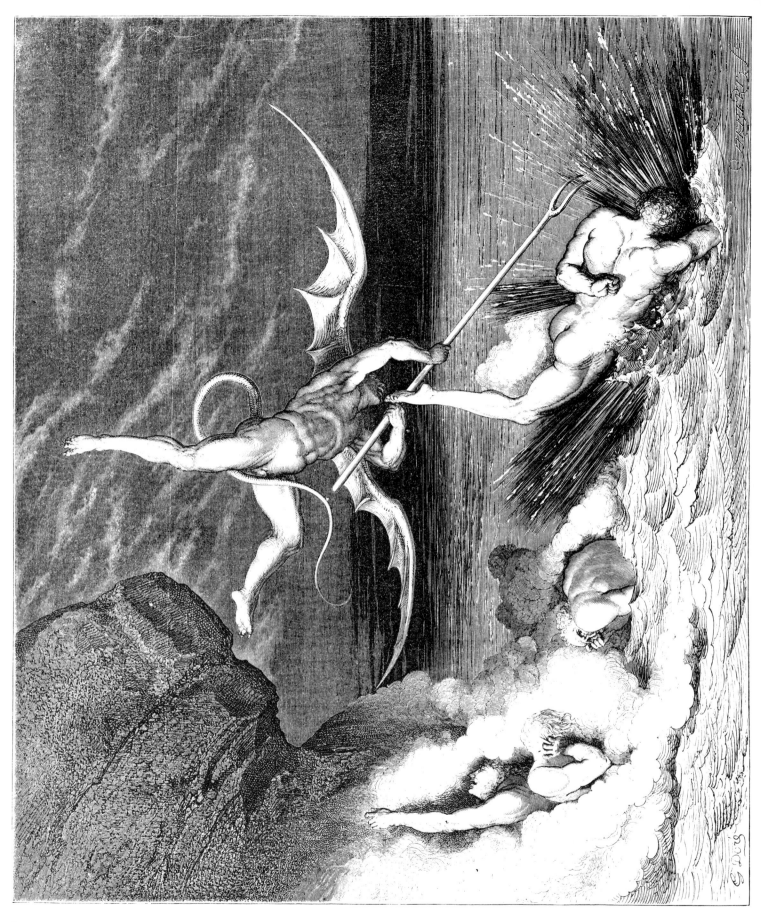

**Dante's Inferno**

**Canto XXII, lines 125–6**

> *In pursuit*
> *He therefore sped, exclaiming "Thou art caught".*

Dante, whilst in the eighth circle of Hell, is witness to a great wrangle between condemned spirits and demons. One spirit, Ciampolo, makes a frantic attempt to escape. He is pursued and caught by a demon with a prong.

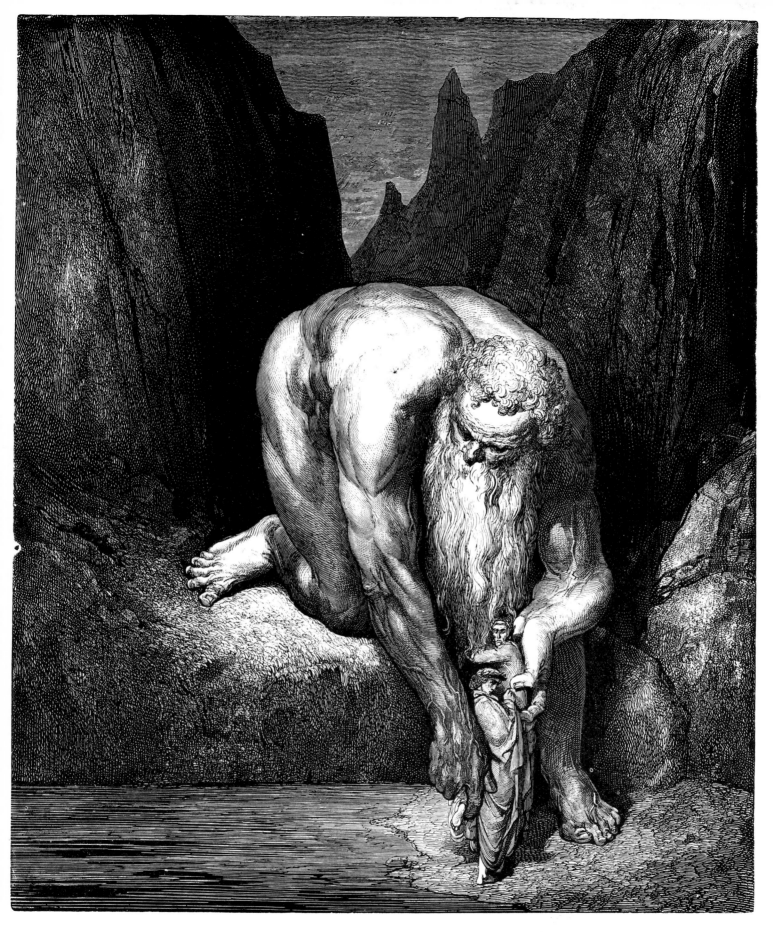

**Dante's Inferno**

**Canto XXXI, lines 133–5**

*Yet in the abyss,*
*That Lucifer with Judas low ingulfs,*
*Lightly he placed us.*

Dante and Virgil are led by the sound of a horn to the ninth circle of Hell. Dante appears to see a number of great towers, but they are fettered giants immersed to the middle in a deep pit. Virgil begs the one unfettered giant, Antaeus, to lower them into the abyss. Gently he does as he is asked.

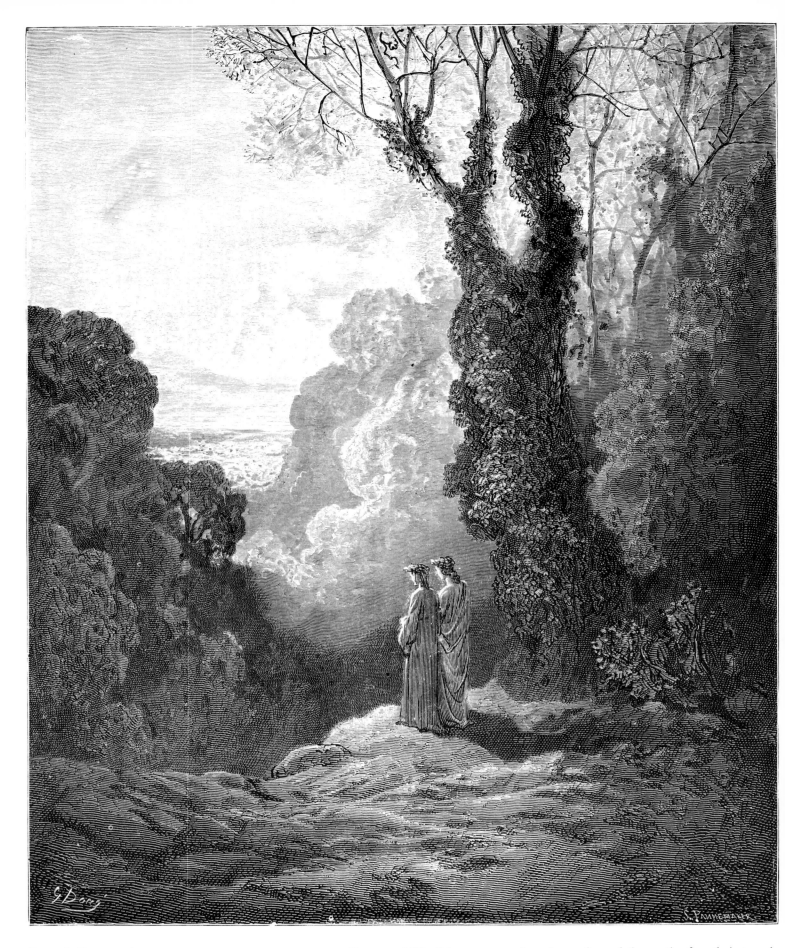

**Dante's Purgatorio**

**Canto I, lines 19–21**

*The radiant planet, that to love invites,*
*Made all the orient laugh, and veil'd beneath*
*The Pisces' light, that in his escort came.*

Dante and Virgil have returned to the surface of the earth after their travels in the infernal regions. They see the dawn sky sprinkled with stars, and, by the description, it would appear that the poet has set his Purgatory in the Southern hemisphere.

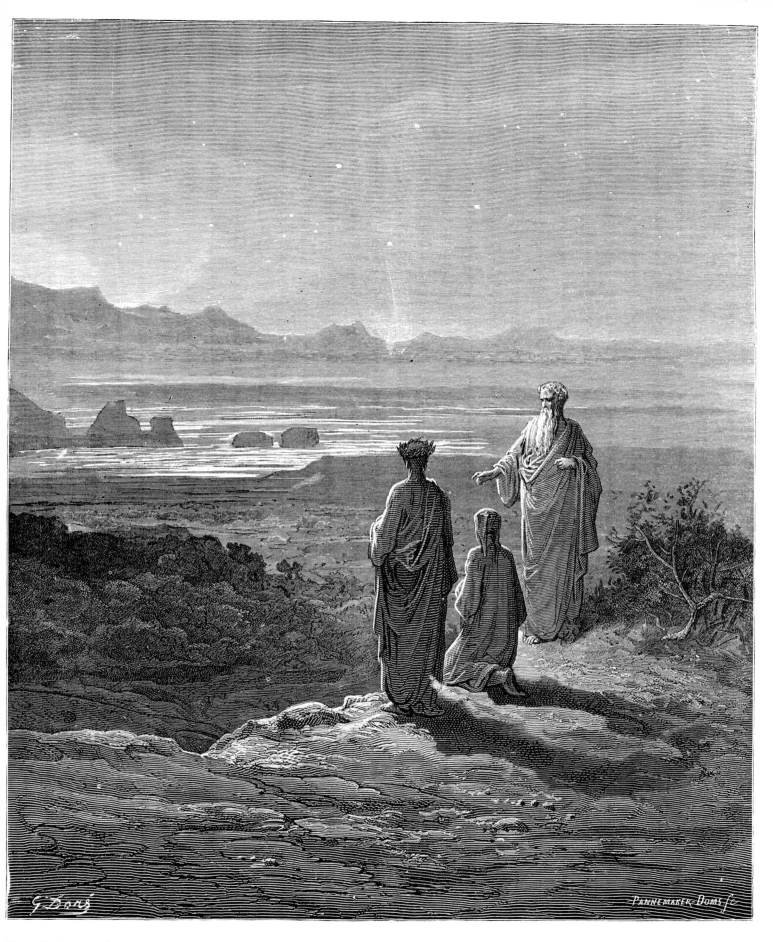

**Dante's Purgatorio**

**Canto I, lines 49–52**

*My guide, then laying hold on me, by words*
*And intimations given with hand and head,*
*Made my bent knees and eye submissive pay*
*Due reverence.*

Dante and Virgil stand on the shore of the ocean which surrounds the island of Purgatory. They are accosted by a venerable old man. He is Cato of Utica, one of the wisest and most virtuous of the ancient Italians.

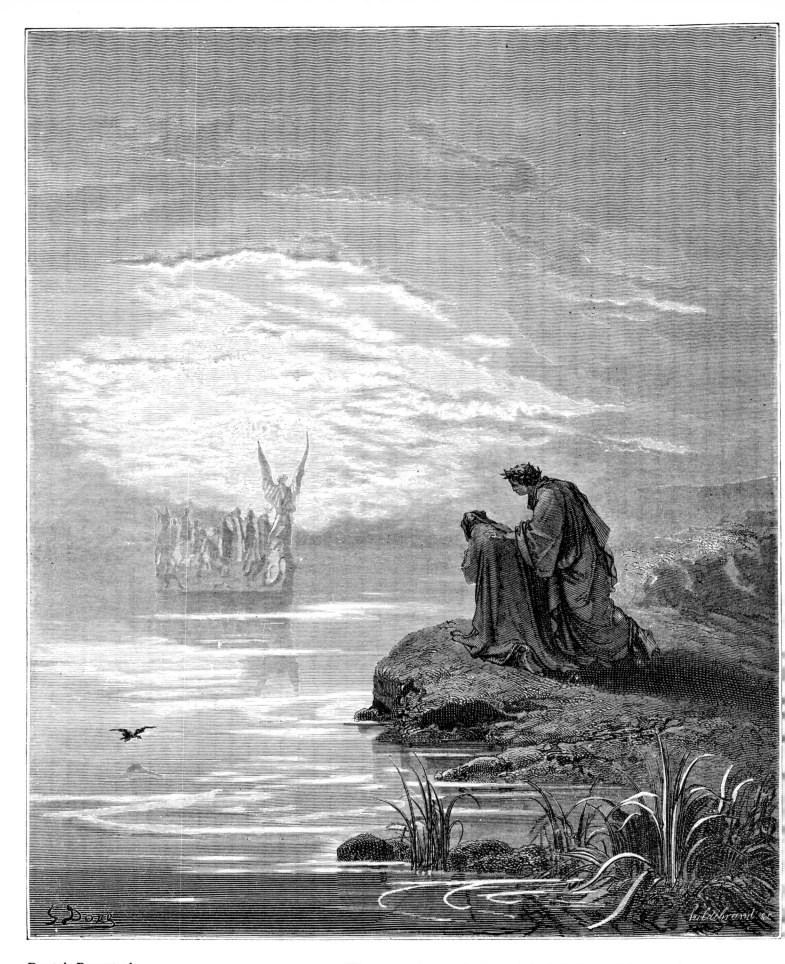

**Dante's Purgatorio**

**Canto II, lines 27–30**

> *Then when he knew*
> *The pilot, cried aloud, "Down, down; bend low*
> *Thy knees; behold God's angel; fold thy hands:*
> *Now shalt thou see true ministers indeed."*

The companions await the arrival of the Boat of Souls as it comes over the water from Purgatory.

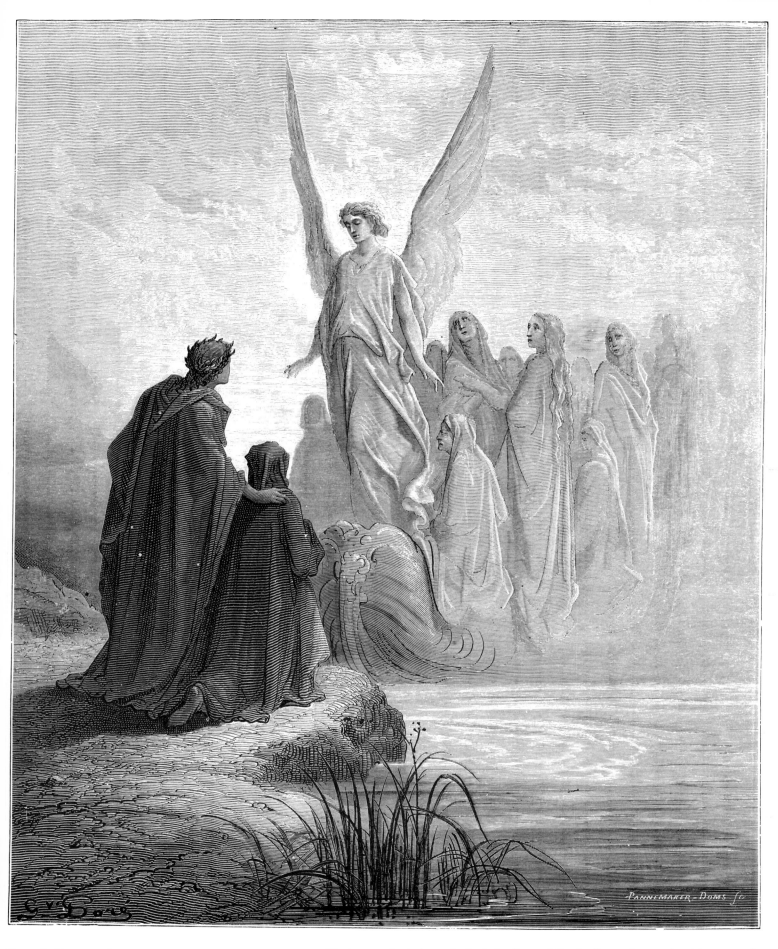

**Dante's Purgatorio**

**Canto II, lines 42–3**

*The heavenly steersman at the prow was seen,*
*Visibly written Blessed in his looks.*

Having awaited the arrival of the Boat of Souls, Dante is struck with awe and wonder at the sight of the Angel who guides the boat.

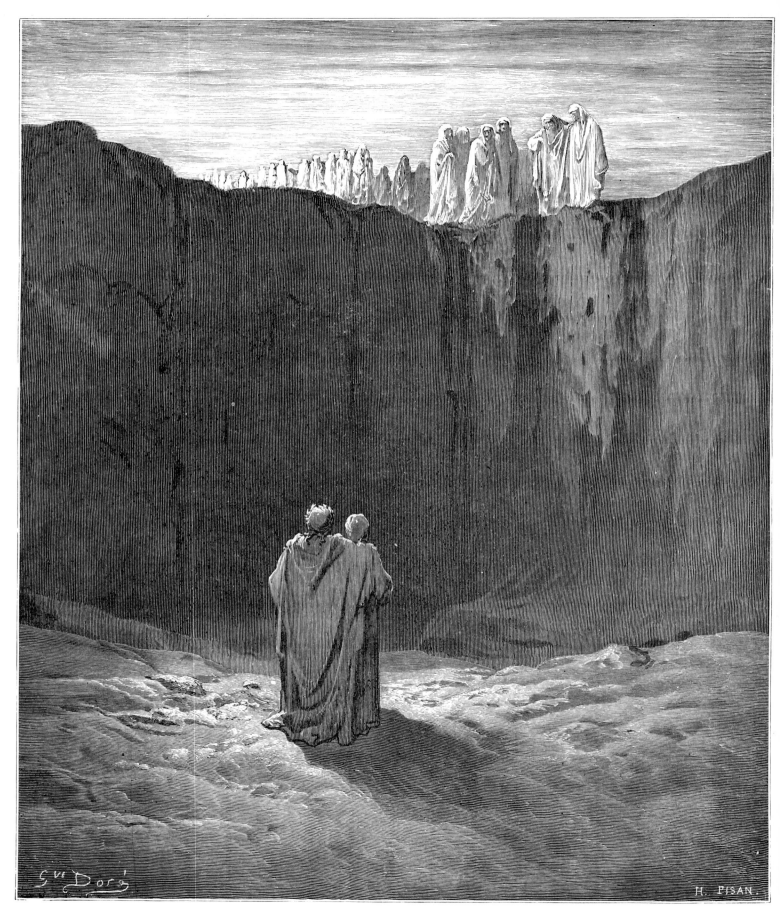

**Dante's Purgatorio**

**Canto III, lines 55–9**

*The meaning of the pathway he explored,*
*And I gazed upward round the stony height;*
*On the left hand appear'd to us a troop*
*Of spirits, that toward us moved their steps;*
*Yet moving seem'd not, they so slow approach'd.*

Virgil and Dante reach the foot of the Mount of Purgatory; they find the face so sheer that they are unable to ascend.

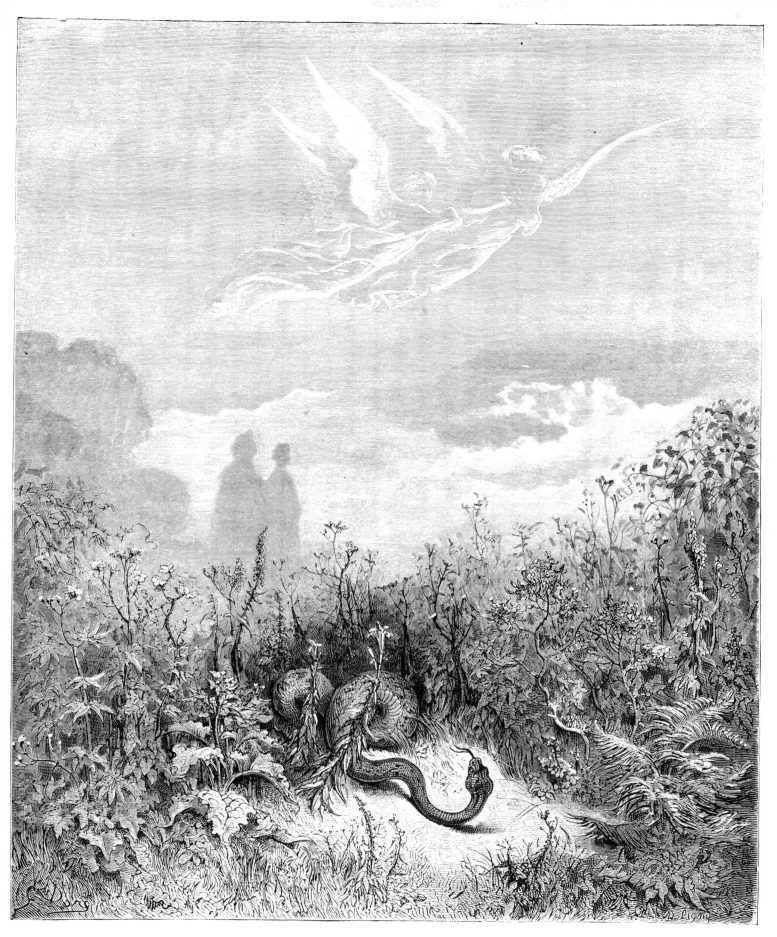

**Dante's Purgatorio**

**Canto VIII, lines 105–7**

*Hearing the air cut by their verdant plumes,*
*The serpent fled; and, to their stations, back*
*The angels up return'd with equal flight.*

Having entered Purgatory, Dante and Virgil find themselves in a beautiful valley. Two angels appear in the sky, and when a serpent writhes near to them the angels put it to flight.

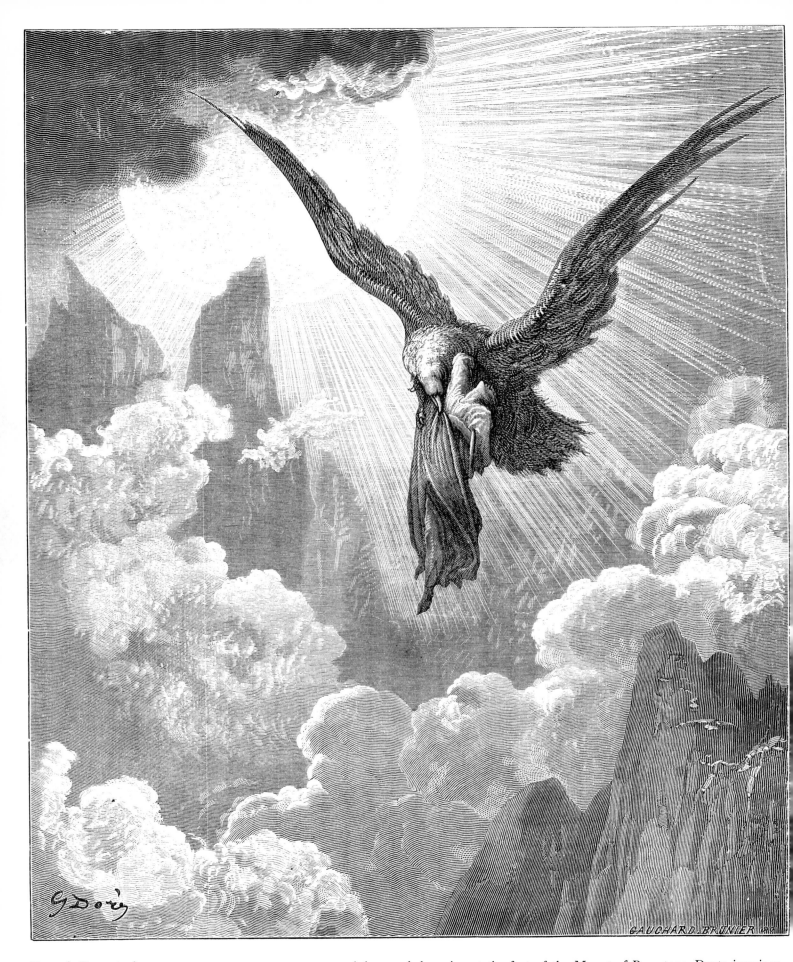

**Dante's Purgatorio**

**Canto IX, lines 29–31**

*There both, I thought, the eagle and myself*
*Did burn; and so intense the imagined flames,*
*That needs my sleep was broken off.*

Asleep and dreaming at the foot of the Mount of Purgatory, Dante imagines he is carried aloft by an eagle toward the sun. Awaking he finds he has been carried up the mount by Lucia, a female spirit.

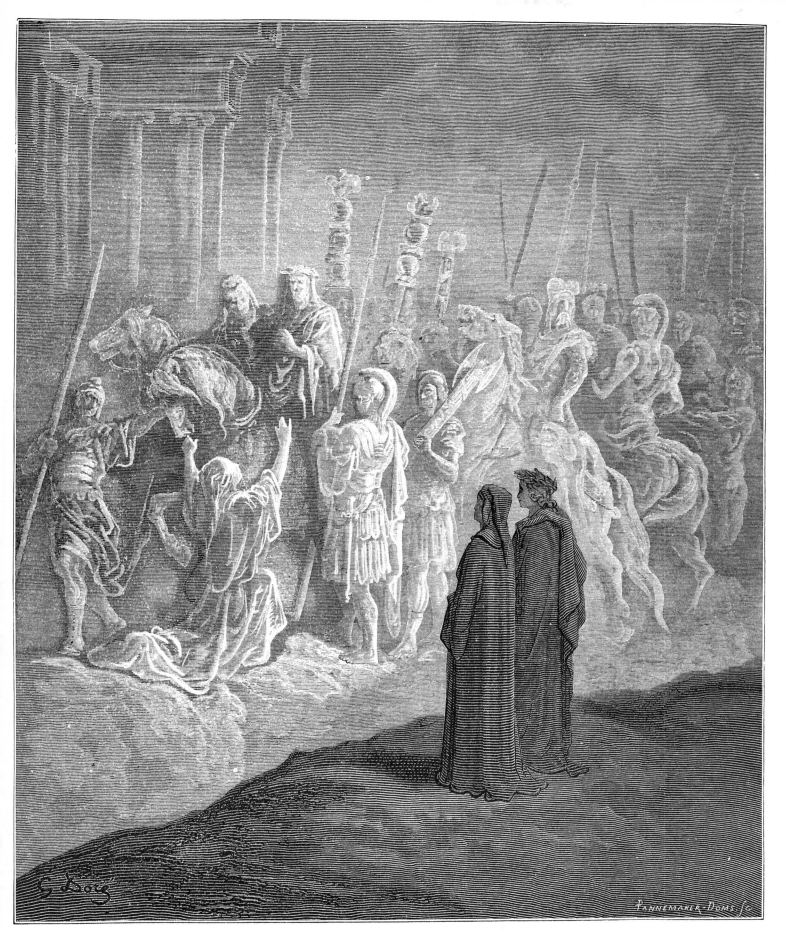

**Dante's Purgatorio**

**Canto X, lines 74–6**

*The wretch appear'd amid all those to say:*
*"Grant vengeance, sire! for, woe beshrew this heart,*
*My son is murder'd."*

Part of the Mount, formed of white marble, is engraved with figures illustrating humility. The scene depicts the legend of the Emperor Trajan, who was accosted by a widow asking for vengeance on the killers of her son.

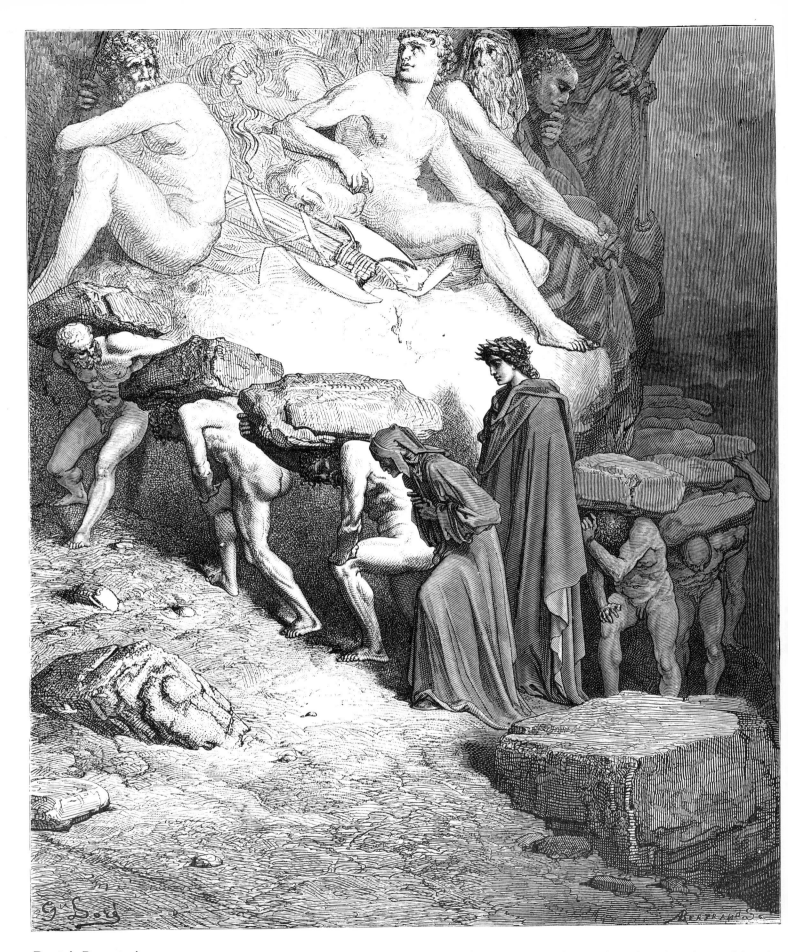

**Dante's Purgatorio**

**Canto XII, lines 1–3**

*With equal pace, as oxen in the yoke,*
*I, with that laden spirit, journey'd on,*
*Long as the mild instructor suffer'd me.*

Dante sees and converses with one of a number of spirits who are labouring under the weight of great stones. These are expiating the sin of pride. Behind them can be seen giant sculptures representing pride in history or myth.

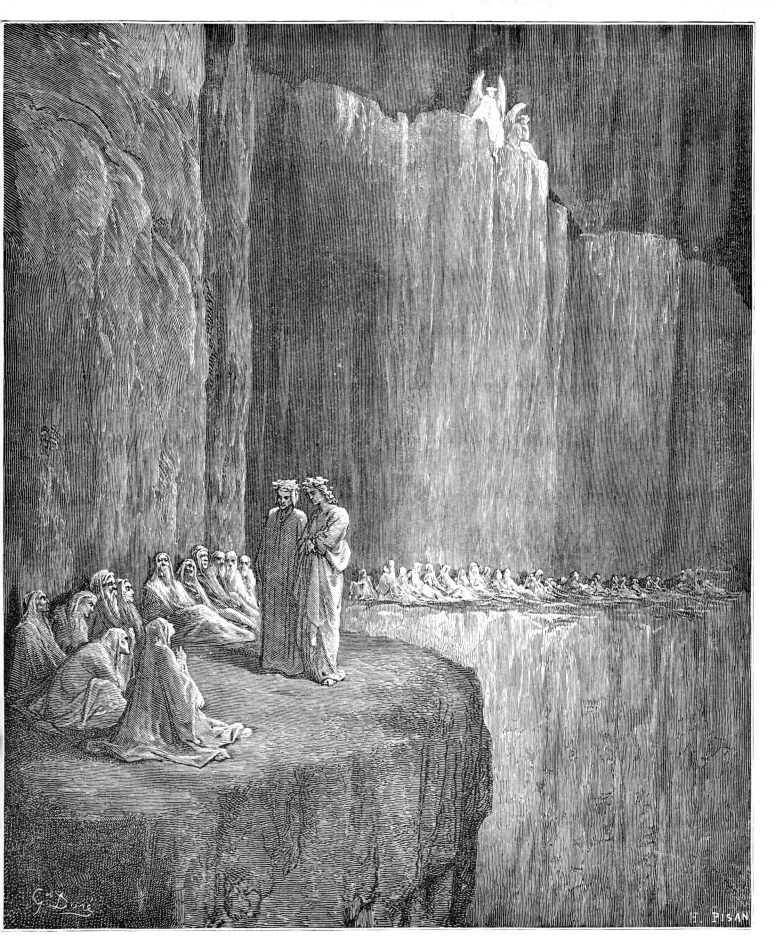

**Dante's Purgatorio**

**Canto XIII, lines 129–30**

*"Who, then, amongst us here aloft,*
*Hath brought thee, if thou meanest to return?"*

Here, on the second cornice of the Mount of Purgatory, are to be found figures garbed in sackcloth, their eyes sewn up with iron thread. They are expiating the sin of envy.

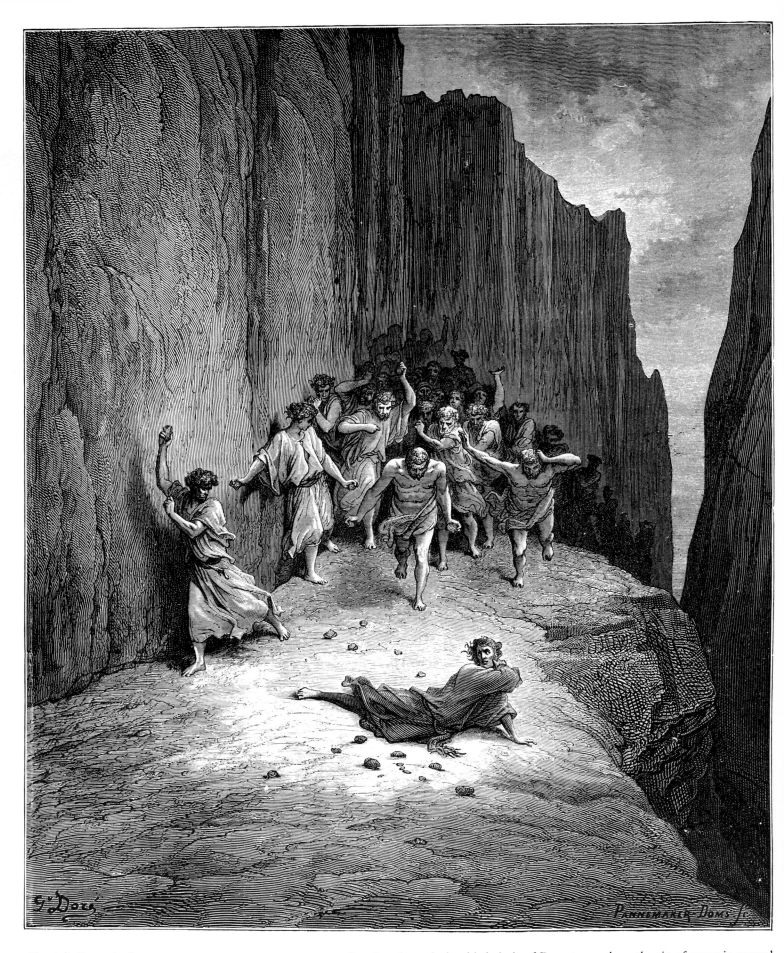

**Dante's Purgatorio**

**Canto XV, lines 103–6**

*After that I saw*
*A multitude, in fury burning, slay*
*With stones a stripling youth,*

Pressing through the third circle of Purgatory, where the sin of anger is purged, Dante has a vision in which he beholds the death of St Stephen the martyr re-enacted.

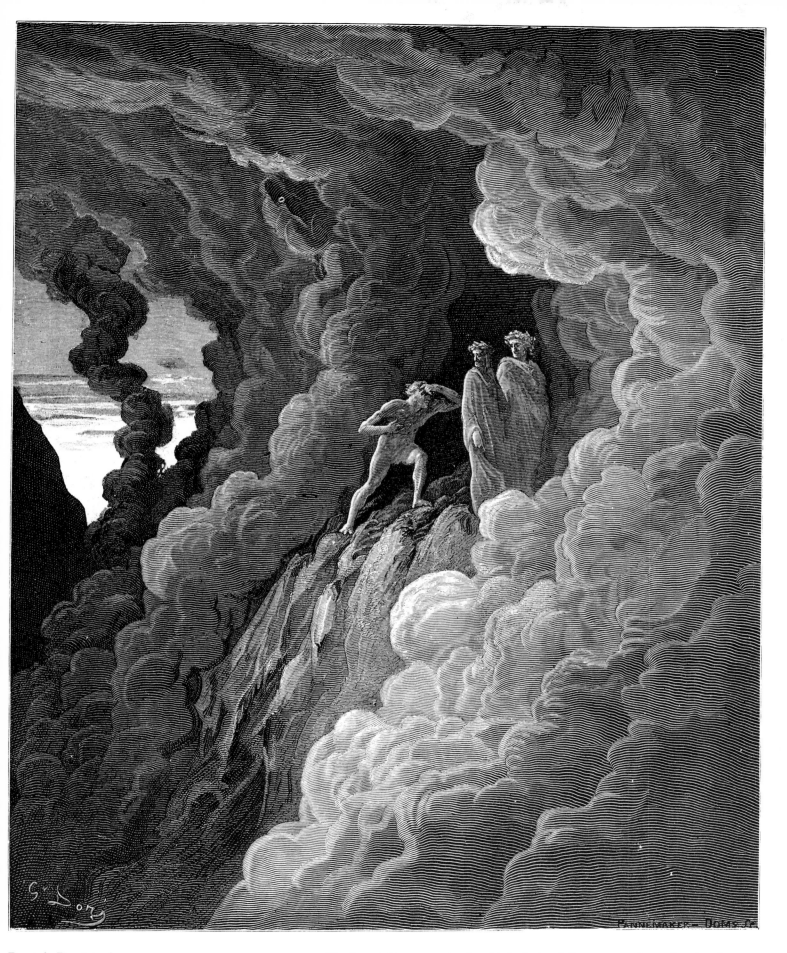

**Dante's Purgatorio**

**Canto XVI, lines 32–5**

*"Long as 'tis lawful for me, shall my steps
Follow on thine; and since the cloudy smoke
Forbids the seeing, hearing in its stead
Shall keep us join'd."*

Virgil and Dante are in the third circle of Purgatory, where the sin of anger is expiated, and are enveloped in a dense fog. The spirit of Marc Lombardo asks to join them, and they converse.

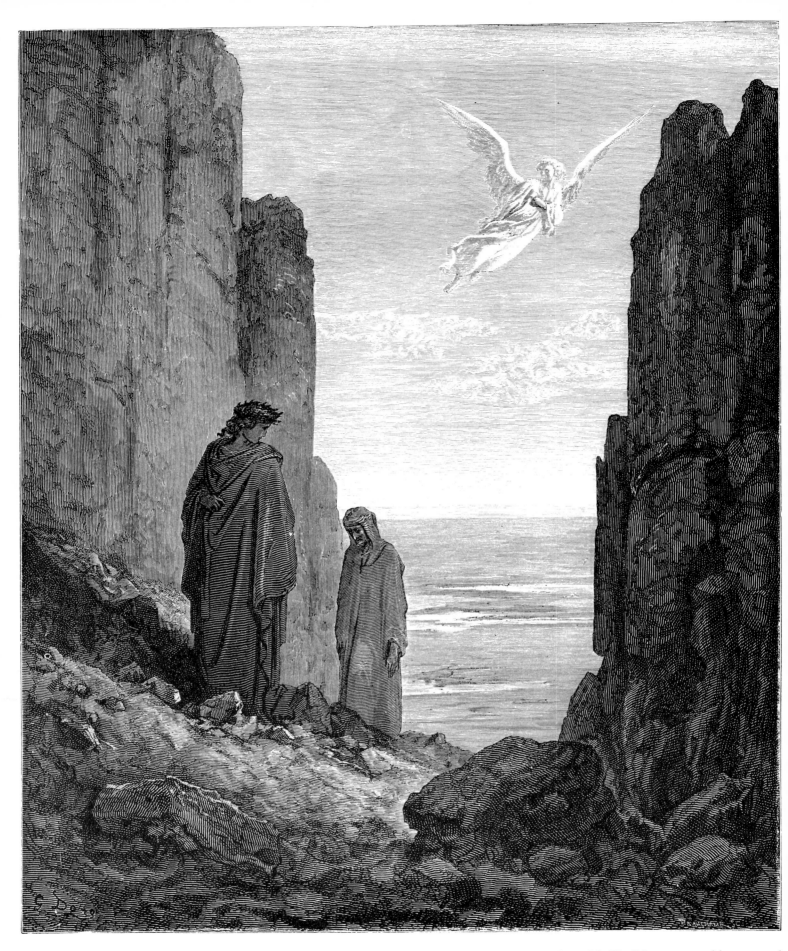

**Dante's Purgatorio**

**Canto XIX, lines 51–3**

*"What aileth thee, that thou still look'st to earth?"*
*Began my leader; while the angelic shape*
*A little over us his station took.*

Dante awakes from a dream and together with Virgil is summoned by an angel
to ascend to the fifth level of Purgatory.

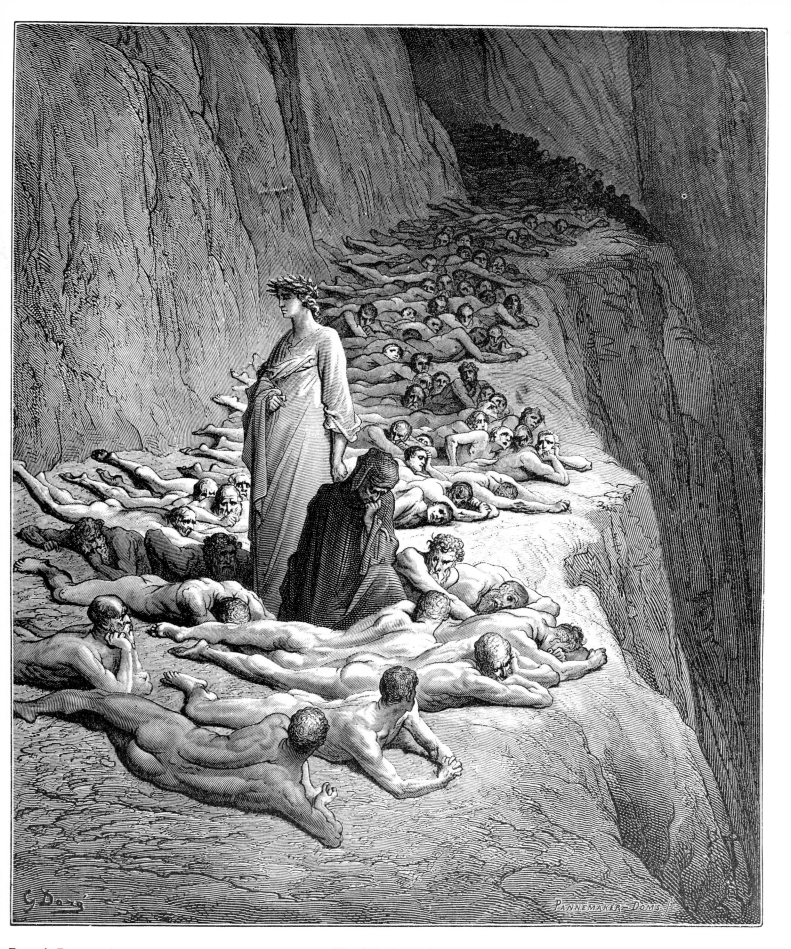

**Dante's Purgatorio**

**Canto XIX, lines 131–3**

"*Up*", *he exclaim'd, "brother! upon thy feet*
*Arise; err not: thy fellow servant I,*
*(Thine and all others;) of one Sovran Power.*"

The fifth circle of Purgatory is reserved for those expiating the sin of avarice.
Dante and Virgil encounter a large number of spirits prone on the ground.
Dante speaks to one, Pope Adrian V, and kneels beside him. He is exhorted
to rise by the spirit of the Pope.

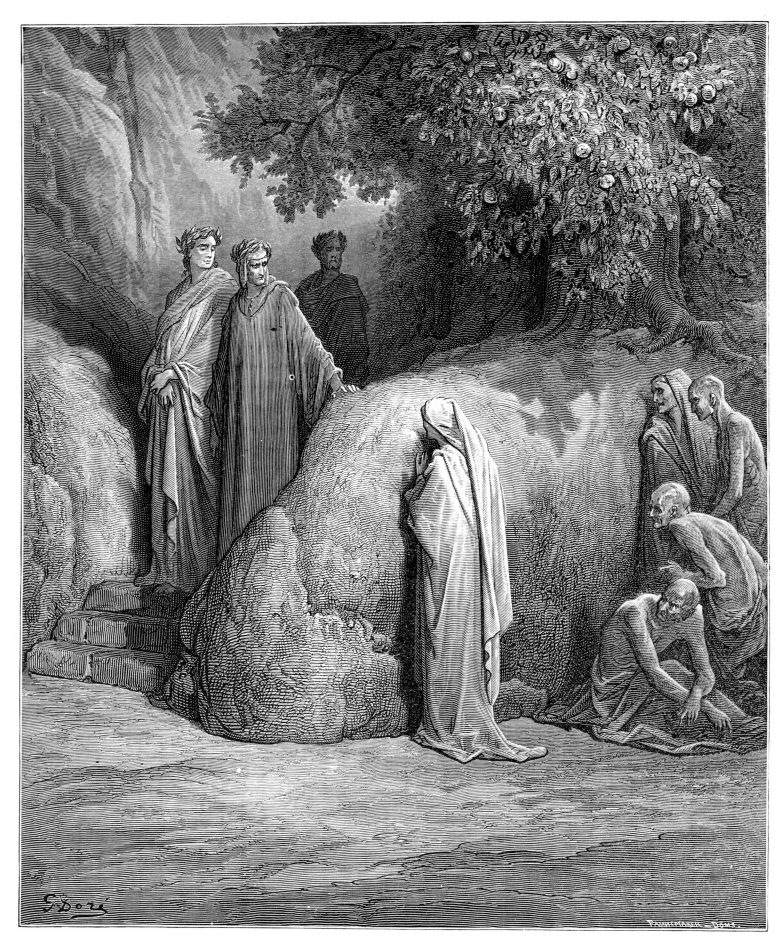

**Dante's Purgatorio**
**Canto XXIII, lines 47–9**

> *And who*
> *Are those twain spirits, that escort thee there?*
> *Be it not said thou scorn'st to talk with me.*

Dante, Virgil and Statius are in the sixth circle of Purgatory, where spirits are cleansed of the sin of gluttony. Here they meet a troop of emaciated souls, one of whom is Dante's friend, Forese, another poet. He implores Dante to speak with him.

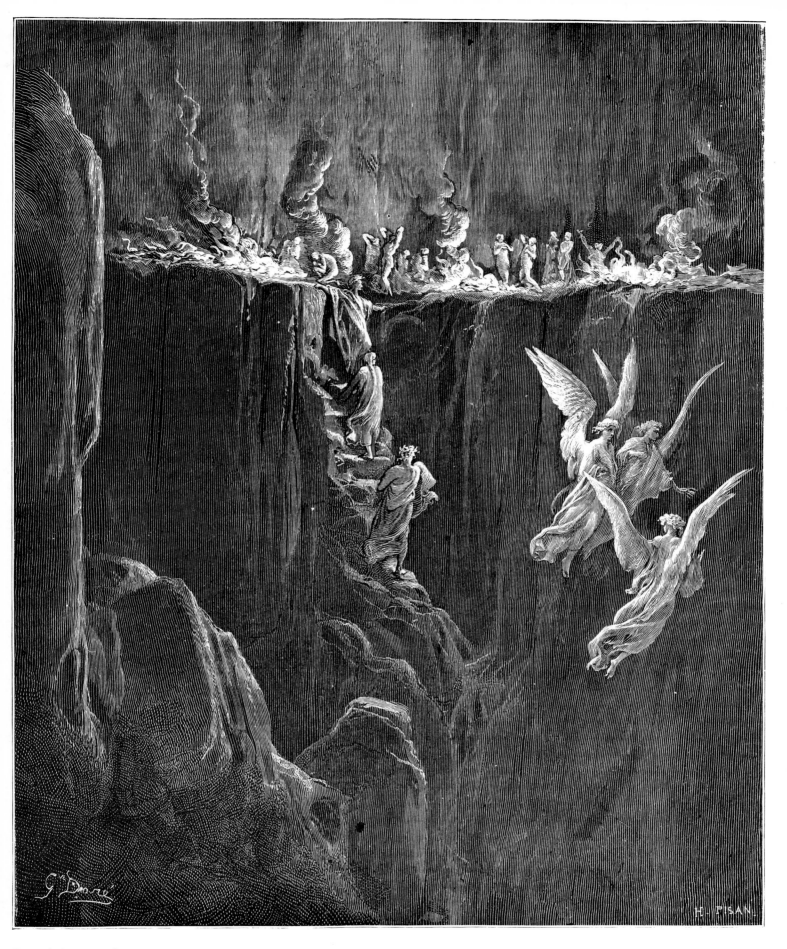

**Dante's Purgatorio**

**Canto XXV, lines 107–10**

> *Here the rocky precipice*
> *Hurls forth redundant flames; and from the ruin*
> *A blast up-blown, with forcible rebuff,*
> *Driveth them back, sequester'd from its bound.*

Dante and his two companions have reached the eighth and last cornice of Purgatory. Here, spirits who in life had been guilty of incontinence are exposed to violent winds and flames.

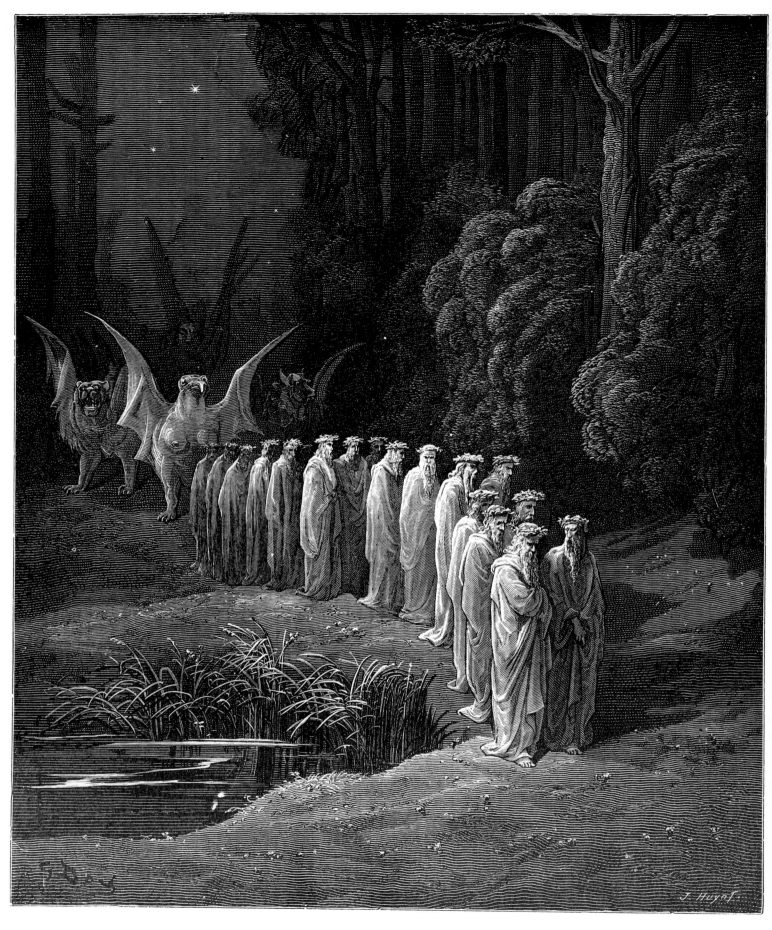

**Dante's Purgatorio**

**Canto XXIX, lines 80–2**

*Beneath a sky*
*So beautiful, came four and twenty elders,*
*By two and two, with flower-de-luce crown'd.*

Dante, wandering in the forest of Terrestrial Paradise, comes to a stream on the further bank of which he sees a beautiful lady gathering flowers. He then experiences the mystical vision of the elders and the strange beasts.

186

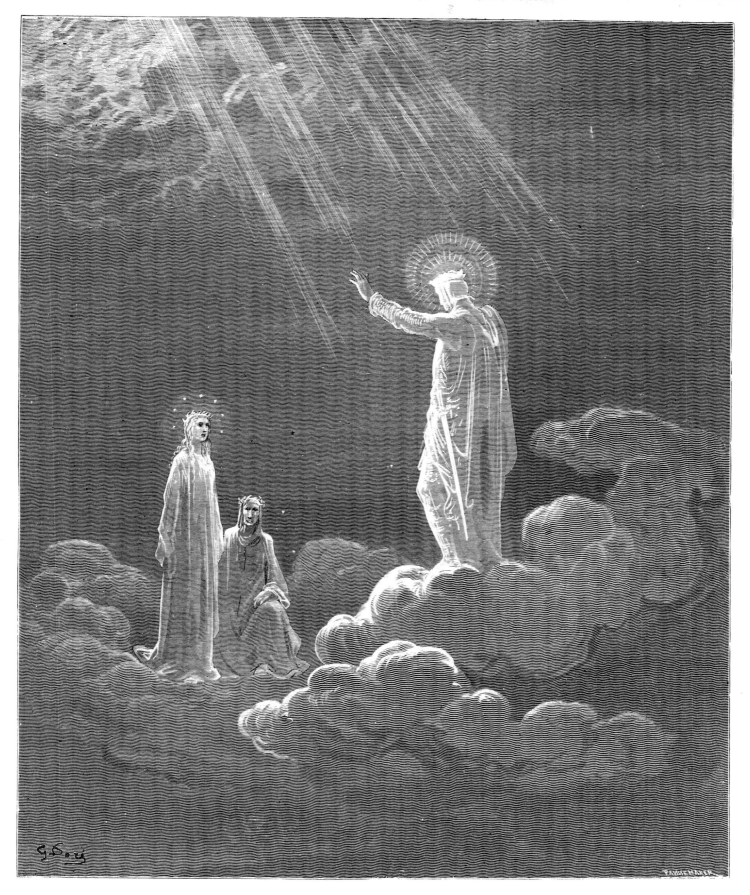

**Dante's Paradise**

**Canto VIII, lines 60–2**

> *The left bank,*
> *That Rhone, when he hath mix'd with Songa, loves*
> *In me its lord expected.*

On the planet Venus, the third heaven, Dante meets the spirit of Charles Martel, King of Hungary, and son of Charles II, King of Naples and Sicily. In life he had been a good friend to Dante.

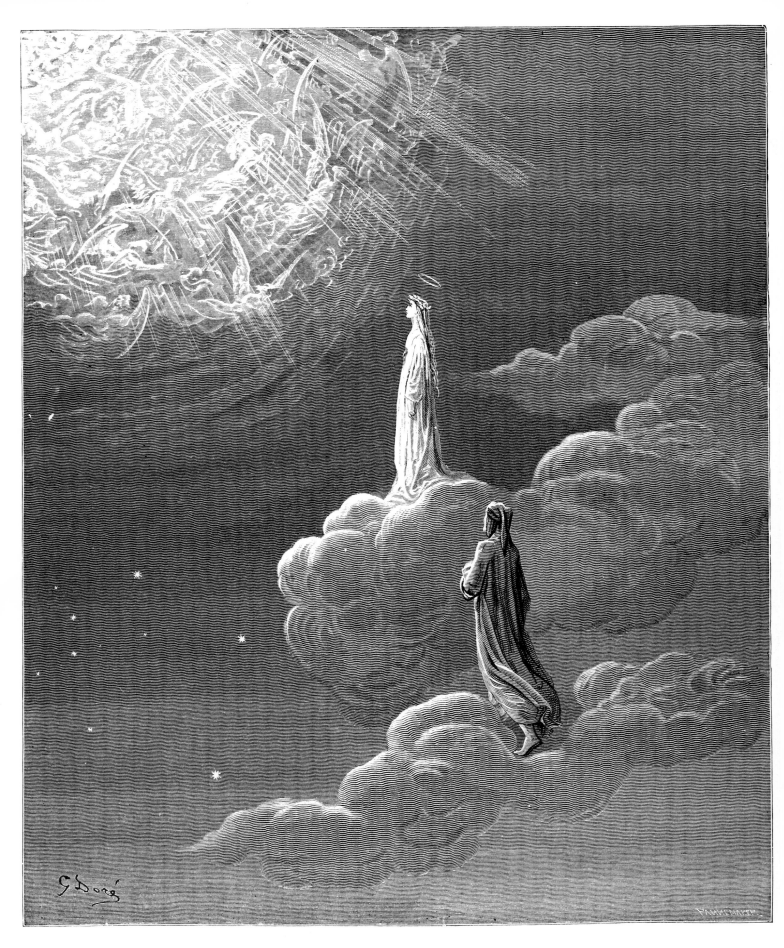

**Dante's Paradise**

**Canto XIV, lines 77–9**

*And I beheld myself,*
*Sole with my lady, to more lofty bliss*
*Translated.*

Dante and Beatrice rise together toward the fifth heaven, which is on the planet Mars.

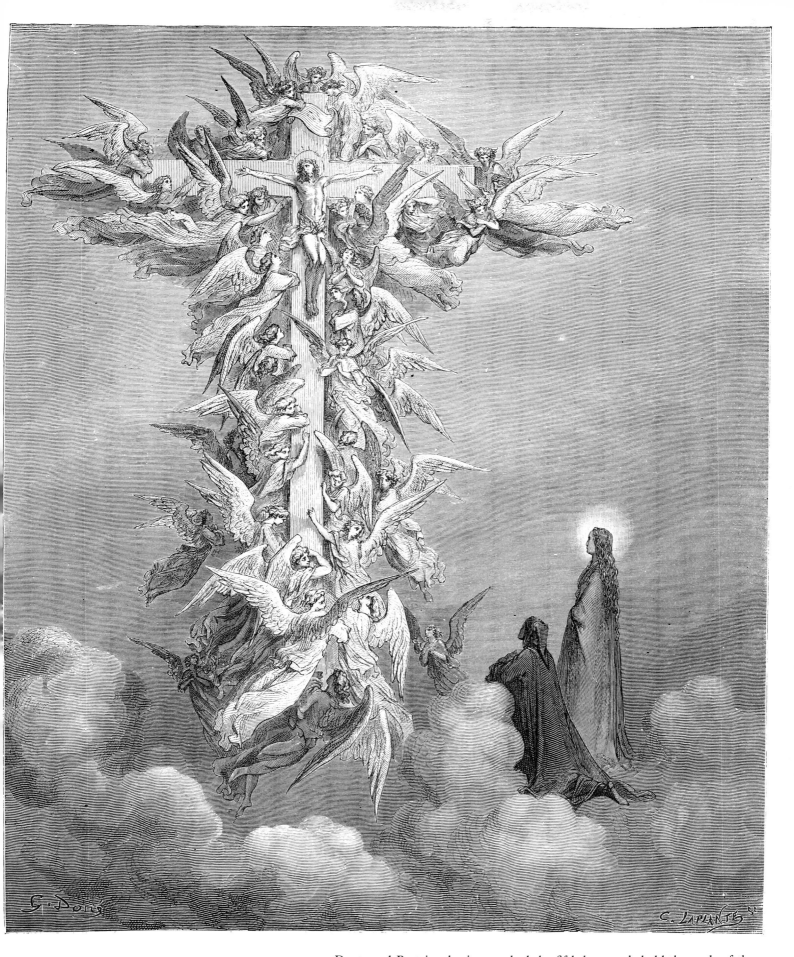

**Dante's Paradise**

**Canto XIV, lines 96–7**

*Christ*
*Beamed on that cross; and pattern fails me now.*

Dante and Beatrice, having reached the fifth heaven, behold the souls of those who had died for Christianity during the crusades. They are arranged in the sign of a cross.

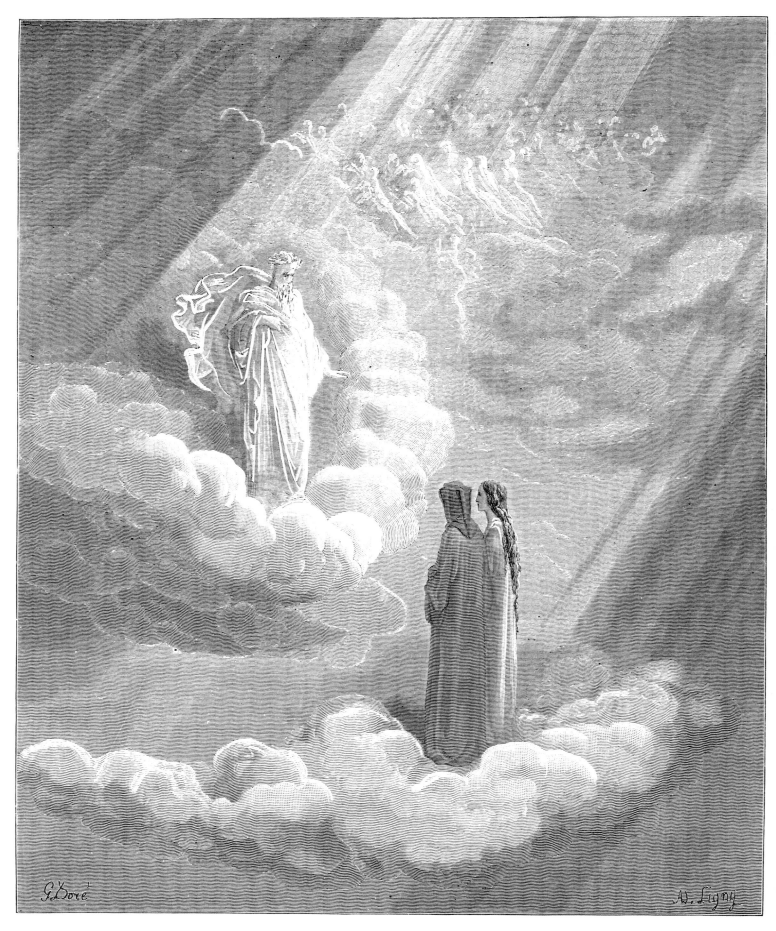

**Dante's Paradise**

**Canto XVI, lines 143–5**

*But so was doom'd:*
*Florence! on that maim'd stone which guards the bridge,*
*The victim, when thy peace departed, fell.*

Cacciaguida, an ancestor of Dante's, descends from the cross and tells the poet of the luxury and profligacy now existing in Florence in contrast to his times.

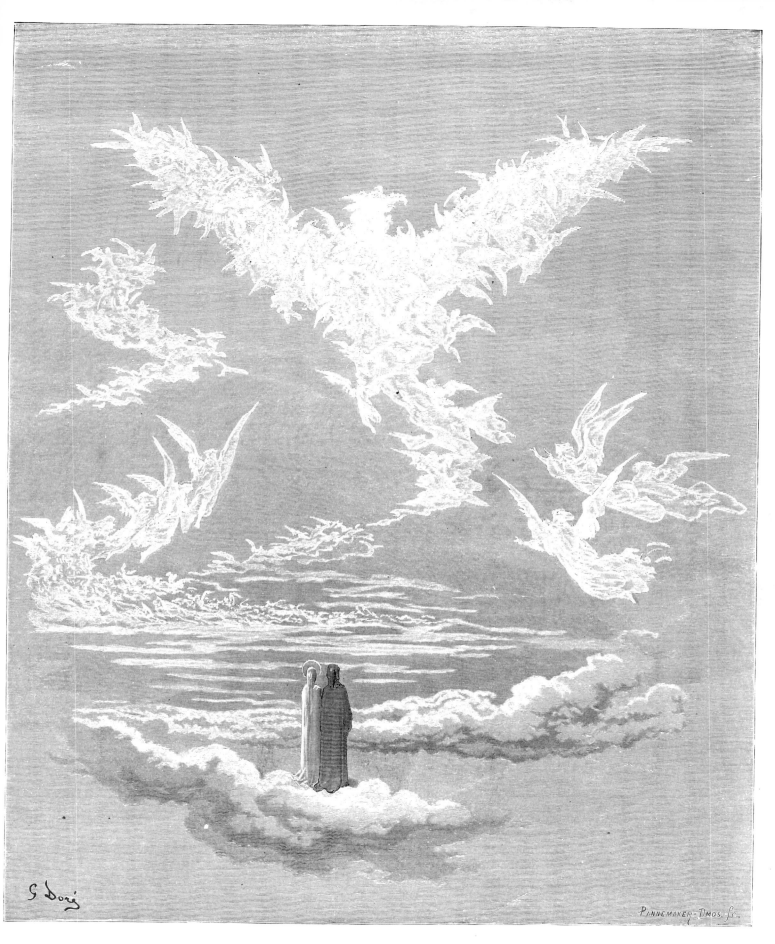

**Dante's Paradise**

**Canto XIX, lines 1–3**

*Before my sight appear'd with open wings,*
*The Beauteous image; in fruition sweet,*
*Gladdening the thronged spirits.*

In the sixth heaven, Dante and Beatrice see the souls of those who have ruled justly on earth disposed in the air in the form of an eagle.

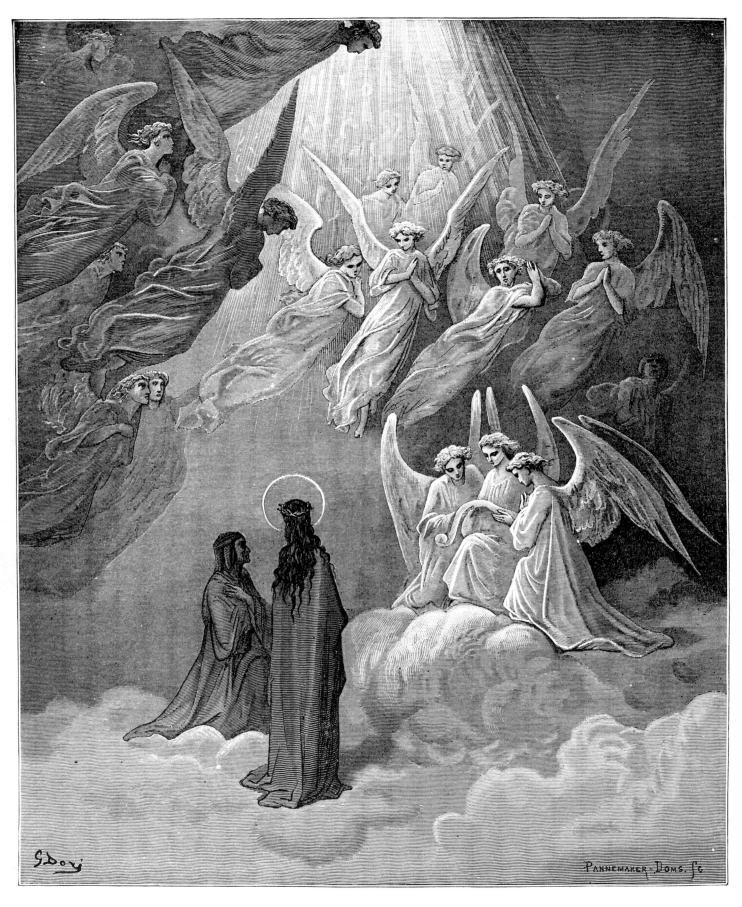

**Dante's Paradise**

**Canto XX, lines 10–12**

> For that all those living lights,
> Waxing in splendour, burst forth into songs,
> Such as from memory glide and fall away.

Here is another version of the vision of the eagle in the sixth heaven.

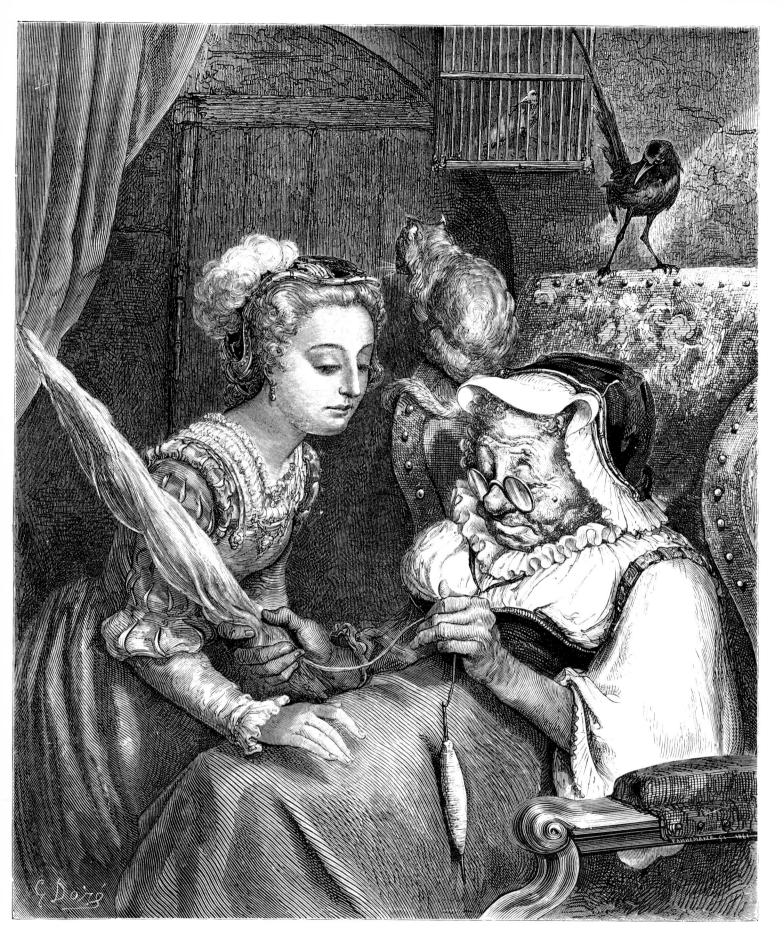

**Perrault's Fairy Realm**

**The Sleeping Beauty**

*The Princess looked in at the door and said
"What bonny white wool, and what bonny white thread."*

The Princess is seen in a remote room in the palace. She is talking to the old fairy Spite, who works the enchantment later recorded.

**Perrault's Fairy Realm**
**The Sleeping Beauty**

The palace of the Sleeping Beauty is seen in all its enchanted drowsiness.

**Perrault's Fairy Realm**

**The Sleeping Beauty**

*He sees a flight of steps, a gate o'ergrown with truant roses,*
*And someone who beside the gate in that warm sunshine dozes.*

The Prince, who is to dissolve the enchantment, approaches the palace down a long, dark avenue of trees. At the far end is seen the sleeping figure of the porter.

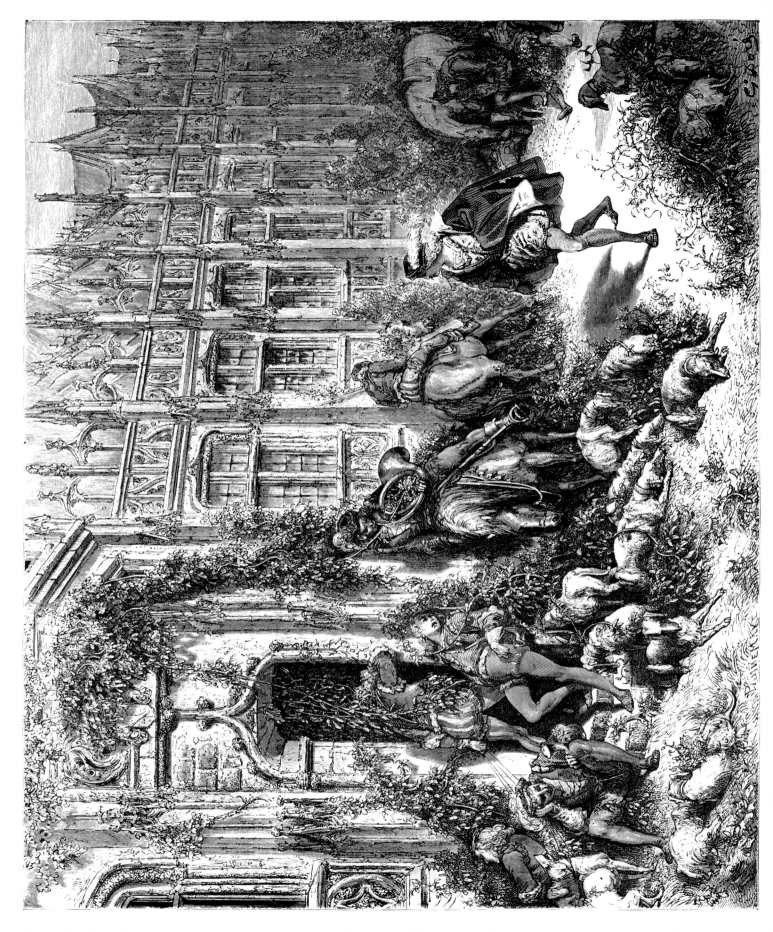

**Perrault's Fairy Realm**

**The Sleeping Beauty**

*Huntsmen bold returned from sport
Snoring, horns to lips!*

The young Prince approaches one of the entrances to the Palace. A party of huntsmen are seen frozen in attitudes of sudden sleep.

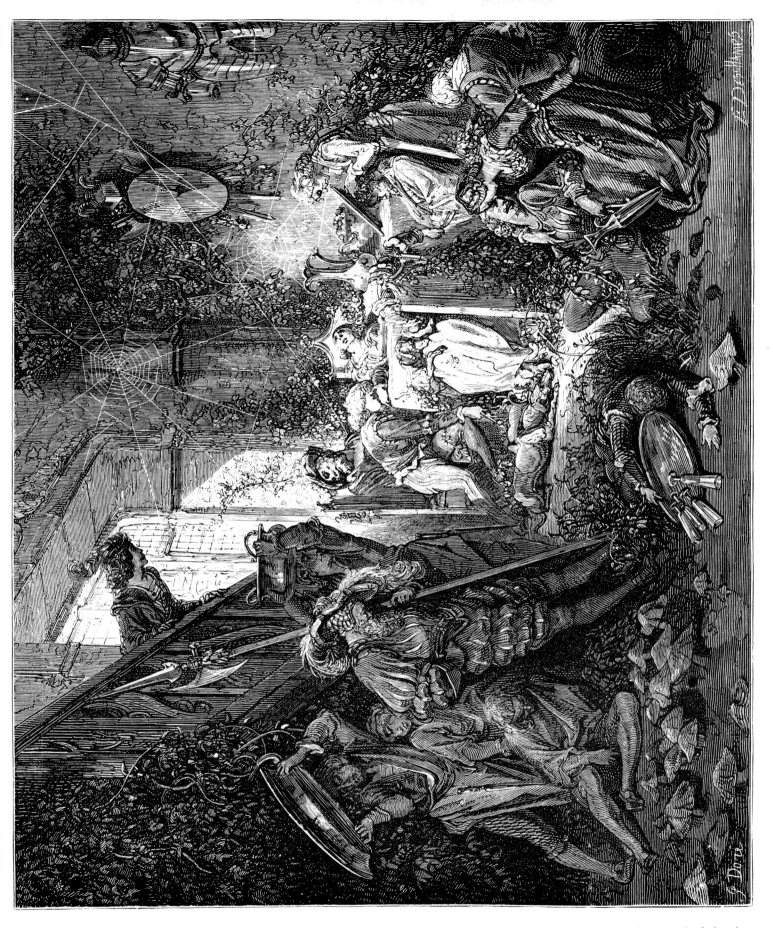

**Perrault's Fairy Realm**

**The Sleeping Beauty**

*Until he reached the grandest room of all,*
*The banquet hall.*

The Prince is depicted looking down from a gallery on the crowd of sleeping figures.

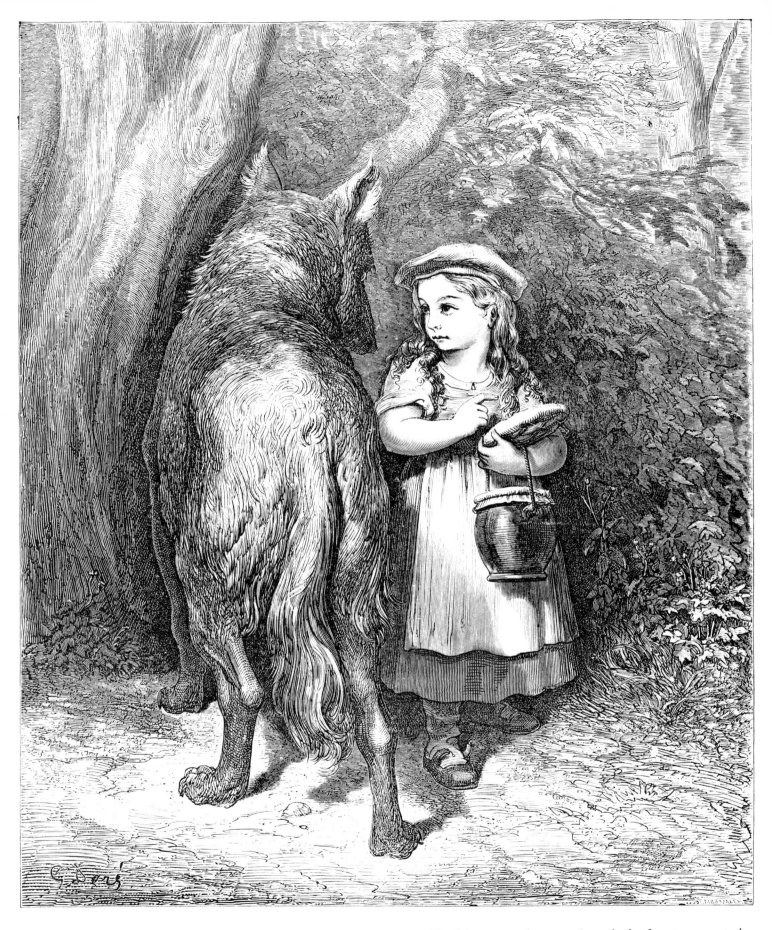

**Perrault's Fairy Realm**

**Little Red Riding Hood**

*"I'm going to my granny's, to carry this jar*
*And this cake for my mother." "Indeed! is it far?"*

Little Red Riding Hood is seen on her way through the forest, encountering the wolf.

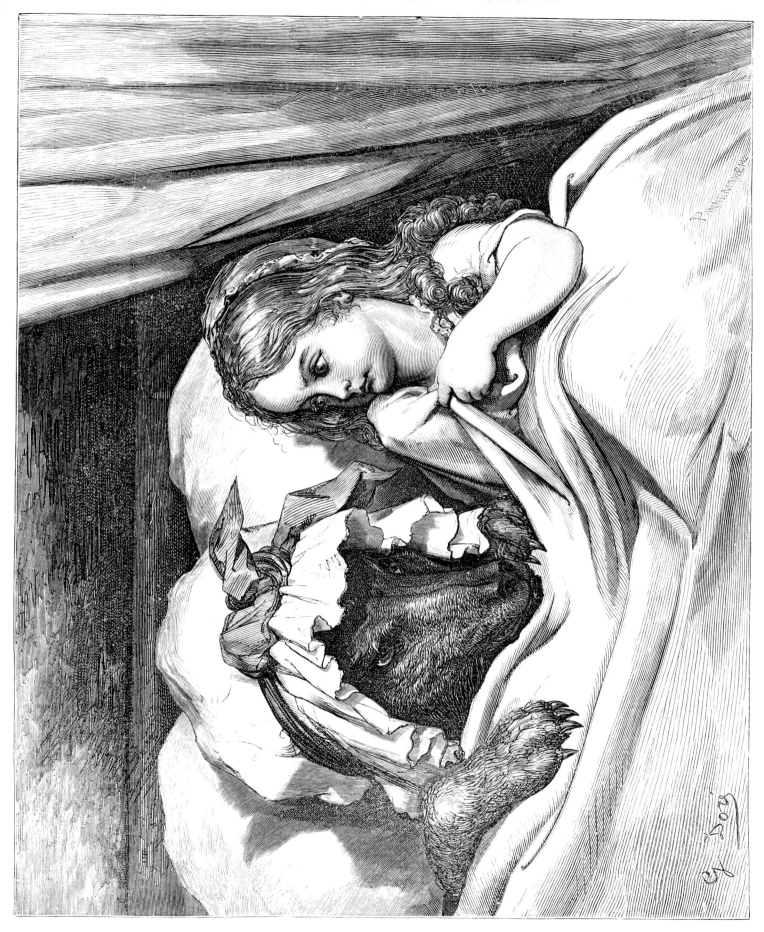

The wolf reveals himself.

**Perrault's Fairy Realm**

**Little Red Riding Hood**

*"Oh, granny, your teeth are tremendous in size!"*
*"They're to eat you!" and he ate her.*

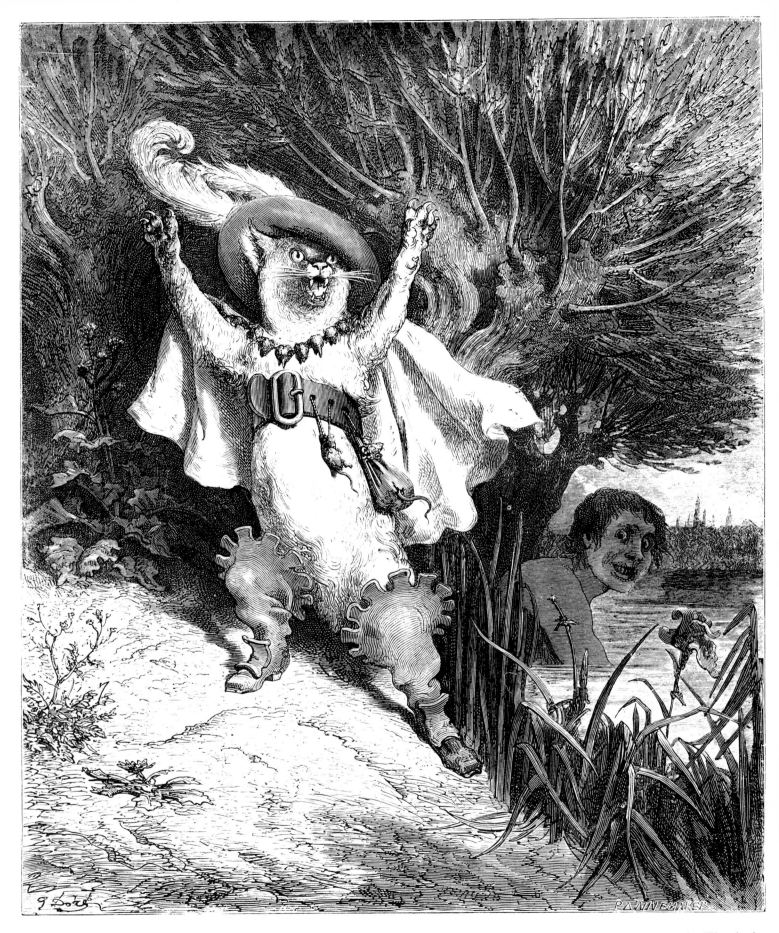

**Perrault's Fairy Realm**

**Puss in Boots**

*His cries the whole neighbourhood round might awaken—
"The Marquis of Casabas' clothes have been taken."*

Here is illustrated the well-known scene where Puss, knowing the King is due to pass by, gets his master to bathe in the river, hides his clothes, and then proclaims him to be the Marquis. The King supplies the bogus noble with a magnificent suit from his own wardrobe.

**Perrault's Fairy Realm**

**Hop o' my Thumb**

*While this way or that way each rapidly shoots off,*
*Hop o' my Thumb takes the Seven League Boots off.*

Hop o' my Thumb is seen carefully removing the ogre's magic boots whilst his friends escape.

**Perrault's Fairy Realm**

**Hop o' my Thumb**

*Far away*
*Shone a single ray.*

Lost at night with his little brothers, Hop o' my Thumb climbs to the top of a tree and sees a distant light. They are unaware it comes from the ogre's house.

**Perrault's Fairy Realm**

**Hop o' my Thumb**

*Who are you*
*You queer little crew?*

After a wearying journey, Hop o' my Thumb and his brothers arrive by night at the house of the ogre. The ogress is seen shining the light from a lantern on to the party of little people.

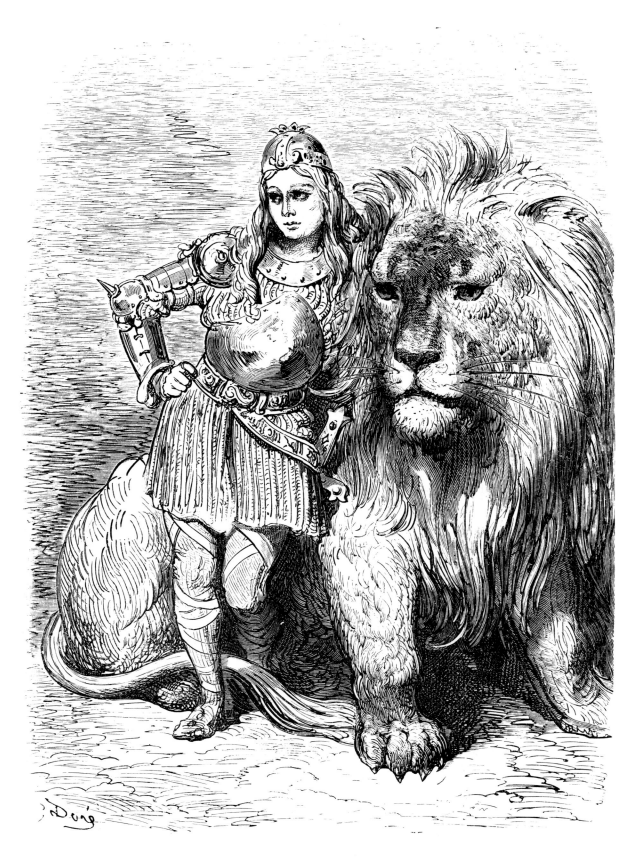

**The Legend of Croquemitaine**

**Mitaine and Oghris**

Mitaine is the heroine of the original romance by L'Epine. She is the god-child of Charlemagne and is in love with the famous knight Roland. Here she is seen with the lion Oghris, once owned by a Saracen warrior, but now greatly attached to Mitaine.

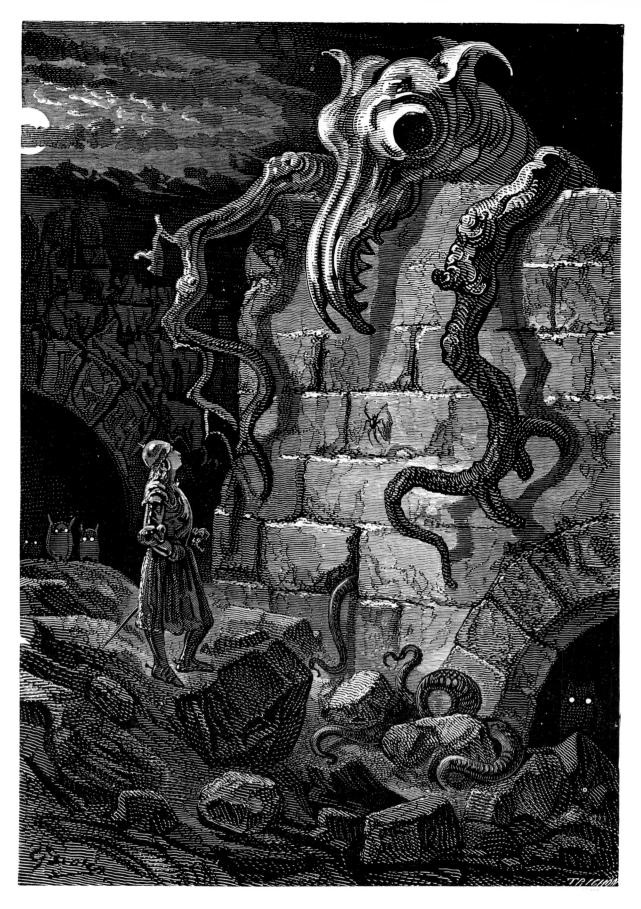

**The Legend of Croquemitaine**

**The Gnarled Monster**

Mitaine undertakes to find and destroy the Fortress of Fear. She encounters a great monster on the crest of a ruined wall. Praying to St Landri, she summons up her courage and gives the wall a vigorous kick. The wall collapses and the monster is seen for what it is, an old and harmless tree.

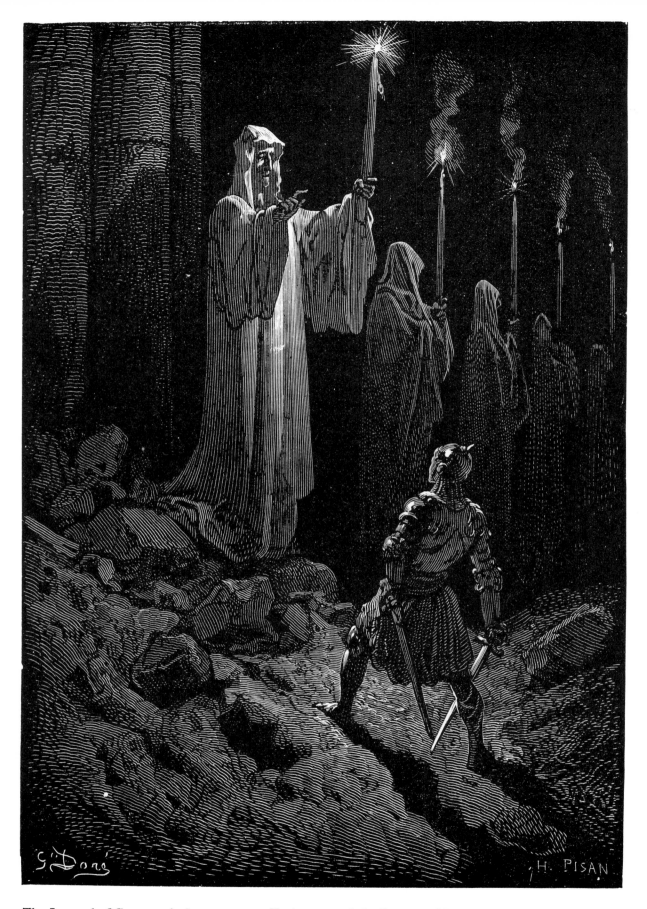

**The Legend of Croquemitaine**

**The Corpse Candles**

Having entered the Fortress of Fear, Mitaine finds herself in a vast gallery, lit only by the moon. Before her open a series of folding doors, while on her right are huge columns which crumble as she passes them, each being replaced by a corpse in its winding-sheet and holding in its hand a lighted torch.

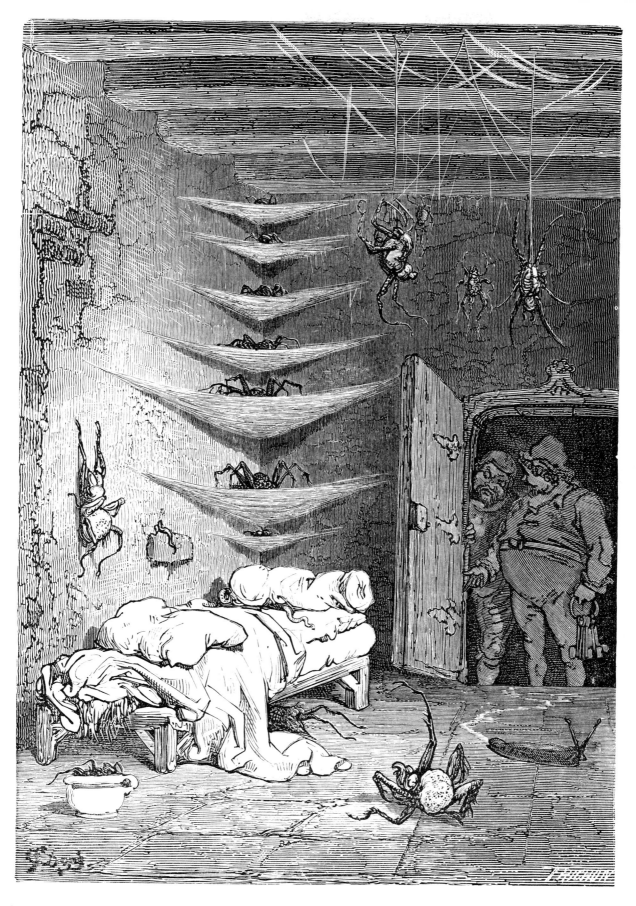

**The Legend of Croquemitaine**

**The Spare Bed at "The Crocodile"**

Four adventurous knights arrive at night and seek lodging at an inn, "The Crocodile". The scoundrel of a landlord shows them to what he calls his best bedroom. This hideous chamber is well represented in the drawing.

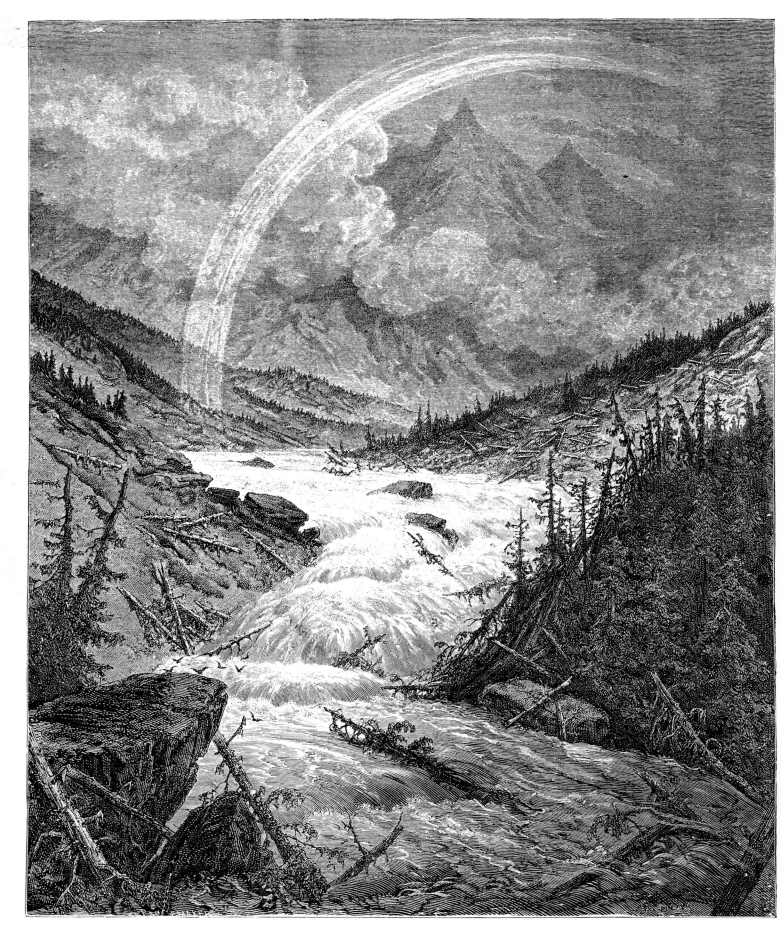

**Chateaubriand's Atala**

This magnificent landscape shows the Mississippi river in full spate.

**Prologue**
*At intervals the swollen river raises its voice
while passing over the resisting heaps.*

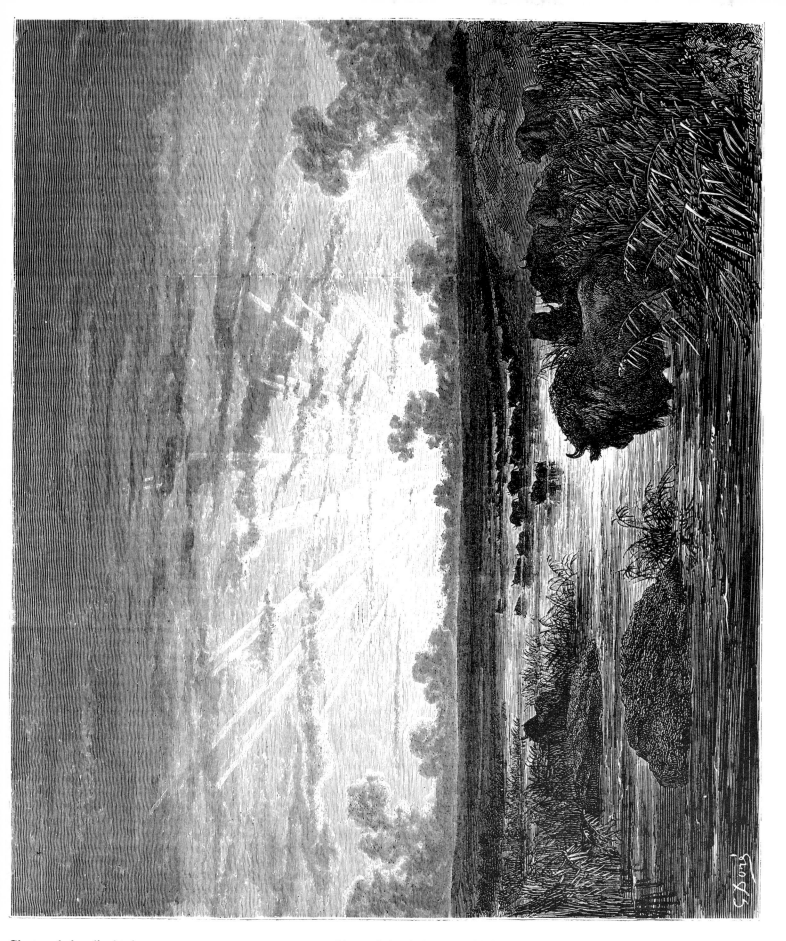

## Chateaubriand's Atala

**Prologue**

*In these limitless meadows herds of three or four*
*thousand wild buffaloes wander at random.*

Chateaubriand gives a vivid description of the vast Savannahs which spread for miles on the western bank of the Mississippi.

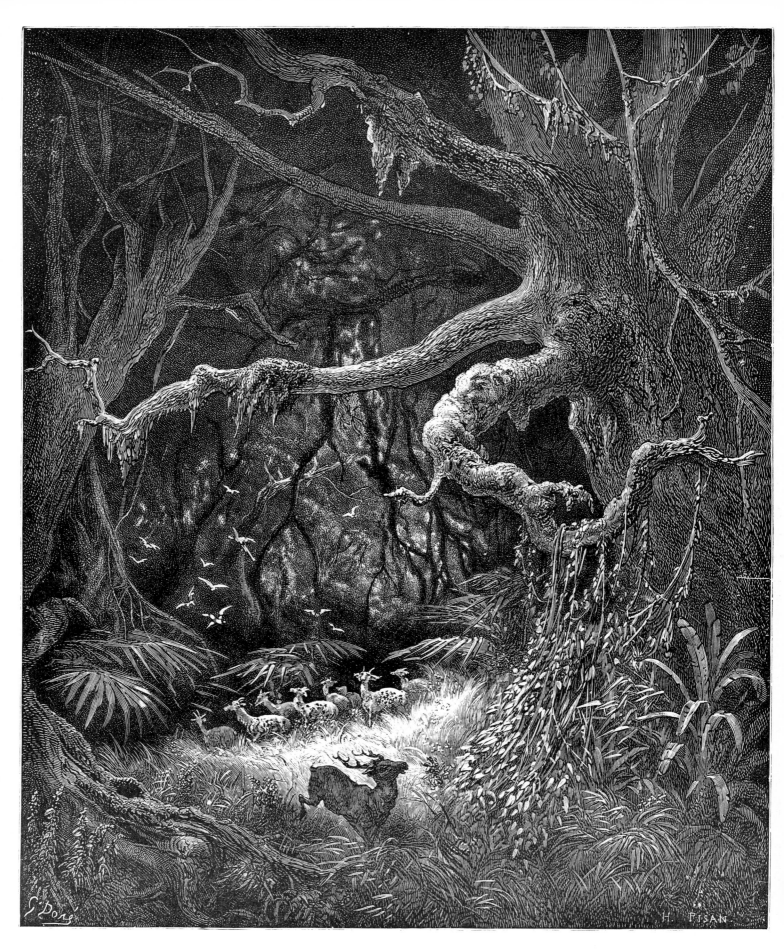

**Chateaubriand's Atala**

**Prologue**

*All here, on the contrary, is sound and motion.*

Here are depicted the huge dense forests which line the eastern banks of the river.

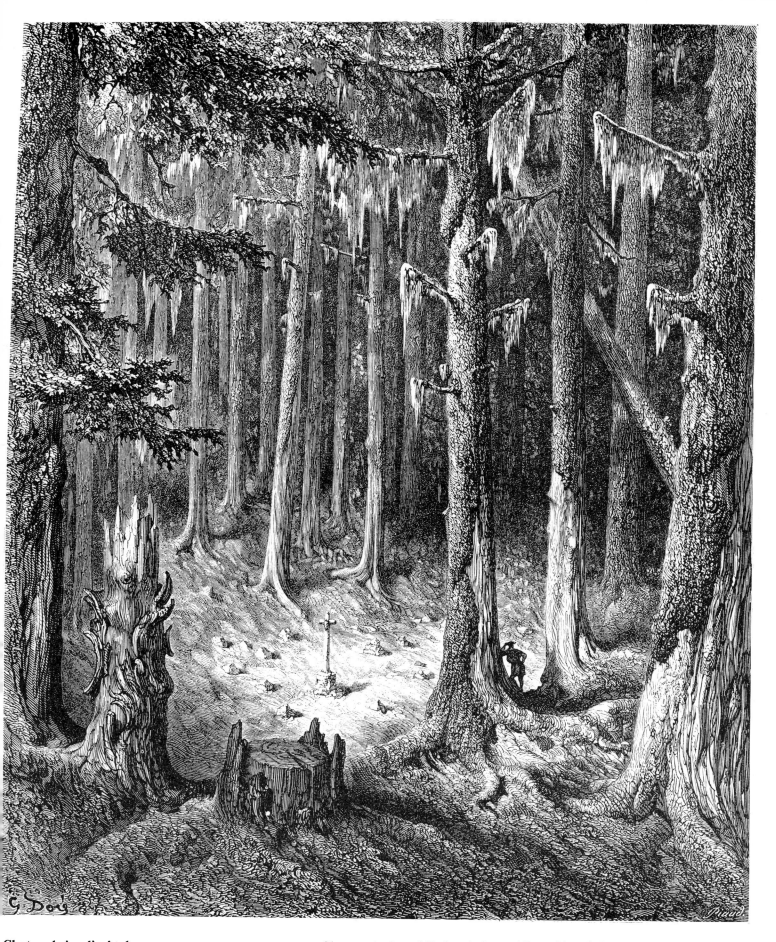

## Chateaubriand's Atala

### Narrative

*We remarked a religious sound, similar to the half-suppressed murmurs of an organ beneath the roof of a church.*

Chactas, Atala and Father Aubry, while making their way to the Mission, come upon the Cemetery of Christianised Indians, a place the natives call the "Groves of Death".

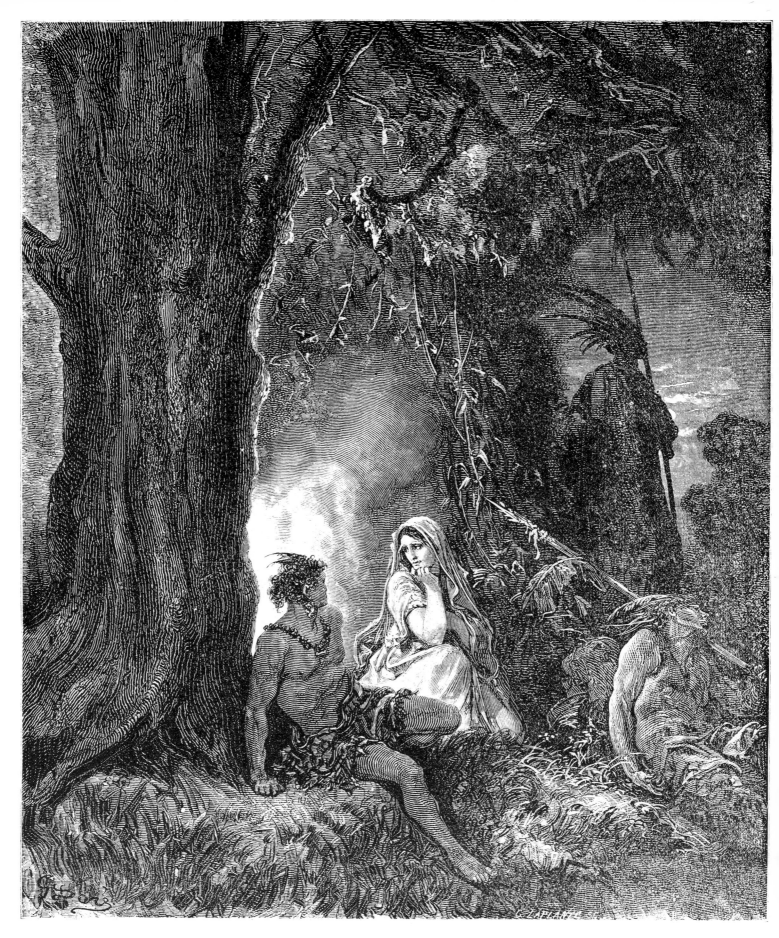

## Chateaubriand's Atala

### Narrative

*All of a sudden, I heard the sound of a dress upon the grass.*

Chactus, now a prisoner of the Muscogulges and Seminoles, is visited for the first time by Atala.

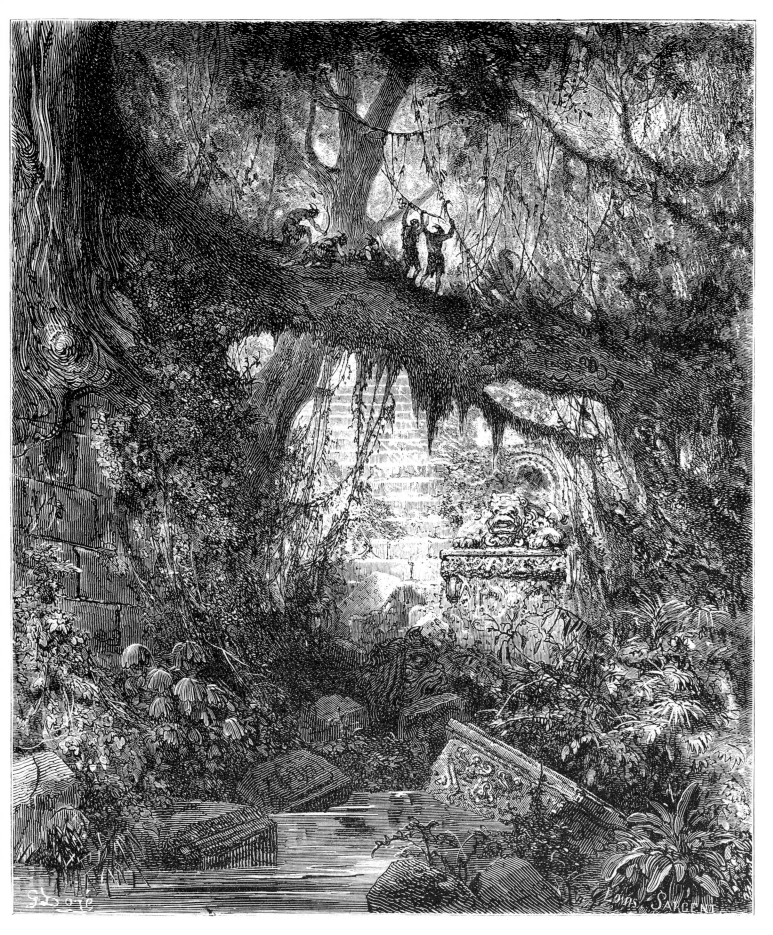

**Chateaubriand's Atala**

**Narrative**

Chactas, a prisoner, is conveyed to the Wood of Blood, where he is to be tortured and killed. In the course of night Atala frees him from his bonds, and they escape together.

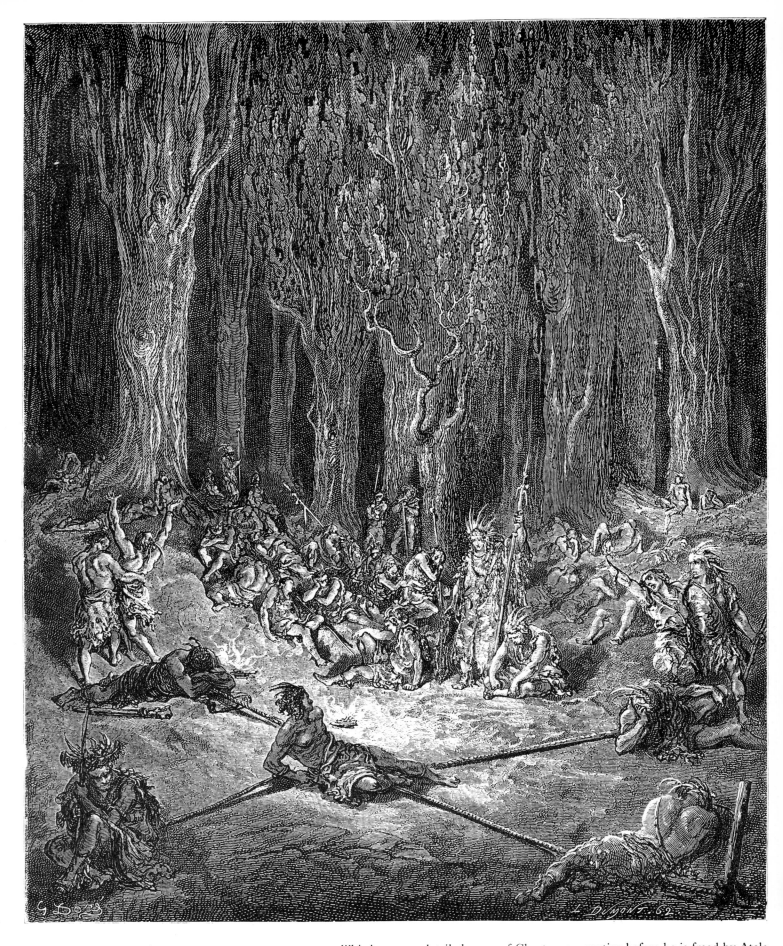

## Chateaubriand's Atala

This is a more detailed scene of Chactas as a captive before he is freed by Atala.

### Narrative

*At last they all fell asleep; but as the noise of men became pacified, that of the desert seemed to increase, and to the tumult of voices succeeded the howlings of the winds in the forests.*

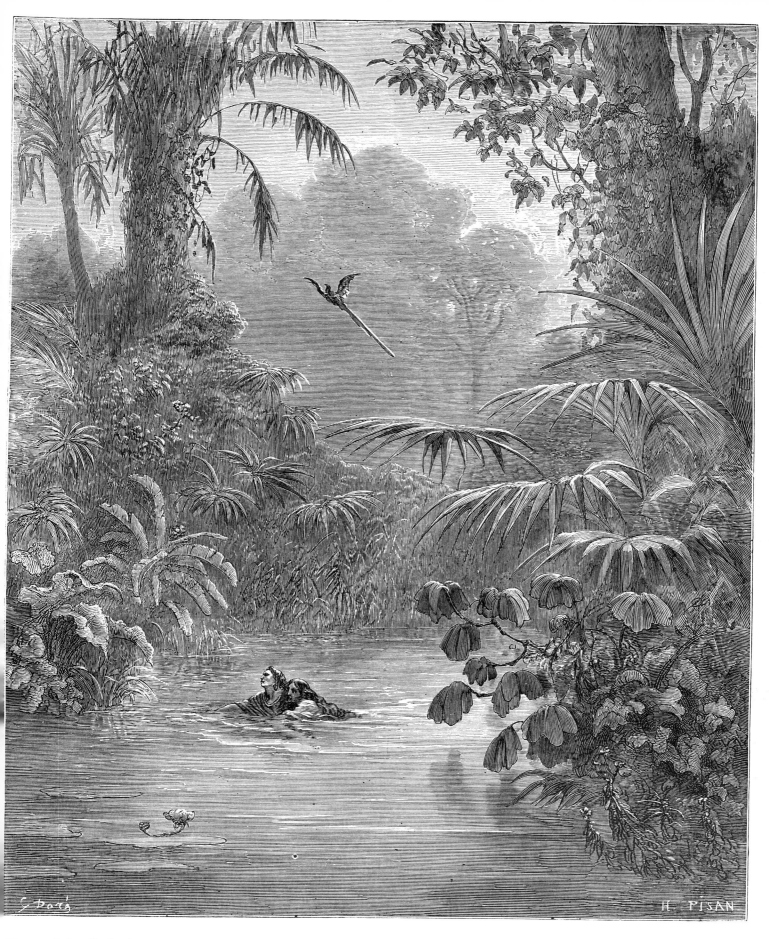

## Chateaubriand's Atala

### Narrative

*Like a pair of migratory swans, we traversed the solitary waves.*

Chactas and Atala flee through dense forests and across deserts to escape their possible pursuers.

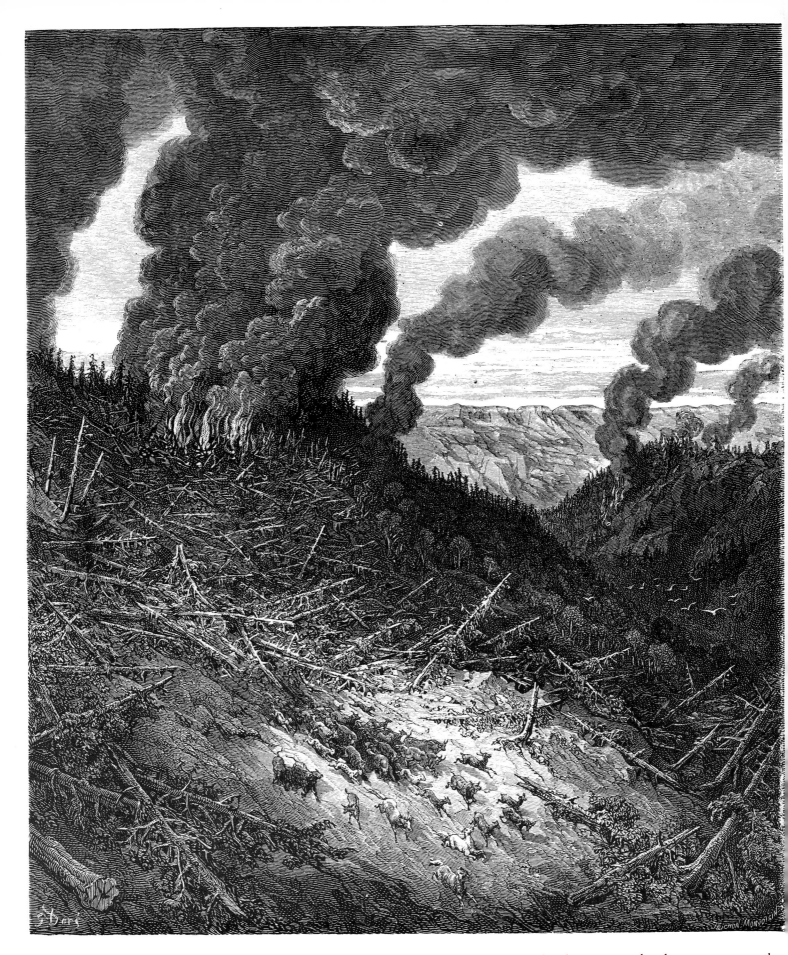

**Chateaubriand's Atala**

**Narrative**

*The conflagration extended like a headdress of flame.*

During their escape, the hero and heroine are overtaken by a great storm, the lightning from which sets the forest ablaze.

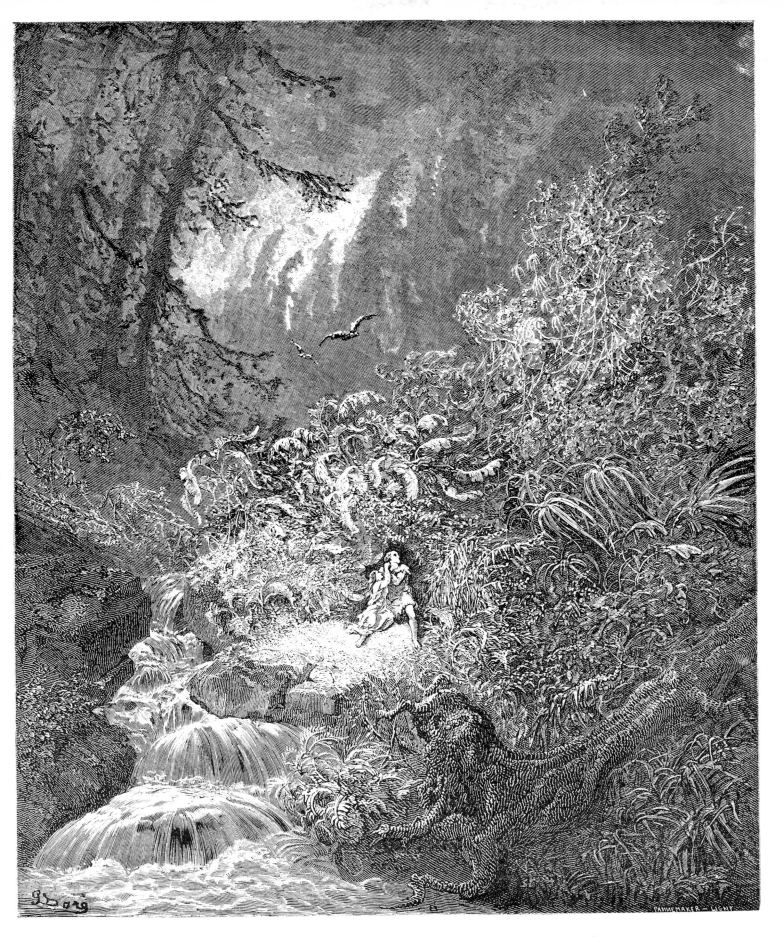

**Chateaubriand's Atala**

**Narrative**

*The Great Spirit knows that at this moment I saw and thought of nothing but Atala.*

Here is another scene of the great storm in the forest.

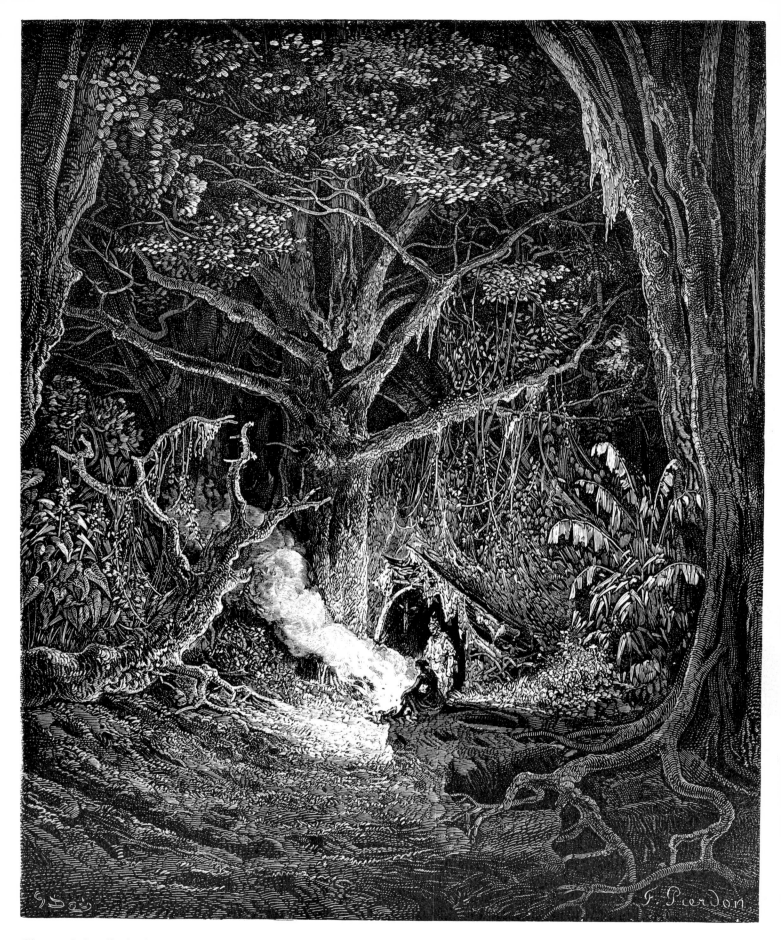

**Chateaubriand's Atala**

**Narrative**

*Every evening we lighted a large fire and built a travelling hut.*

Chactas and Atala are seen in the forest, during their escape, preparing for the night.

218

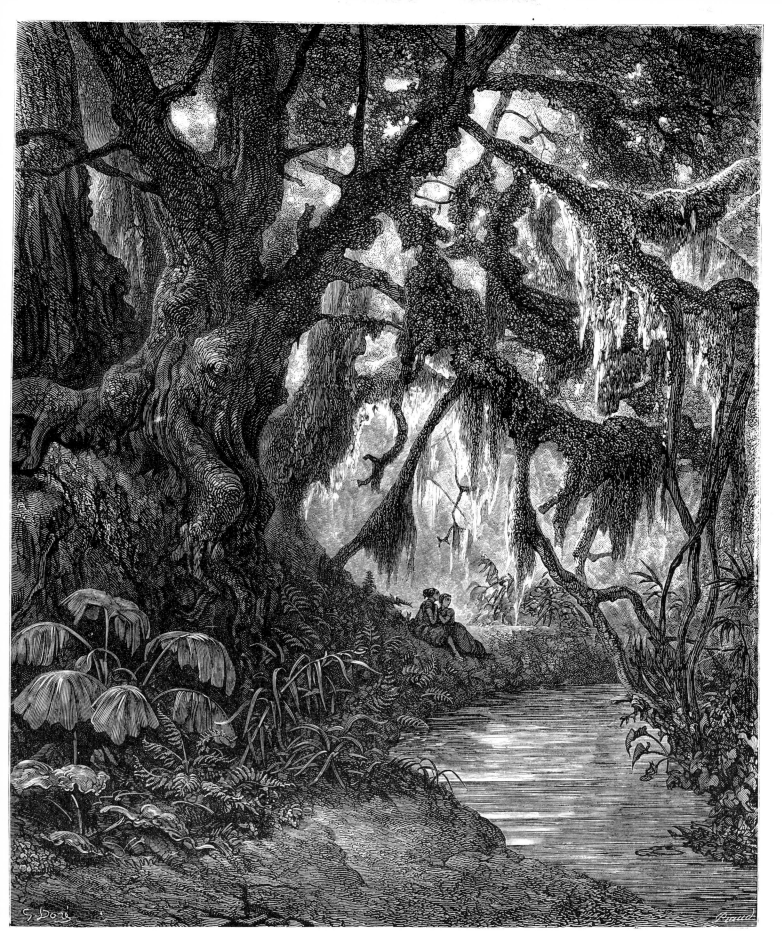

## Chateaubriand's Atala

### Narrative

*It was in the shade of such smiling quarters prepared by the Great Spirit, that we stopped to repose ourselves.*

"During the heat of the day," recounts Chactas, "we frequently sought shelter beneath the moss of the cedars." We see the lovers seated on the bank of a forest stream.

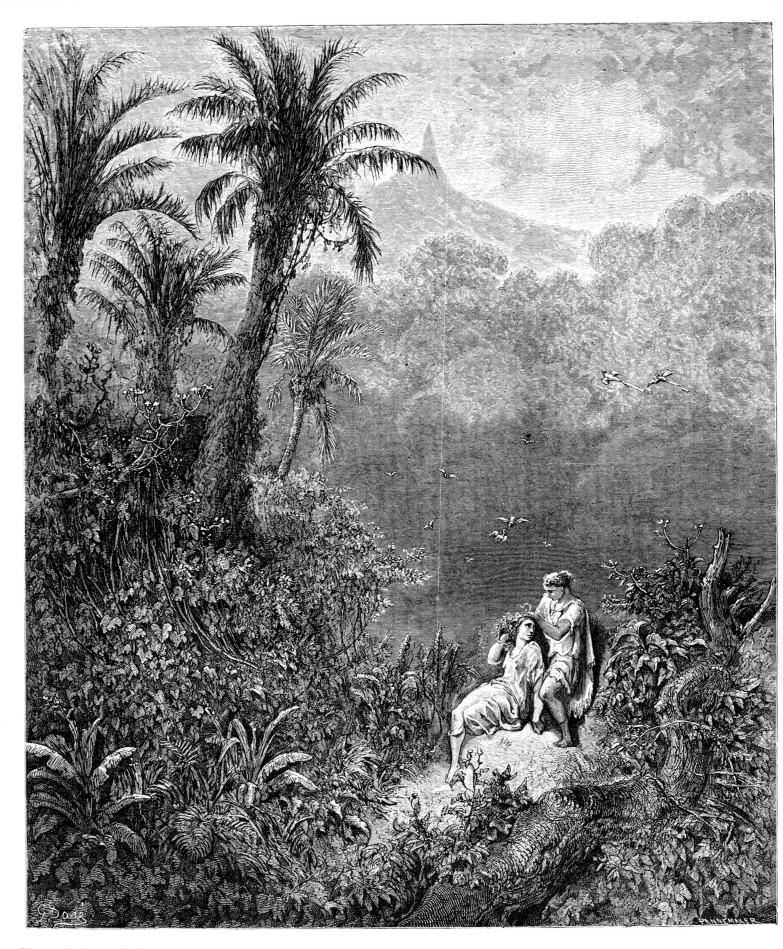

**Chateaubriand's Atala**

**Narrative**

*In my turn, I did all in my power to ornament her attire.*

The lovers feel themselves free from pursuit. Atala makes her lover a cloak and some moccasins, while Chactas makes her a crown of blue mallow flowers and a necklace of red azalea berries.

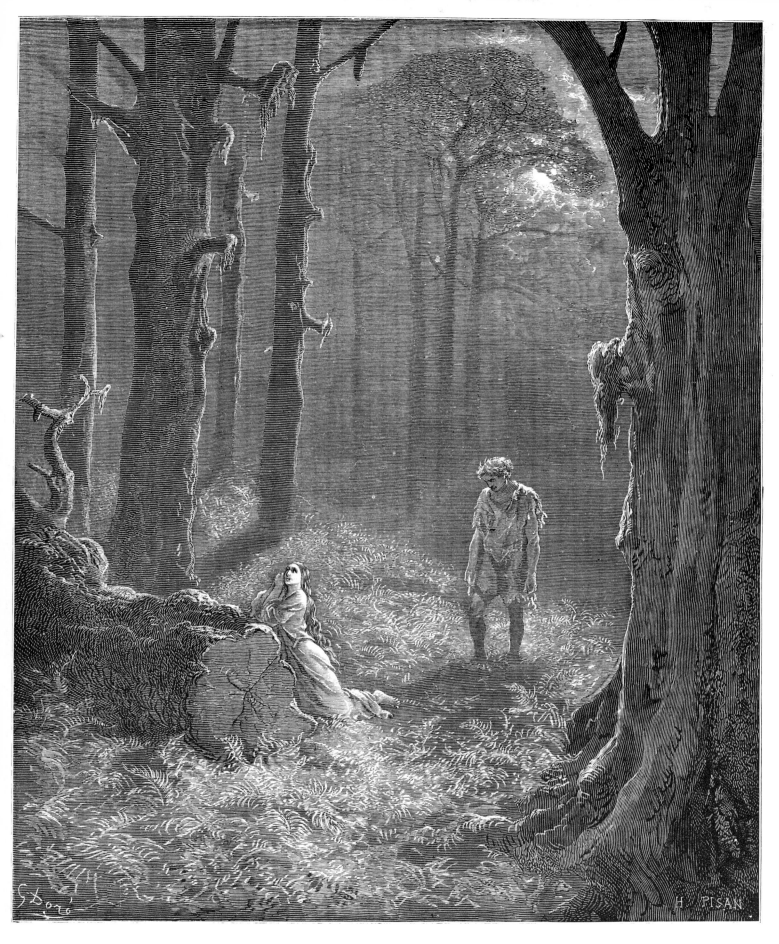

## Chateaubriand's Atala

### Narrative

*Several times it appeared to me as though she were about to take her flight to heaven.*

Alone in the forest, Atala and Chactas become more and more attracted to each other. Atala, having taken a vow of chastity, prays for strength to fulfil that undertaking.

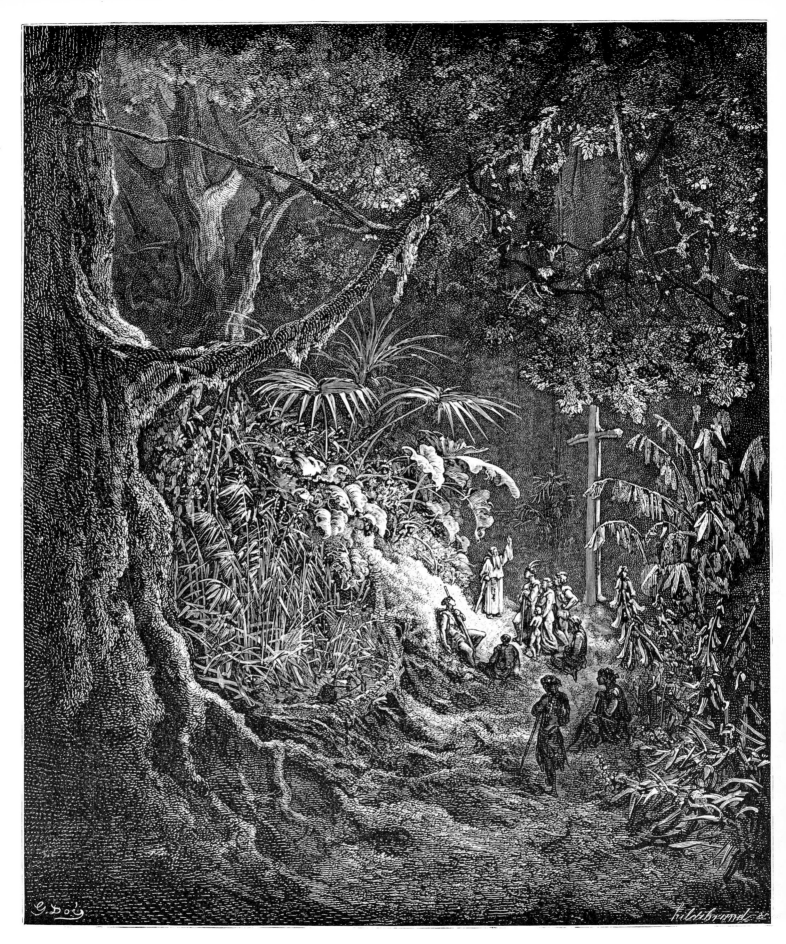

**Chateaubriand's Atala**

**Narrative**

*He alluded to God in every topic he touched upon.*

The two lovers come across the old hermit preaching in the forest.

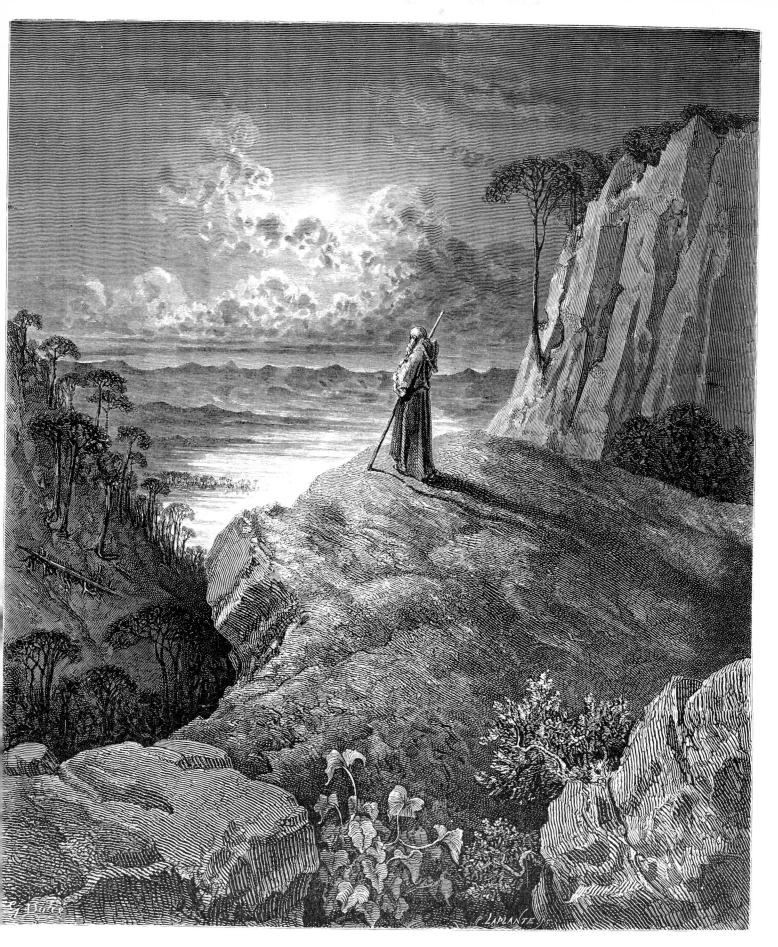

**Chateaubriand's Atala**

**Narrative**

*He had gone to contemplate the beauty of the heavens,
and to pray to God on the top of the mountain.*

The old hermit is depicted, absorbed in contemplation, on the top of a high
mountain at night.

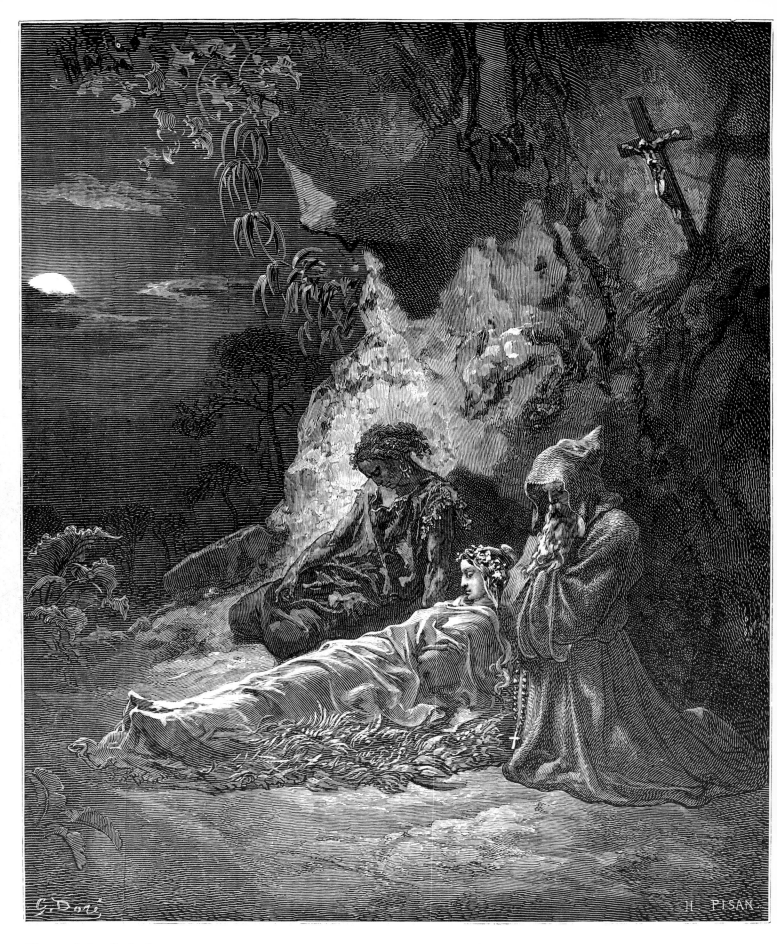

## Chateaubriand's Atala

### Narrative

*The Moon lent her pale light to this funereal watching.*

Atala has taken poison rather than invite further temptation. Her corpse is seen laid out, the old hermit praying on one side and Chactas, listless with grief, on the other.

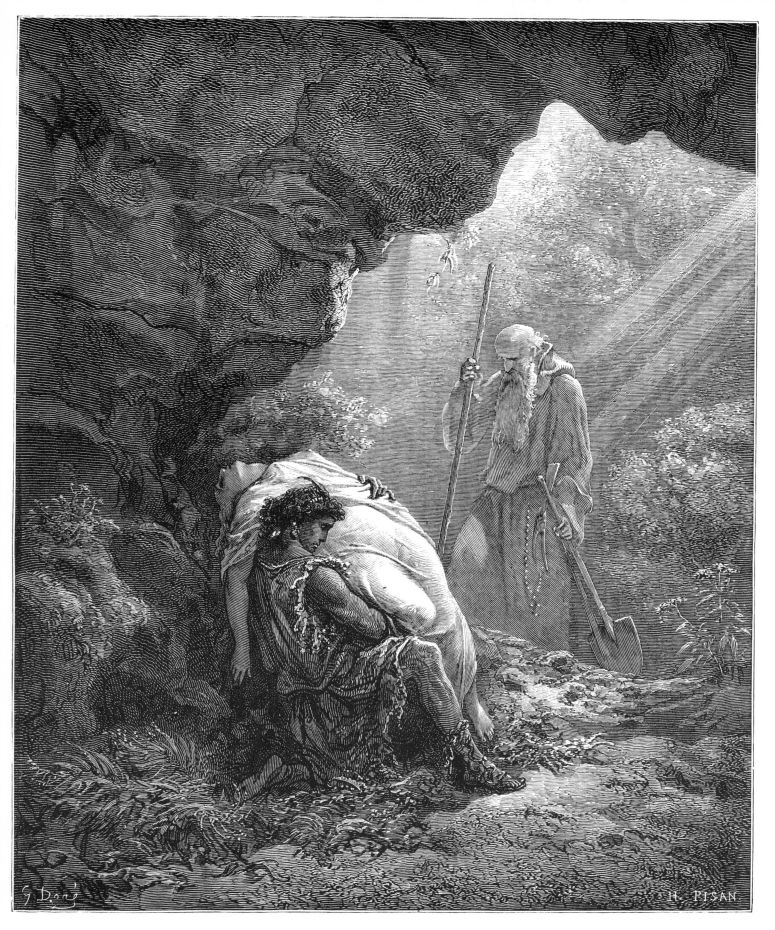

Chactas carries the corpse of Atala to her burial place.

**Chateaubriand's Atala**

**Narrative**

*Bending beneath the burden, I was obliged to lay it
down often upon the moss, to recover my strength.*

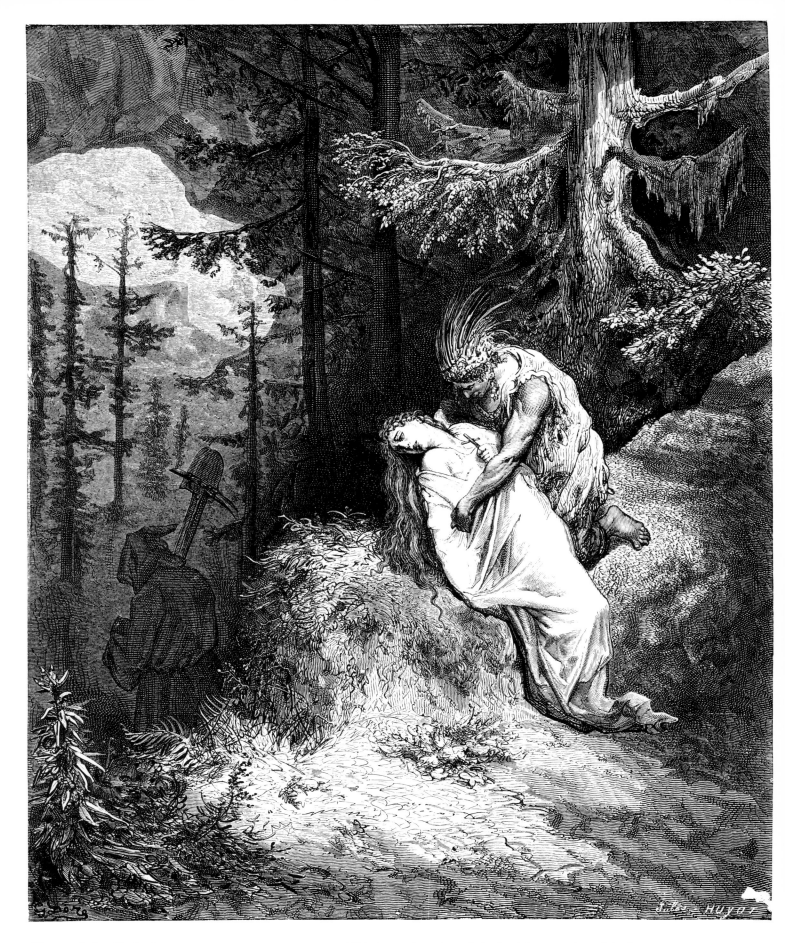

## Chateaubriand's Atala

### Narrative

*I took the body on my shoulders; the hermit walked in
front of me, a spade in his hand.*

This is another view of the burial procession of Atala.

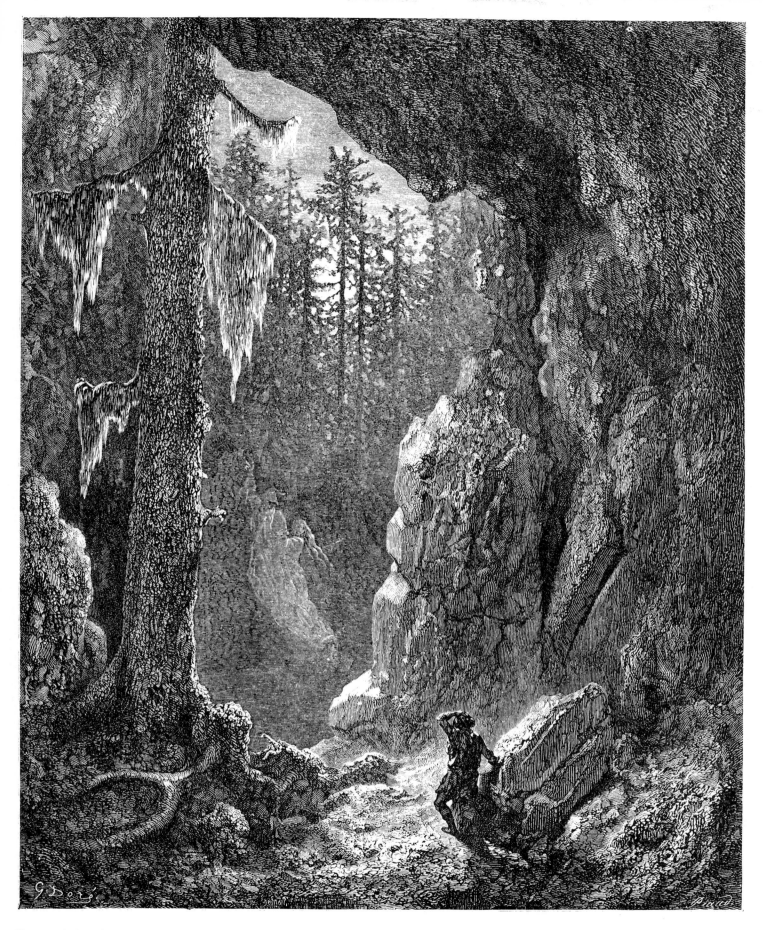

## Chateaubriand's Atala

### Narrative

*He fancied he saw the shades of Atala and Father Aubry rise out of the misty twilight.*

Some time after the death of Atala and the killing of Father Aubry, Chactas returns to the Christian burial ground. He finds it destroyed by floods. Chance directs him to the graves of Atala and the hermit.

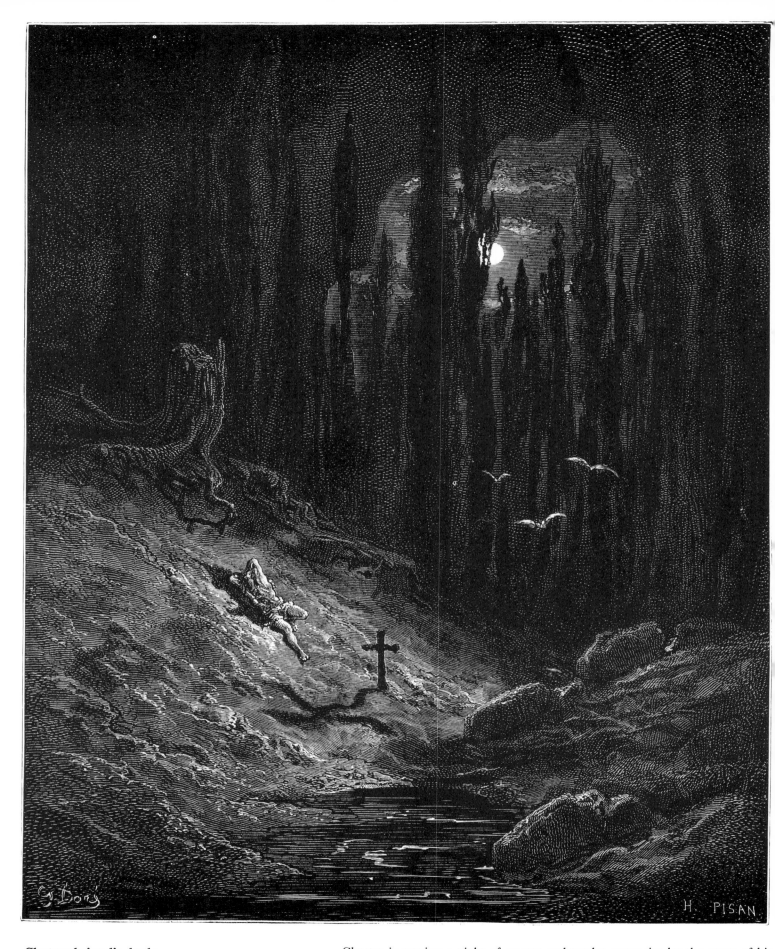

**Chateaubriand's Atala**

**Narrative**

*Three times I evoked the soul of Atala; three times
the genius of the desert responded to my cries beneath
the funereal arch.*

Chactas is passing a night of sorrow and tender memories by the grave of his
recently buried love.

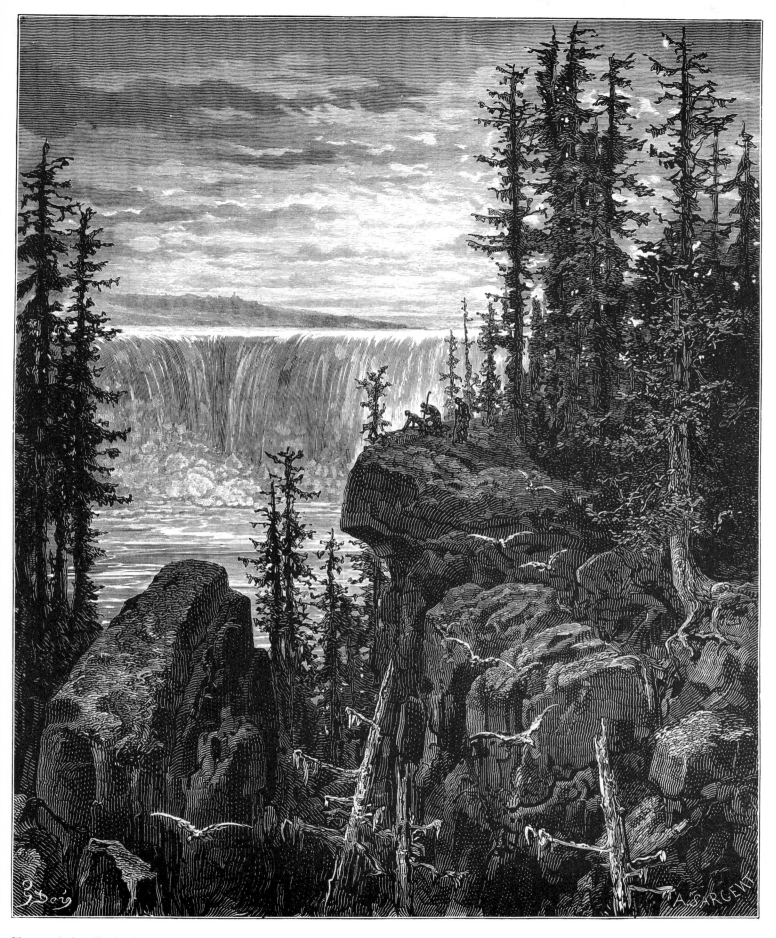

**Chateaubriand's Atala**

**Epilogue**

*We soon arrived at the border of the cataract, which
announced itself with frightful roarings.*

Here are depicted the Falls of Niagara, little known to Europeans at the date
of publication of the story.

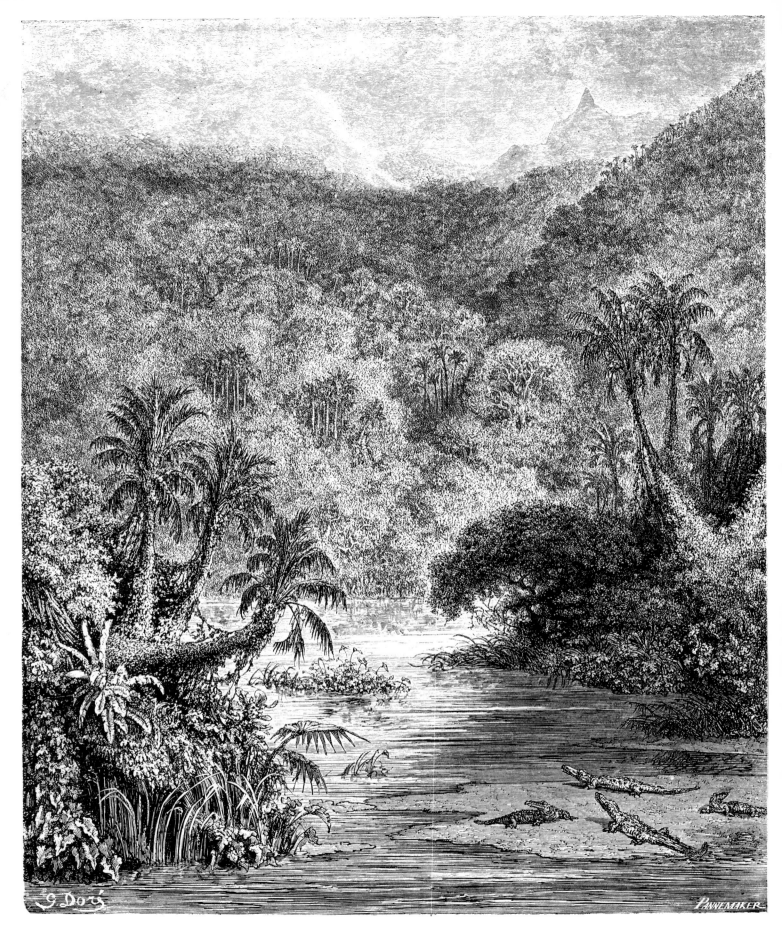

**Chateaubriand's Atala**

**Epilogue**

*Trees of every form, of every colour, and of every perfume.*

This detailed landscape shows the magnificent forest scenery on the banks of the Mississippi.

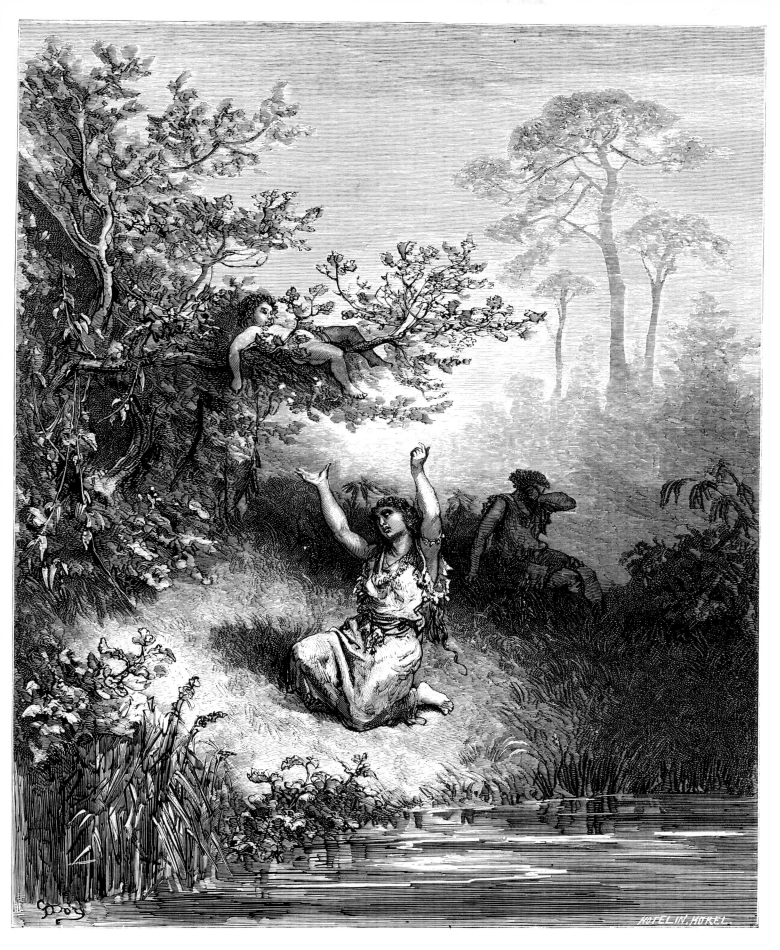

**Chateaubriand's Atala**

**Epilogue**

*She selected a maple with red flowers, festooned with garlands of apios that emitted the sweetest perfumes.*

The author gives an account of the funeral rites of an Indian mother over the body of her dead child.

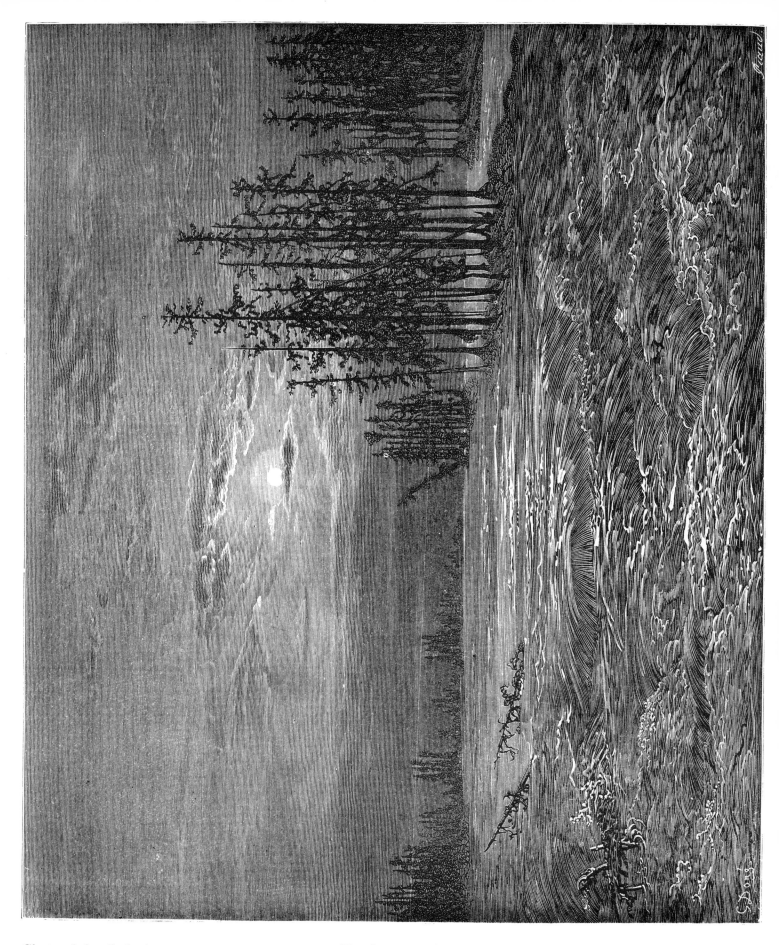

**Chateaubriand's Atala**

**Epilogue**

*From Lake Erie to the Falls, the river flows with a rapid inclination.*

Here is seen another fine landscape of then little-known country.

**Raspè**

**The Adventures of Baron Munchausen**

**Baron Munchausen**

Here is shown an imaginary bust of this droll figure.

**Raspè**

**The Adventures of Baron Munchausen**

**The Lion and the Crocodile**

The intrepid Baron, pursued by a lion, encounters a huge crocodile. To his amazement and relief, the lion's spring carries it straight into the gaping jaws of the crocodile.

**Raspè**

**The Adventures of Baron Munchausen**

*Some, standing in a circle, sang choruses of inexpressible beauty.*

During a visit to England, the Baron meets a sea-horse on the shore. He tames it and rides on its back into the sea. The horse gallops swiftly over the bottom of the sea and our hero sees many extraordinary sights on his journey.

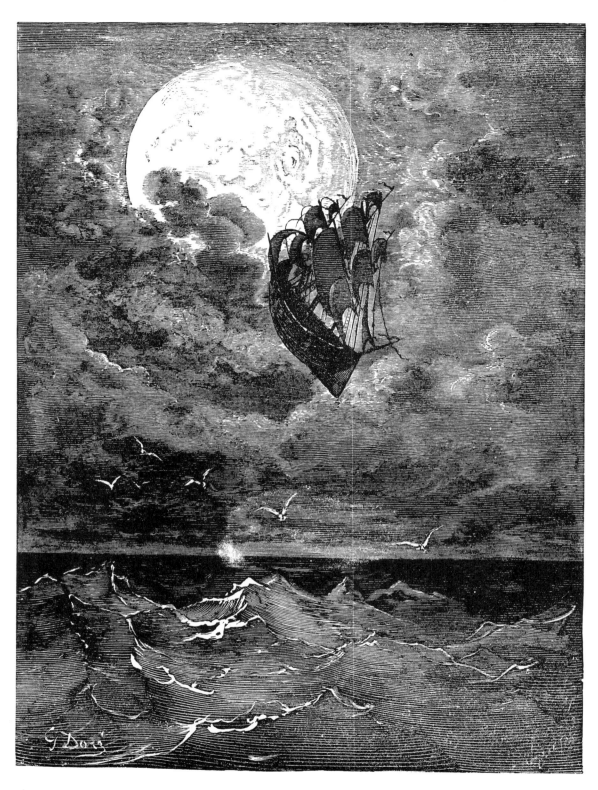

**Raspè**

**The Adventures of Baron Munchausen**

*A Voyage to the Moon.*

Our hero sets out by ship with a relative, on a voyage of discovery. A hurricane seizes their vessel and whirls it a thousand leagues into the air. They travel through the sky for six weeks until they see land in the distance. It looks round, shining, and proves indeed to be the moon.

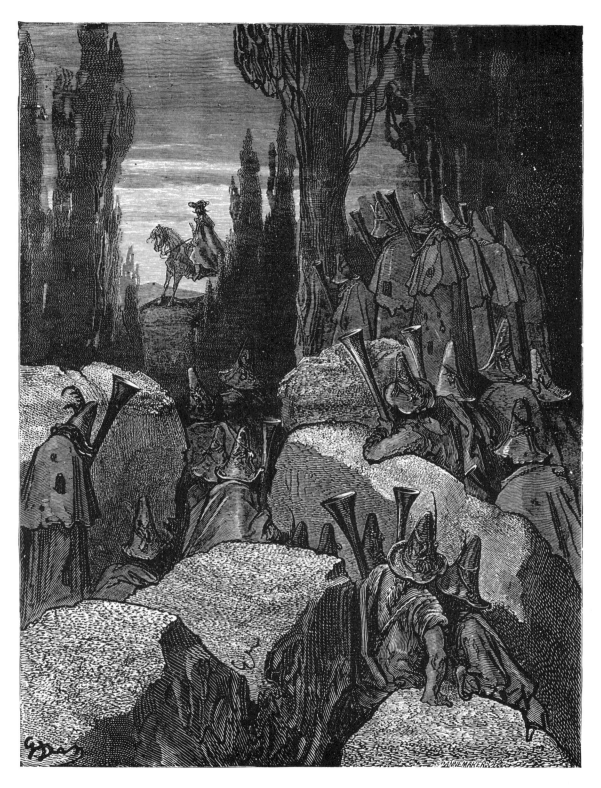

**Raspè**

**The Adventures of Baron Munchausen**

**Italian Highwaymen**

While travelling in Loretto, near Rome, the gallant Baron is set upon and robbed by a band of brigands.

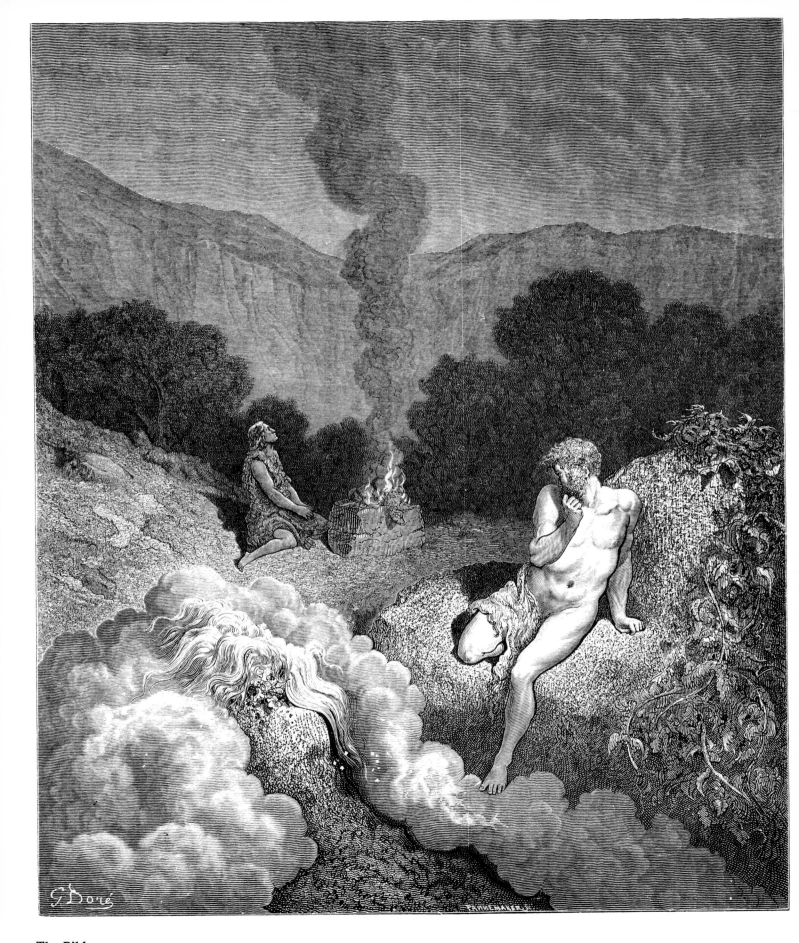

**The Bible**

**Gen. iv. 3–5**

*It came to pass that Cain brought of the fruit of the ground an offering unto the
Lord. And Abel, he also brought of the firstlings of his flock and of the fat thereof.
And the Lord had respect unto Abel and to his offering: but unto Cain and his
offering he had not respect. And Cain was very wroth, and his countenance fell.*

238

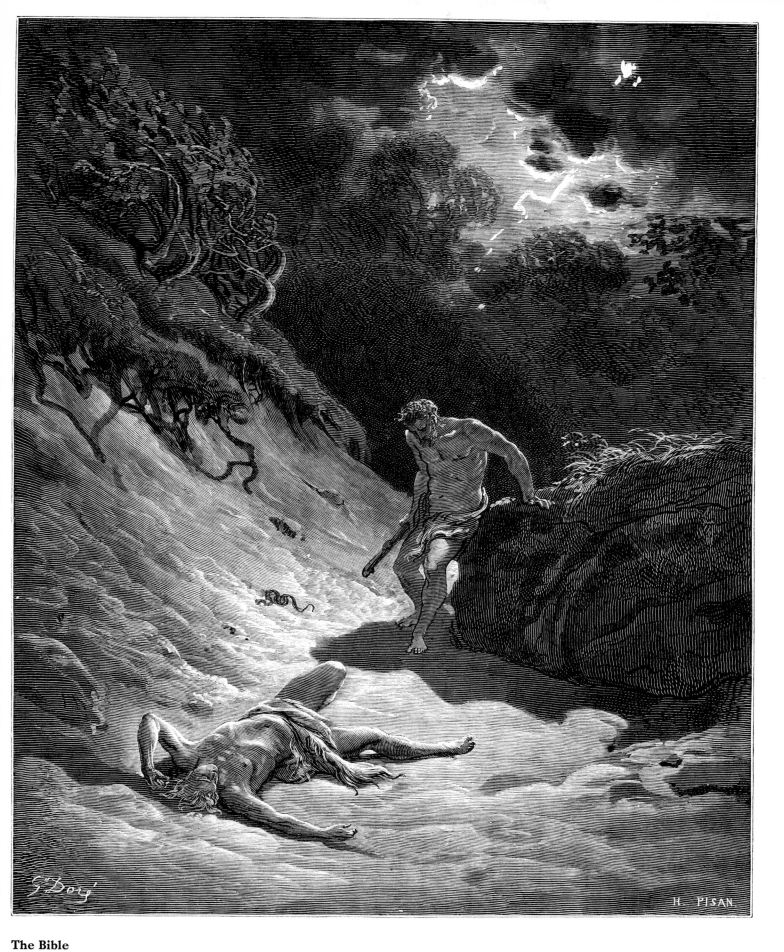

**The Bible**

**Gen. iv. 8**

*And Cain talked with Abel his brother: and it came to pass, when they were in the field, that Cain rose up against Abel his brother and slew him.*

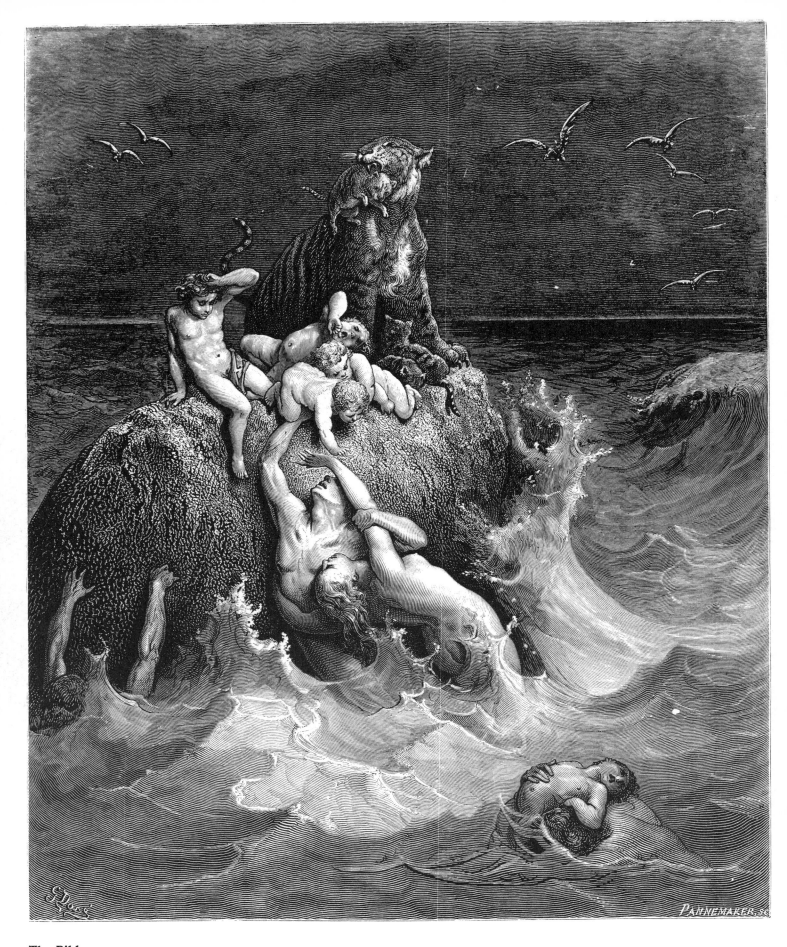

**The Bible**

**Gen. vii. 20–1**

*Fifteen cubits upward did the waters prevail; and the mountains were covered. And all flesh died that moved upon the earth both of foal, and of cattle, and of beast, and of every creeping thing that creepeth upon the earth, and every man.*

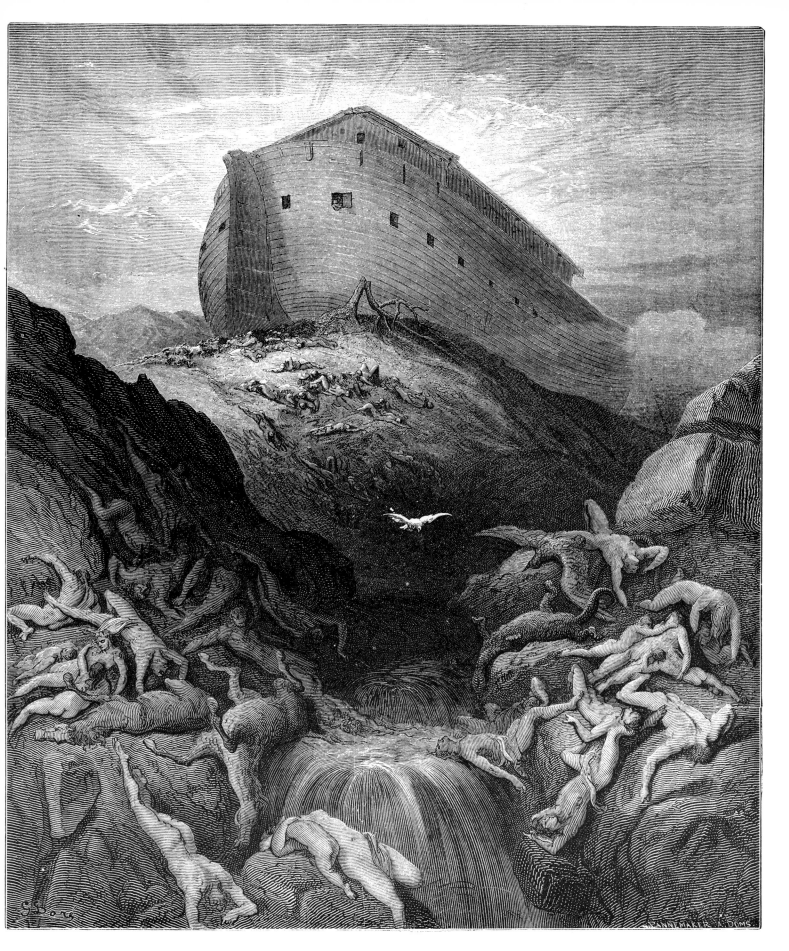

**The Bible**

**Gen. viii. 8–9**

*Also he [Noah] sent forth a dove from him, to see if the waters were abated from off the face of the ground. But the dove found no rest for the sole of her foot, and she returned unto him into the ark, for the waters were on the face of the whole earth.*

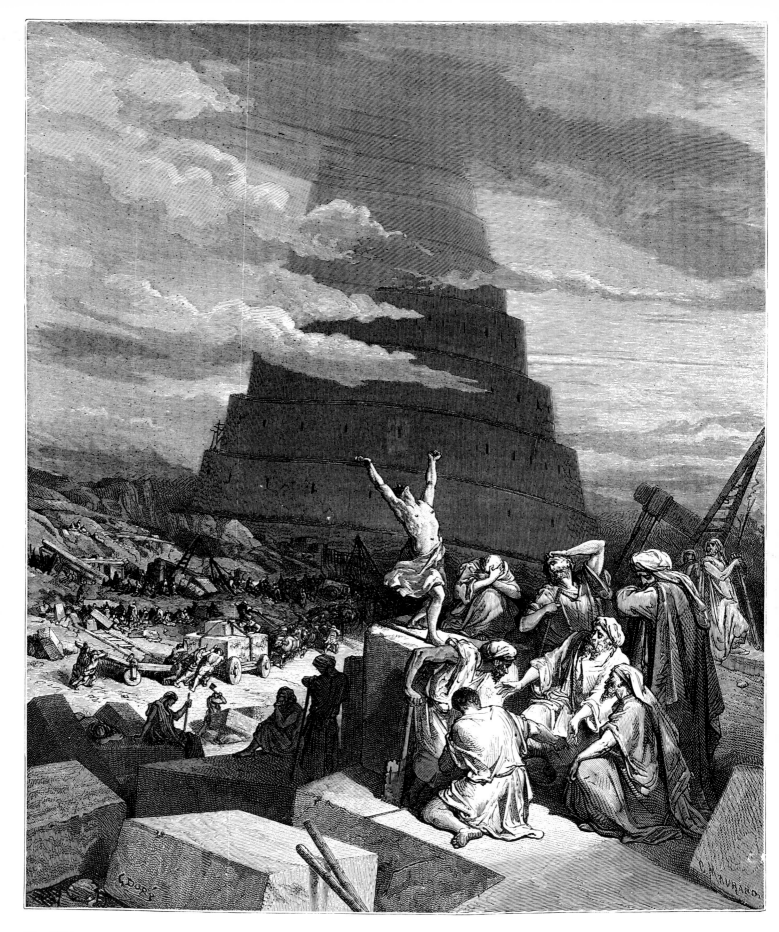

**The Bible**

**Gen. xi**

*Go to, let us go down, and there confound their language, that they may not under-
stand one another's speech. So the Lord scattered them abroad from thence upon
the face of all the earth: and they left off to build the city. Therefore is the name
of it called Babel; because the Lord did there confound the language of all the earth:
and from thence did the Lord scatter them abroad upon the face of all the earth.*

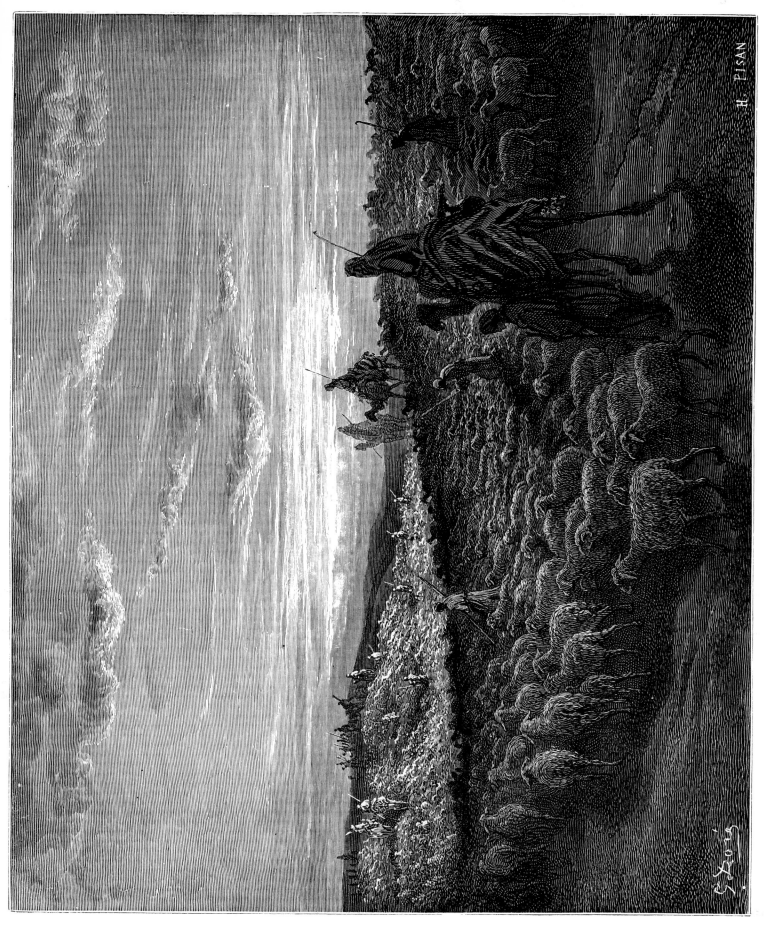

**The Bible**

**Gen. xiii. 1–4**

Here is illustrated the journey of Abraham, with his flocks and his servants, to the land of Canaan.

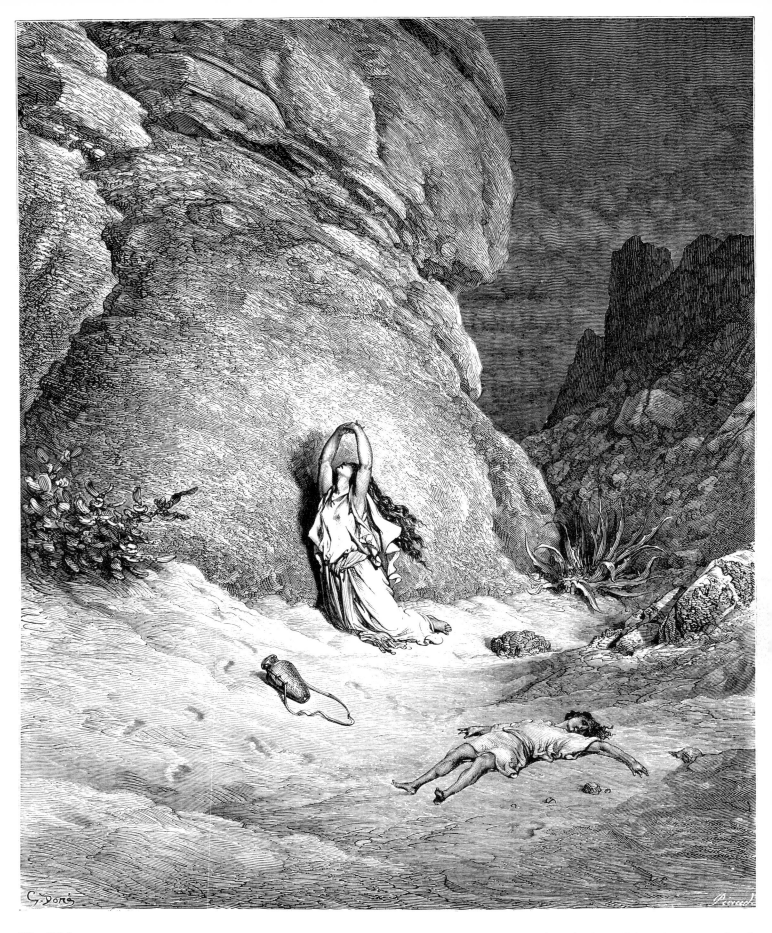

**The Bible**

**Gen. xxi. 14–19**

Hagar, a bondswoman, and her child by Abraham, Ishmael, are sent by the will of God into the arid desert of Beersheba. They soon use up all their water and Hagar weeps in despair. God hears her lamentations and opens her eyes so that she sees a well of water.

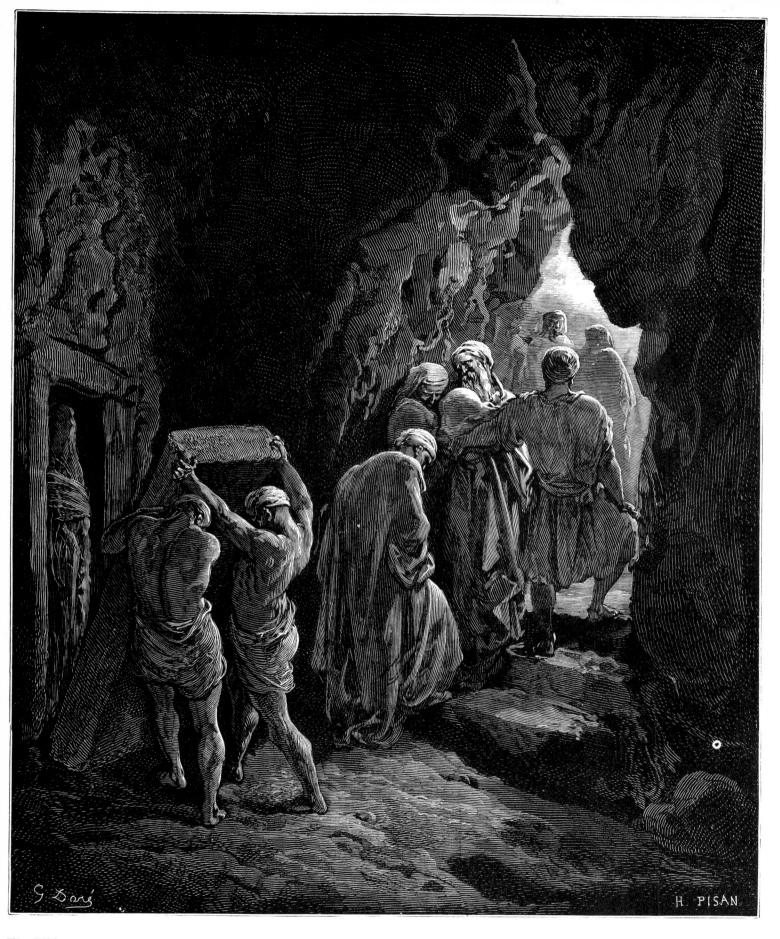

**The Bible**
**Gen. xxiii. 19–20**

Here is depicted the burial of Sarah in a cave in Canaan. She is reported to have lived one hundred and twenty-seven years.

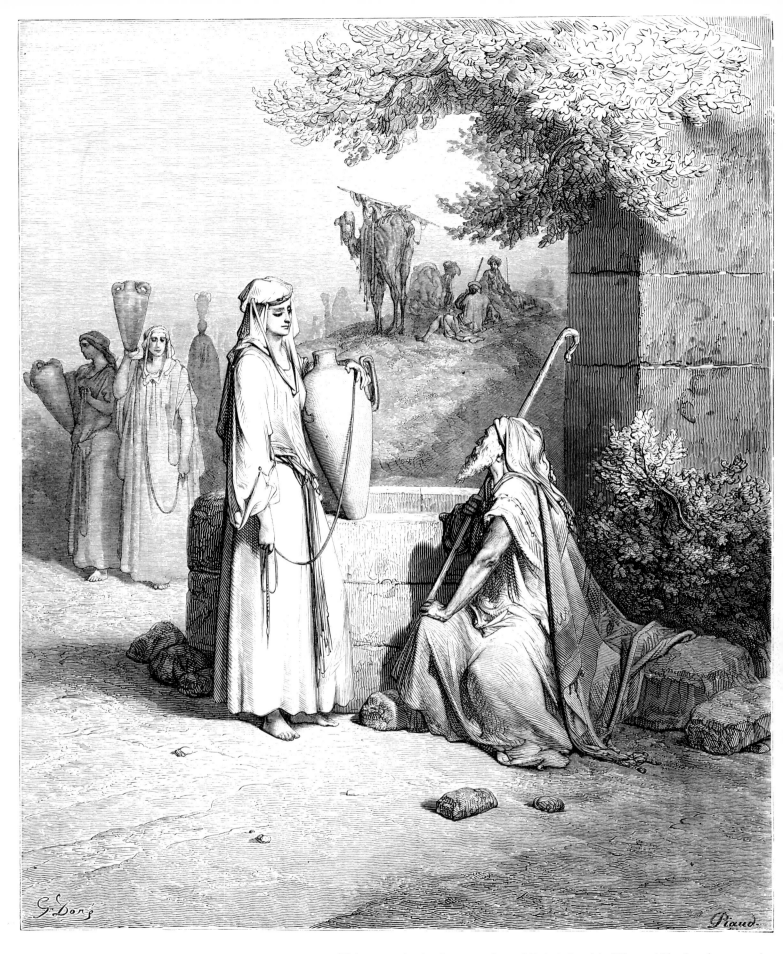

**The Bible**

**Gen. xxiv. 15–21**

This scene is the first meeting of Rebekah with Eliezer (Abraham's servant). Rebekah is seen carrying her pitcher to the well.

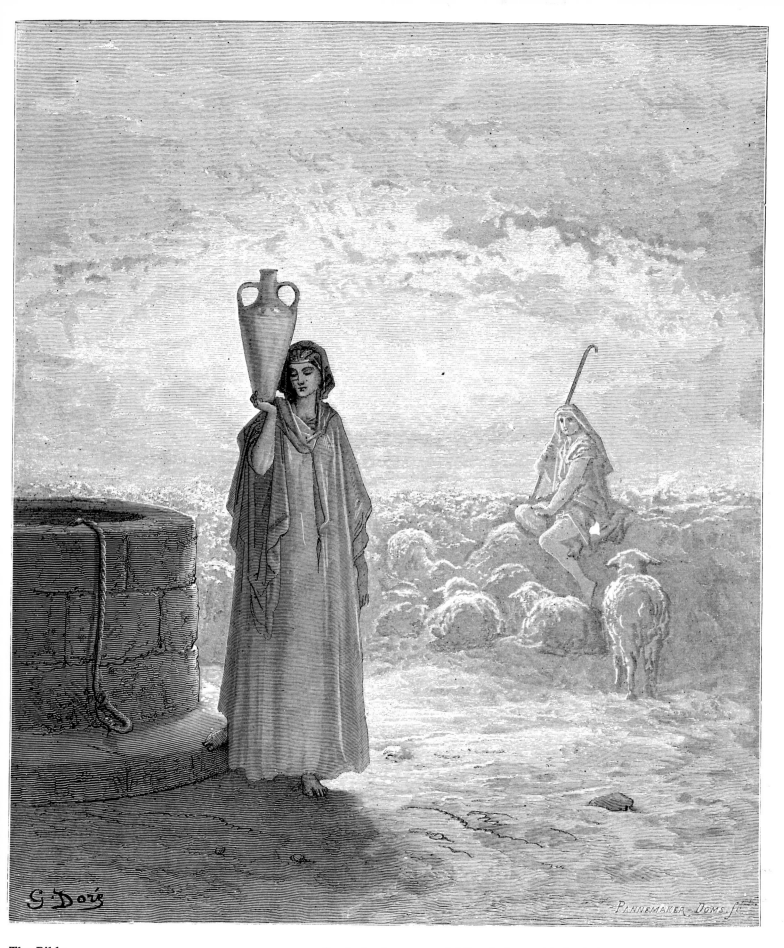

**The Bible**

**Gen. xxix. 20**

Jacob, having met and fallen in love with Rachel, who is the younger of the two daughters of Laban, offers to serve Laban for seven years in return for the hand of Rachel in marriage. Here we see Jacob acting as Laban's shepherd, while Rachel draws water from a well.

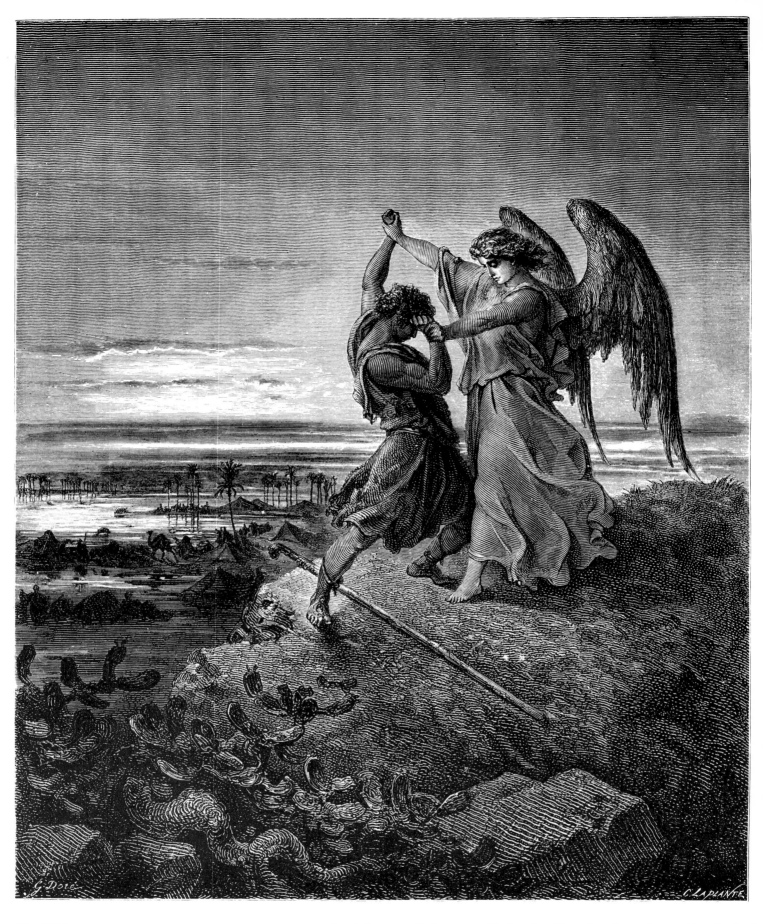

**The Bible**
**Gen. xxxii. 24–30**

Jacob has travelled to meet his brother Esau, but fears the meeting for he is afraid of Esau. He sends presents of cattle ahead to his brother, then sends his servants and family over the river to wait for him. All night he is forced to wrestle with a man who reveals himself as an angel and who proclaims that Jacob shall henceforth be called Israel.

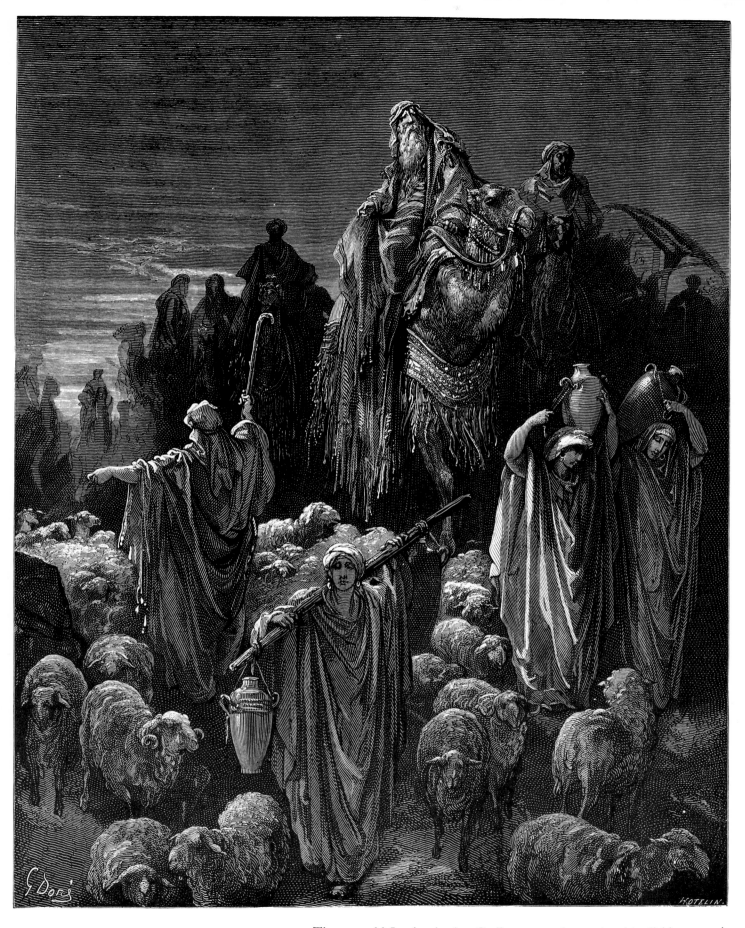

**The Bible**

**Gen. xlvi. 5–7**

The now old Jacob, obeying God's command, travels with all his possessions and family from the land of Canaan into Egypt.

**The Bible**

**Exod. ii. 1–4**

The new Pharaoh of Egypt proclaims that all the male children born to the Hebrews shall be drowned in the river. A man and wife of the house of Levi bear a male child, Moses. The woman hides the child for three months, then makes a boat of rushes and pitch, places the infant in it, and hides it at the river's edge, where it is found by Pharaoh's daughter.

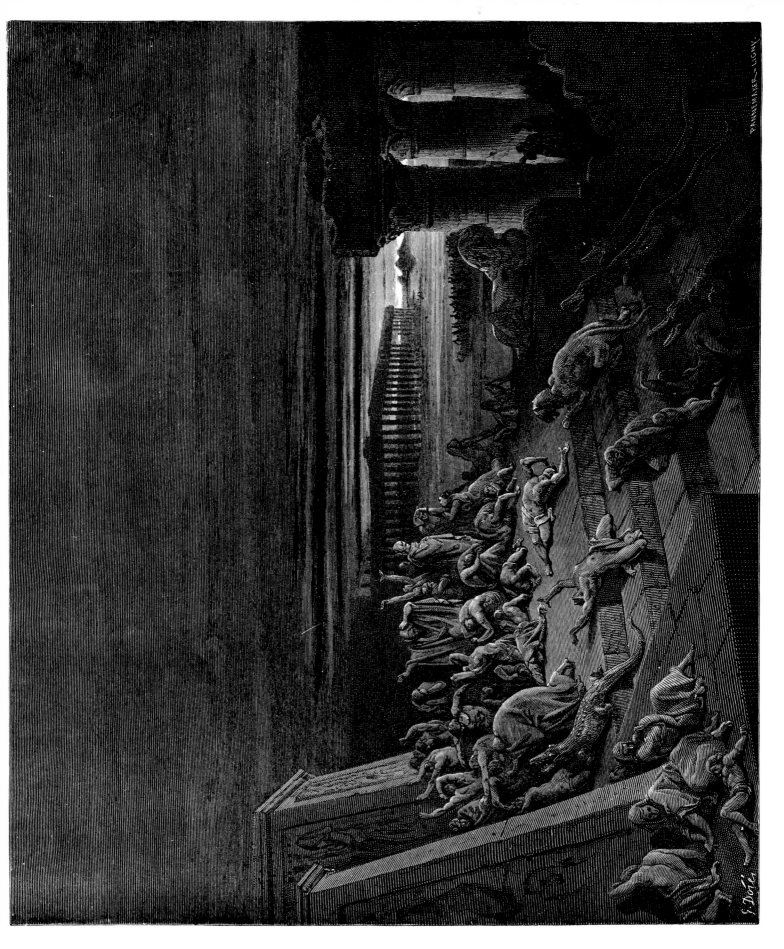

**The Bible**

**Exod. x. 22–3**

*And Moses stretched forth his hand toward heaven; and there was a thick darkness
in all the land of Egypt three days.*

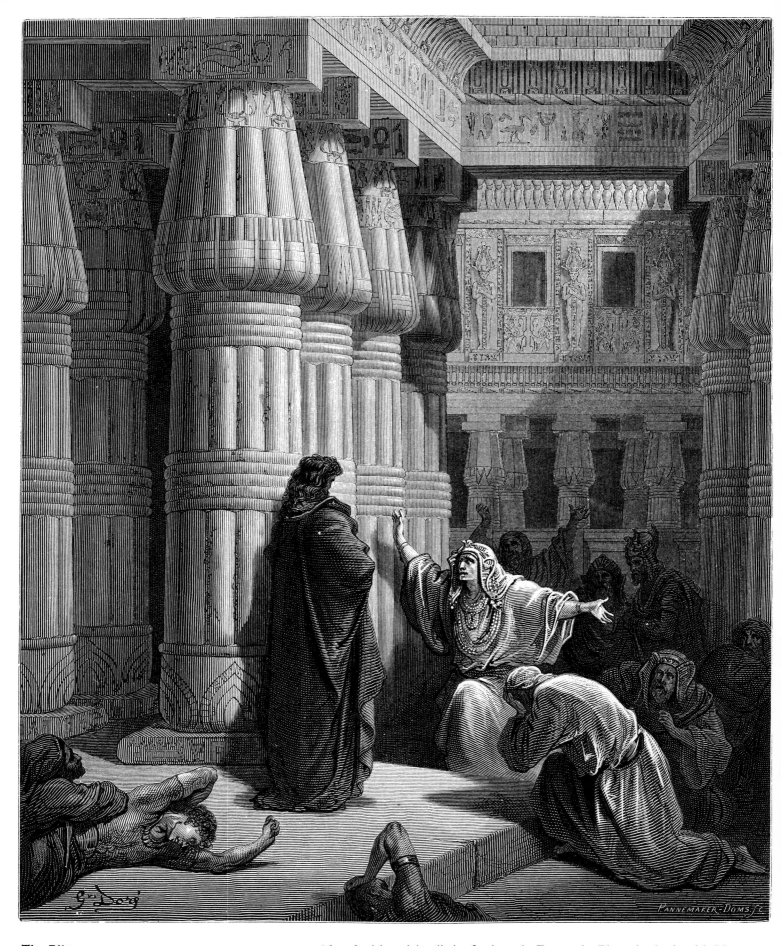

**The Bible**

**Exod. xii. 31–3**

After God has slain all the firstborn in Egypt, the Pharaoh pleads with Moses
to depart.

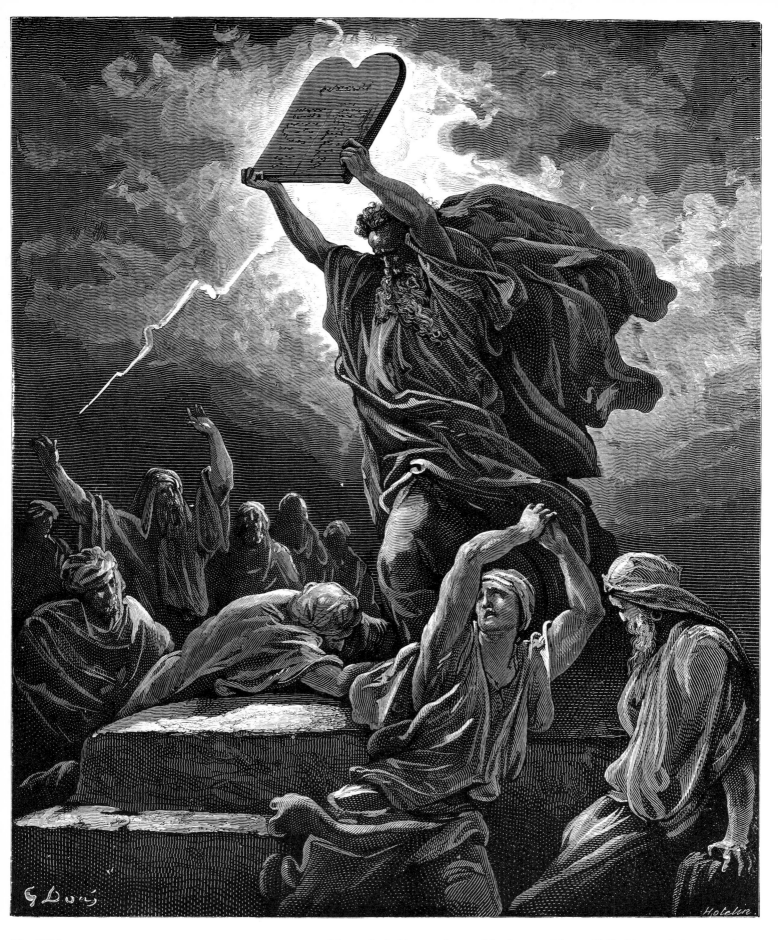

**The Bible**
**Exod. xxxii. 19**

Moses finds his people worshipping a golden calf. In his wrath he casts down and breaks the tables of the law.

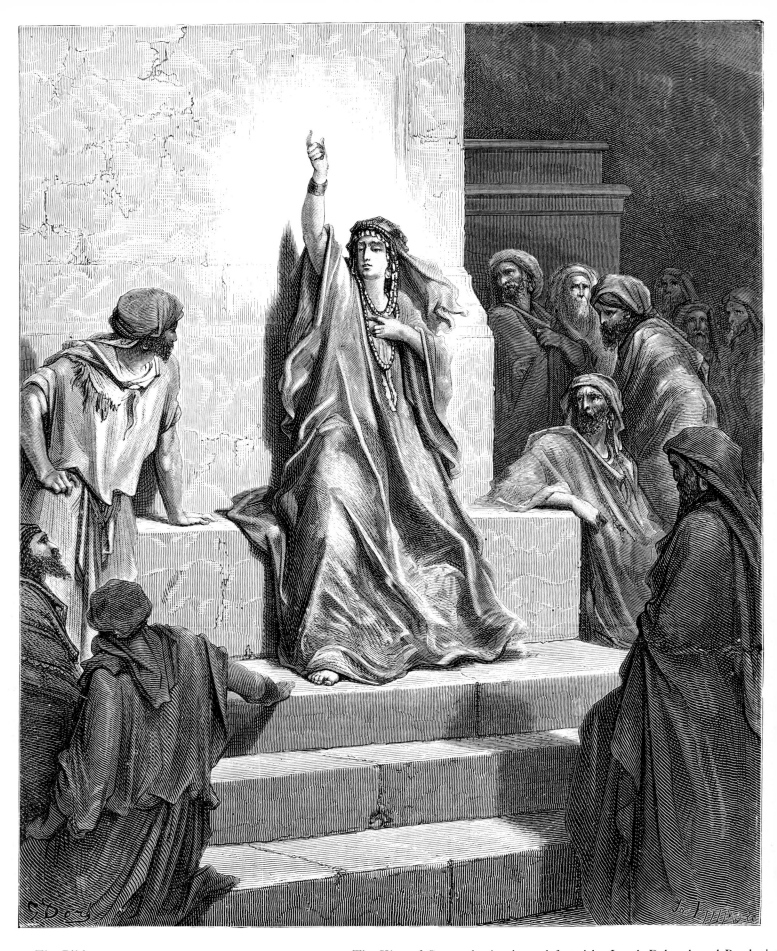

**The Bible**

**Judges v. 1-2**

The King of Canaan having been defeated by Israel, Deborah and Barak sin
the praises of the Lord for the avenging of Israel.

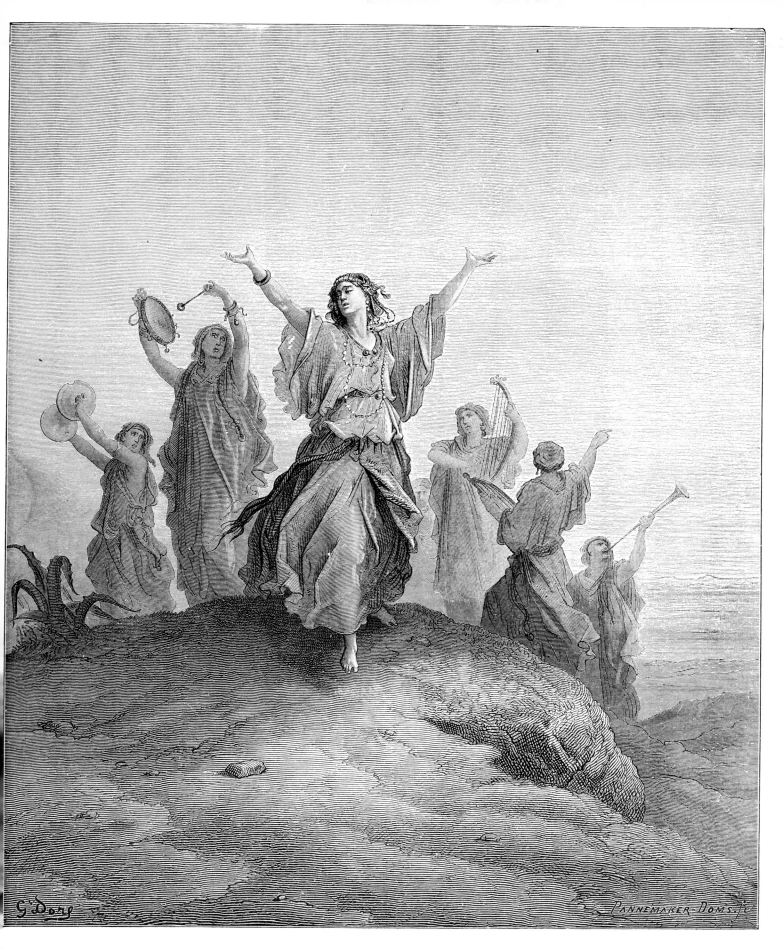

**The Bible**
**Judges xi. 34-6**

Jephthah promises God that in return for His help in defeating the Ammonites he will offer up as a burnt offering the first person to meet him when he returns home to Mizpeh. However, the first to greet Jephthah is his only daughter, and he is obliged to honour his vow.

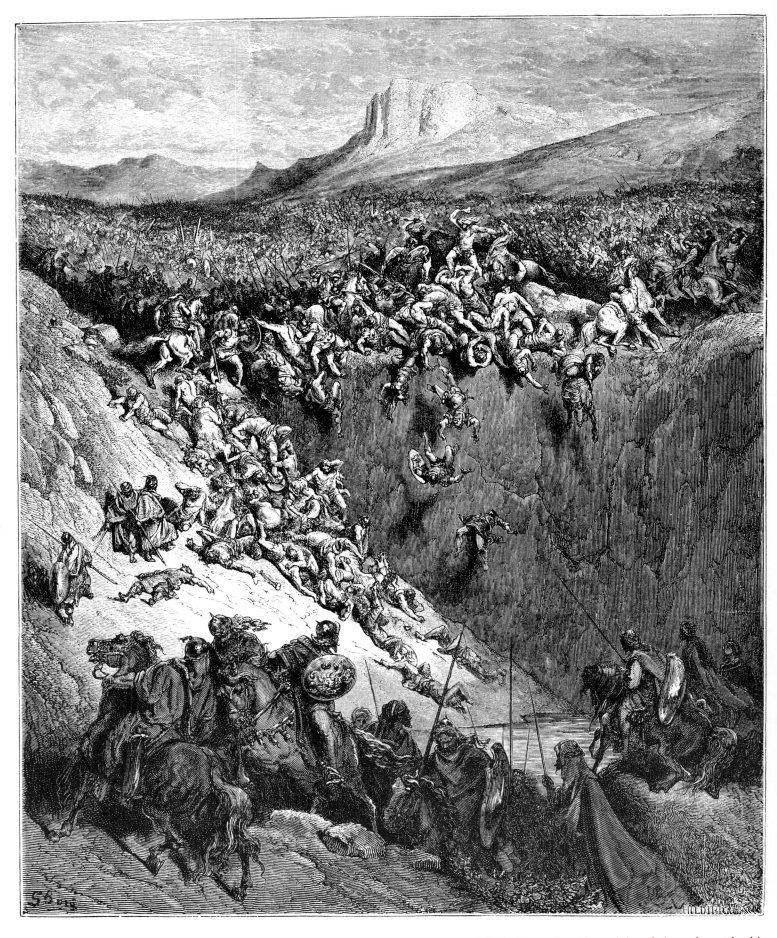

**The Bible**

**Judges xv. 15**

The Philistines, having killed Samson's wife and her father, then take him prisoner and bind his arms. With God's help he breaks the bonds, and with the jawbone of an ass slays a thousand men.

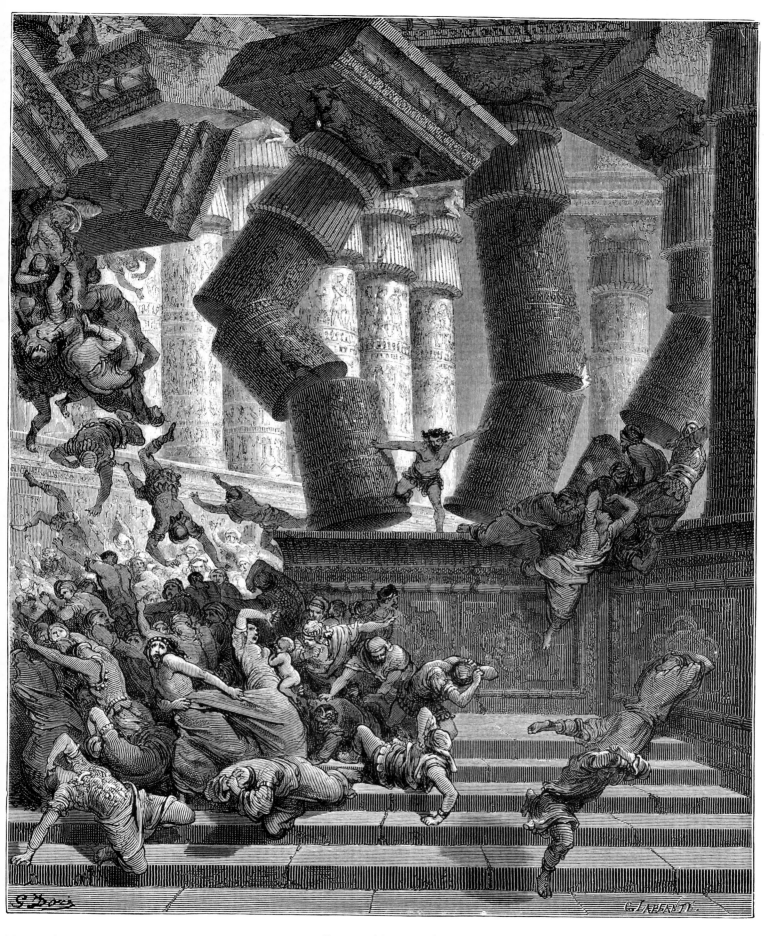

**The Bible**
**Judges xvi. 28–30**

Samson, his strength having been taken from him by the wiles of Delilah, is imprisoned by the Philistines. His eyes are put out, his head is shaven and he is put to labour in the mill at Gaza. Later the Philistine lords hold a great sacrificial meeting for their god Dagon. They call for Samson to be shown to the people and be mocked. However, Samson prays to God for strength and brings down the main supporting pillars of the building so that all present perish.

257

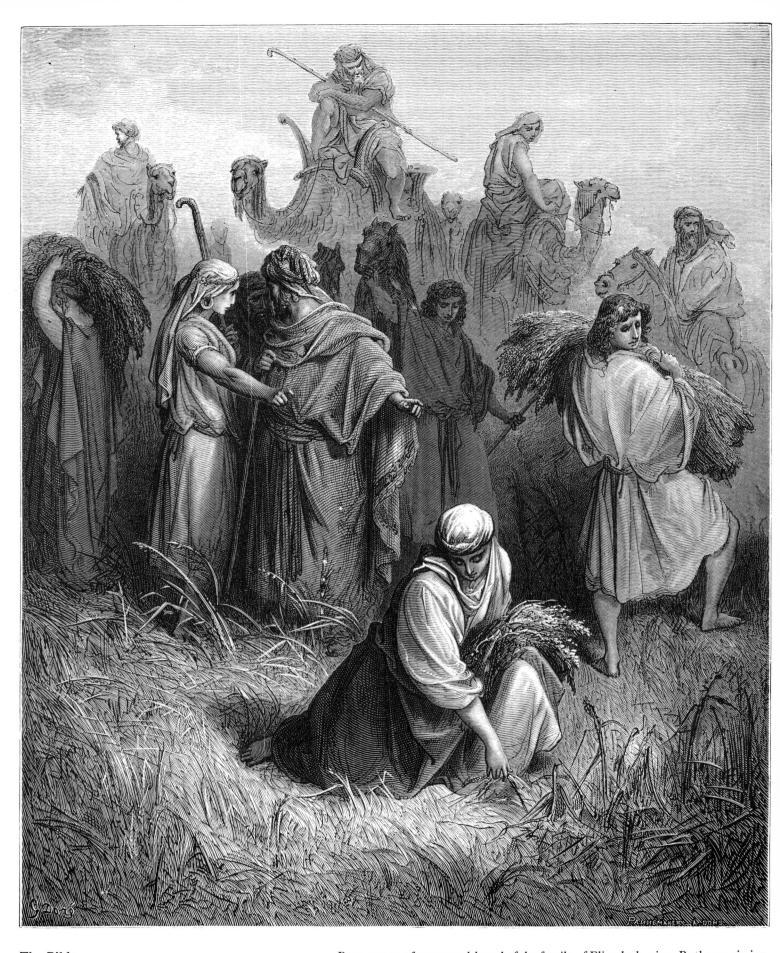

**The Bible**
**Ruth ii. 6–7**

Boaz, a man of great wealth and of the family of Elimelech, gives Ruth permission to glean and gather after the reapers.

**The Bible**
**I Sam. vi. 13–15**

The Holy ark of the Lord is returned to Beth-shemesh, having been seven months in the land of the Philistines.

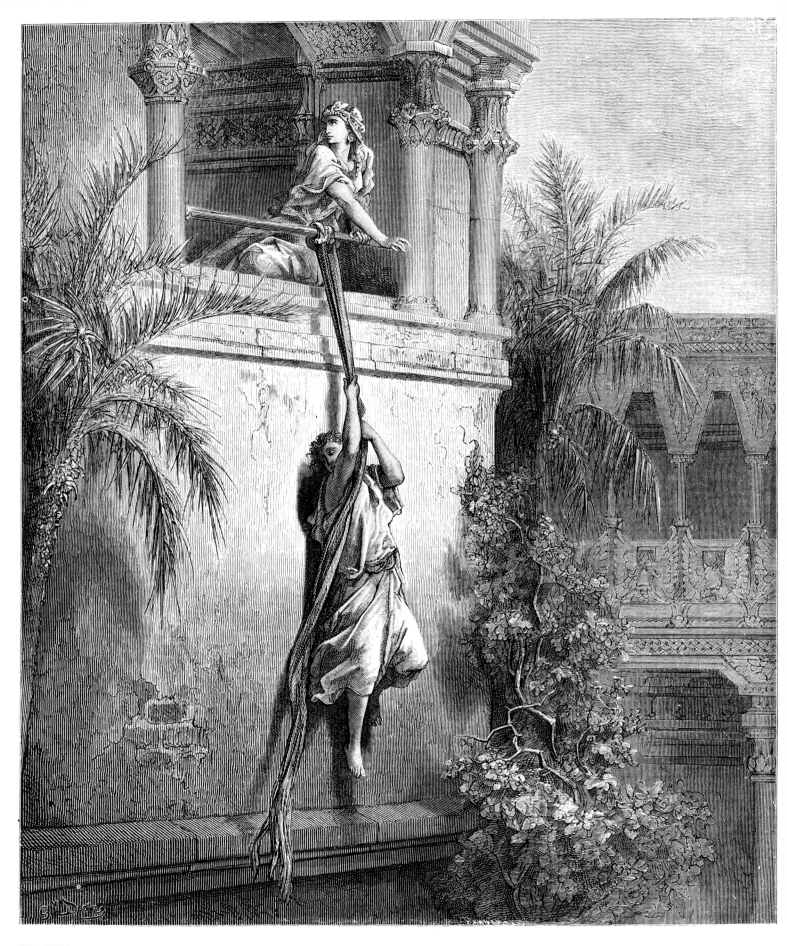

**The Bible**
**I·Sam. xix. 12**

An evil spirit having affected Saul, he tries to kill David with a spear. David flees into the night and hides in his own house. Michal, the wife of David, warns him that if he stays in his house he will surely be found and killed; so Michal helps David to escape through a window.

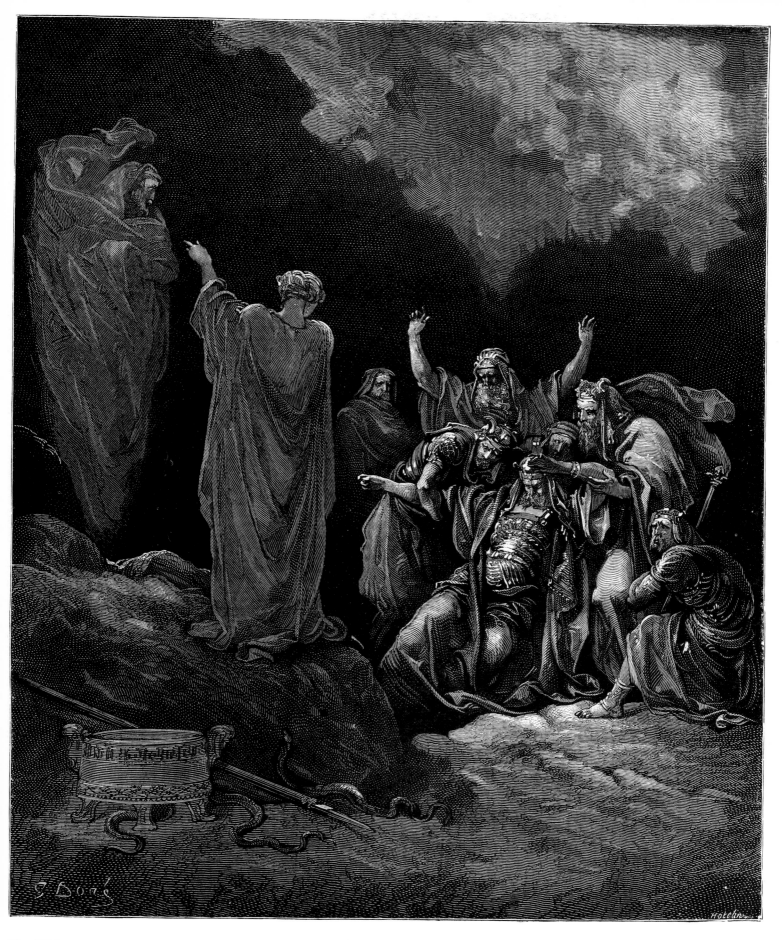

**The Bible**

**I Sam. xxviii. 14**

Saul, who is in great fear of a forthcoming battle against the Philistines, seeks the advice of a witch at Endor. She conjures up the spirit of Samuel, who rebukes Saul for turning away from the path of the Lord.

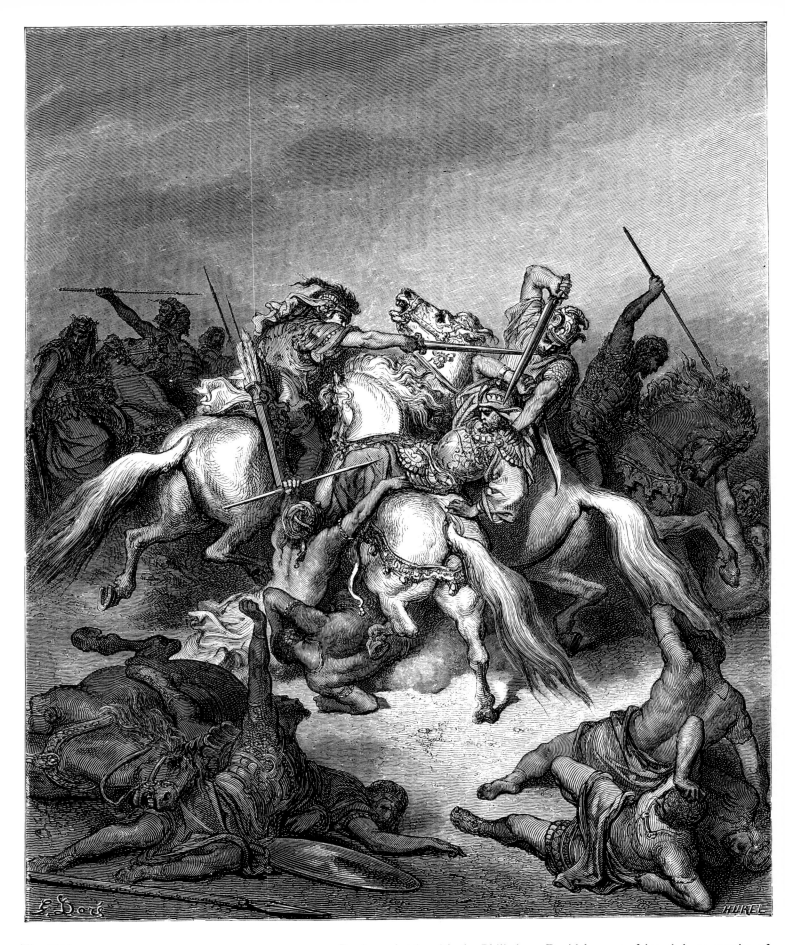

**The Bible**
**II Sam. xxi. 16–17**

During a battle with the Philistines, David becomes faint. A huge warrior of giant's stature called Ishbi-benob takes advantage of this and attempts to kill David. David is saved by the intervention of Abishai, who slays the Philistine.

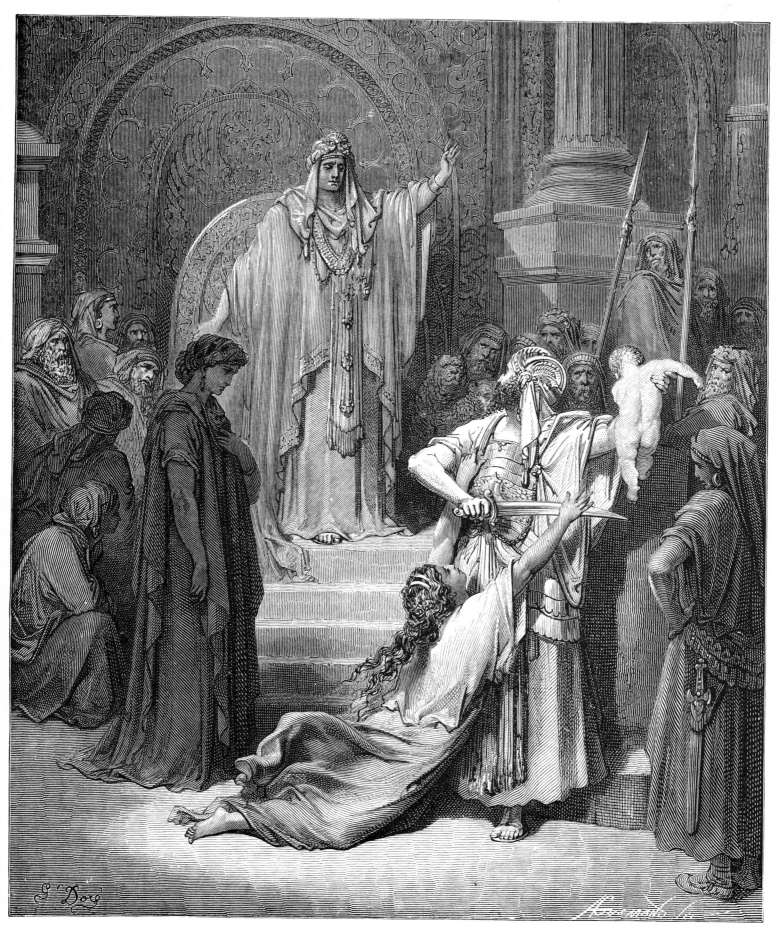

**The Bible**
**I Kings iii. 24–8**

Solomon, on being asked to pronounce which of two women is the mother of an infant brought before him, and the evidence being inconclusive, says that the child should be cut in two and each claimant be given one half. One woman cries that the child should be spared and given to the other, whilst the other agrees with the King's verdict. Solomon rightly decrees the first woman to be the true mother.

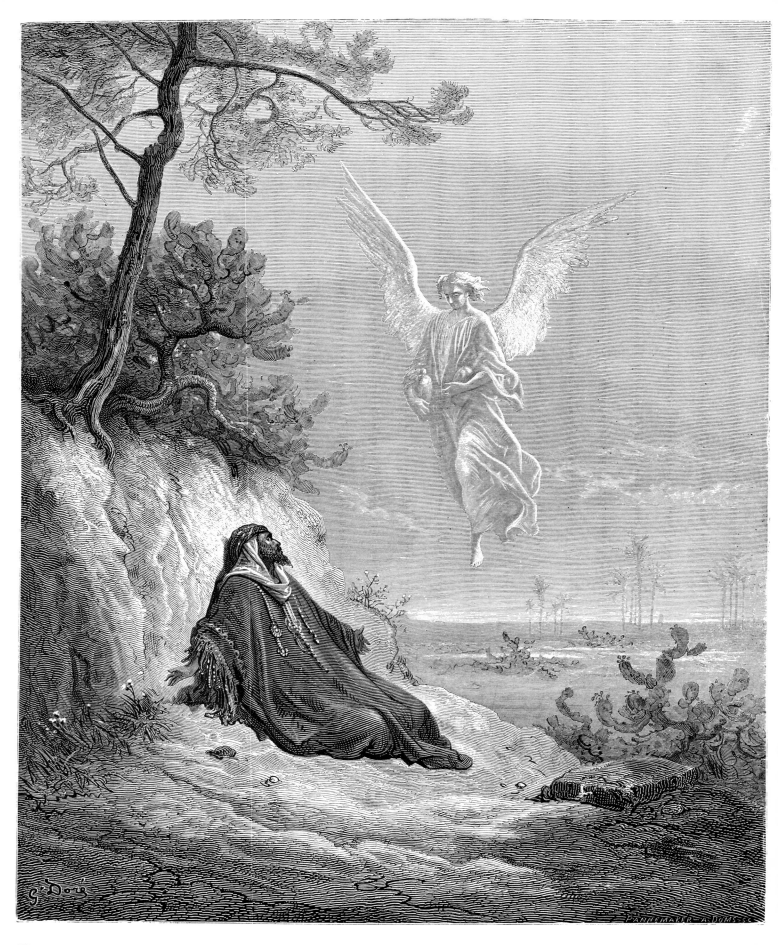

**The Bible**

**I Kings xix. 4–8**

Elijah, having slain the false prophets of Baal, goes to Beersheba. He travels into the wilderness where, in great depression, he asks God that he might die as he feels himself unworthy. He is woken by an angel who twice feeds him, thus giving him strength for a journey of forty days and nights to Horeb, the mount of God.

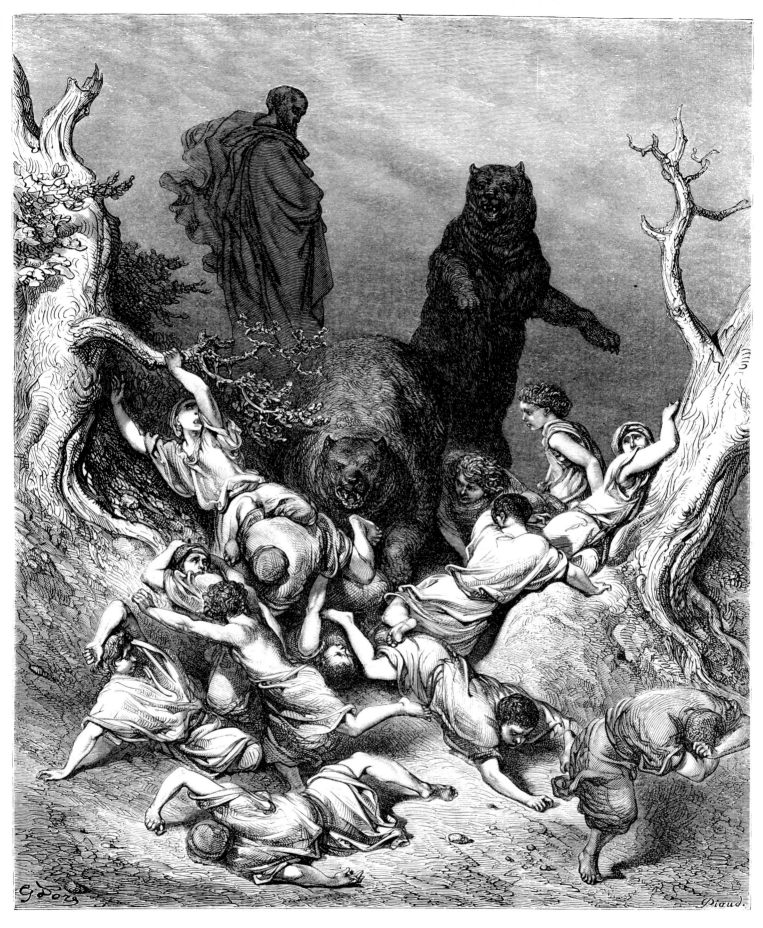

**The Bible**
**II Kings ii. 23–4**

This macabre scene shows how Elisha, having been mocked by the children of Bethel, curses them in the name of the Lord. Two she-bears appear and tear at the children.

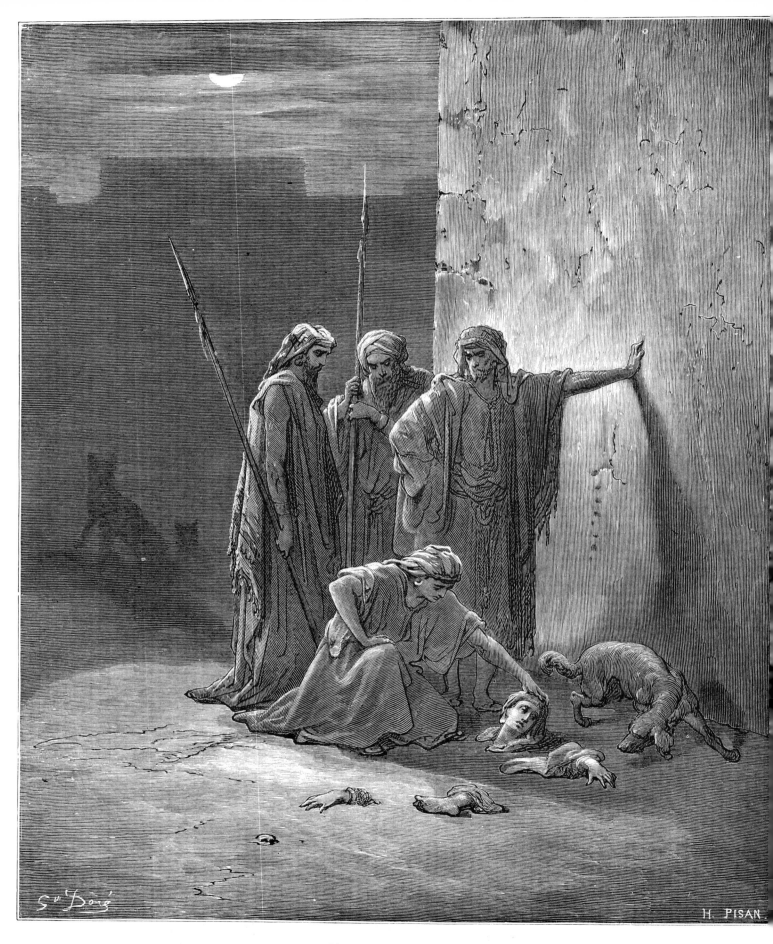

**The Bible**

**II Kings ix. 34–5**

Elisha has prophesied the destruction of the house of Ahab and that the flesh of Jezebel would be eaten by dogs. Here are seen Jehu and his companions finding the remains of Jezebel.

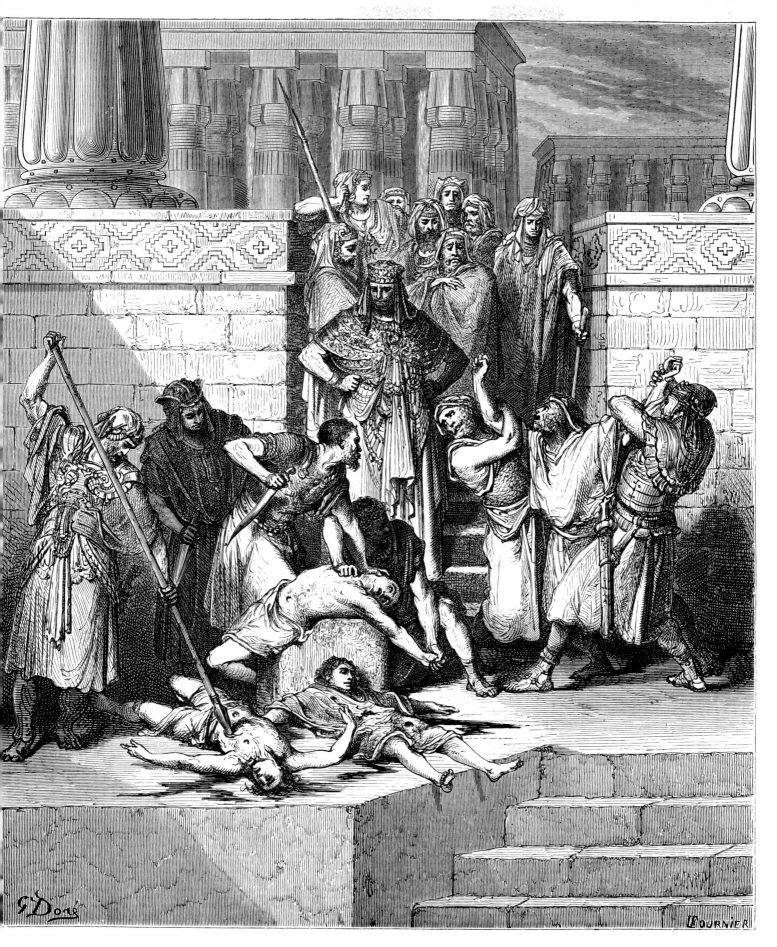

**The Bible**

**II Kings xxv. 7**

In the ninth year of the reign of Zedekiah, Nebuchadnezzar the King of Babylon besieged Jerusalem for over two years. Such a famine grew in the city that the defenders fled into the plains of Jericho. They were pursued and captured, and finally the sons of Zedekiah were slain in front of his eyes, before the King himself had his own eyes put out and was carried captive to Babylon.

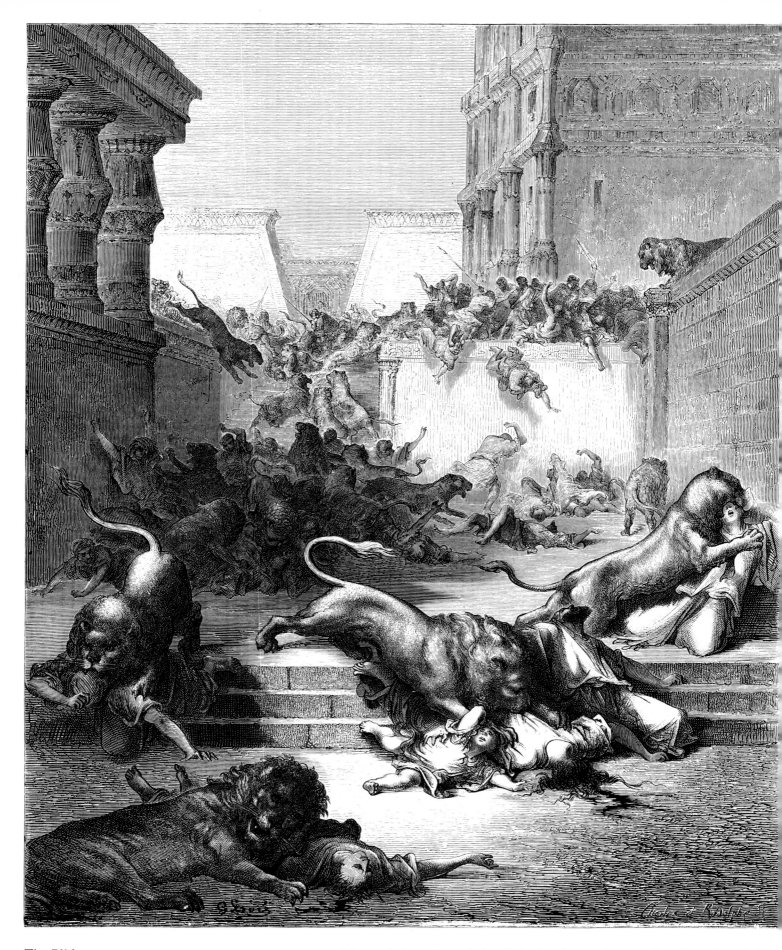

**The Bible**
**II Kings xvii. 25–6**

Many of the tribes of Israel, having been taken to Samaria, rejected the Commandments of the Lord and worshipped false idols. The Lord in His wrath sent amongst them lions which slew many of them.

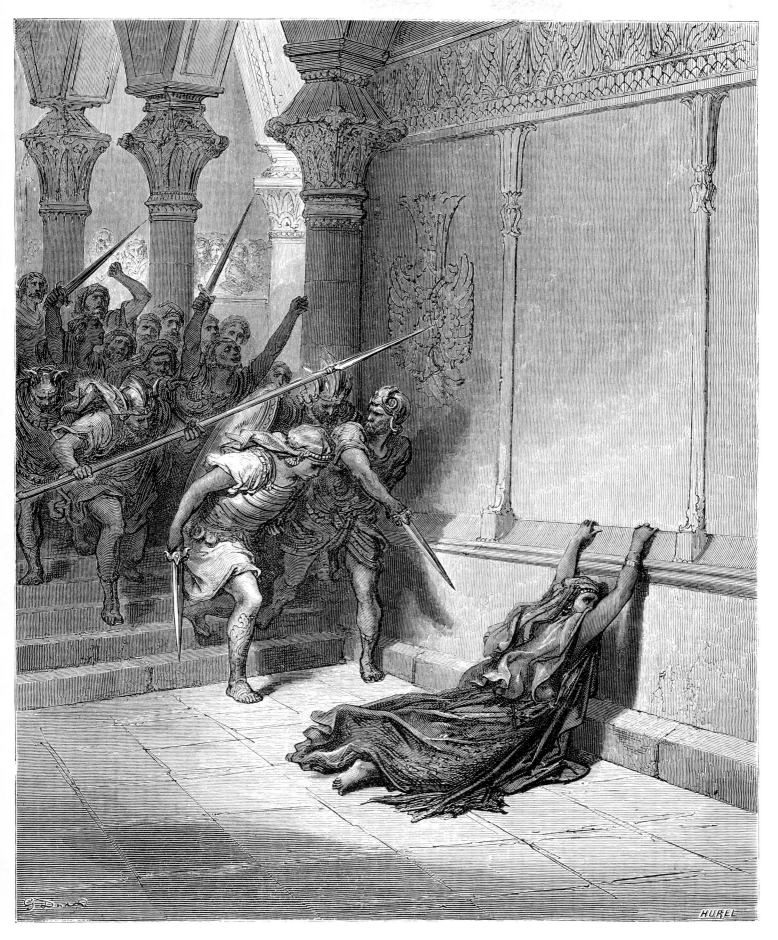

**The Bible**
**II Chron. xxiii. 14–15**

At the crowning of Joash, Athaliah, who had for a time usurped the kingdom, raised a tumult in the temple of Jerusalem. However, the people drove her out and she was slain by the horse gate of the king's house.

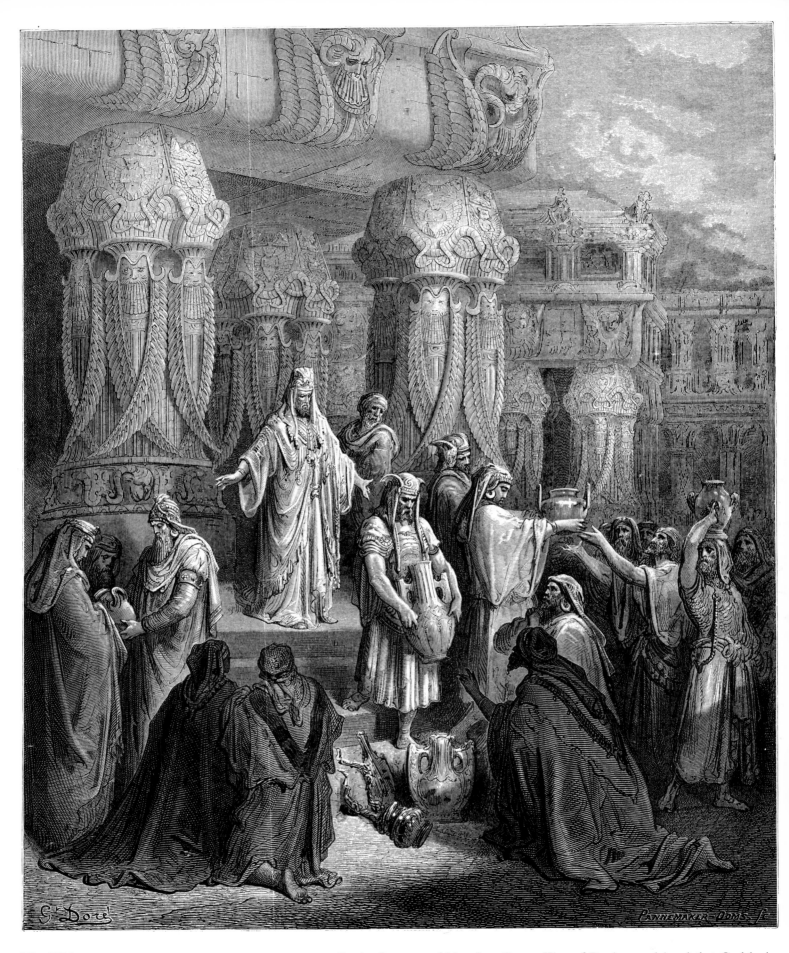

**The Bible**

**Ezra i. 7–11**

In the first year of his reign, Cyrus, King of Persia, proclaimed that God had commanded him to build a temple at Jerusalem. He did so and, further, restored all the vessels and treasures that had been stolen by Nebuchadnezzar.

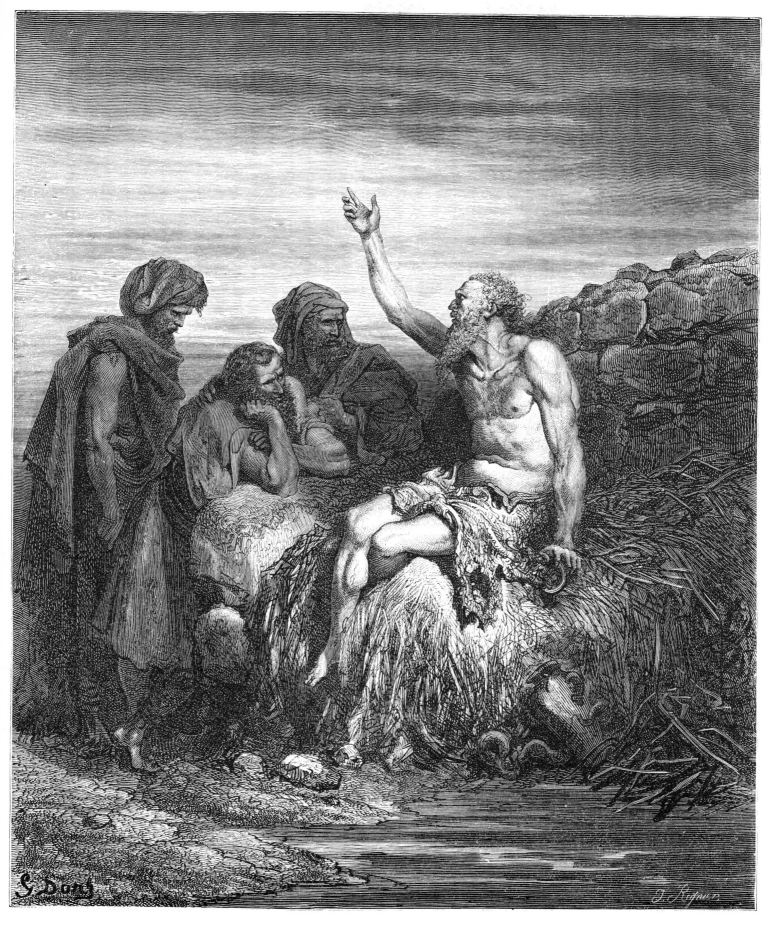

**The Bible**
**Job vi. 1–4**

The grief-torn figure of Job is seen as he tells his three friends of his manifold misfortunes.

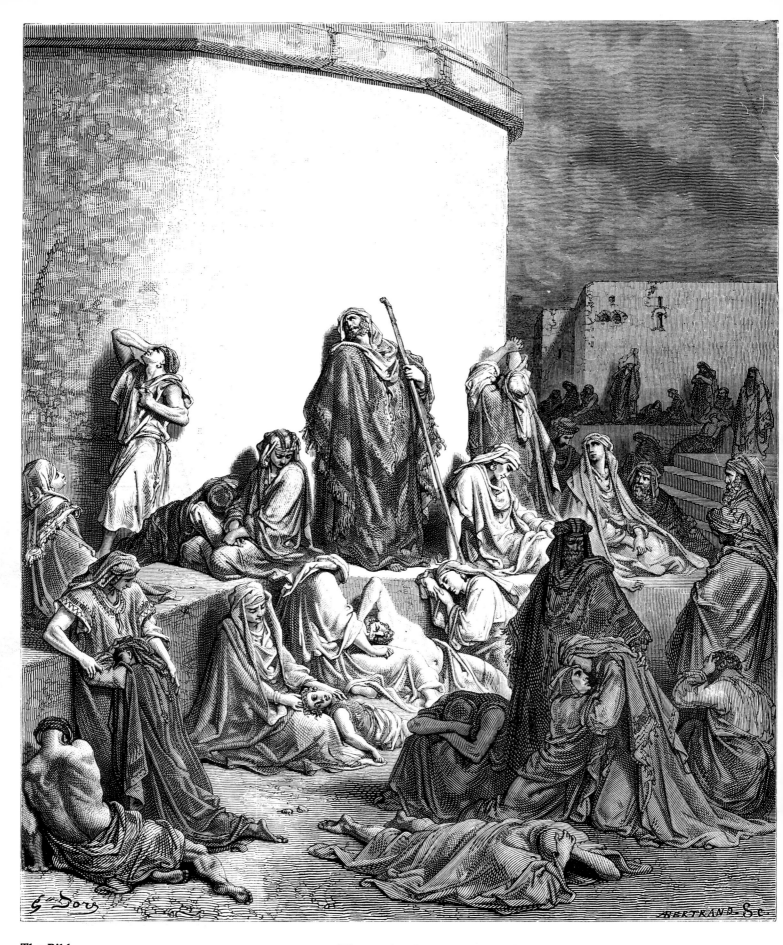

**The Bible**
**Lam. i. 1–2**

The prophet Jeremiah laments the fall of Jerusalem. Here the people are seen mourning in the ruins of the city.

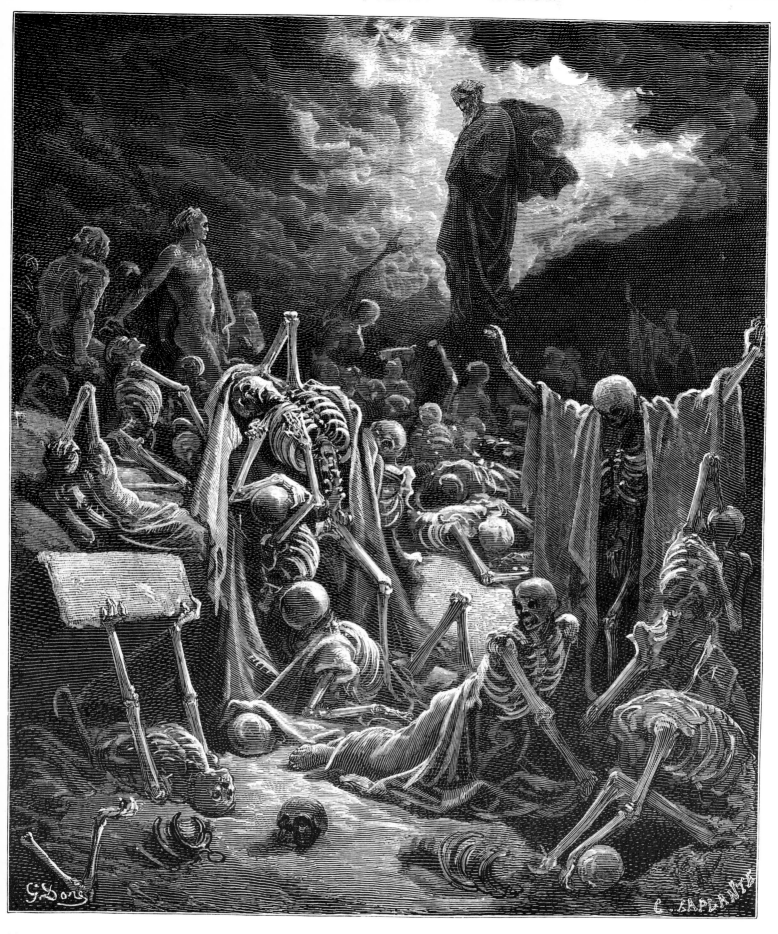

**The Bible**

**Ezek. xxxvii. 1–2**

The prophet is commanded by God to go to a valley full of dry bones and preach to them. He does so, and sinews and flesh grow on the bones as they come together. A great wind arises and blows breath into the bodies so that they live again.

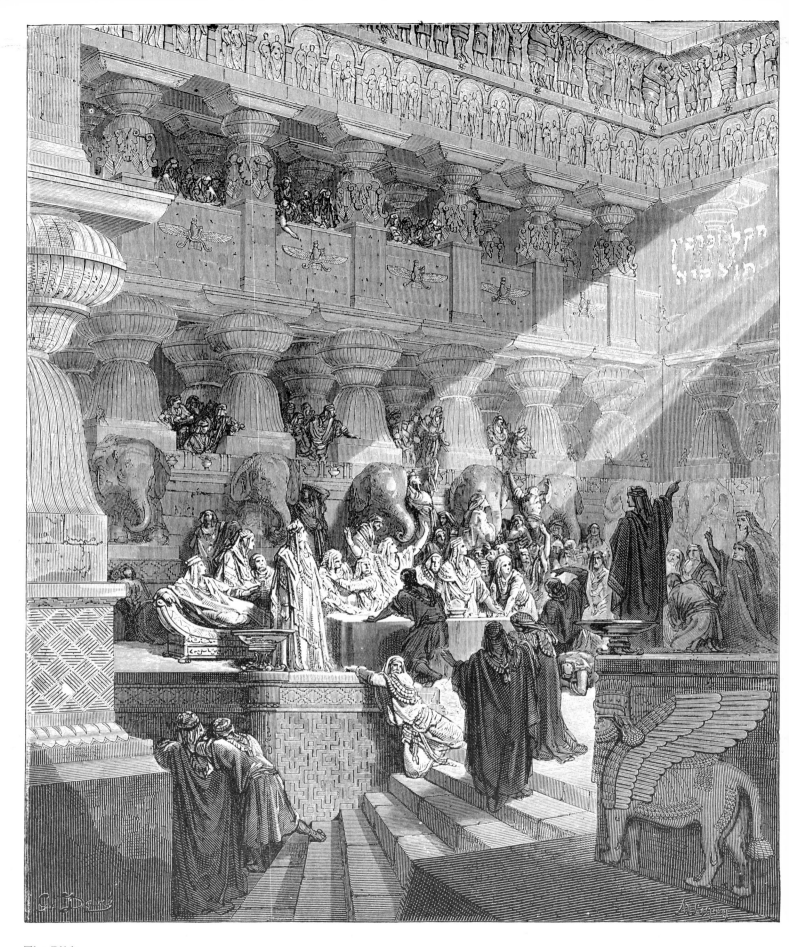

**The Bible**

**Dan. v. 25–8**

Belshazzar, King of Chaldea, is at a great feast in his palace when the strange words "Mene, Mene, Tekel, Upharsin" appear on the walls. Daniel interprets them as a warning that God has judged the kingdom and found it wanting, and that it will be overthrown by the Medes and Persians. That night, Belshazzar is killed and Darius the Mede captures the Kingdom.

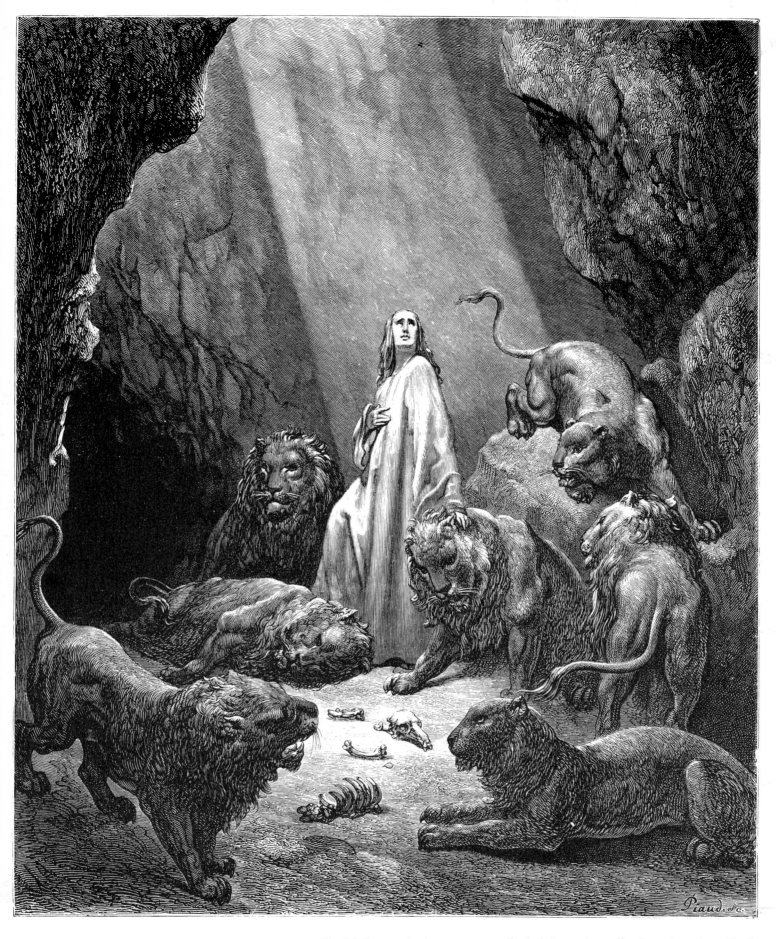

**The Bible**

**Dan. vi. 16–17**

Daniel, by continuing to pray to God thrice a day, offends against the will of Darius the king. Daniel is cast into a den of lions and told that if his God is so great, then He will save him. The King hurries to the den in the morning, finds Daniel unharmed, and is so impressed by this that he is converted to the true God.

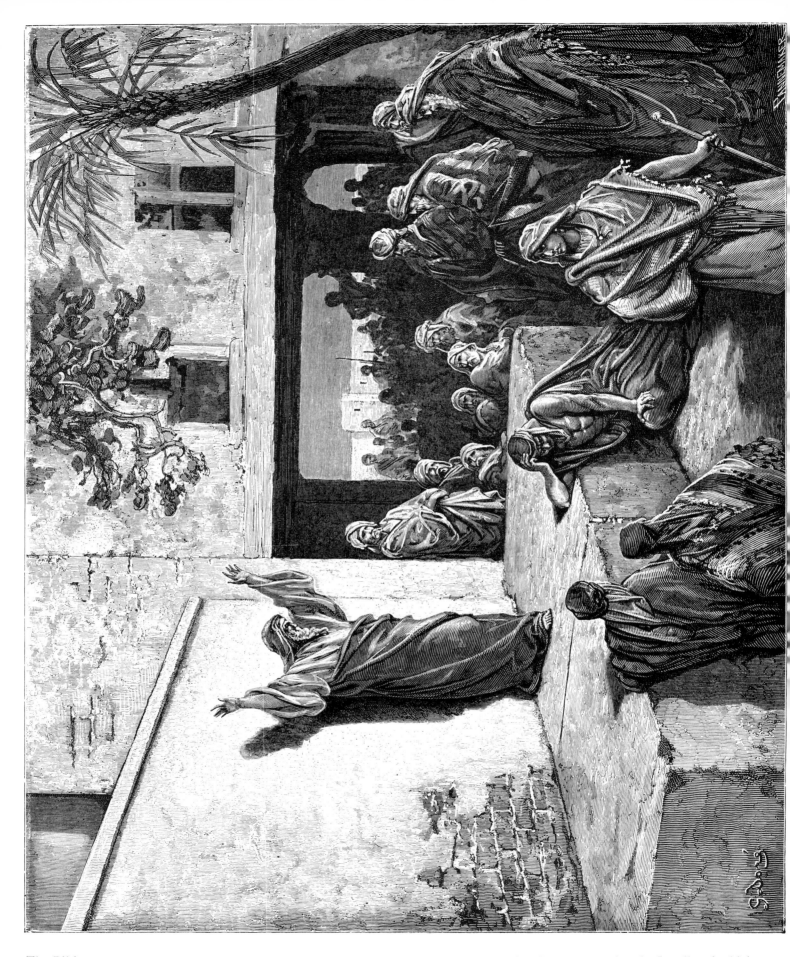

**The Bible**
**Micah i. 1–3**

The prophet Micah the Morasthite is seen reproving the Israelites for idolatry, and exhorting them to mourning.

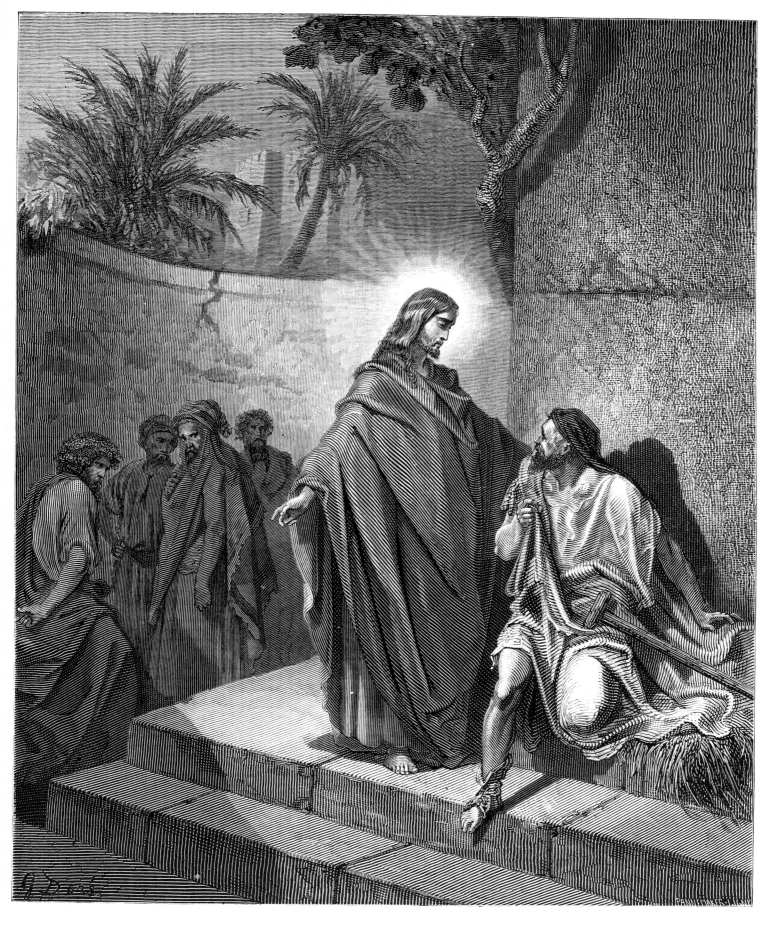

**The Bible**
**Matt. ix. 1–8**

The relatives of a man sick of the palsy bring him to Jesus that he might cure him. Jesus, seeing their great faith, says to the sick man, "Arise, take up thy bed, and go unto thine house." The man is cured and able to rise at once.

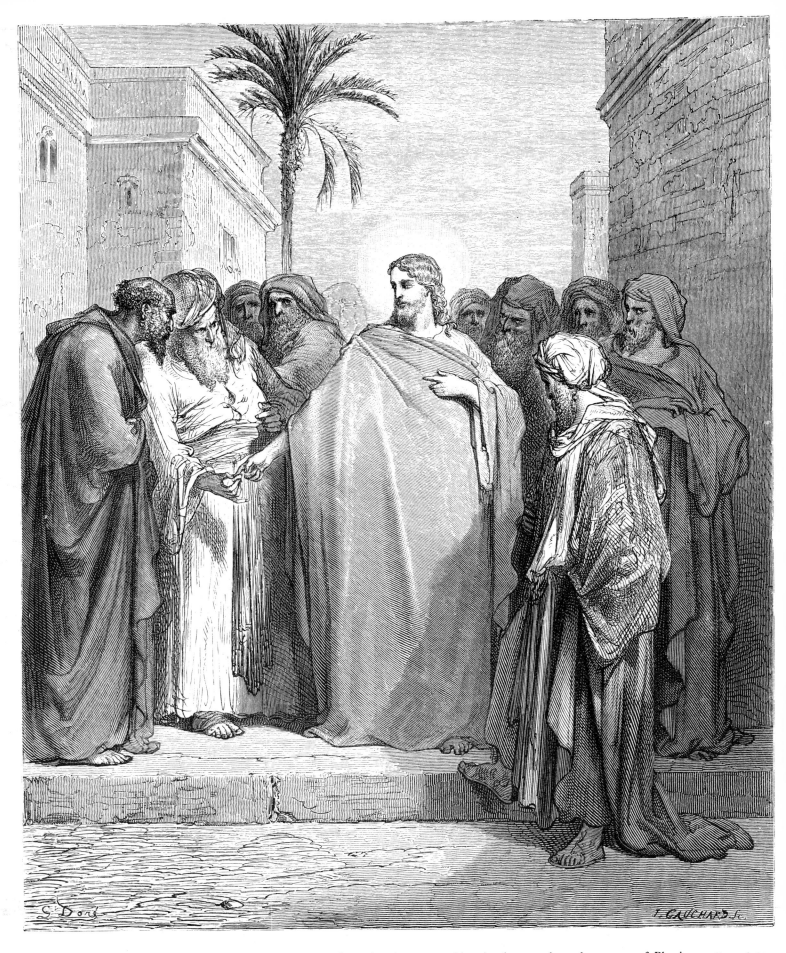

**The Bible**

**Matt. xxii. 17**

Jesus has been preaching in the temple and a group of Pharisees attempt to outwit him in debate. They ask whether it is lawful to pay tribute to Caesar or not. Jesus asks them whose image is graven on a coin; they answer, "Caesar's". Jesus then replies, "Render therefore unto Caesar the things which are Caesar's; and unto God the things that are God's."

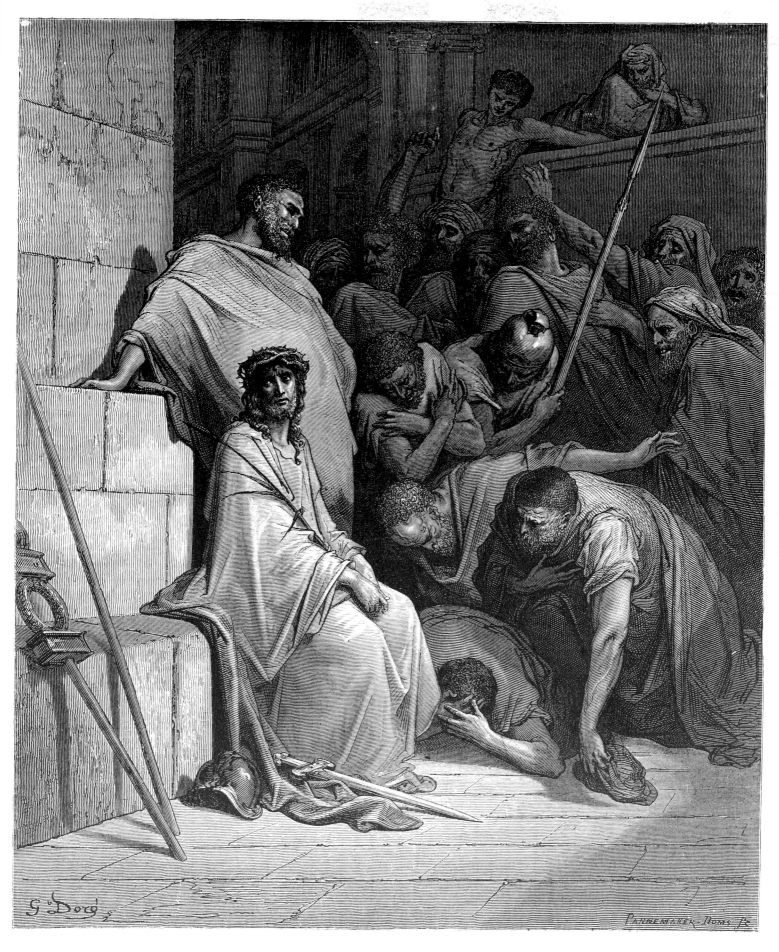

**The Bible**
**Matt. xxvii. 29–31**

*And when they had plaited a crown of thorns, they put it upon his head, and a reed in his right hand: and then they bowed before him and mocked him, saying, "Hail King of the Jews!"*

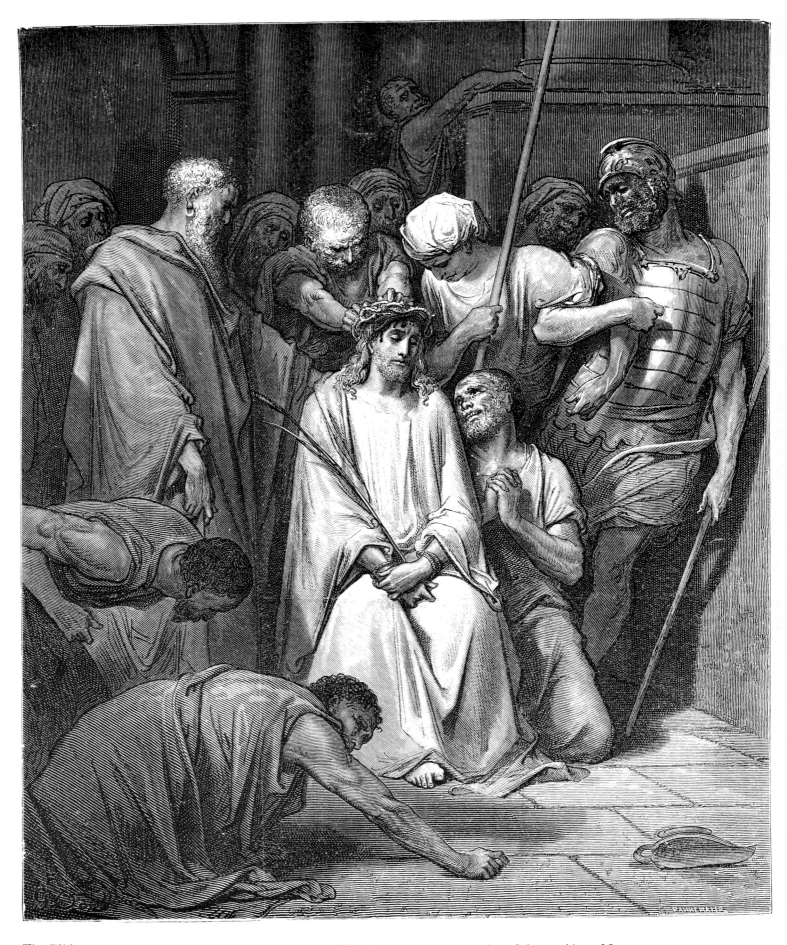

**The Bible**
**Matt. xxvii. 29–30**

This is another representation of the mocking of Jesus.

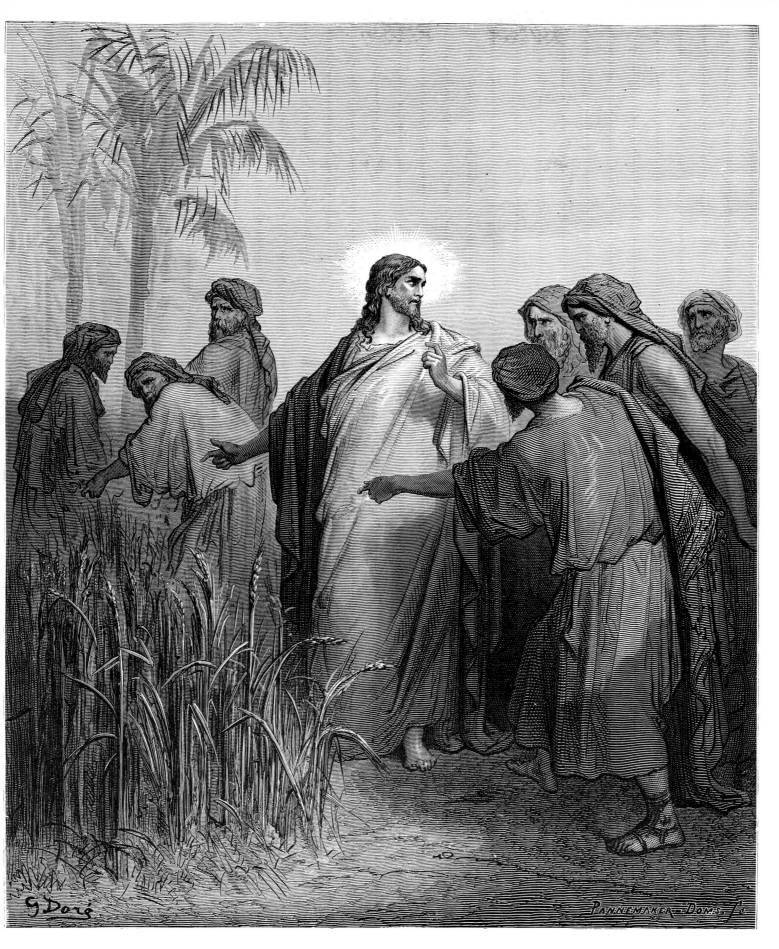

**The Bible**

**Mark ii. 23**

This scene depicts the famous occasion when Jesus and his disciples go into the cornfields on the sabbath. The Pharisees rebuke Jesus for acting unlawfully. He replies, "The sabbath was made for man, and not man for the sabbath."

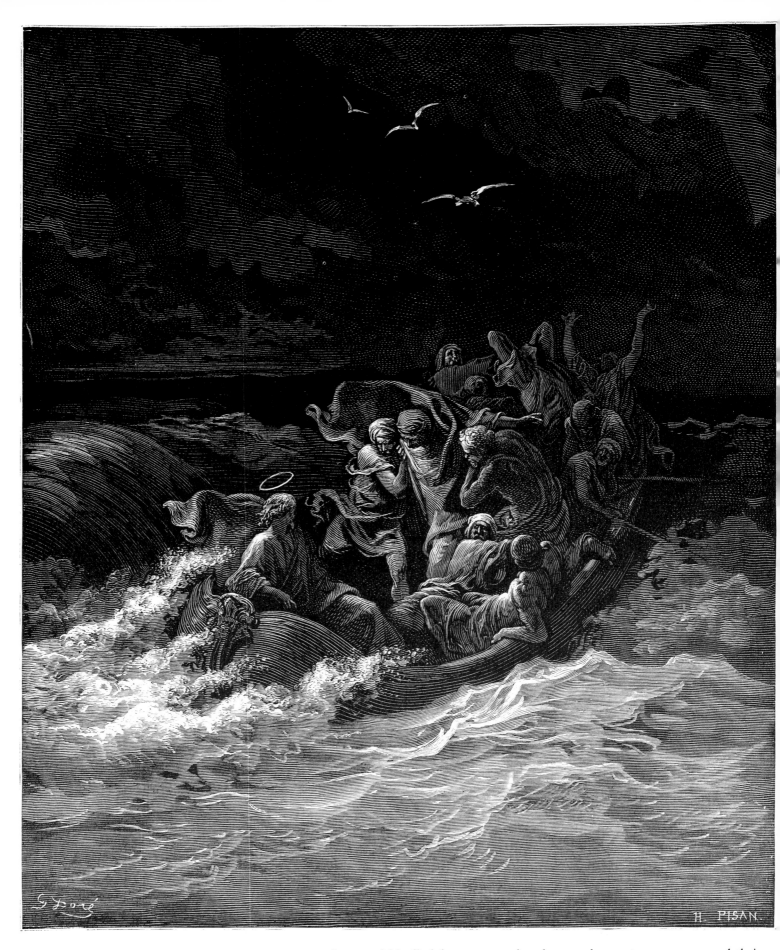

**The Bible**

**Mark iv. 37–9**

Jesus and his disciples were crossing the sea when a storm came on and their vessel was near to foundering. The disciples, being afraid, woke Jesus, who was asleep in the stern of the ship; upon which "he arose, and rebuked the wind, and said unto the sea, Peace, be still. And the wind ceased, and there was a great calm." He then rebuked the disciples for their lack of faith.

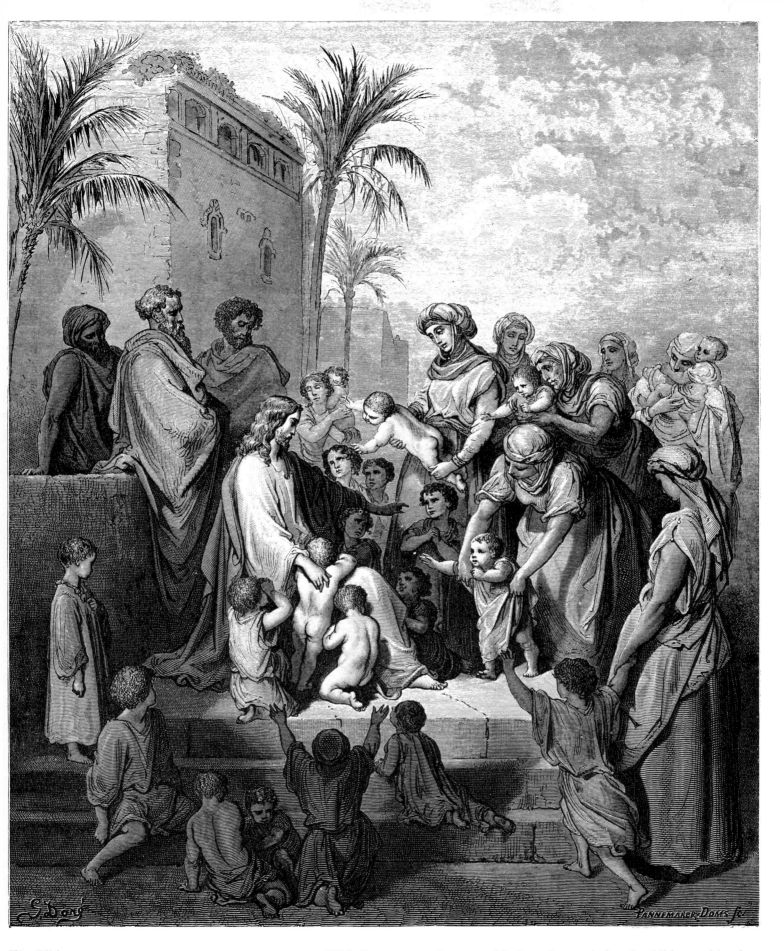

**The Bible**

**Mark x. 13–16**

While Jesus was on the coast of Judaea, the people bought children to him that he might touch them. The disciples rebuked them for this. Jesus, displeased, said, "Suffer the little children to come unto me, and forbid them not: for of such is the Kingdom of God. Verily I say unto you. Whosoever shall not receive the Kingdom of God as a little child, he shall not enter therein."

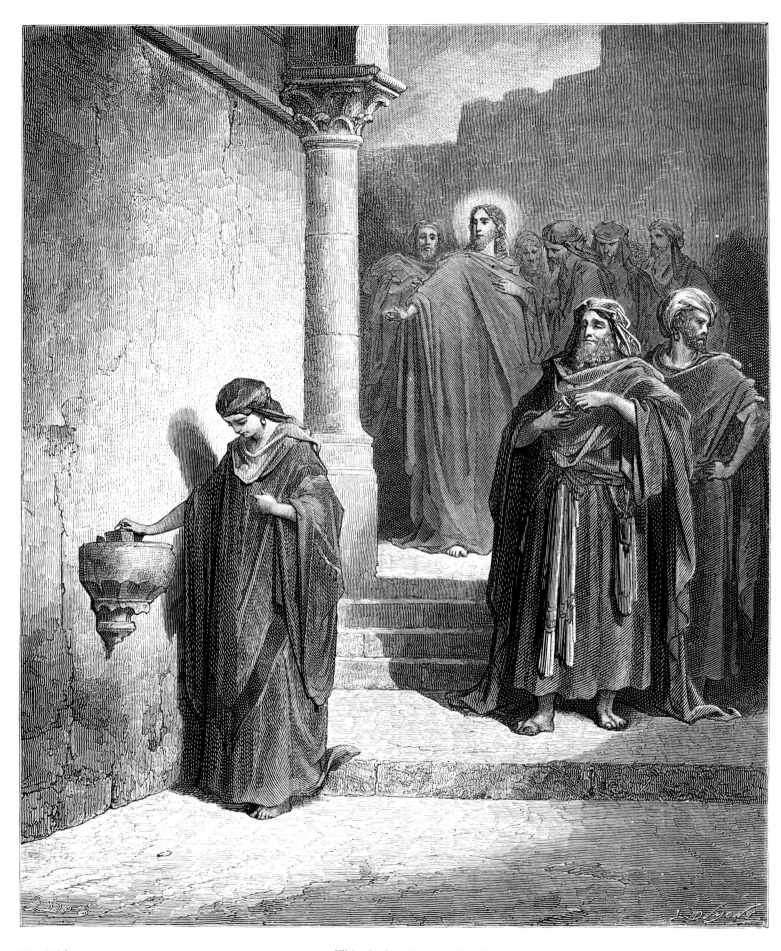

**The Bible**

**Mark xii. 41–4**

This depicts the parable of the widow's mite. Jesus sees the rich men osten-
tatiously cast money into the treasury in the temple, in contrast with the widow's
humble offering. He says, "For all they·did cast in of their abundance: but she
of her want cast in all that she had, even all her living."

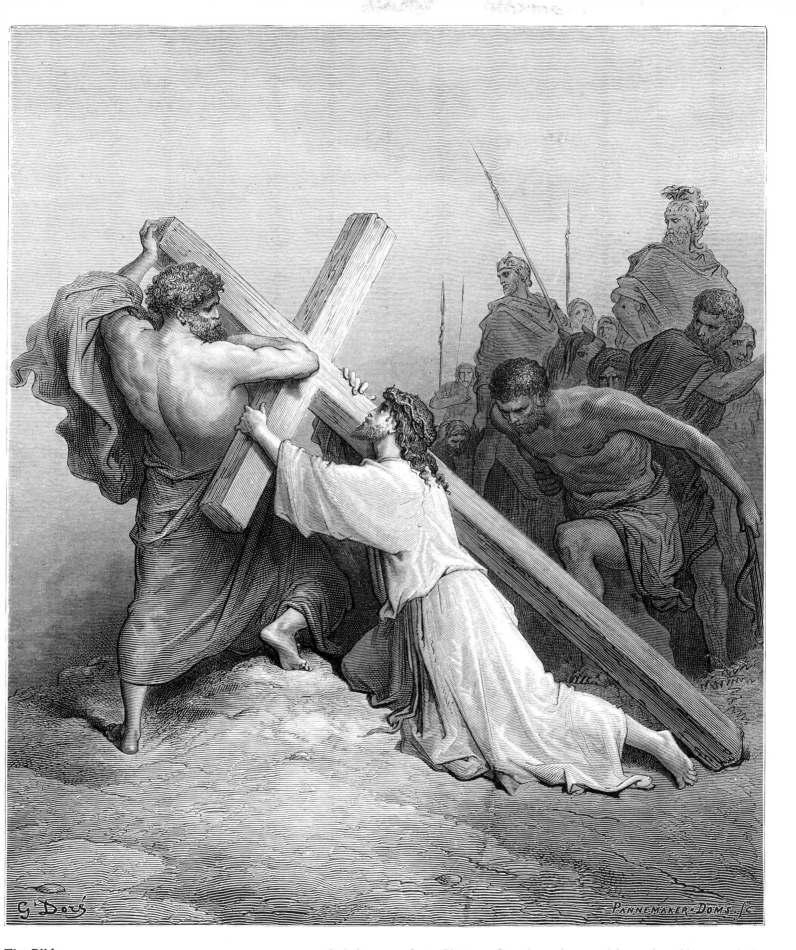

**The Bible**
**Mark xv. 21–2**

*And they compel one Simon, a Cyrenian, who passed by, to bear his cross. And they bring him unto the place Golgotha, which is, being interpreted, the place of a skull.*

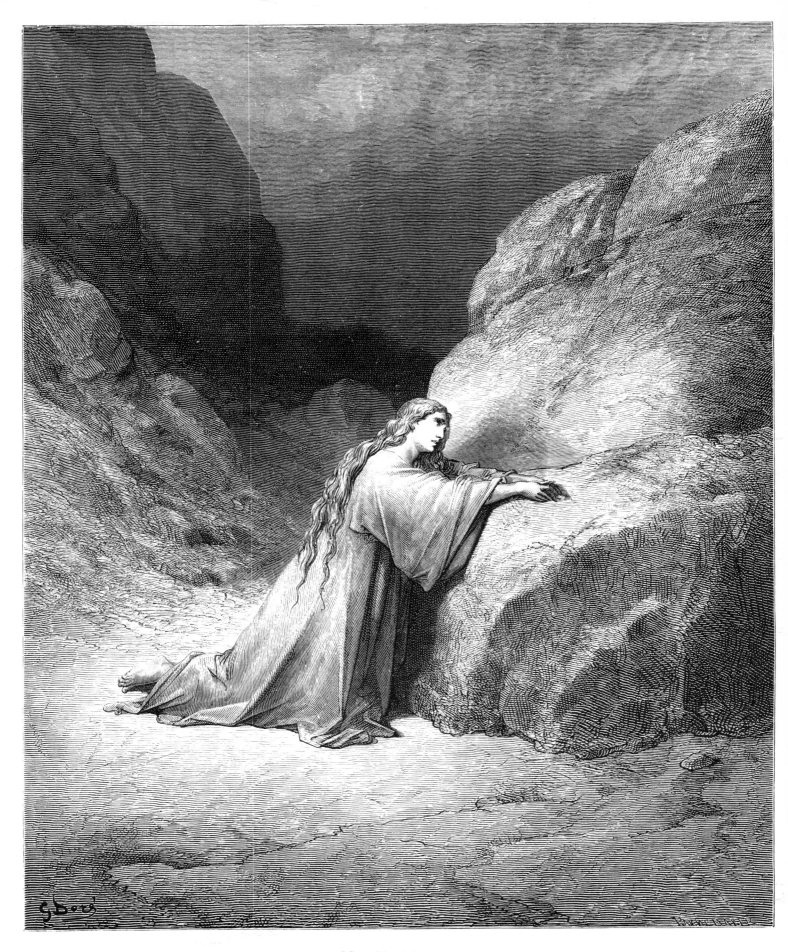

**The Bible**
**Luke vii. 47**

Mary Magdalene repentant.

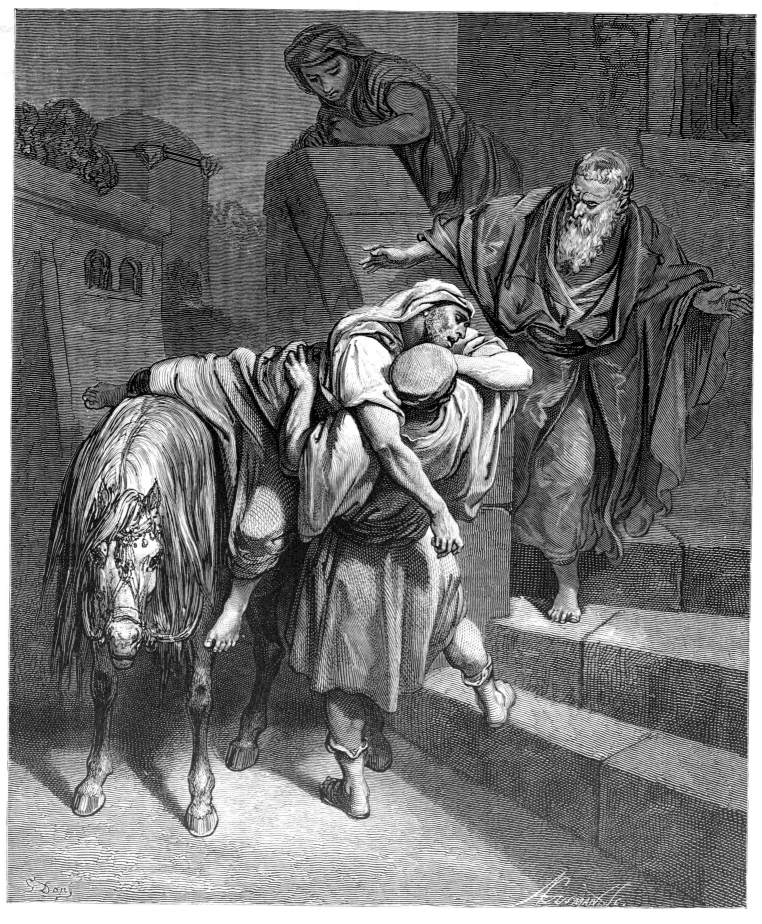

**The Bible**

**Luke x. 33–5**

Jesus having been asked how a man might inherit eternal life, answers that a man must not only love the Lord, but also love his neighbour as himself. To explain the latter Commandment he tells the famous parable of the Good Samaritan. Here we see the wounded man being helped into the inn, where the Samaritan enjoins the landlord to look after him at his expense.

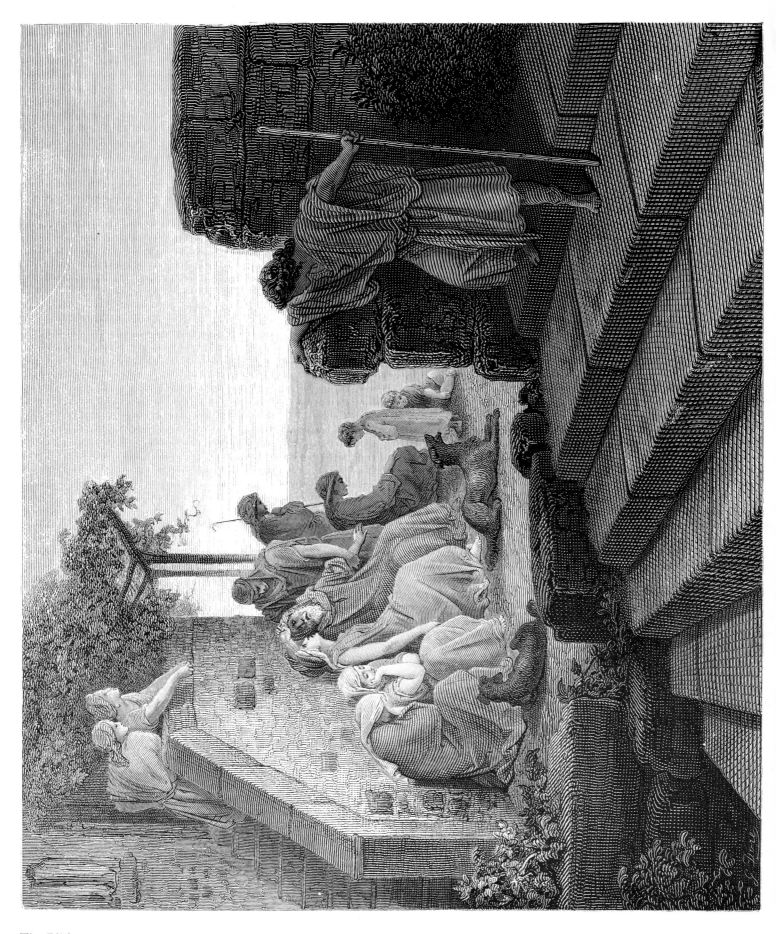

**The Bible**

**Luke xv. 18–19**

Here is seen the tentative approach of the repentant profligate to his father. The patriarch is surrounded by his family and not yet aware of the return of his prodigal son.

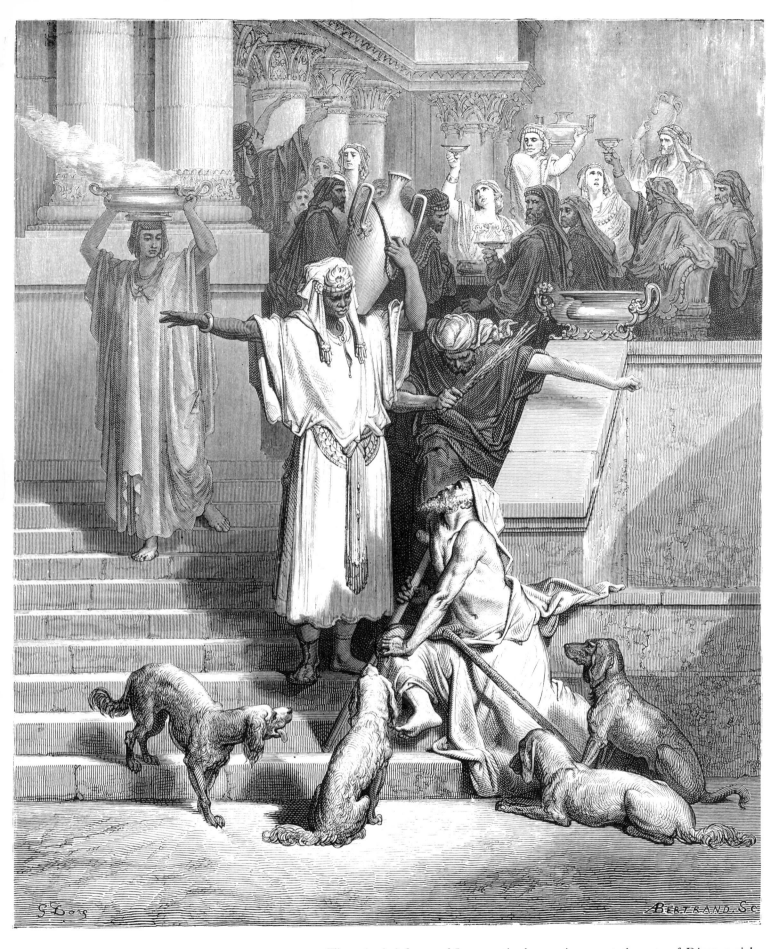

**The Bible**
**Luke xvi. 19–21**

The crippled figure of Lazarus the beggar is seen at the gate of Dives, a rich man. He begs for even the crumbs that fall from the table but is rejected. Soon afterward, both Dives and Lazarus die. The latter is transported to Heaven, and Dives to Hell.

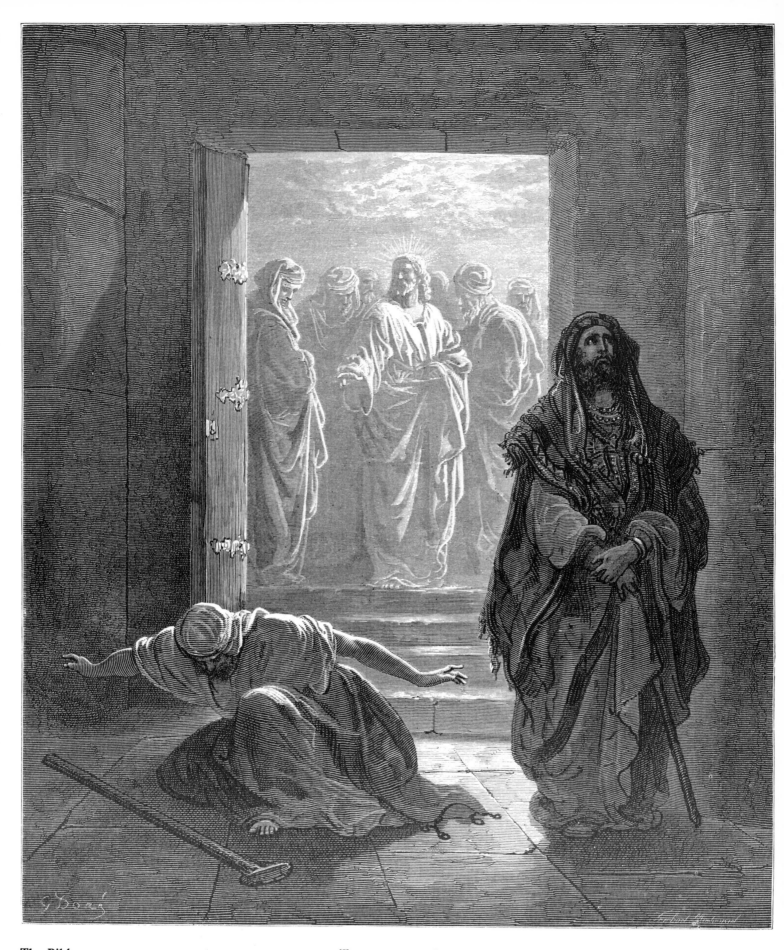

**The Bible**
**Luke xviii. 10–13**

Two men go to the temple to pray, one a Pharisee, the other a publican. The Pharisee thanks God that "he is not as other men are" whilst the publican pleads for forgiveness of his sins. Jesus says, "everyone that exalteth himself shall be abased; and he that humbleth himself shall be exalted."

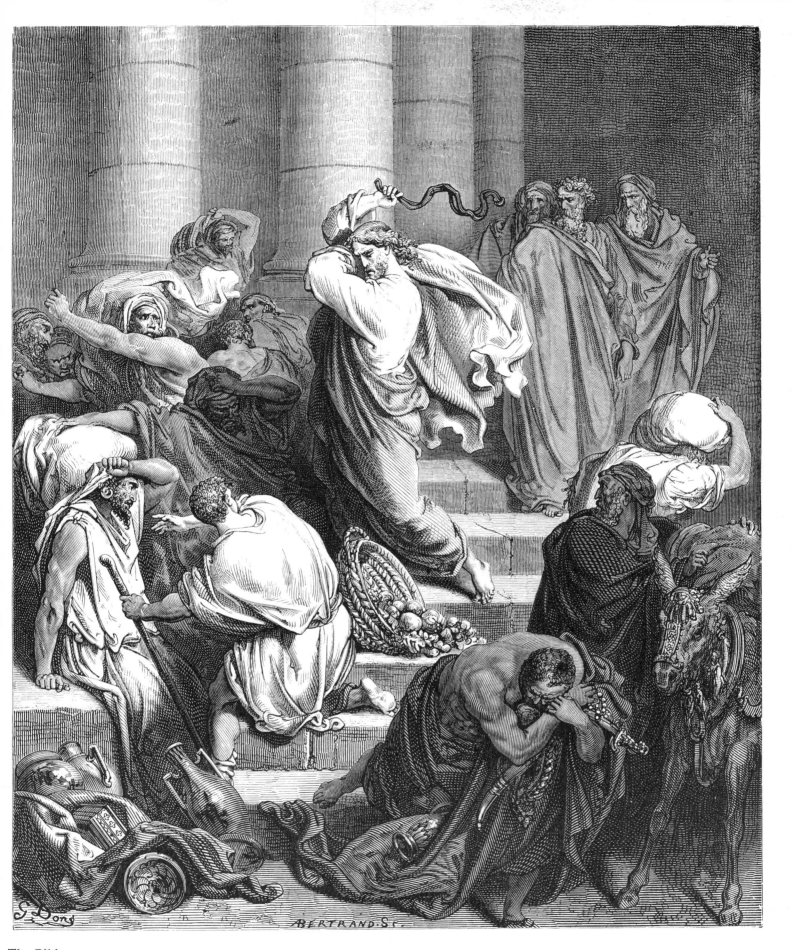

**The Bible**

**Luke xix. 45–6**

*And he went into the temple, and began to cast out them that sold therein, and them that bought: saying unto them, "It is written, My house is the house of prayer: but ye have made it a den of thieves."*

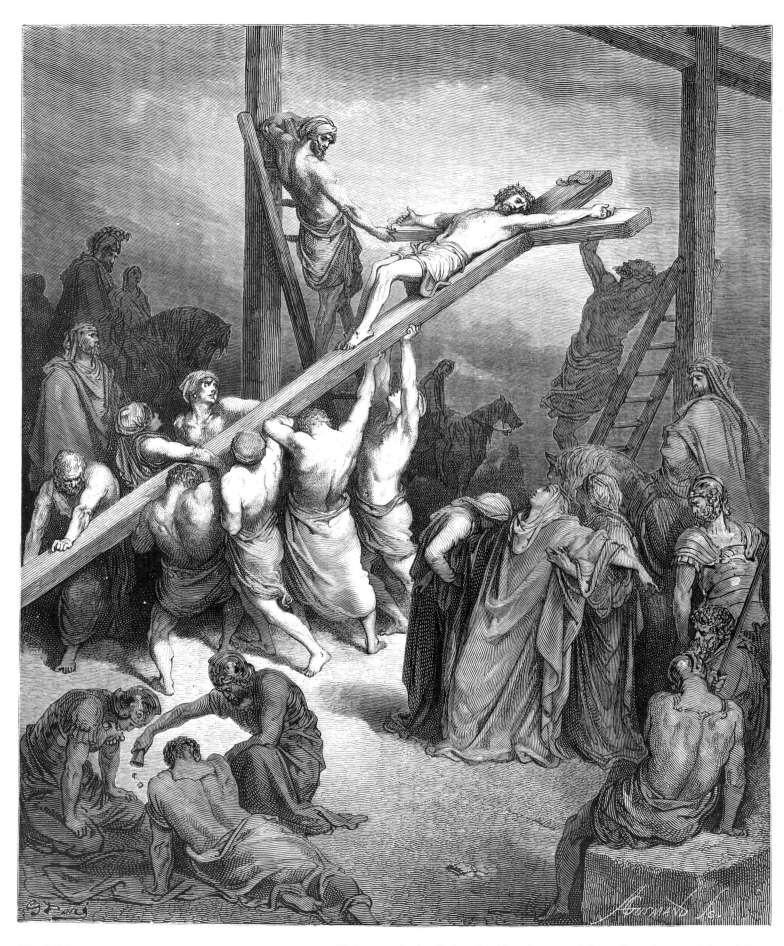

**The Bible**
**Luke xxiii. 32–3**

This scene is detailed and self-explanatory. The callous figures of the soldiers are seen in the foreground, as is the fainting figure of Mary in the arms of two women.

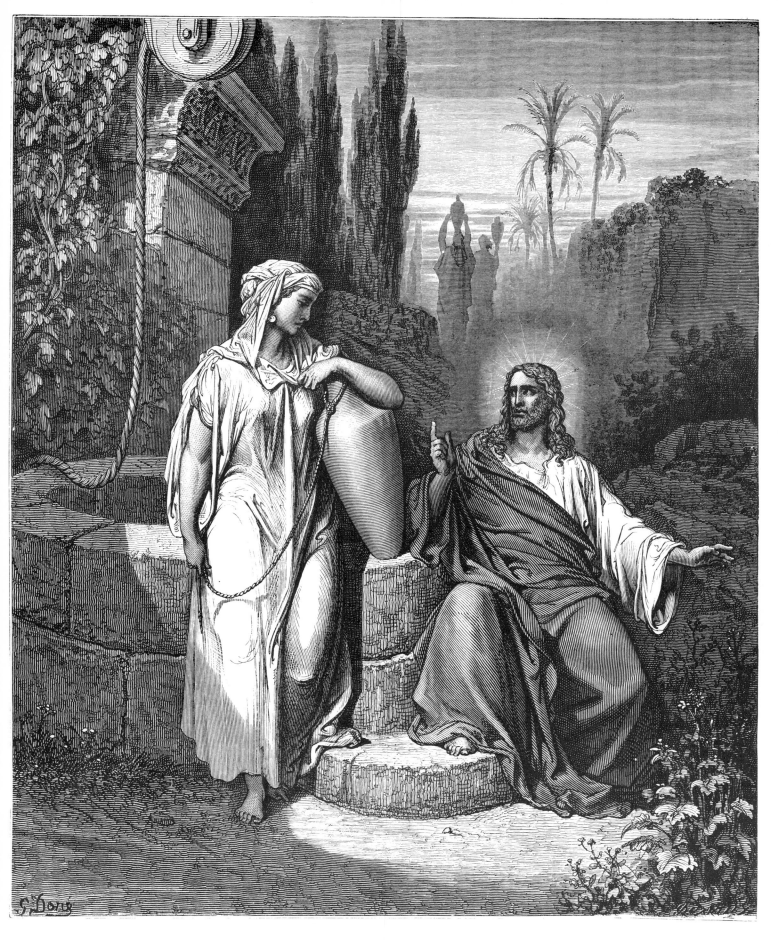

**The Bible**
**John iv. 7–10**

Jesus, wearied by a journey, is resting by Jacob's well. He meets a Samaritan woman who is surprised that a Jew will talk with her. Jesus holds long converse with her and proclaims himself to be the true Messiah.

**The Bible**

**John vi. 19–21**

Jesus, having fed the five thousand, goes down to a mountain to avoid the multitudes. As evening falls, the disciples start to sail across the Sea of Galilee and a great wind arises. They have gone but little distance when they see Jesus walking across the water to the boat.

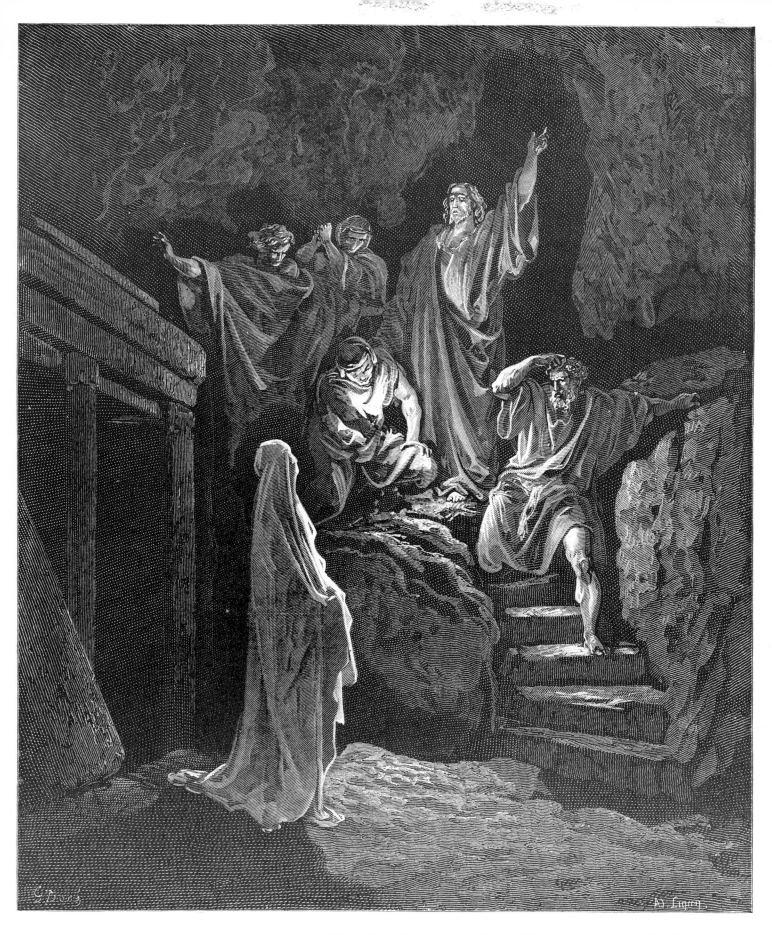

**The Bible**
**John xi. 41-4**

Mary Magdalene and Martha send for Jesus as their brother Lazarus is very ill. Jesus, because of his love for them, stays two days with the family to comfort them. He then travels to Judea with his disciples, where he hears of Lazarus's death. He returns when Lazarus has been in his tomb four days, and calls to Lazarus to come forth. Lazarus is resurrected from the dead.

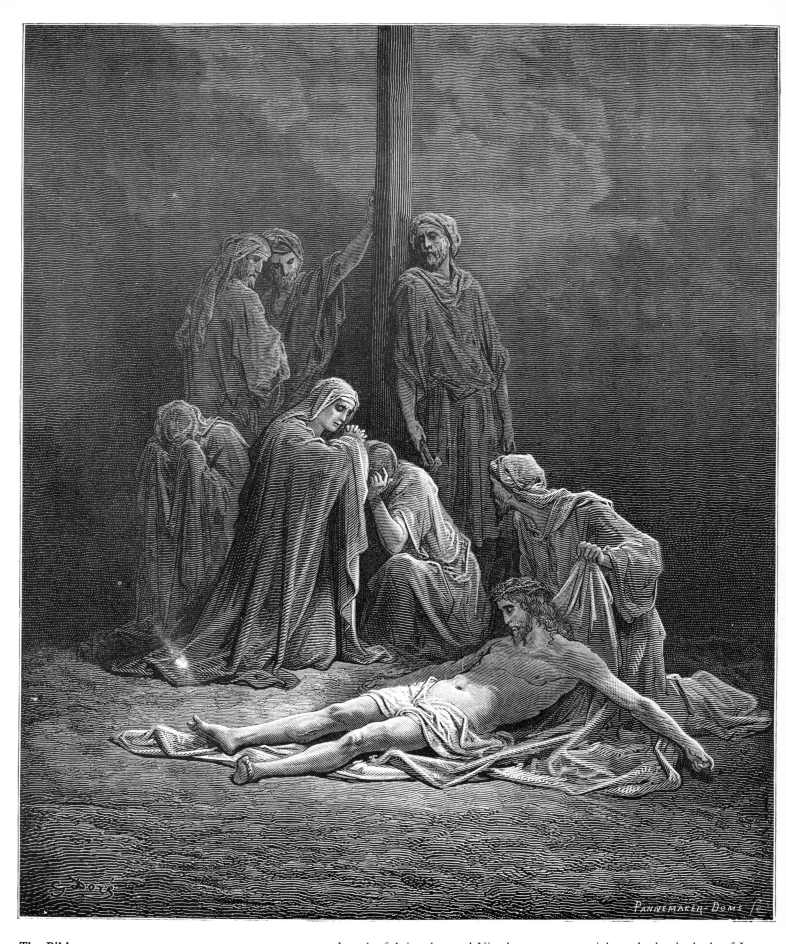

**The Bible**

**John xix. 40–2**

Joseph of Arimathea and Nicodemus come at night and take the body of Jesus down from the cross.

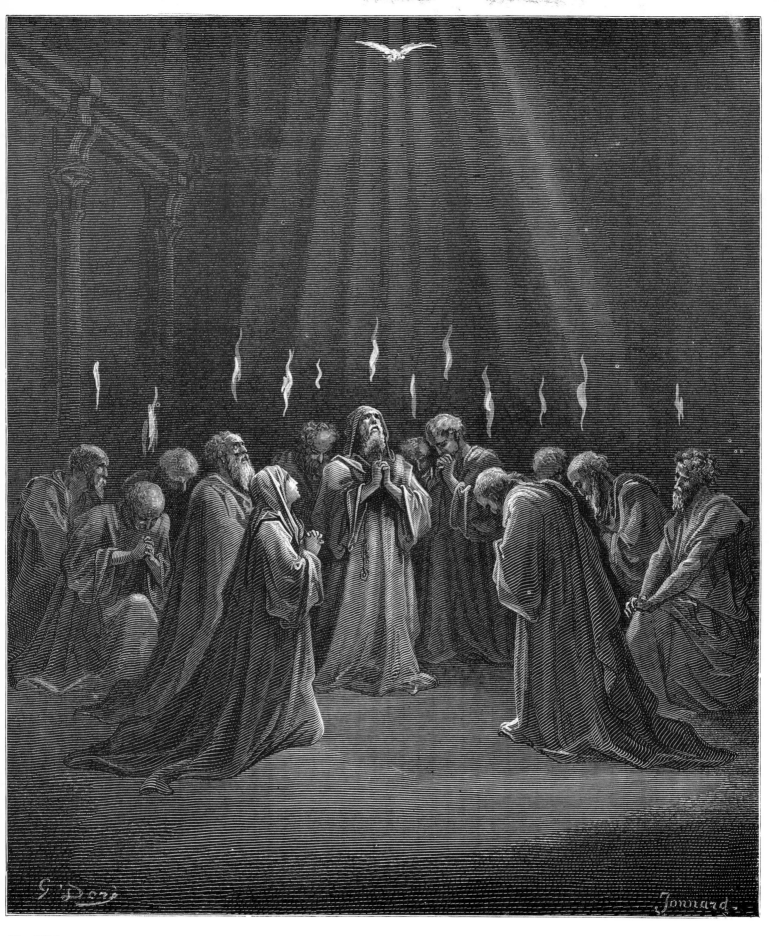

**The Bible**

**Acts ii. 2–4**

After the death of Jesus, on the day of Pentecost, the apostles are together. Suddenly the house is filled with the sound of a great wind. They see cloven tongues of fire and are filled with the spirit of the Holy Ghost.

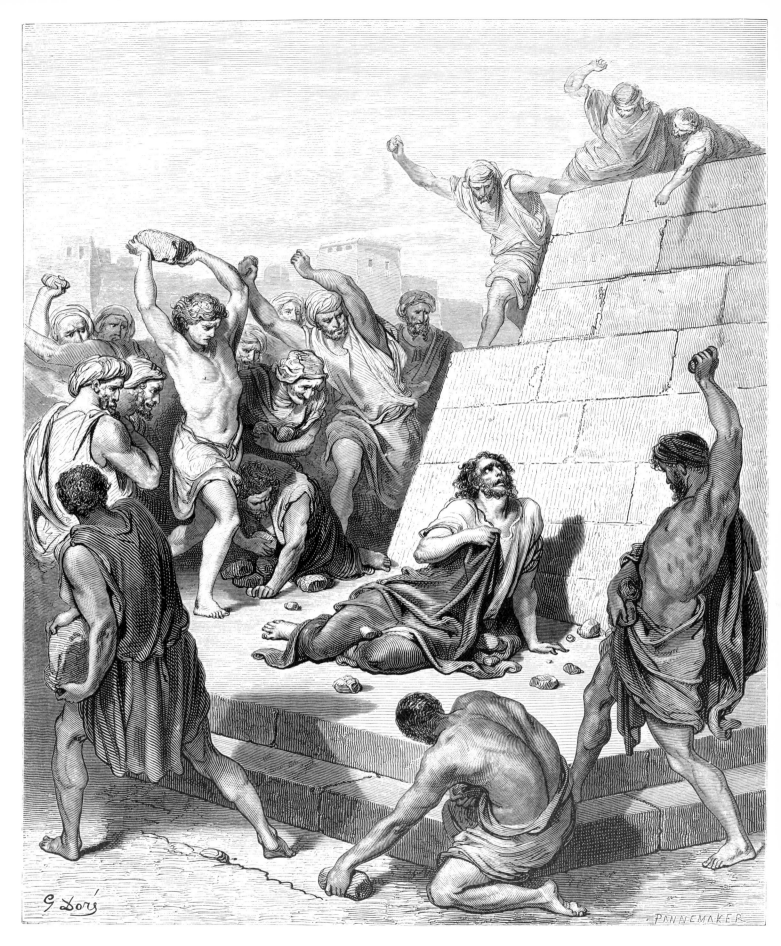

**The Bible**

**Acts vii. 58–60**

St Stephen, in answer to an accusation of blasphemy, delivers a long discourse in which he rebukes the Jews for their treatment of the prophets. Angered by this, the crowd set upon him and stone him to death. Before death, he calls on God to forgive them their sin.

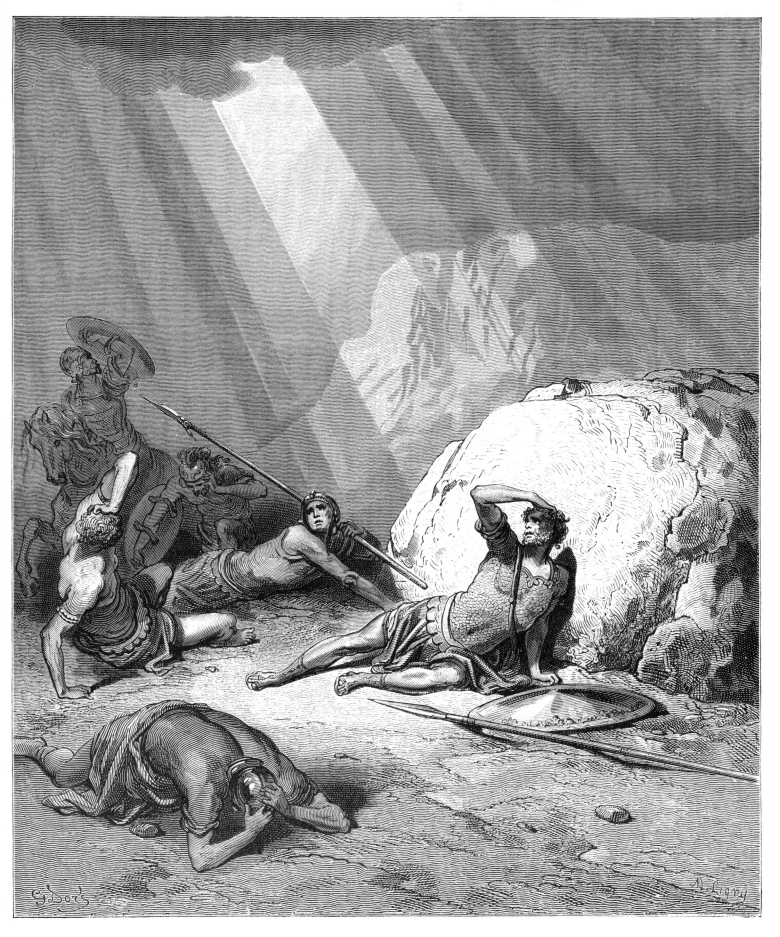

**The Bible**

**Acts iv. 1–6**

Saul, who eventually becomes known as Paul, was an enemy of the Christians. He obtained letters from the high priest in Jerusalem to take to Damascus giving authority for all followers of the new faith to be taken prisoner. On the road to Damascus, he is temporarily blinded by a great light and is spoken to by Jesus. His conversion is complete.

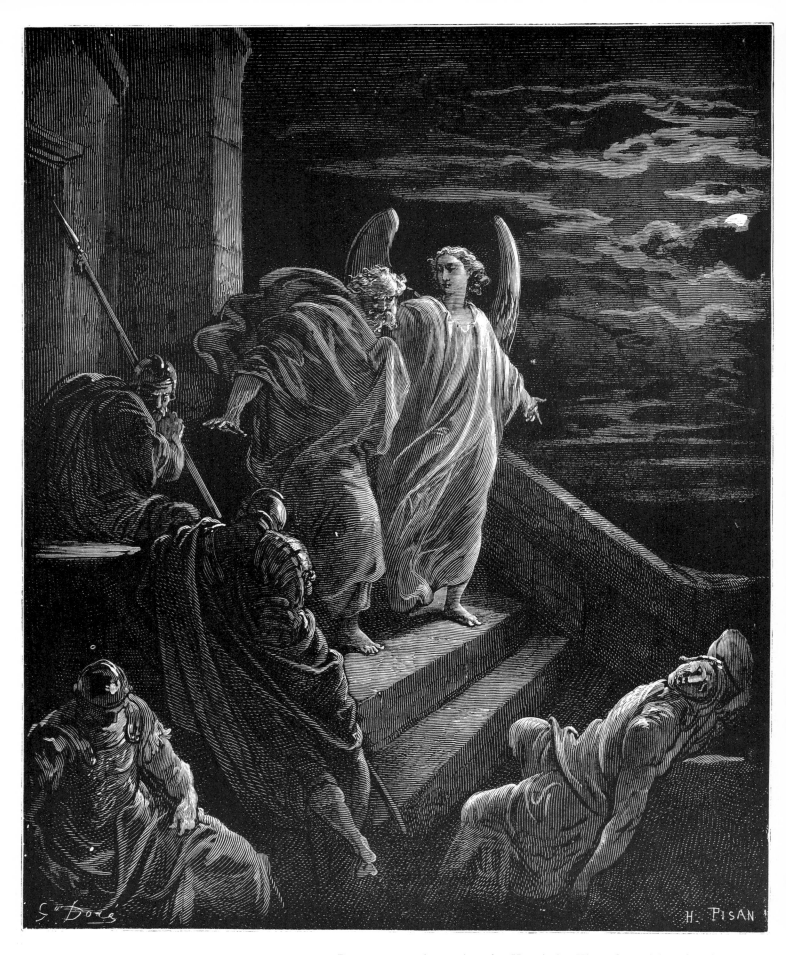

**The Bible**

**Acts xii. 7–10**

Peter was put into prison by Herod the King. One night when Peter was asleep, chained between two soldiers, an angel appeared. The chains fell from his hands and he was able to dress and leave the prison between the sleeping guards; even the series of prison gates opened before him.

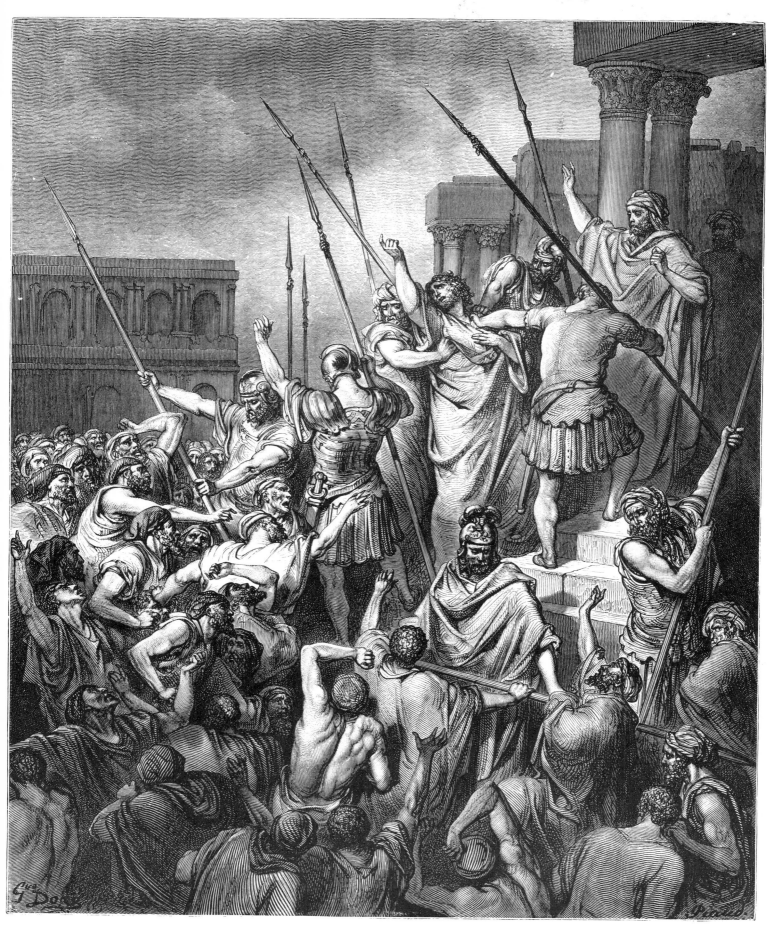

**The Bible**

**Acts xxi. 31–5**

Paul, on going to Jerusalem, is accused of preaching false doctrine in the temple. The anger of the crowds is so great that rioting breaks out and he is saved from harm by Roman soldiers.

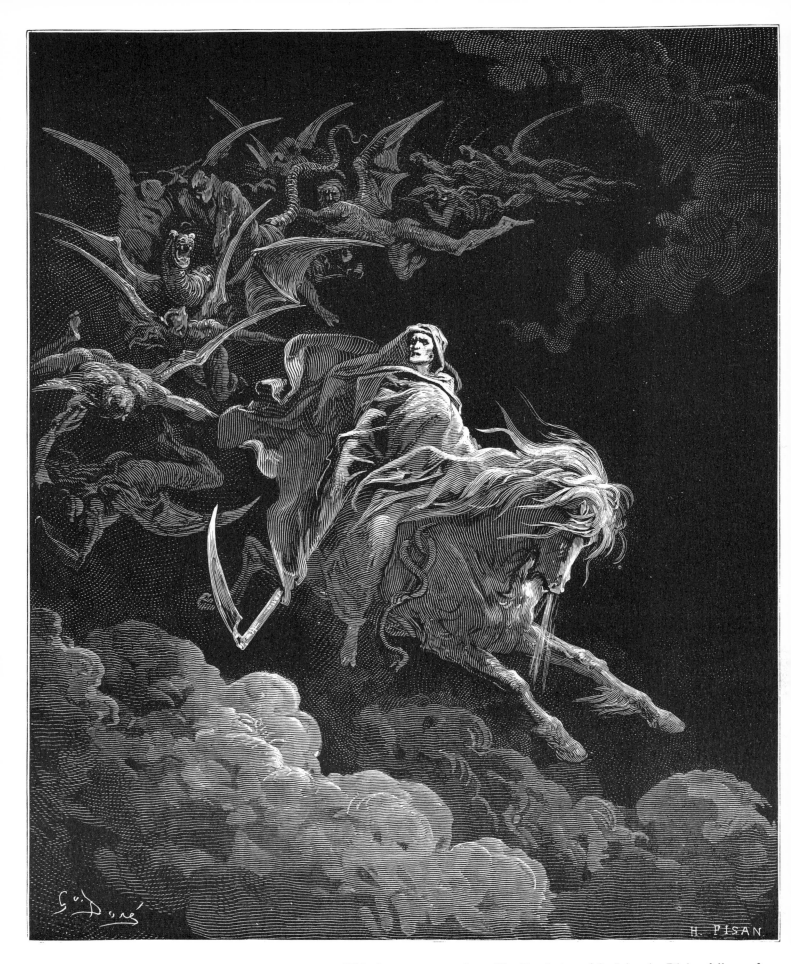

**The Bible**

**Rev. vi. 8**
"*And I looked, and beheld a pale horse:
and his name that sat on him was Death,
and Hell followed with him.*"

This famous passage from The Revelation of St John the Divine follows after the breaking of the fourth seal.

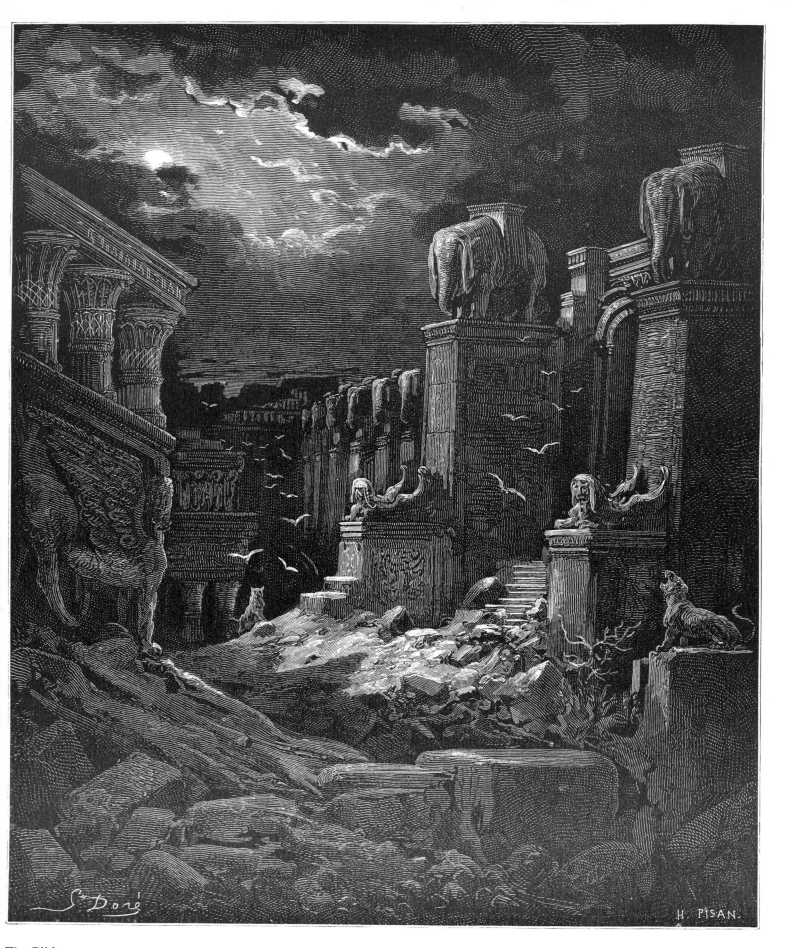

**The Bible**

**Rev. xviii. 2**

"*I saw another angel came down from heaven, having great power; and the earth
was lightened with his glory. And he cried mightily with a strong voice, saying,
Babylon the great is fallen, is fallen, and is become the habitation of devils.*"

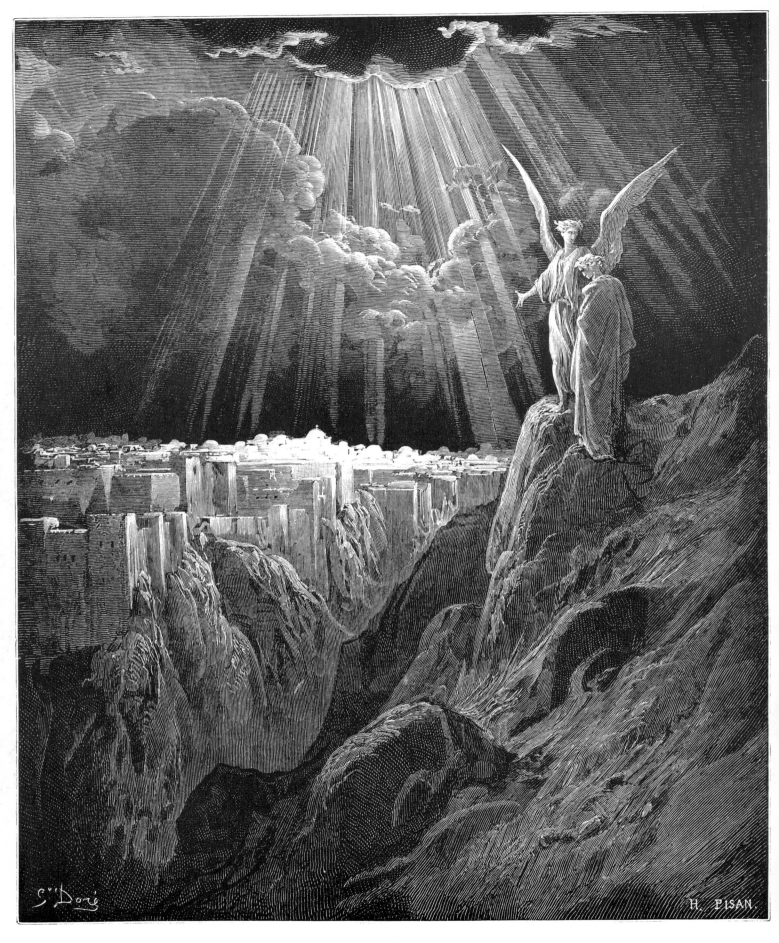

**The Bible**
**Rev. xxi. 10**

Chapter XXI of Revelations opens with the famous lines, "*And I saw a new heaven and a new earth: for the first heaven and the first earth were passed away; and there was no more sea.*" Later, one of the seven angels shows St John the new Jerusalem, here illustrated.